YAYOI KUSAMA INFINITY MIRRORS

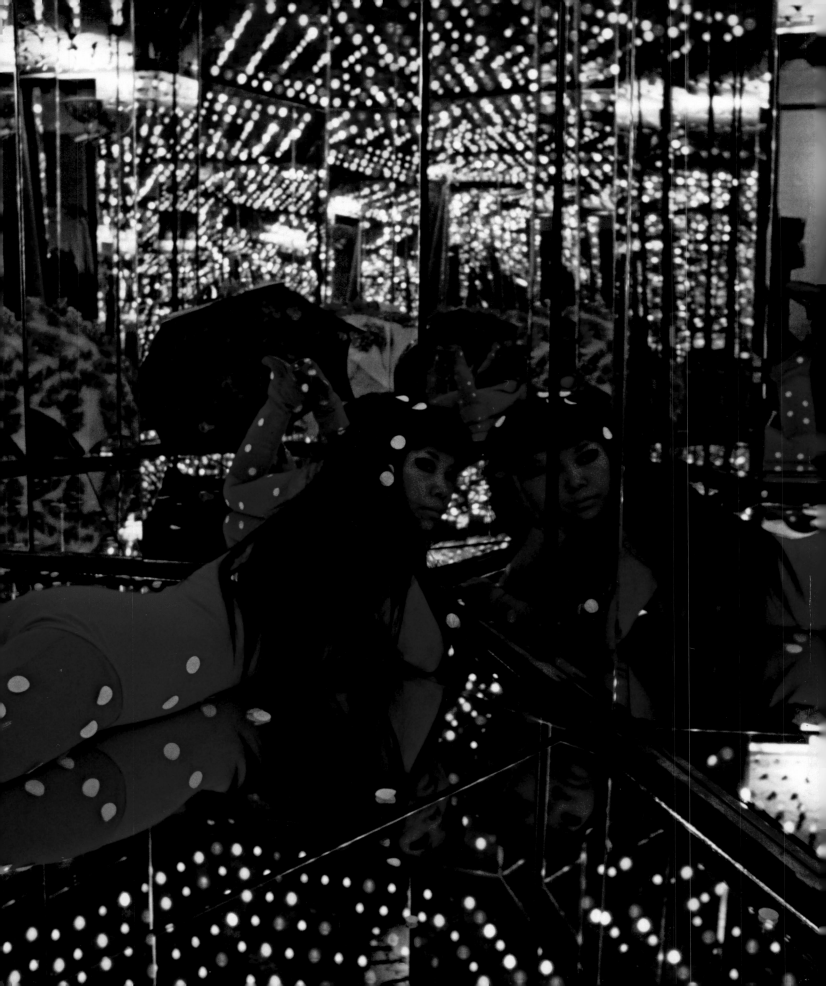

YAYOI KUSAMA INFINITY MIRRORS

Edited by Mika Yoshitake

With contributions by
Melissa Chiu
Alexander Dumbadze
Alex Jones
Gloria Sutton
Miwako Tezuka
Mika Yoshitake

Hirshhorn Museum and Sculpture Garden
Washington, DC

DelMonico Books • Prestel
Munich, London, New York

This catalogue is published in conjunction with the exhibition *Yayoi Kusama: Infinity Mirrors,* organized by the Hirshhorn Museum and Sculpture Garden, Smithsonian Institution, Washington, DC, February 23–May 14, 2017.

Exhibition tour:
Seattle Art Museum, June 30–September 10, 2017
The Broad, Los Angeles, October 21, 2017–January 1, 2018
Art Gallery of Ontario, Toronto, March 3–May 27, 2018
Cleveland Museum of Art, July 9–September 30, 2018
High Museum of Art, Atlanta, November 18, 2018–
 February 17, 2019

Yayoi Kusama: Infinity Mirrors has been made possible through generous lead support from Ota Fine Arts, Tokyo/Singapore, and Victoria Miro, London.

Major support has been provided by The Broad Art Foundation, Benjamin R. Hunter, and David Zwirner, New York/London.

The Museum is also grateful for the additional funding provided by Thierry Porté, Peggy P. and Ralph Burnet, the Hirshhorn International Council and the Hirshhorn Collectors' Council, as well as the contributions of Yayoi Kusama Inc. and the Embassy of Japan.

Contents

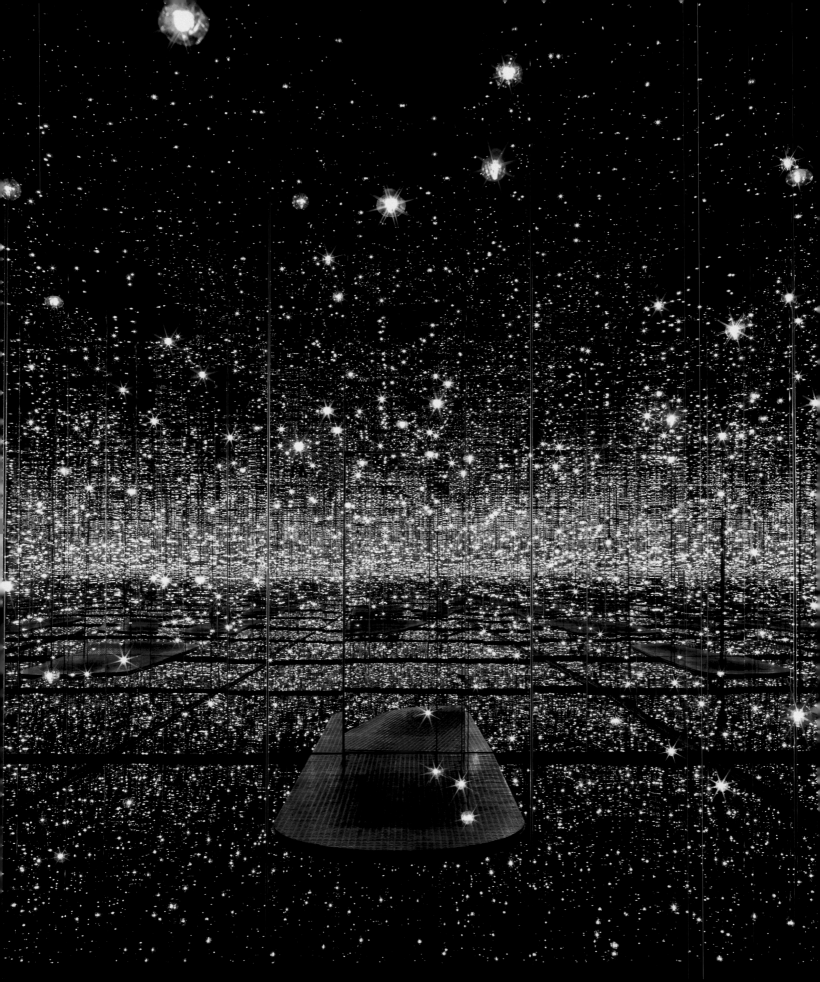

Foreword

A luminary in the cultural sphere who was named one of the "100 Most Influential People" by *Time* magazine in May 2016, Yayoi Kusama has now achieved an exalted status among the artists of our time. While numerous critical surveys have investigated Kusama's oeuvre in depth, *Yayoi Kusama: Infinity Mirrors* is the first institutional exhibition to explore the evolution of the celebrated Japanese artist's immersive, multireflective installations created over more than five decades. On view from February 23 to May 14, 2017, at the Hirshhorn Museum and Sculpture Garden, this ambitious exhibition addresses the phenomenological impact of Kusama's Infinity Mirror Rooms in relation to her career as a whole and presents some of her most iconic kaleidoscopic environments alongside key paintings, sculptures, and works on paper from the early 1950s to the present. It is also the first Kusama exhibition to tour North America in nearly two decades.

Organized by Hirshhorn Museum Curator Mika Yoshitake, the exhibition begins with a new iteration of the artist's landmark installation *Infinity Mirror Room—Phalli's Field* (1965), in which Kusama displayed a dense field of hundreds of red-spotted phallic sculptures in a room lined with mirrors. The exhibition also includes *Infinity Mirrored Room—Love Forever* (1966/1994), a hexagonal mirror chamber that the artist used to stage performances inside her studio and into which viewers peer to see endlessly reflected flashing lights. Kusama's signature bold polka dots are featured in *Dots Obsession—Love Transformed into Dots* (2007), a multimedia installation with a domed mirror room surrounded by multiple inflatables suspended from the ceiling. In more recent LED-lit environments, such as *Infinity Mirrored Room—Aftermath of Obliteration of Eternity* (2009) and *Infinity Mirrored Room—The Souls of Millions of Light Years Away* (2013), lanterns and crystalline beads hover in realms of virtual space. This will also be the institutional debut of *Infinity Mirrored Room—All the Eternal Love I Have for the Pumpkins* (2016), featuring dozens of her signature bright yellow dotted pumpkins.

The Hirshhorn's circular architecture, which can be read as an infinite space in itself, provides an ideal setting for these constructed environments. Visitors exploring the building inevitably become part of the works, activating them by participating in Kusama's sensory pilgrimage. The Infinity Mirror Rooms invite viewers to experience a myriad of dualities and challenge preconceived notions of autonomy, time, and space. Integrated into the exhibition along with

the Infinity Mirror Rooms is a selection of more than sixty paintings, sculptures, and works on paper, showcasing many of Kusama's lesser-known collages made after her return to Japan in 1973. The exhibition traces the artist's trajectory from her early Surrealist-inspired works on paper, Net paintings, and Accumulation assemblages to My Eternal Soul, her latest series of vibrantly colored paintings, as well as soft sculptures, highlighting recurring themes of nature and fantasy, unity and isolation, obsession and detachment, and life and death. The presentation concludes with Kusama's iconic participatory installation *The Obliteration Room* (2002), an all-white replica of a traditional domestic setting. Upon entering, visitors are invited to cover every surface of the furnished gallery with multicolored polka dot stickers, gradually engulfing the entire space in pulsating color.

This catalogue takes an interdisciplinary approach to Kusama's work and includes a catalogue raisonné of the artist's Infinity Mirror Rooms to date. The book's essays— by Mika Yoshitake, Gloria Sutton, and Alexander Dumbadze— introduce new scholarly perspectives on this pioneering contemporary artist. The illustrated chronology by Miwako Tezuka incorporates newly published archival material. Also included are an annotated bibliography by Alex Jones and my own recent one-on-one interview with Yayoi Kusama.

Organizing an exhibition of this scale requires the good will of many individuals and organizations. On behalf of the Trustees and staff of the Museum, I express our profound thanks to the lenders and institutions that have generously allowed us to borrow their treasured artworks. In addition, numerous private individuals and museum colleagues helped bring this complex exhibition to fruition, and to them I express my deepest gratitude.

The exhibition and publication were conceived and organized by Mika Yoshitake, whose expertise in postwar Japanese art and bilingual abilities were essential for communication with the artist's studio and the success of this project. I sincerely thank Mika for her insight and deft management of such an ambitious undertaking, and I join her in acknowledging the outstanding efforts of the entire Hirshhorn staff for contributing to the realization of this endeavor. All of us at the Hirshhorn are appreciative of the strong support that we have been given by the Smithsonian's institutional leadership, particularly David J. Skorton, Smithsonian Secretary, and Richard Kurin, Acting Provost and Undersecretary for Museums and Research.

We are thankful for the generous funding that we received from the sponsors of the exhibition. *Yayoi Kusama: Infinity Mirrors* has been made possible through generous lead support from Ota Fine Arts, Tokyo/Singapore, and Victoria Miro, London. Major support has been provided by The Broad Art Foundation, Benjamin R. Hunter, and David Zwirner, New York/London. The Museum is also grateful for the additional funding provided by Thierry Porté, Peggy P. and Ralph Burnet, the Hirshhorn International Council and the Hirshhorn Collectors' Council, as well as the contributions of Yayoi Kusama Inc. and the Embassy of Japan.

I would like to extend a very special thank you to our exhibition tour partners and especially to their directors— Kimerly Rorschach at the Seattle Art Museum; Joanne Heyler at The Broad, Los Angeles; Stephan Jost at the Art Gallery of Ontario, Toronto; William M. Griswold at the Cleveland Museum of Art; and Rand Suffolk at the High Museum of Art, Atlanta—for their shared courage and enthusiasm in bringing this ambitious exhibition to their respective communities.

Finally, I extend the Hirshhorn's deepest gratitude to Yayoi Kusama, whose unwavering energy and support have been a true inspiration. We have been extremely fortunate to work with Kusama and to have received incredible support from so many individuals and organizations, all of whom have enabled *Yayoi Kusama: Infinity Mirrors* to fulfill the Hirshhorn's continuing commitment to the global and transformative art of our time.

Melissa Chiu
Director
Hirshhorn Museum and Sculpture Garden

Acknowledgments

Yayoi Kusama: Infinity Mirrors traces the evolution of Kusama's Infinity Mirror Rooms and her unique world of "self-obliteration" from a strategy of radical connectivity and political liberation during the Vietnam War to a shared condition of social harmony in the present. It sheds light on the importance of the artist as a pioneer of early kinetic, participatory, and performance art practices while offering insight into how the Infinity Mirror Rooms allow us to reassess the artist's practice through a new critical understanding of our tactile relation to objects and the immateriality of virtual space.

An exhibition of this complexity would not be possible without the contributions of many. First and foremost, I thank Yayoi Kusama for her remarkable career—one that has touched millions of people and continues to challenge and inspire us. I am indebted to Yayoi Kusama Studio for its tireless work and meticulous attention to each and every aspect of this exhibition. From the very beginning, it has helped to make the technical and conceptual complexities of this project remarkably pleasant. On behalf of the studio, we thank Owl Corporation for its flawless realization of the Infinity Mirror Rooms.

Kusama's galleries have played a key role in the realization of this exhibition. At Ota Fine Arts, Tokyo, I thank Hidenori Ota and his team for their critical roles in introducing me to Kusama and her studio staff and for their incredible support of the exhibition. At David Zwirner, New York, my deep appreciation goes to Hanna Schouwink and her assistant Cristina Vere Nicoll; to Christopher D'Amelio and his assistant Veronica Tyler for helping to locate and secure key works on paper; to Chris Medina and Stephanie Daniel for technical and registrarial advice; and to Chris Rawson for images. At Victoria Miro, London, I am grateful to Glenn Scott Wright, Erin Manns, Rob Phillips, Mary Taylor, Rachel Taylor, and Anja Ziegler for aiding in the myriad of details on installation specifications and the catalogue.

In developing this project, I have been personally moved by the generosity of our lenders for agreeing to include their valuable works on this long tour. Profound thanks are due to Yayoi Kusama Inc.; Brendan Becht of the Agnes and Frits Becht Collection; Suzanne Deal Booth; Guoqing Chen; Ethan Cohen Fine Arts; Charles and Val Diker; Mark Diker and Deborah Colson; Carla Emil and Rich Silverstein; Sandra and Howard Hoffen; Sheldon Inwentash and Lynn Factor; Miyoung Lee and Neil Simpkins; The Rachel and Jean-Pierre Lehmann Collection; Ota Fine Arts, Tokyo/Singapore;

Hart Perry of the Hart and Beatrice Perry Collection; Howard and Cindy Rachofsky of The Rachofsky Collection; Ushio and Noriko Shinohara; Ryūtarō Takahashi of the Takahashi Collection; Jerry Yang and Akiko Yamazaki; and lenders who wish to remain anonymous. We are grateful to Lauren Ryan and David Moos for their critical assistance in securing key loans. Thanks also to IKEA Washington, DC, for generously donating the furniture for *The Obliteration Room* at the Hirshhorn.

I am equally indebted to colleagues at various institutions for agreeing to lend some of their most cherished collection works: Theresa Bembnister at the Akron Art Museum; Kristen Hileman and Mary Sebera at the Baltimore Museum of Art; Veronica Roberts at the Blanton Museum of Art, the University of Texas at Austin; Gavin Delahunty at the Dallas Museum of Art; Akira Shibutami at the Matsumoto City Museum of Art; Cora Rosevear, Lucy Gallun, and Tasha Lutek at the Museum of Modern Art, New York; Harry Cooper at the National Gallery of Art, Washington, DC; Aya Katō at the Setagaya Art Museum; and Aaron Seeto and Reuben Keehan at the Queensland Art Gallery, Brisbane.

This exhibition would not have been possible without the remarkable efforts of the Hirshhorn staff. I thank Director Melissa Chiu for spearheading this project—a longtime dream of hers—and for her leadership in bringing the show to fruition. Thanks also to Deputy Director Elizabeth Duggal's tireless and impressive administrative management and to Chief Curator Stéphane Aquin, who was a true supporter of the show from the beginning. I am so grateful to my former Curatorial Research Assistant Alex Jones for her invaluable assistance in coordinating every aspect of this major exhibition during and after my maternity leave in fall 2015. She has been a true intellectual companion, contributing a brilliant annotated bibliography in this volume. Curatorial Assistant Sandy Guttman, who came to this project when it was well underway, contributed to its success in myriad ways. She wrote didactics, led numerous tours, and gracefully managed the additional loan requests for the exhibition's tour. Betsy Johnson, also a Curatorial Assistant, kindly stepped away from her other projects to lead tours and offer insight.

My greatest thanks go to our exhibition manager Lawrence Hyman for his unbelievable organization in overseeing the budget and contracts and for making this five-venue exhibition a reality. I could not ask for a more professional team in our Exhibits Department staff under the leadership of Al Masino, who brought incredible insight and effort into overseeing the particular environmental, safety, and fabrication challenges of displaying multiple Infinity Mirror Rooms. My heartfelt thanks to Scott Larson for working so closely with the studio and for his thoughtful work in managing the complex production and execution of the Infinity Mirror Rooms, to John Klink for his meticulous work in drafting the scaled plans, and to William "Tex" Andrews for leading the installation at the tour venues. Larissa Raddell organized and oversaw the installation of *The Obliteration Room*. Chief Registrar Raj Solanki and Exhibits Registrar, Melissa Altman Sapsford, did incredible work managing this massive, multivenue exhibition. Thanks to Conservators Stephanie Lussier and Gwynne Ryan, whose knowledge has been extremely valuable for both the exhibition and tour. I am grateful to New Media Coordinator Drew Doucette and ARTLAB+'s Cody Coltharp for their work on the virtual reality device for handicap accessibility and to Jacob Kim for his creative website design. Beth Skirkanich and Kristi Mathias produced beautiful graphics for the exhibition and announcement materials. Thanks to Emily Moqtaderi, Lindsay Gabryszak, and Heidi Sweely in the Hirshhorn's Advancement office for their fundraising efforts. Thanks also go to Jean Belitsky, who managed the influx of new memberships, and to Dominique Lopes and Toni Callahan for their hard work. Allison Peck and Hilary-Morgan Watt in Communications did a great job of managing media outreach and coordinating publicity with all of the tour venues. Visitor Services Manager Samir Bitar brought extraordinary skills to bear in coordinating advanced planning for crowd control and ticketing. Vincent Deschamps and Kevin Hull spent long days, nights, and weekends at the Hirshhorn. They worked with the Museum's Gallery Guides and Visitor Services Attendants to ensure that our visitors had positive experiences at the Museum. Ed Howell at Smithsonian Enterprises provided absolutely critical logistical ticketing support for the exhibition. I also thank Ray Moore for producing wonderful merchandise for the Museum store and former librarian Anna Brooke for obtaining Kusama publications and assisting with research. Chris Wailoo and his team provided essential financial management services, and Amy Bower deftly and gracefully coordinated all public programs related to the project. Ashley Meadows coordinated countless group tours with unflagging enthusiasm. Last, but not least, curatorial colleagues Evelyn Hankins, Gianni Jetzer, and Valerie Fletcher provided wonderful moral support.

This publication reflects new insights into Kusama's work, and I thank our fabulous contributors for providing new research and contextual frameworks. Gloria Sutton touches on the Infinity Mirror Rooms in the context of Expanded Cinema and new media, while Alexander Dumbadze discusses the social and political context of Kusama's mirror rooms and performances against the backdrop of the Vietnam War. Melissa Chiu's interview illuminates the artist's life and latest work, while Miwako Tezuka's illustrated chronology brings new archival material to light, and Alex Jones's annotated bibliography surveys the historical and recent discourse on the artist's environments. My most profound gratitude goes to our outside editorial consultant for her encyclopedic knowledge of Kusama's practice. We also thank Reiko Tomii, Sen Uesaki, and Midori Yoshimoto for their archival assistance and expertise. The catalogue texts benefited greatly from Tom Fredrickson's acumen and thorough editorial work. Designer Miko McGinty, along with Rita Jules, has produced a powerful and elegant design that resolved the challenges of reproducing the Infinity Mirror Rooms. I am utterly grateful to Mary DelMonico and her team at DelMonico Books • Prestel, Luke Chase and Karen Farquhar, for their professionalism and enthusiasm for the project. I am also indebted to Rhys Conlon, the Hirshhorn's Editor and Publications Manager, for her important organizational role early in the project and for leaving us in great hands during her maternity leave; and to Publications Assistant Molly Harrington for her efficient organizational assistance with procuring images and rights and proofreading. Profound thanks are due to Cathy Carver for producing, with the assistance of Julia Murphy, beautiful new photography, as well as to intern Lindsey Yancich for overall assistance with the catalogue. I thank the individuals and institutions that helped with images: Arnold Tunstall at the Akron Art Museum, Ohio; Suzanne Stephens at the Birmingham Museum of Art, Alabama; Takayuki Tani at Bungeishunju;

Vlad Sludskiy at Ethan Cohen Fine Arts; John Tain at the Getty Research Institute, Los Angeles; Tom Haar; Eikoh and Kenji Hosoe; Christian and Franziska Megert; Meguro Museum of Art; Takao Miyakaku; Mami Kataoka at the Mori Art Museum, Tokyo; Jennifer Belt at Art Resource for the Museum of Modern Art, New York; Mika Kuraya at the National Museum of Modern Art, Tokyo; Hart Perry; the Queensland Art Gallery, Brisbane; the Setagaya Museum of Art; Harrie Verstappen; the Whitney Museum of American Art, New York; and ZERO Foundation, Dusseldorf. Thanks also to Sydney Kilgore, Media Coordinator at the Fine Arts Library of the University of Texas at Austin, for sharing the interviews conducted for the seminal 1989 exhibition *Yayoi Kusama: A Retrospective*.

We are especially grateful to our tour partners for their enthusiasm and incredible professionalism: Zora Hutlova Foy and Catharina Manchanda at the Seattle Art Museum; Vicki Gambill and Sarah Loyer at The Broad; Stephanie Smith, Adelina Vlas, and Jessica Bright at the Art Gallery of Ontario; Heidi Strean and Reto Thüring at the Cleveland Museum of Art; and Amy Simon and Michael Rooks at the High Museum of Art, Atlanta.

Finally, I thank the friends and colleagues who provided warm encouragement along the way—in particular, Kelly Gordon, Melissa Ho, Nancy Lim, Yasmil Raymond, Gloria Sutton, Akira Tatehata, and Ming Tiampo. A very special thanks to my mother, Hitomi, for her support during the many research trips in Japan; to my husband, Todd Forsgren, for his heroic patience; and to my baby daughter, Sora Wren, for being the world's greatest distraction and inspiration.

Mika Yoshitake
Curator
Hirshhorn Museum and Sculpture Garden

Infinity Mirrors: Doors of Perception

Mika Yoshitake

I discovered Kusama's art in Washington, several years ago, and at once I felt that I was in the presence of an original talent. Those early paintings, without beginning, without end, without form, without definition, seemed to actualize the infinity of space. Now, with perfect consistency, she creates forms that proliferate like mycelium and seal the consciousness in their white integument. It is an autonomous art, the most authentic type of super-reality. This image of strange beauty presses on our organs of perception with terrifying persistence.[1]

—Herbert Read, 1964

In a 1965 photograph Yayoi Kusama lies on a bed of stuffed, polka-dotted phalluses along the edge of a mirror-lined room (fig. 1). This image puts the viewer in a voyeuristic position, watching the artist recede into an abyss of red polka dots in a red bodysuit as she is endlessly reflected in the mirrors surrounding her. This virtual field of reflections makes up *Infinity Mirror Room—Phalli's Field*, Kusama's first room-sized mirror installation for her solo exhibition *Floor Show* in November 1965 at Castellane Gallery, New York. In this participatory installation, visitors walked down a narrow red-dotted pathway to the center of the room, where they were confronted by multiple reflections of themselves among hundreds of thick white phalli emerging from the floor. The artist's intent was to create a space in which people "could walk barefoot through the phallus meadow, becoming one with the work and experience their own figures and movements as part of the sculpture."[2] This aim was aptly captured by avant-garde photographer Eikoh Hosoe, whose images offered dizzying fragments of Kusama, her face dispersed into multiple phantasms (fig. 2).[3] As Alexandra Munroe once noted, Hosoe's photographs "elicit a psychedelic vision of the self caught in a labyrinth of infinity," simulating the liminal space between consciousness and the unconscious.[4]

While Kusama's career has been extensively documented, the narrative arc of her Infinity Mirror Rooms is a story that remains to be told.[5] The artist has produced twenty distinct mirror rooms since 1965. They have evolved from *Phalli's Field,* her first full-scale room (pp. 46–51); to ten peep-show-like chambers lined inside and out with mirrors in the 1980s and 1990s; to the multimedia installations of the late 1990s featuring domed mirror rooms surrounded by polka-dotted vinyl inflatable balloons

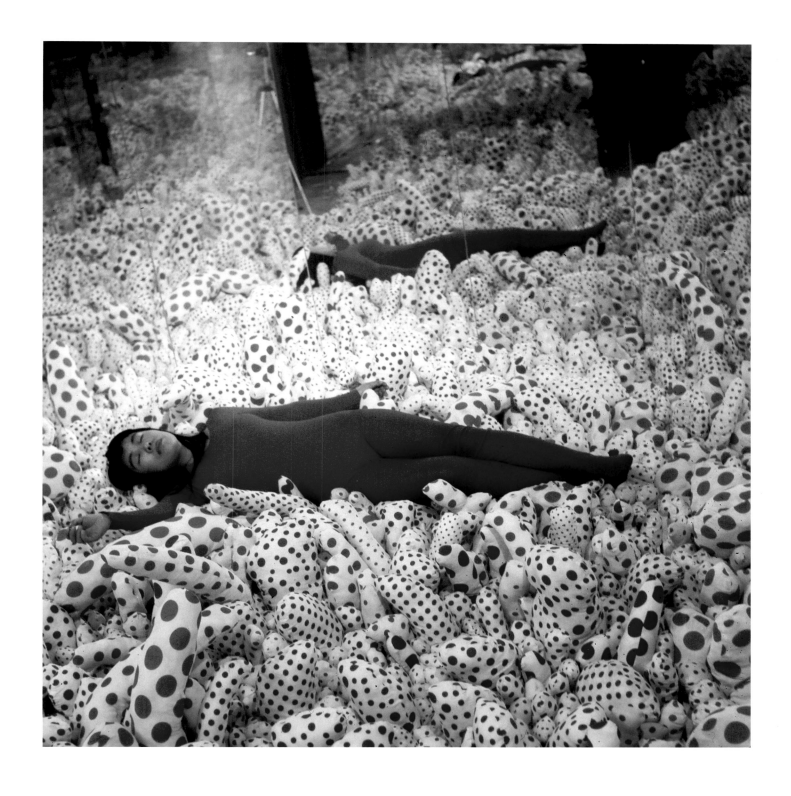

Fig. 1. Kusama in *Infinity Mirror Room—Phalli's Field,* 1965, in *Floor Show*, Castellane Gallery, New York, 1965

suspended from the ceiling; to her most recent series of darkened mirrored environments lit by hundreds of light bulbs. With each new room, Kusama heightened the suspension of time and space, increasingly emphasizing the participatory experience of the public and the notion of the mirror rooms as bodily structures.

The Infinity Mirror Rooms have prompted numerous interpretations. Some critics describe them as producing a disturbing effect in which the viewer's body virtually disintegrates into the infinitely receding reflections that surround him or her; others see the rooms as embodying a utopian challenge that addresses multiple modes of being beyond private, individual experience that remain fundamental to communal living.[6] Both of these positions see the Infinity Mirror Rooms as evolving from early generators of unsettling experiences to more ethereal, harmonious environments, in which the body's phenomenological encounter with space is central. From her drawings of the 1950s to her Infinity Nets and more recent paintings, Kusama has been deeply invested in working at both a microscopic and cosmological scale, creating works in which the simultaneous experience of intimate compression and epic expansion of the body in space remains a constant feature. In addition to this shifting of scale, the physicality of Kusama's artistic labor—whether in the endless gestures of marking dots or nets on canvas or stuffing and sewing what would become known as her phallic Accumulation sculptures—produces a cathartic perceptual experience through full-scale environments

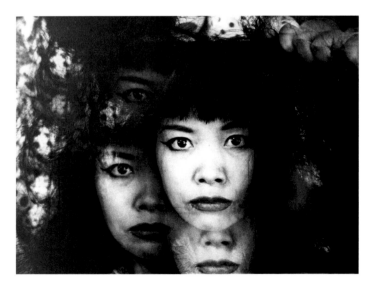

Fig. 2. Kusama, portrait by Eikoh Hosoe, c. 1965

replete with proliferating motifs (dots, pumpkins, lights) and hypnotic reflective surfaces. Her installations and performances of the late 1960s involved the communal application of polka dots and the enactment of the self-styled notion of "self-obliteration" to radically connect individuals—a process that correlates with the understanding of the phenomenological body as operating at the edge of perceptual awareness in the dual experience of interiority and exteriority. These themes all come together in the Infinity Mirror Rooms, which inform key aspects of Kusama's prolific practice that culminate in her most recent body of work, My Eternal Soul (begun in 2009).

Shifting Scales

> Our earth is only one polka dot among a million stars in the cosmos.
>
> —Yayoi Kusama, 1968[7]

A well-rehearsed feature of Kusama scholarship is the acknowledgment of how the artist's early hallucinations of a world obliterated by dots eventually came to govern her artistic style. "During the dark days of war when I felt I could no longer go on as a young girl, behind my house was a river upon which lay millions of white stones, the basis for a mysterious vision confirming their 'being' one by one under the glistening sun. Aside from this direct revelation from nature, I was also possessed by a strange world inside my psyche with images of an immaterial drive."[8] This mysterious encounter with countless sunlit stones signaled the emergence of the dot motif. We also gain a glimpse of her otherworldly vision in the nightmarish, spiraling crest of bodies in *Accumulation of the Corpses (Prisoner Surrounded by the Curtain of Depersonalization)* (1950; fig. 3). The vortex at the center of this painting was deeply personal; she spoke of having been "tormented by a thin, silk-like curtain of indeterminate grey that would fall between me and my surroundings"[9] during World War II. For Kusama, the dot (soon to be joined by nets and phalluses and reflections), replicated ad infinitum, may have been a way to fill this haunting *horror vacui*, a signifier that allowed her to simultaneously confront the void (one's uncontrollable fate in the whirlpool of death) and obliterate it through a compulsive process of repetition.

Kusama's early works on paper—drawn at an intimate scale in rapid, almost manic succession while still living in

Fig. 3. *Accumulation of the Corpses (Prisoner Surrounded by the Curtain of Depersonalization),* 1950. Oil and enamel on seed sack, 28½ x 36 in. (72.3 x 91.5 cm). National Museum of Modern Art, Tokyo

her hometown of Matsumoto—consist of abstract forms that evoke orbs, eggs, amoebae, and columns. These works feel ephemeral, as if appearing for a split second like a glowing light and then disappearing back into a dream. In *Infinity* (pl. 1), a small drawing from 1952, black watery dots hover in a dense mass like cells growing in a petri dish;

some of the dots seeped through the back of the textured matte paper. Dots reappear in *A Woman* (1952; pl. 2), an unmistakable self-portrait in which a dynamically outlined abstract form is covered with a swarm of red dots, its interior marked by rapid, centrifugal lines of black ink. In others, such as *Flower QQ2* (1954; pl. 3), they glow like red lights emerging from a distant haze. *The Island in the Sea No. 1* (1953; pl. 4), *Inward Vision No. 4* (1954; pl. 5), *Hidden Flames* (1956; pl. 6), and *Long Island* (1959; pl. 18) employ decalcomania, a Surrealist technique of blotting the surface of the paper with wet gouache and pressing another sheet against it to spread the pigment. On these Kusama drew a layer of ink or pastel, thus giving the watercolors a luminescence that seems to emanate from within the paper and leaving the inscribed objects afloat. *The Island in the Sea No. 1* resonates with *Blasted Corn Leaf* (1948; fig. 4), an early sketch in which she outlined the remnants of a dried cornhusk in blue and magenta like glowing lights of the aurora borealis.

Upon seeing her first solo exhibition at Matsumoto City Community Center in 1952, the eminent painter Masao Tsuruoka praised her for developing a unique aesthetic world using a variety of paints and the gradation of points and lines in free compositions. Artist Kenjirō Okamoto commended her distinctiveness: "Kusama combines

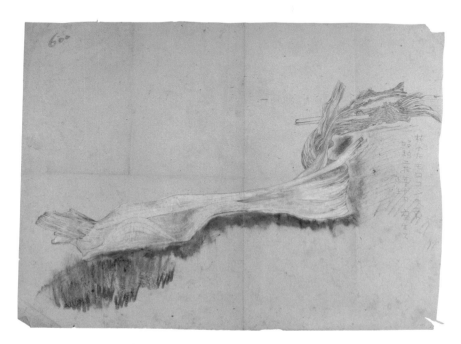

Fig. 4. *Blasted Corn Leaf,* 1948. Mineral pigment on paper, 15 x 19⅝ in. (38 x 50 cm). Collection of the artist

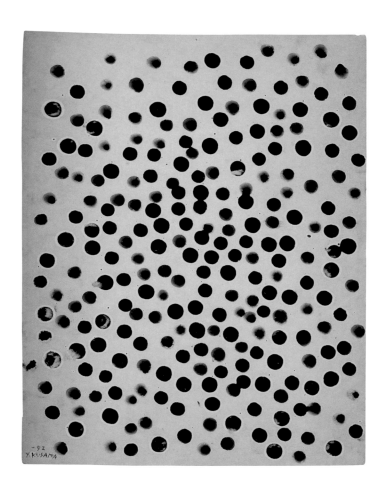

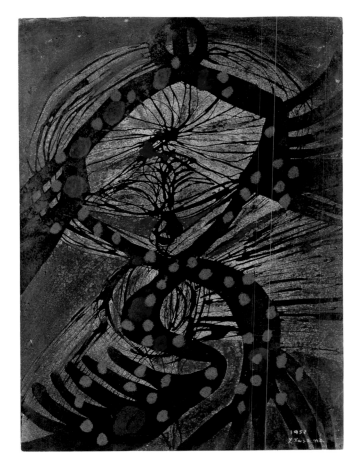

Plate 1. *Infinity*, 1952. Ink on paper, 9 x 12 in. (23.2 x 30.3 cm). Collection of the artist

Plate 2. *A Woman*, 1952. Pastel, tempera, and black ink on buff paper, 13⅝ x 9¾ in. (34.6 x 24.8 cm). Sheldon Inwentash and Lynn Factor, Toronto

Plate 3. *Flower QQ2,* 1954. Pastel, tempera, and ink on
paper, 16¾ x 13¾ in. (42.5 x 34.9 cm). Private collection.
Courtesy David Zwirner, New York/London

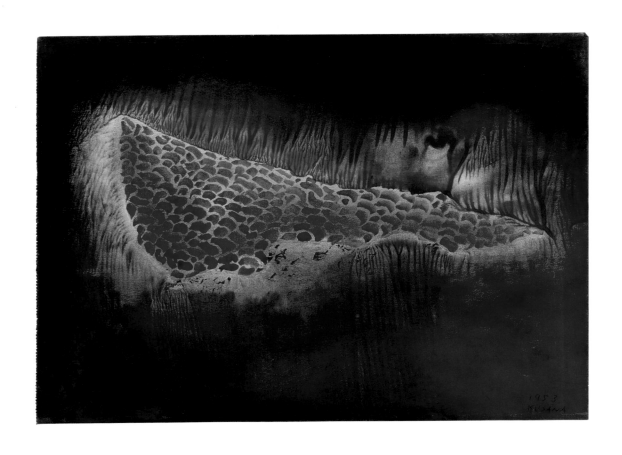

Plate 4. *The Island in the Sea No. 1*, 1953. Gouache and pastel on paper, 9½ x 13½ in. (24.1 x 34.3 cm). Private collection. Courtesy David Zwirner, New York/London

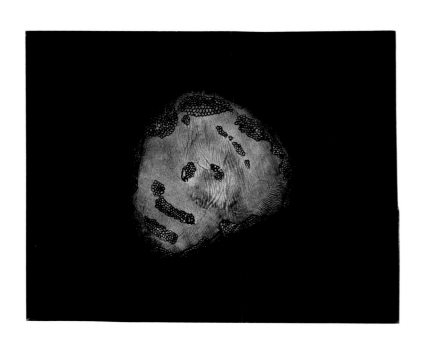

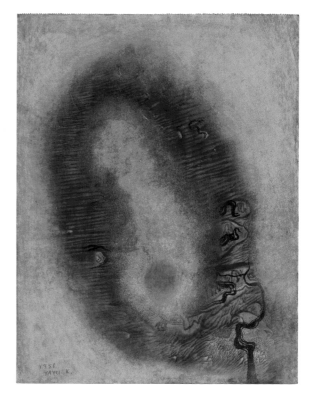

Plate 5. *Inward Vision No. 4*, 1954. Pastel with black ink, watercolor, and tempera on buff paper, 13⅛ x 16⅛ in. (33.3 x 41 cm). Collection of Carla Emil and Rich Silverstein

Plate 6. *Hidden Flames,* 1956. Pastel, ink, and watercolor on paper, 13½ x 9⅞ in. (34.3 x 25.1 cm). Collection of Daniel Rowen and Stuart Sproule

various Surrealist, cubist techniques such as decalcomania, frottage, but makes them her own."[10] These early drawings are intimate and organic microcosms that paralleled the concerns of other leading artists then developing the dot as a repetitive motif, such as Japan-based Korean artist Lee Ufan (born 1936), who stated, "[T]the entirety of the universe begins and returns to one point."[11] Many of Kusama's works on paper came to notice in the United States in her first stateside solo exhibition, held at Zoë Dusanne Gallery, Seattle, in 1957. Kusama gained entrée to this community through Kenneth Callahan, a Washington-based artist associated with the "Northwest mystics," such as Mark Tobey and Morris Graves, whose paintings were imbued with spirituality and Asian and Native American aesthetics. Kusama had blindly written to Callahan and Georgia O'Keeffe, both of whom, to her great surprise, expressed support of her work, which encouraged her to move to Seattle in 1957 and then to New York in 1958.

In one of Kusama's first large-scale abstract paintings, *Pacific Ocean* (1958), made in New York, lines swell like rippling waves inspired by the vast view of the Pacific Ocean during her flight from Tokyo. These undulating effects, also seen in her large black and red watercolors from 1959 of the same title (pls. 19–20), were precursors to her "interminable nets" (later called Infinity Nets), in which repetitive patterns of interconnecting arcs were described by brushes loaded with thick paint on dark grounds. These lattices of pigment form the negative spaces around dots in her paintings and became her dominant motif at this time. Five large white Net paintings at her first solo show in New York, at Brata Gallery in 1959, mark the emergence of an immaterial, environmental effect in her art. As Donald Judd noted in his review of the show, "The total quality suggests an analogy to a large, fragile, but vigorously carved grill or to a massive, solid lace."[12] Judd's description lends the works a sculptural quality and picks up on Kusama's unwaveringly intricate application of brushstrokes—like a skilled metal engraver—that nonetheless achieves a sweeping monumentality. Likening these Net paintings to Jackson Pollock's *Shimmering Substance* (1946), a work with thick yellow arcs interwoven with saturated red orbs, Sidney Tillim offered an ontological and spiritual reading: "A gentle radiance imbues the surface with great dignity. What comes through from behind is no longer a naturalistic space but something like a memory of the place where things used to be rather than a void in which anything can happen. The impassive veil . . . which Miss Kusama draws over the world of appearances absorbs this mnemonic

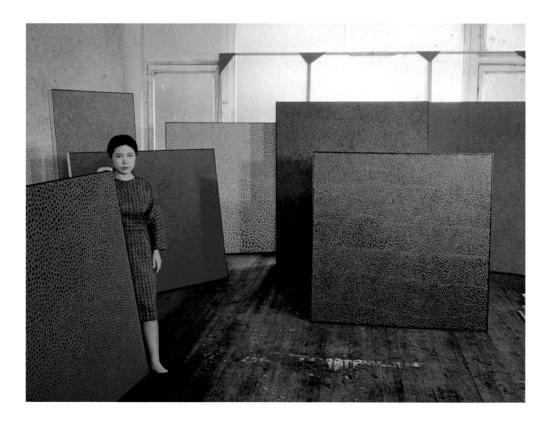

Fig. 5. Kusama with Net paintings in her New York studio, 1960

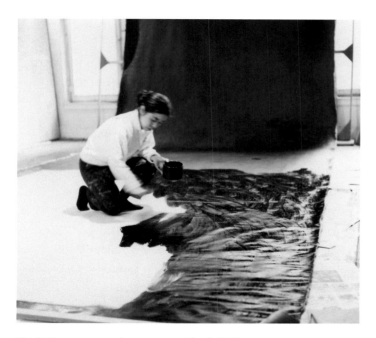

Fig. 6. Kusama preparing a canvas, March 1961

a stretch, "like being carried on a conveyor belt without ending to my death," she recalled.[17] One can only imagine how Kusama's nets evolved from a purely optical encounter, in which one's eyes trace each intricate repetitive arc, to a wholly corporeal effect, wherein experience is defined through the body's relation to the sheer magnitude of the canvas (fig. 6). She observed that

> to repeat one touch [after] another thousand and million times almost astronomically in the unlimited time would seem very unimpressive [from] the viewpoint . . . of paintings and the idea of general art. However the accumulation of this "meaninglessness" is merely an uninterrupted continuous action against the infinite. [My] basic method of painting . . . is primitive and simple, but with the surface repeated exactly in monotone like the gear of the machine, [it] has produced billions of microcosmic nets with amazing, obsessive patience.[18]

plane. What results is a profound symbol of detachment."[13] The readings of Judd and Tillim, while typical of a modernist discourse that assumed the interiority of expression, also hint at Kusama's wholly methodical process.

The mesmerizing and meditative white paintings were soon joined by colored Net paintings featuring vividly tactile and optical effects, such as *Infinity Nets Yellow* (1960; pl. 28) and *No. Green No. 1* (1961; pl. 31), as well as the intense, snakeskin-like quality of *No. I.Q* (1961; pl. 29).[14] We can discern the continued transition from dots to nets in the latter work, where the artist painted the negative space of black "dots" over the coral-red ground. This is especially evident in a photograph showing paintings in her New York studio in April 1960 (fig. 5) taken before her first solo exhibition at Gres Gallery in Washington, DC. Many of the colored Net paintings were consigned to Beatrice Perry, the owner of the gallery, where Kusama held exhibitions in April 1960 and December 1961 (and also where British art critic Herbert Read first saw her paintings).[15]

As the artist stated, "My net-paintings were very large canvases without composition—without beginning, end or center."[16] Kusama's creativity—and stamina—proved almost inexhaustible with her thirty-three-foot (10 m) wide white Net painting *White X.X.A* (1961), which filled an entire wall at her 1961 solo exhibition at Stephen Radich Gallery in New York. She painted nonstop for fifty or sixty hours at

This shift—though with a different notion of repetition—is also evident in her first immersive installation, *Aggregation: One Thousand Boats Show* (1963) at Gertrude Stein Gallery, New York. Here, the artist presented a nine-foot (3 m) long rowboat (salvaged, with the help of Judd, from the street across from her studio in New York) covered with dozens of stuffed fabric phallic tubes that were painted white. Hundreds of photographic reproductions of the same boat covered the gallery's walls. Lynn Zelevansky has noted that by displaying the original in the same space as its reproductions, "the boat-sculpture, known and anticipated before it was seen, like a canonical masterpiece, became the original of all the reproductions that surrounded it."[19] This critique of the original through the play of repetition was achieved not through the general tendency toward a numbing Warholian seriality—as proposed by the *Multiplicity* exhibition at the Institute of Contemporary Art, Boston (1966)—but rather through the overwhelming physicality of the accumulated phalli that shrouded the boat like a fungus. The work also points to a crucial technological development that transformed Kusama's process-based production from physical repetition (as in, for example, the Net paintings) to photographic reproduction (in *Aggregation: One Thousand Boats Show*) to instantaneous reflection (in the Infinity Mirror Rooms). *Aggregation: One Thousand Boats Show* initiated an ongoing

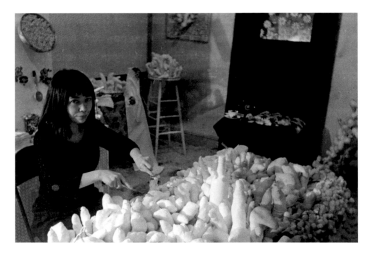

Fig. 7. Kusama at *Driving Image Show*, Castellane Gallery, New York, 1964

"My Aggregation-Sculpture is a logical development of everything I have done since I was a child. It arises from a deep, driving compulsion to realize in visible form the repetitive image inside of me. When this image is given freedom, it overflows the limits of time and space."[20]

From Accumulation to Boundless Transience

The Net paintings and *Aggregation: One Thousand Boats Show* helped launch the next advance in Kusama's practice toward the production of *immaterial* environments. The artist transferred the decentered visual effects of her paintings and sculptures into nonobjective, phenomenological spaces in which visitors became active participants. Kusama had included a vanity mirror in her April 1964 exhibition at Castellane Gallery, *Kusama: Driving Image Show* (fig. 7)[21]— which featured a total environment of sofas, chairs, step ladders, dressers, and a ten-person dining table each with an anthropomorphic overgrowth of white phalluses, works

series that has continued throughout Kusama's career, with works produced in silver (1981), colorful dotted and striped fabrics (1988 and 1989), pink (1992), violet (*Violet Obsession,* 1994; pl. 45), and red (2000). As Kusama has remarked:

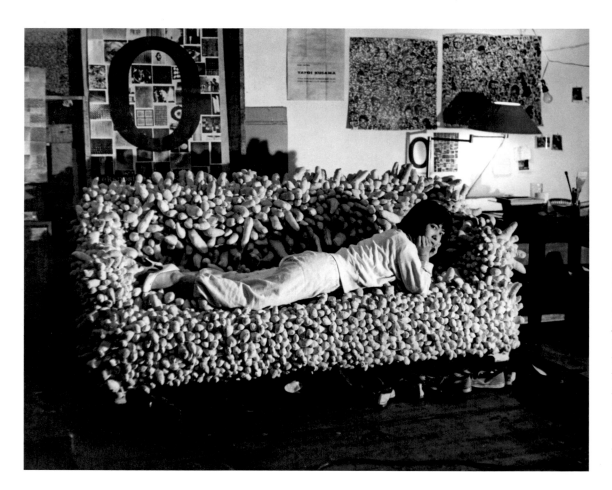

Fig. 8. Kusama reclining on *Accumulation No. 2* (1962), c. 1962. Visible in the background are *Accumulation of Faces, No. 2* (1962) and posters for *Tentoonstelling Nul* at the Stedelijk Museum, Amsterdam, 1962, and *Recent Painting: Yayoi Kusama* at Stephen Radich Gallery, New York, 1961. Photograph by Hal Reiff

Fig. 9. Kusama with Lucio Fontana at the *Nul 1965* exhibition, Stedelijk Museum, Amsterdam

materiality of space and technology led to his call for a "spatialist" art that would synthesize time and environment with sound, color, and movement and break down conventional distinctions between painting, sculpture, and architecture (fig. 9). Kusama's turn toward total physical environments (in *Aggregation: One Thousand Boats Show* and then the Accumulation series) likewise transcended the medium of painting and sculpture into immersive environments.

The 1962 Nul exhibition remains pivotal for its exploration of the theme of light. Sections of the show were devoted to the reflection, absorption, and transformation of light and featured works ranging from a space filled with a blinding floodlight to a pitch-black installation consisting of walls covered with industrial tires and black linen.[24] Kusama's massive 1961 Net painting *White X.X.A,* which had filled the entire height and length of one wall of Stephen Radich Gallery, was treated as an "environmental" piece. Another exhibitor who displayed a total environment was the Swiss artist Christian Megert. Though Kusama was unable to attend the exhibition, she was aware of Megert's monumental *Mirror Wall* (1962; fig. 10), which consisted of two rows of rectangular mirrors reflecting the shifting bodies of viewers, and eventually visited Megert's studio in 1965 on the occasion of another Nul exhibition.[25] Megert's interest in the mirror as a medium stems from a metaphysics of space expressed in his 1961 manifesto "Ein neuer Raum" (A New Space): "I want to build a new space, a space without beginning or end, where everything lives and is invited to live. . . . If you hold up a mirror to a mirror,

that would come to be known as Accumulation sculptures. It was not until *Phalli's Field* in 1965, however, that she used mirrors as multireflective devices, transposing the intense physical labor that had marked her earlier works—inscribing countless arcs on enormous canvases, stuffing and sewing hundreds of phalluses—into an instantaneous perceptual experience. The description of *Phalli's Field* in the gallery's press release aptly captures the organic proliferation at the core of her art: "Kusama creates a joyous fairyland of organic growths, vigorously sprouting and spreading over the floor of the Castellane Gallery. Like the most basic life processes of nature, Kusama's plant forms are in a state of continuous multiplication. . . . She does it with mirrors, entirely covering the walls of the gallery, so that these organic forms are reflected endlessly."[22]

Kusama's interest in mirrors as an instantaneous device for endless proliferation can be traced back to her experience exhibiting with artists associated with the Dutch Nul, German Zero, and Italian Azimuth groups.[23] Dutch artist Henk Peeters, who first saw one of Kusama's Net paintings in a print advertisement in the May 1961 issue of *Cimaise* magazine, invited her to participate in *Tentoonstelling Nul* (Nul Exhibition) at the Stedelijk Museum, Amsterdam, in 1962 (fig. 8). Thus, Kusama entered a milieu in which artists were actively utilizing new industrial materials, such as plastic and electric lights, and natural elements such as air, wind, and fire to create atmospheric effects through kinetic movement, espousing a revisionist conception of the object. A pivotal figure in this field was the Argentine-born Italian artist Lucio Fontana, whose interest in the

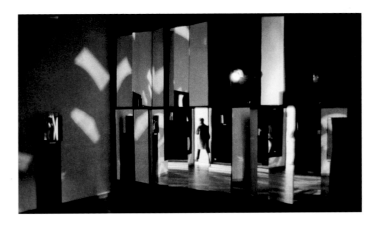

Fig. 10. Christian Megert's *Mirror Wall* (1962) in *Tentoonstelling Nul* at the Stedelijk Museum, Amsterdam, 1962. Photograph by Oscar van Alphen; courtesy Oscar van Alphen Archive, Netherlands Fotomuseum, Rotterdam

Fig. 11. Kusama with
Blue Spots and
Red Stripes, 1965
(pls. 39–40) at
International Galerij
Orez, the Hague,
May 1965. Photo-
graph by Marianne
Dommisse

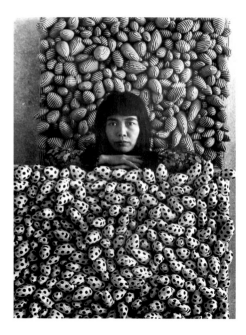

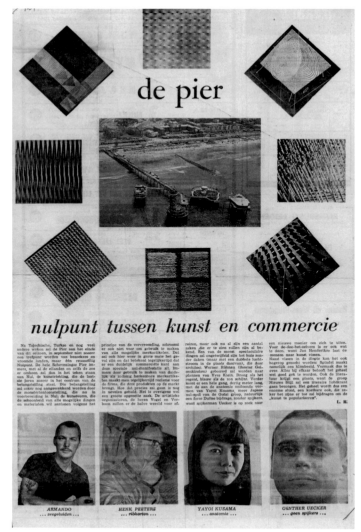

Fig. 12. Armando, Yayoi Kusama, Henk Peeters, and Gunther Uecker, "De pier, nulpunt tussen kunst en commercie" (The Pier, Zero Point between Art and Commerce), announcement for unrealized exhibition, Zero op Zee, Scheveningen Pier, the Netherlands, 1966. Courtesy of ZERO Foundation, Düsseldorf

you will find a space without end, without limits, a space with endless possibilities, a new metaphysical space."[26]

Megert's ambitions resonate with Kusama's quest for boundlessness that took her beyond the edges of her canvases, which she described as being "like a vast outer space filled with microcosmic accumulations of stardust" that lay "underneath a simple yet complex unconscious of black and white."[27] Megert's later mirror boxes, in which cascading images reflected in mirror fragments inside a light box extend infinitely to a vanishing horizon line, resemble the spatial effects of Kusama's Infinity Mirror Rooms, first seen in *Phalli's Field* and later, beginning in 2000, in her dark, illuminated environments.[28] However, the incorporation of phallic forms into the landscape of *Phalli's Field* distinguishes Kusama's art from Megert's, which was defined by his overriding concern for the optics of spatial expansion.

This difference is further heightened in a plan, dated October 3, 1965, for the *Floor Show* exhibition at Castellane Gallery showing two overlapping diagrams: *Phalli's Field,* with multiple two-by-seven-foot mirror panels lining the gallery walls, and an octagonal space filled by a rough drawing of a spiral, demarcating a walkway.[29] The octagon (p. 54) was an early rendering of what would become *Kusama's Peep Show or Endless Love Show* (later called *Love Forever,* among other titles; pp. 52–57), a hexagonal chamber with mirrors lining the interior walls and the exterior painted

black. Shown in March 1966 at Castellane Gallery, this work featured a concentric arrangement of flashing halogen lights on the ceiling whose reflections produced an infinite honeycomb pattern while Beatles music played in the background along with the loud rattle of lights switching on and off. Visitors could peer into the compartment through two cutout squares placed at eye level and gaze at each other's faces and the lights reflecting endlessly in the mirrors. The installation, now titled *Endless Love Show,* functioned as a live peep show at the *Multiplicity* exhibition at the ICA Boston, where people could enter the chamber

and roam through while others peered in—an endless panoply of seeing and being seen, producing a hypnotic sensation that Kusama said "allows you to see things that you can not touch."[30]

In July 1965 Kusama was invited by Albert Vogel and Leo Verboon of International Galerij Orez in the Hague (where she began exhibiting in 1965; fig. 11) to submit plans for Zero op Zee (Zero on Sea), a site-specific exhibition that was to take place that fall on Scheveningen Pier in the Netherlands (fig. 12).[31] Verboon, Vogel, and Peeters solicited proposals for a wide range of performative experiments from artists affiliated with Japan's Gutai Group, Zero, and Nul. Peeters's project included floating mirror-lined pyramid-shaped vessels, while Nul artist Armando proposed a human-sized cabin that played a recording of the sea to be broadcast across the pier. Otto Piene envisioned a work consisting of three balloons—red, black, and silver—lit like artificial planets by searchlights, while fellow Zero artist Heinz Mack submitted a plan for aluminum masts that would be anchored in the sea and moved by the wind—a "tower of light, which trembles and vibrates and fiercely reflects light" (fig. 13).[32] The show was cancelled due to lack of funds, but had it been realized, Zero op Zee would have amounted to a *Gesamtkunstwerk* uniting natural and ephemeral elements in an outdoor environment of sky and sea.

Kusama's proposal for the event (p. 55) consisted of an enlarged version of *Kusama's Peep Show* in which flashing letters spelled out "Love Forever" in Dutch inside the chamber while people danced.

> This was the materialization of a state of rapture I myself had experienced, in which my spirit was whisked away to wander the border between life and death. I gave this enormous environmental sculpture the title *Love Forever* because I intended it as an electric monument to love itself. . . . This was my living, breathing manifesto of Love. Thousands of illuminated colors blinking at the speed of light—isn't this the very illusion of Life in our transient world?[33]

Produced at the height of the psychedelic era, this kinesthetic monument was driven by a utopian desire for radical connectivity.[34]

Self-Obliteration and Radical Connectivity

The reflections in *Phalli's Field* and *Kusama's Peep Show* bring to the fore what Kusama called "self-obliteration," a term referring to the manner in which dot patterns—polka dots in the former, blinking lights in the latter—would replicate endlessly and thus atomize the self into minute particles. "The positives and negatives become one," said Kusama. "At that moment, I become obliterated."[35] This leads us to consider the Infinity Mirror Rooms in terms of what Lee Ufan in 1969 described as a nonobjective space. Citing immaterial works of kinetic and light art, he noted how these creations—culled from the sphere of contemporary industrial technology, an apparatus of modern reason and the automation of production—signal a "mechanized objectification of the world."[36] The viewer consequently loses sight of a ground continuous with the world and this loss of oneself through the automation of mechanized production represents a point of crisis.

Kusama's self-obliteration counteracts the mechanized notion of nonobjective space. In her works the self remains

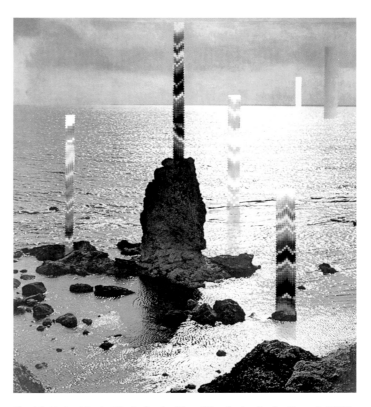

Fig. 13. Heinz Mack. *Die Stelen im Meer* (The Stelae in the Ocean), 1960. Photo-collage, 47¾ x 35⅜ in. (106 x 90 cm). Courtesy of ZERO Foundation, Düsseldorf

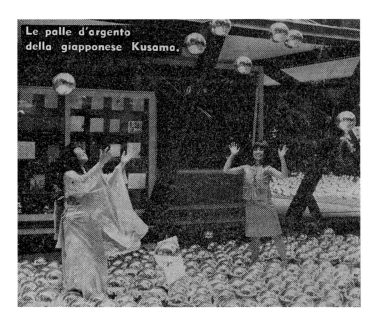

Le palle d'argento della giapponese Kusama.

Fig. 14. Photo appearing with an article about Kusama's *Narcissus Garden* at the Venice Biennale in *Corriere d'Informazione* (Milan) from June 21–22, 1966

conscious of its projection, even as it is dispersed in a myriad of reflections, and is always understood *in relation* to the surrounding environment. In *Narcissus Garden*, one of her first public performances, Kusama displayed 1,500 plastic mirror balls in two gardens outside the Italian Pavilion at the 1966 Venice Biennale (fig. 14).[37] The artist, decked out in a gold kimono, sold each ball for two dollars before a large sign that read "Your Narcissism for Sale." A playful protest against the commodification of contemporary art, the one-day event proved to be a brilliant media success, as the artist appeared amidst the thousands of balls that reflected infinitely regressing images of the sky, the bucolic garden, and adjacent balls. In a statement, Kusama said that the "silver ball [is] representative of the moon, of sunshine, and peace. In essence it symbolizes the union of man and nature. When the people see their own reflection multiplied to infinity they then sense that there is no limit to man's ability to project himself into endless space."[38]

By 1966 the phallic sculptures of *Phalli's Field*, the mirrors of *Peep Show*, and the mirrored balls of *Narcissus Garden* resurfaced in the various performances Kusama began to stage in and around her studio. For a performance entitled *14th Street Happening* (pl. 24) she placed a large floor panel from *Phalli's Field* out on the busy sidewalk and lay on top of the polka-dotted phallic bed in a black dress, her hands on her breasts, looking up at the sky. The performance was staged in collaboration with Hosoe, who produced twenty-nine photographs using a prismatic lens from the fire escape outside her studio several stories above. The shots, which contain ghostly multiple angles, show people crowding around to watch her impromptu act (as well as a bus and a man strolling with a baby)—a burst of echoing images.

Both *Narcissus Garden* and *14th Street Happening* addressed the experience of the body as simultaneously in and continuous with the surrounding environment—an idea foundational to Kusama's notion of self-obliteration, and one that that would take on a politically charged character in her body-painting festivals of 1967 and 1968. Kusama organized numerous events at her studio (such as *Mirror Performances*, 1968) in which dancers were invited to daub polka dots on each other's naked bodies using Day-Glo paints. Performed under black lights in a dimmed room, thus obscuring people's bodies, the result was a kinetic frenzy of dots glowing in the darkness (see pl. 37).[39] Kusama described the ensuing spirit of radical connectivity as a way to free each individual and simultaneously reconnect them in mutual obligation.

In 1968 Kusama began staging nude Body Festivals every Sunday in Washington Square Park as well as one-off Happenings called *Anatomic Explosions* at such sites as the Brooklyn Bridge, the New York Stock Exchange, and Wall Street in which she and her cohorts burned American flags to protest the Vietnam War. As art historian Mignon Nixon has argued, these guerilla-like works gave Kusama's notion of "self-obliteration" an activist spin, allowing participants to symbolically reclaim the destructive agency of the United States and displace their alienated condition from the state.[40] In an open letter to President Richard Nixon, the artist exclaimed: "You can't eradicate violence by using more violence. . . . Lose yourself in the timeless stream of eternity. Self-obliteration points out the way. Kusama will show you how by covering your body with polka dots."[41] In an astute play on words, she closed the letter saying "'Anatomic explosions are better than atomic explosions.'"

After a period traveling in Europe and staging more of these Happenings, Kusama returned to Japan in 1973 to undergo a medical procedure. Though this was initially planned as a temporary visit, Kusama has resided in Japan ever since. The mid-1970s represented a radical turn toward interiority and reflection for the artist. Perhaps among the least recognized and anomalous works in Kusama's oeuvre are her collages, presented in *A Message of Death from*

Hades at Nishimura Gallery, Tokyo, in 1975—her first solo exhibition since returning to Japan. The collages are linked to her works on paper from the 1950s by their scale and experimentation with various techniques and materials, yet their tone is decisively different. While the drawings are imbued with cosmic elements of transience and wonder, the collages are dominated by themes of mortality and death. Created in remembrance of American artist Joseph Cornell, who died in 1972 and with whom Kusama had a profoundly close friendship, these deeply intricate works portray subterranean marvels of nature. Cutout eyes of owls, butterfly wings, snakeskins, and birds were applied gently over dreamlike landscapes. Round silk fabrics reappear in *Flower* and *Polka Dots of Polka Dots* (both 1975; pls. 21–22). In *Soul Going Back to Its Home* (1975; pl. 8), cutout photographs of butterflies frame a lake reflecting a sunset that, with the work's title, suggests a gateway into an imaginary underworld. Commenting on this work, critic Toshiaki Minemura said the "soul is not waiting for its messenger to come from the home of the living, but its way back to the home beyond life."[42] This work contemplates not only the premonition and perceived proximity of the artist's own death but also the soul's liberation through death—and the possibility, in Minemura's words, of joining "the people who were once tied together with the bond of love and hatred."[43] The intertwining themes self-obliteration and connection as realized through death are likewise expressed in a poem written on the verso of Kusama's collage titled *Now that You Died* (1975; pl. 7):

> Now that you died
> your spirit rises above a worthless cloud
> covered with the powder of rainbow light
> perishing into disappearance
>
> Yet you and I
> even at the endless thresholds of
> hate and love
> we will never meet again
> nor part ways
>
> We are born as children into this world of others
> parting is like the silence of footsteps
> inside a flower path
> far beyond the clouds at sunset
> into stillness without sound[44]

Body Memories

All of the themes of Kusama's earlier work—the shifts from microcosm to macrocosm and back again (traced by the progress from her intimate drawings of the 1950s to the environmentally scaled Net paintings in the 1960s to her collages of the 1970s); the journey from superabundant physical accumulations (of polka dots, of phalli) to countless dematerialized receding reflections; the paradoxical pursuit of self-obliteration to the point of profound connectedness—are woven together in the Infinity Mirror Rooms. In 1981 Kusama began making miniature peep-show-box versions of *Phalli's Field* with sewn and stuffed red printed phalli (*Endless Love Room,* 1966–c. 1981; pp. 58–59) and boxes with silver-painted phalli covering the exterior (*Mirrored Room—Love-Forever No. 3,* 1965–c. 1981; pp. 62–63) and presenting them in exhibitions with large-scale sculptural installations at such venues as Fuji Television Gallery, Tokyo (1982). The phallic soft sculptures were later presented in the mirror-lined corridors of *Passage of Mirrors* (1996; pp. 76–77). *Mirror Room (Pumpkin)* (1991; pp. 64–67) was Kusama's first full-scale mirror room since *Phalli's Field.* Exhibited at the 1993 Venice Biennale, it consisted of a peep-show-type box housed within a room enveloped in bright yellow with black dots. The box, its exterior entirely covered with mirrors, was camouflaged by reflections of the room as viewers stepped on a platform to peer through a square hole to see distorted yellow pumpkins with black dots endlessly reflected in mirrors lining the interior of the box. *Mirror Room (Pumpkin)* was created as the artist was making installations featuring plant-like floor sculptures, which culminated in the artist's first major outdoor sculpture, the yellow resin *Pumpkin,* commissioned in 1994 for the Benesse Art Site in Naoshima, Japan. Pumpkins are perhaps the most beloved of Kusama's motifs, owing to their endearing yet grotesque form and swift growth as well as to memories of her youth growing up in her family's seed nursery. They reappear in a glowing meadow in a recent mirror room, *Infinity Mirrored Room —All the Eternal Love I Have for the Pumpkins* (2016; pp. 112–15).

While pumpkins began to evolve and expand through the artist's paintings, sculptures, and installations, the polka-dot motif proliferated in total environments at a rapid pace as if imprinted on our collective unconscious. In *Repetitive Vision* (1996; pp. 74–75), one enters a dark corridor and

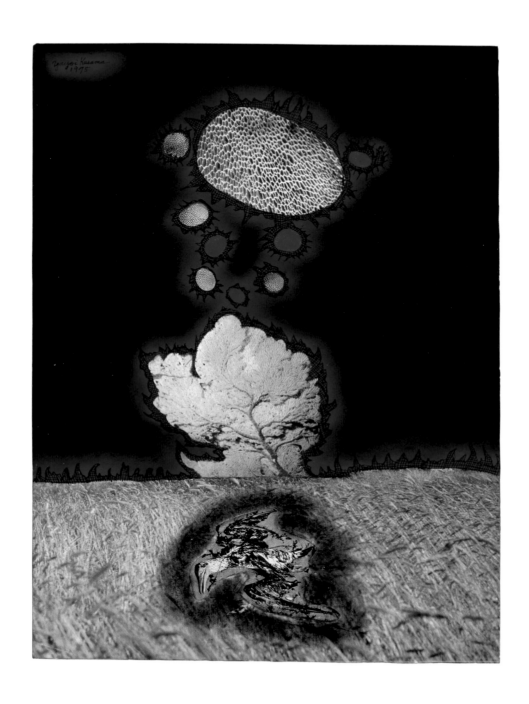

Plate 7. *Now that You Died*, 1975. Collage with ink and pastel on paper, 23½ x 15⅝ in. (54.8 x 39.7 cm). Setagaya Art Museum

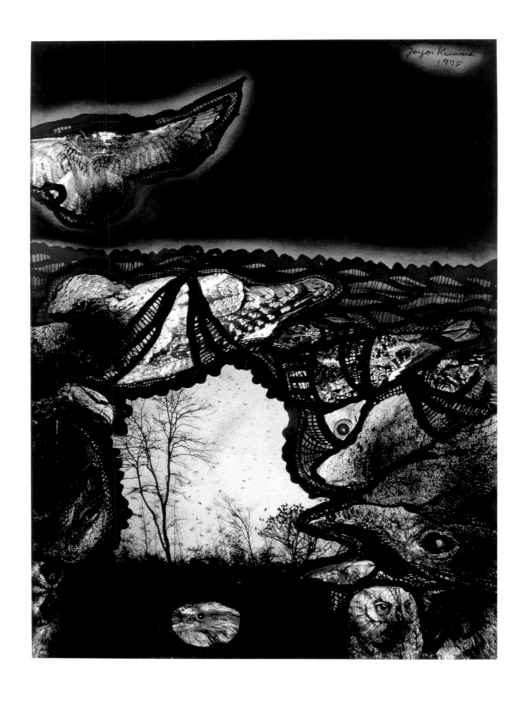

Plate 8. *Soul Going Back to Its Home*, 1975. Collage with ink and pastel on paper, 21½ x 15½ in. (53.5 x 38 cm). Setagaya Art Museum

then emerges into a bright mirror-lined space with white floors decorated with large red dots. Three white-painted female mannequins appear covered in red dots and infinitely reflected on the walls and ceiling. This work, which appeared on the cover of the February 1997 issue of *Artforum* magazine, recalls the vibrantly colored polka-dotted mannequins in *Infinity Polka Dot Room* (1967; fig. 15) at International Galerij Orez. In *Dots Obsession* (1998; pp. 78–79) the phallic accumulations of *Phalli's Field* are transformed into huge red vinyl balloons shaped like bobbing bowling pins and decorated with white polka dots that endlessly replicate in a bright room surrounded by mirrored panels. The unsettling nature of *Phalli's Field* began shifting toward the carnivalesque with a new series in yellow and black, red and white, and pink and black installations. *Dots Obsession* (2006) includes a mirrored dome populated with dotted round illuminated inflatables, a mirrored peep-show-type structure, and projections of the artist in a pink wig reciting a poem.

In a contrast to the festive, joyful nature of the *Dots Obsession* installations, Kusama in 2000 presented her first darkened mirror room, *Infinity Mirror Room—Fireflies on the Water* (pp. 80–83), an environment inspired by a childhood dream of seeing hundreds of fireflies on the river in Matsumoto on a midsummer night.[45] Visitors traversed a platform surrounded by a pool of water and entered an environment animated by the multicolored radiance of 150 strings of lightbulbs suspended from the ceiling and blinking in a timed sequence. Unlike previous mirror rooms—in which one was endlessly reflected within a field of sculptural forms (phalli, dots, pumpkins)—*Fireflies* stressed light

Fig. 16. Kusama painting on a sidewalk near International Galerij Orez, the Hague, 1967. Photograph by Harrie Verstappen

itself: glimmers of light that appeared along the occasional ripples on the surface of the water, the kinetic pulse of lights dancing on the ceiling. It is unclear exactly where the mirrors meet the water, so any distinction between actual bulbs and their reflections is effaced. The viewer all but vanishes in the stillness, suspended in a seamless, boundless, weightless cosmos.

The rooms that followed incorporated unique types of illumination and were configured so that the audience could enter one or two at a time through a single door onto a narrow platform surrounded by water inside a small room lined with mirrors. In Kusama's second full-scale darkened Infinity Mirror Room, *Soul under the Moon* (2002; pp. 86–87), the celestial effects of *Fireflies on the Water* are, if anything, heightened.[46] Here, hundreds of Ping-Pong balls covered in fluorescent paint seem to float below ceiling panels lit with ultraviolet lights to create a vivid Day-Glo effect evocative of the neon-gridded environment of the 1982 science fiction film *Tron*. The element of water is crucial to the installation, says curator Reuben Keehan, so as "to recreate the enigmatic impression of dozens of tiny moons hovering over a body of water."[47] Now in the collection of the Queensland Art Gallery, Brisbane, *Soul under the Moon* is installed with a version of *Narcissus Garden* in which hundreds of balls float in a pool of water like reflected moons. This latter version was first presented on the Yokohama Canal at the 2001 Yokohama Triennial together with an indoor mirror room, *Endless Narcissus Show* (2001; pp. 84–85).

Kusama introduced LED lights in *Gleaming Lights of the Souls* (2008; pp. 100–01), in which thousands of glowing bulbs replicate a cosmic realm. If such associations have

Fig. 15. Kusama in *Infinity Polka Dot Room*, International Galerij Orez, the Hague, 1967. Photograph by Harrie Verstappen

from the beginning been central to the Infinity Mirror Rooms, since 2009 a focus on the transcendent nature of the soul and transience of life has come to the fore. Kusama has said "to live is to be at the cusp of life and death."[48] In *Infinity Mirrored Room—Aftermath of Obliteration of Eternity* (2009; pp. 102–03) strings of golden LEDs slowly flicker like flames inside cylindrical lanterns, recalling *tōrō nagashi,* the Japanese tradition of floating paper lanterns down a river to guide ancestral spirits back to their resting places on the last evening of the summer *obon* festivals. The tradition has become especially meaningful in commemorating the victims of the atomic bombs at the end of World War II (fig. 17).

The experience of the Infinity Mirror Rooms heightens awareness of our dual condition of interiority and exteriority. In "Eye and Mind" (1964), a seminal text for artists and critics of Minimalist sculpture, French philosopher Maurice Merleau-Ponty expressed his notion of the body as a site of perceptual intersection between subject and object, wherein the very act of perception occurs prior to the intervention of consciousness and informs our body's contingency of being in the world. Speaking of the body, he said, "I live in it from the inside; I am immersed in it. After all, the world is all around me, not in front of me."[49] Our perception of a space is defined by the body's spatiotemporal extension into the environment. In a darkened Infinity Mirror Room, reflections produce an "out-of-body" experience as our eyes are disembodied and dispersed like the millions of reflected lights that are directed back to us. *Infinity Mirrored Room—Filled with the Brilliance of Life* (2011; pp. 104–05), which features spheres glowing with the shifting colors of LED lights, and *Infinity Mirrored Room—The Souls of Millions of Light Years Away* (2013, pp. 106–07) achieve this effect, with hundreds of crystalline beads symbolizing both the embodied and disembodied eye. These works exemplify the perceptual experiences that, as Merleau-Ponty argued, define us: we exist in an external space and continually lie outside the perceiving subject.[50] Electricity is replaced with natural sunlight in *Where the Lights in My Heart Go* (2016; pp. 116–17), her most recent mirror room, in which specks of light peek through holes punched into a cubic stainless-steel room, creating the sense of being in a galaxy millions of light years away, where one's body disappears in total darkness.

The Infinity Mirror Rooms allow us to reassess Kusama's entire artistic practice by offering a new understanding

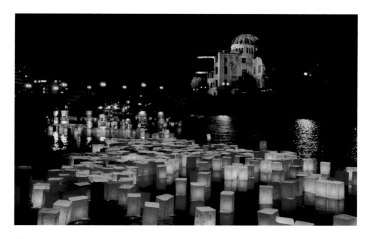

Fig. 17. The Peace Message Lantern Floating Ceremony, Motoyasu River, Hiroshima Peace Memorial Park, August 6, 2012

of the corporeal limits of perception under conditions that define optics, tactility, and intuition of matter. Kusama's latest series of paintings, entitled My Eternal Soul and begun in 2009, complement the mirror rooms, whose ethereal nature and rhythms of flickering light resonate with the paintings' vibrant spectrum of contrasting colors and figurative motifs—all-encompassing accumulations of dots, eyes, profiles, and otherworldly creatures—charmingly rendered in rough all-over compositions.[51] For many of these paintings, the artist works from the outside of the canvas in, turning it on a circular axis, resulting in compositions with textile-like borders. Recalling the decentered visual effects of the Net paintings and the cosmic weightlessness elicited by the mirror rooms, the jagged, wispy edges in *I Love Myself, I Adore Myself So* (2010; pl. 47) and *Ends of the Universe, Abode of Love* (2012; pl. 63) frame interiors filled with organic forms recalling ancient stone walls or hundreds of dots that resemble goldfish eyes. A strikingly consistent feature of these paintings is how each produces a dynamic optical effect: *Far End of Disappointment* (2015; pl. 58) and *The Wind Blows* (2016; pl. 56), for example, feature bright fluorescent oranges, blues, and pinks overpainted with equally bright hues whose edges induce halations, while *Whispering of the Heart* (2015; pl. 55) and *Aggregation of Spirits* (2016; pl. 51) contain wild and bold forms that dance on shimmering copper grounds.

Critics such as Roberta Smith have noted a resemblance between the My Eternal Soul paintings and aboriginal or outsider art. More pertinent, perhaps, is what the series reveals of Kusama's tremendous capacity to access her body memory.[52] With her lack of premeditation and her practice

of letting her hand lead the way, she has, in phenomenological terms, trained her body to acquire its own sense of memory, which is cumulative and gradual in character and thus thrives on repetition.[53] This is a memory that is intrinsic to the body, to its own ways of remembering: how we remember in and by and through the body.[54] This notion of habit memory, as French philosopher Henri Bergson noted, "no longer represents our past to us; it acts it" and "tends to be directed at its own accomplishment in the near-term future: its forward movement bears [it] on to action and to life."[55] Kusama's paintings exist at the cusp of consciousness, demonstrating how the body mediates the world when subject and object are in parity. This edge of awareness mediates our phenomenological experience of the Infinity Mirror Rooms, which fully reveal the seemingly opposing states of detachment and relationality, finite experience and infinite expanse present in Kusama's oeuvre as solemn affirmations of life.

Notes

1 Herbert Read, statement for *Kusama: Driving Image Show,* Castellane Gallery, New York (1964). Beatrice Perry Papers, New York.

2 Yayoi Kusama, "Create, then Obliterate," in *Infinity Net: The Autobiography of Yayoi Kusama,* trans. Ralph McCarthy (Chicago: University of Chicago Press, 2011), 51.

3 Experimental photographer and filmmaker Eikoh Hosoe (born 1933) is best known for his psychologically and erotically charged images of *butoh* dancer Tatsumi Hijikata and novelist Yukio Mishima. He photographed Kusama during his stays in New York in 1965 and 1966. Hosoe's use of prismatic and fish-eye lenses resulted in dramatic portraits of Kusama that anticipated the sense of spatiotemporal suspension inherent in her Infinity Mirror Rooms.

4 Alexandra Munroe, "*Revolt of the Flesh*: Ankoku Butoh and Obsessional Art," in *Japanese Art after 1945: Scream Against the Sky* (New York: Harry N. Abrams, 1994), 197. *Phalli's Field* appeared on the back cover of this monumental survey, thus anchoring the historical significance of the installation.

5 *Yayoi Kusama: A Retrospective* (1989), curated by Alexandra Munroe, stands as the first critical assessment of the artist, with an extensively researched chronology by Bhupendra Karia and Reiko Tomii. This was followed by two groundbreaking retrospectives—*Love Forever: Yayoi Kusama, 1958–1968,* organized by MoMA and LACMA in 1998, and *Yayoi Kusama,* organized by the Tate Modern in 2012—which catapulted the artist to international recognition. Japanese surveys include one by Kitakyushu Municipal Museum of Art in 1987; *Kusamatrix* at the Mori Art Museum (2004); *Yayoi Kusama: Eternity-Modernity* (2004–05), which toured five cities; and *Yayoi Kusama: Eternity of Eternal Eternity* (2012–14). Recent global surveys include *Yayoi Kusama: Obsesión infinita,* which toured Mexico and South America (2013–14); *Yayoi Kusama: A Dream I Dreamed,* which traveled to Korea, Shanghai, and Taiwan (2014–15); and *Yayoi Kusama: In Infinity*

6 See Claire Bishop, *Installation Art* (London: Routledge, 2005), 90; and Jo Applin, *Infinity Mirror Room—Phalli's Field* (London: Afterall; Cambridge, MA: MIT Press 2012), 80–81. Applin's book is a critical resource in thinking about the installation as a communal experience.

7 Yayoi Kusama and Jud Yalkut, "The Polka Dot Way of Life," *New York Free Press,* February 15, 1968; reprinted in Laura Hoptman, Udo Kultermann, Yayoi Kusama, and Akira Tatehata, *Yayoi Kusama* (London: Phaidon, 2000), 110–12.

8 Yayoi Kusama, "Onna hitori kokusai gadan o yuku," *Geijutsu shinchō,* May 1961: 128. My translation.

9 Kusama, *Infinity Net,* 69.

10 See Masao Tsuruoka, *Mizue,* May 1954: 82; and Kenjirō Okamoto, "Kitai sareru shinjin," *Geijutsu shinchō,* May 1955: n.p.

11 Nakahara Yūsuke, "Lee Ufan to kataru: zettai teki na keiken no ba toshite no kaiga seisaku," *Mizue* no. 875 (February 1978): 99.

12 Donald Judd, "Reviews and Previews: New Names This Month—Yayoi Kusama," *Art News* 58, no. 6 (October 1959): 17.

13 Sidney Tillim, *Arts* 34, no. 1 (October 1959): 56. Emphasis added.

14 Kusama's notebook lists *T.W.3.* and *No. Green No. 1.* under Gres Gallery. Kusama Papers, Tokyo.

15 A critical supporter of Kusama, Perry was introduced to Kusama's work through Japanese artist Kenzō Okada, sold her work to prominent collectors on the East Coast, and helped the artist extend her immigrant visa and eventually obtain her Green Card in 1963 (even after Kusama rejected her offer to have Gres Gallery represent her). Perry had moved to Washington with her husband, who worked for the federal government. Her interest in Asian art had been sparked by art historian James Cahill, who was a curator at the Smithsonian's Freer Gallery of Art from 1958 to 1965, and her mother. Beatrice Perry Papers, New York, and Hart Perry II, in discussion with the author, New York, April 15, 2016.

16 Kusama, "Create, then Obliterate," 51.

17 Kusama and Yalkut, "Polka-Dot Way of Life."

18 Yayoi Kusama, "Under the Spell of Accumulation," typewritten excerpt from an article published in *Geijutsu shinchō,* May 1961, Beatrice Perry Papers, New York.

19 "The work was also unabashedly theatrical, a quality not especially prized in the sixties." Lynn Zelevansky, "Driving Image: Yayoi Kusama in New York," in *Love Forever: Yayoi Kusama, 1958–1968* (Los Angeles: Los Angeles County Museum of Art, 1998), 25.

20 Udo Kultermann, "Miss Yayoi Kusama: Interview Prepared for WABC Radio by Gordon Brown, Executive Editor of *Art Voices,*" in *De nieuwe stijl: Werk van de international avant-garde,* ed. Armando (Amsterdam: De Bezige Bij, 1965), 163–64.

21 At this show Kusama distributed copies of the Herbert Read quote that opens this essay; see note 1 above.

22 "Kusama Does It With Mirrors," press release for *Floor Show,* Castellane Gallery, 1965, Kusama Papers, Tokyo.

23 For more on Kusama's connections to Nul and Zero, see Laura Hoptman, "Down to Zero: Kusama and the European New Tendency," in Zelevansky, *Love Forever,* 43–56; and Midori Yamamura, "Infinity: The Arts of Active Social Engagement," in *Yayoi Kusama: Inventing the Singular* (Cambridge, MA: MIT Press, 2015), 45–86. Very special thanks to Yamamura for sharing her important research and for her critical feedback in this volume.

24 See Yamamura, "Infinity," 76–81.

25 Applin, *Infinity Mirror Room,* 19.

26 Christian Megert, "Ein neuer Raum," flyer from Galerie Kopcke, Copenhagen, 1961; reprinted in *Christian Megert: Werke 1956–1978— Bilder, Objekte, Zeichnungen* (Düsseldorf: Kunstverein für die Rheinlande und Westfalen, 1979), n.p.; my translation. A translation of this work by Dagmar Lowe appears in Christian Megert, *Christian Megert: A New Space* (London: Mayor Gallery, 2012), 7.

27 Kusama, "Onna hitori kokusai," 129.

28 While many have compared *Phalli's Field* to Lucas Samaras's *Mirror Room* (produced a year later, in 1966) based on their similarity as enclosed mirrored structures, the two installations could not be more different. Samaras's room includes mirrors not only on the walls but also on the ceiling and floor, thus producing a sterile, glasslike transparency. A mirrored table and chair placed at the center of the space allow viewers to contemplate their fragmented reflections. The smaller mirror panels and screws emphasize the architectural structure of Samaras's work as a literal experience of self-reflexivity that destabilizes perceptions of the self, which have encouraged Lacanian notions of the fragmented self during the mirror stage. See Bishop, *Installation Art,* 91; and Alexandra Munroe, "Obsession, Fantasy and Outrage: The Art of Yayoi Kusama," in *Yayoi Kusama: A Retrospective,* by Bhupendra Karia, Alexandra Munroe, and Reiko Tomii (New York: Center for International Contemporary Arts, 1989), 27–28.

29 The plan was by architect Alan Buchsbaum, who was renowned for his colorful "high-tech" style featured in many New York lofts of the 1970s. I thank Midori Yamamura for sharing this critical primary document with me.

30 Kusama, "Create, then Obliterate," 51.

31 International Galerij Orez to Yayoi Kusama, ca. July 1965, folder "Galerij Orez," Kusama Papers, Tokyo.

32 Caroline Westenholz, "Zero on Sea," in *Nul = 0: The Dutch Nul Group in an International Context,* by Colin Huizing, Tijs Visser, and Antoon Melissen (Schiedam: Stedelijk Museum Schiedam, 2011), 102.

33 Kusama, "Create, then Obliterate," 51.

34 It is critical to note how this idealistic aim contrasted with the technical spectacle at the forefront of French artist Nicolas Schöffer's *Infinite Prism,* a mirror-lined, pyramidal structure containing multicolored lights shifting kaleidoscopically that opened in New York a few weeks after *Phalli's Field,* in November 1965. Schöffer's cybernetic art represented a technological alternative to *Kusama's Peep Show.* This is evidenced by his appearance on the cover of the December 1968 issue of *Bijutsu techō* magazine and his inclusion in the *Electromagica '69* exhibition of international "psytech" art in Tokyo. See "Gendai bijutsu no kyoshō Nikora Shefēru," *Bijutsu techō,* no. 305 (December 1968): 52–74. *Electromagica '69: Kokusai saitekku ato ten* was presented from April 26 to May 25, 1969, at the Sony Building in Ginza, Tokyo. Many of the kinetic- and light-art works in this show, gathered from Japan, France, Germany, and the United States, were seen as anthropomorphic extensions of new media. See Junzō Ishiko, "Gendai bijutsu no shikaku—Miru kara miru e," *Biiku bunka* 19, no. 7 (July 1969): 7.

35 Yayoi Kusama, *Kusama Yayoi tatakau = Kusama's Body Festival in 60s* (Tokyo: ACCESS, 2011), 213.

36 Lee Ufan, "Sekai to kōzō: Taishō no gakai (gendai bijutsu ronkō)," *Dezain hihyō,* no. 9 (June 1969): 122, 130; translated by Stanley Anderson in *Lee Ufan: Marking Infinity,* by Lee Ufan, Alexandra Munroe, Akira Tatehata, and Mika Yoshitake (New York: Guggenheim Museum, 2011), 107.

37 Kusama was invited by Claudio Cardazzo (who first saw the artist on the cover of *Le Arte* in 1965) to make a twenty-five-meter wide sculpture for a garden space outside the Italian Pavilion at the 1966 Venice Biennale. Kusama stayed with Fontana in Milan to produce eight new sculptures for a solo exhibition at Galerie Naviglio, *Driving Image Show* (January 1966). Fontana, whom Kusama had first met at the *Nul 1965* exhibition, was an important supporter of the artist and helped to finance *Narcissus Garden.* Yayoi Kusama to Leo Verboon and Albert Vogel, February 22, 1966, Kusama Papers, Tokyo.

38 Yayoi Kusama, "Narcissus Garden," artist statement, 1966, Kusama Papers, Tokyo.

39 Kusama's neighbor Herb Aach, a painter and writer, introduced her to the use of fluorescent paints under black (ultraviolet) lights to enhance the glowing dots on nude bodies in darkness. See Herb Aach, "On the Use and Phenomena of Fluorescent Pigments in Paintings," *Leonardo* 3, no. 2 (April 1970): 137.

40 Mignon Nixon, "Anatomic Explosion on Wall Street," *October* 142 (Fall 2012): 3–25.

41 Yayoi Kusama, "Open Letter to Richard Nixon," 1968, Kusama Papers, Tokyo.

42 Toshiaki Minemura, "The Soul Going Back to its Home," in *Yayoi Kusama Collage, 1952–1983* (Tokyo: Nabis Gallery; Fuji Television Gallery, 1991), n.p.

43 Ibid.

44 My translation is based on the artist's handwritten script on the verso of *Now that You Died* (1975). I thank Aya Kato of the Setagaya Art Museum for bringing this to my attention.

45 Yayoi Kusama, *Mizutama no rirekisho* (Tokyo: Shūeisha, 2013), 147–48. Three versions of *Fireflies on the Water* exist: Musée des Beaux-Arts, Nancy (2000); Shizuoka Prefectural Museum of Art (2000); and the Whitney Museum of American Art, New York (2002). The last premiered at the 2004 Whitney Biennial.

46 *Soul under the Moon* was created for the 2002 Asia Pacific Triennial and eventually entered the collection of the Queensland Art Gallery. I thank Reuben Keehan, curator at the museum, for sharing his research on the history and context of *Soul under the Moon* and other early Infinity Mirror Rooms.

47 Reuben Keehan, email to the author, April 26, 2016.

48 Kusama, *Kusama Yayoi tatakau,* 213.

49 Maurice Merleau-Ponty, "Eye and Mind," in *Maurice Merleau-Ponty: Basic Writings,* ed. Thomas Baldwin (New York: Routledge, 2003), 313.

50 Ibid.

51 Kusama initially set out to complete 100 paintings, but she has now created more than 500, and her current goal is to reach 1,000.

52 The association with aboriginal art goes back to 1965. In a review of Kusama's sculptural installation *Flowerbed*—exhibited at the same time as *Phalli's Field*—Jan Cremer noted how "Kusama reconciles the opposing forces in her work. She conquers her fears of danger, her evil demons, just as the aboriginal sculptor does, by transforming them into images." Jan Cremer, "Flowerbed," *Art Voices* (Fall 1965): 5.

53 Edward Casey, "Habitual Body and Memory in Merleau-Ponty," *Man and World* (Fall 1984): 280.

54 Edward Casey, "Body Memory," in *Remembering: A Phenomenological Study* (Bloomington: Indiana University Press, 1987), 147.

55 Henri Bergson's *Matter and Memory* quoted in Casey, "Habitual Body," 282.

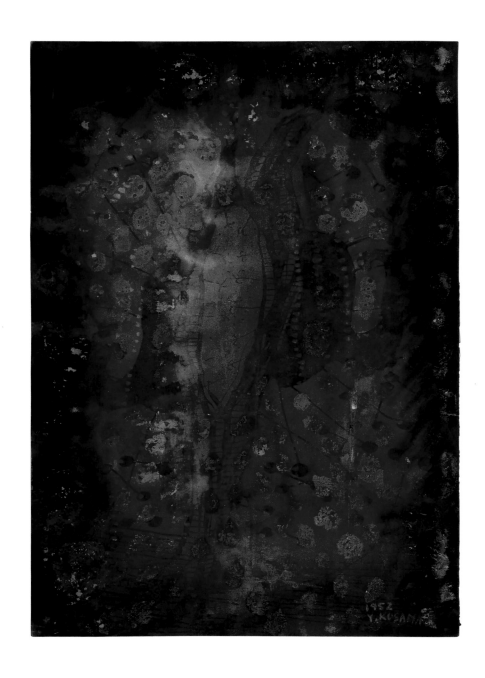

Plate 9. *Untitled,* 1952. Ink, gouache, oil pastel, and
pastel on paper, 10½ x 7⅜ in. (26.8 x 18.8 cm).
Collection of the artist

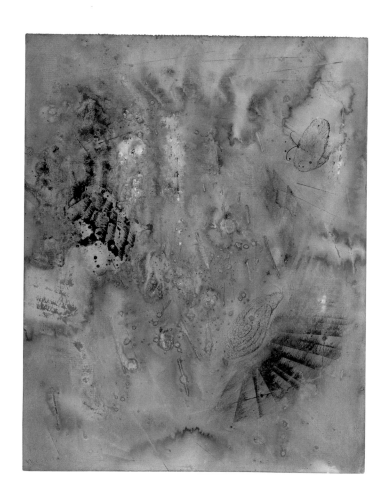

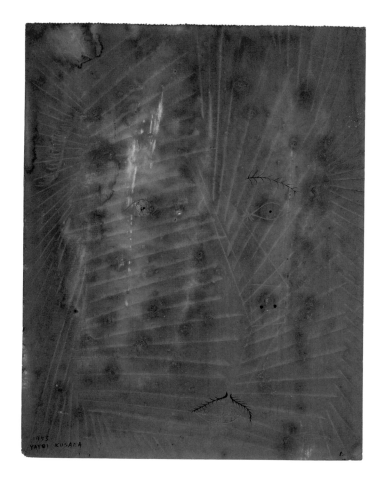

Plate 10. *The World of Insect*, 1953. Ink, gouache, and pastel on paper, 8¾ x 7⅝ in. (22.3 x 19.4 cm). Collection of the artist

Plate 11. *A Man*, 1953. Ink, gouache, and pastel on paper, 11½ x 8¾ in. (29.4 x 22.4 cm). Collection of the artist

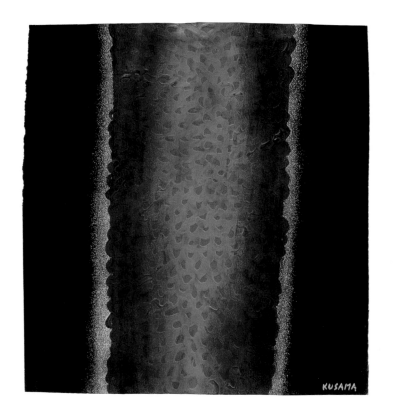

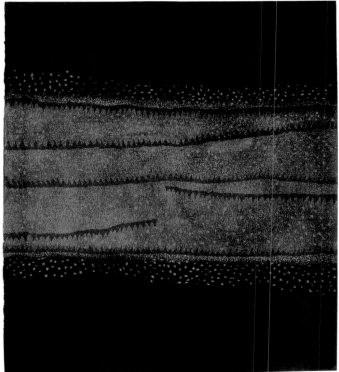

Plate 12. *Column No. GOL,* 1953. Tempera and pastel on paper, 14⅛ x 12⅝ in. (35.9 x 32.1 cm). Collection of Mark Diker and Deborah Colson

Plate 13. *The Hill, 1953 A (No. 30)*, 1953. Gouache, pastel, oil, and wax on paper, 14⅜ x 12⅜ in. (36.3 x 31.4 cm). Hirshhorn Museum and Sculpture Garden, Washington, DC, Museum Purchase, 1996

Plate 14. *Horizontal Love*, 1953. Spray enamel and ink on paper, 16¼ x 13⅛ in. (41.3 x 33.4 cm). Blanton Museum of Art, The University of Texas at Austin, Gift of the Center for International Contemporary Arts; Emanuel and Charlotte Levine Collection, 1992

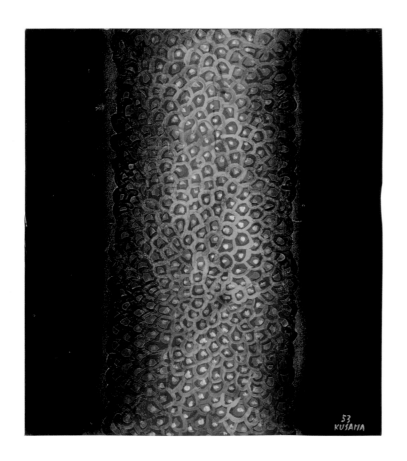

Plate 15. *Column No. 1,* 1953. Tempera and pastel on paper, 15 x 12¾ in. (38.1 x 32.4 cm). Miyoung Lee and Neil Simpkins

Plate 16. *M.A.M. Egg,* 1954/1963. Tempera and pastel on paper, 11⅛ x 13¼ in. (28.3 x 33.7 cm). Private collection. Courtesy David Zwirner, New York/London

Plate 17. *Nets and Red No. 2,* 1958/c. 1963. Pastel on paper
with synthetic netting, 11 x 8⅝ in. (27.9 x 21.9 cm). Private
collection. Courtesy David Zwirner, New York/London

Plate 18. *Long Island*, 1959. Chinese ink on paper, 28⅜ x 23¾ in. (71.9 x 60.4 cm). Collection of the artist

Plate 19. *Pacific Ocean*, 1959. Watercolor on paper, 28 x 23½ in. (71.1 x 58.7 cm). Beatrice and Hart Perry Collection

Plate 20. *Pacific Ocean*, 1959. Watercolor and ink on paper, 22½ x 27⅜ in. (57 x 69.5 cm). Takahashi Collection, Tokyo

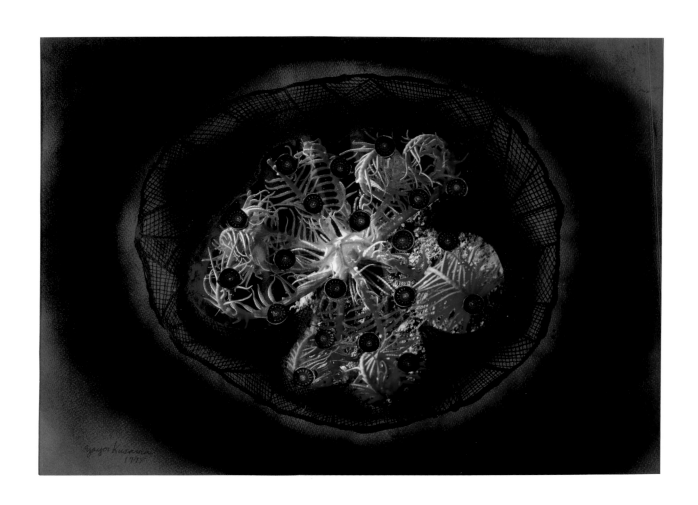

Plate 21. *Flower*, 1975. Collage with pastel, ink,
and fabric on paper, 15⅝ x 21⅜ in. (39.8 x
54.3 cm). Collection of the artist

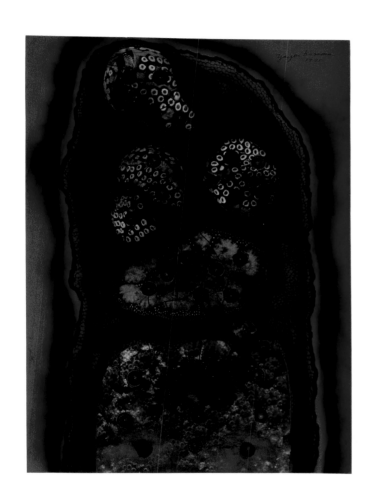

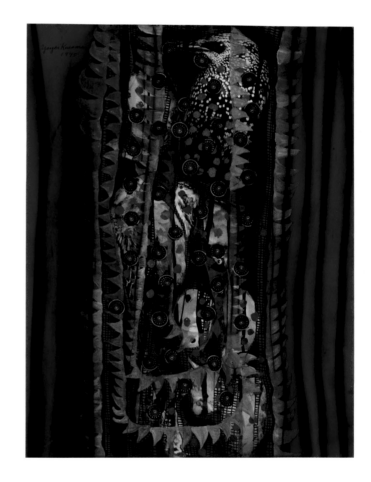

Plate 22. *Polka Dots of Polka Dots*, 1975. Collage with pastel, ink, and fabric on paper, 21½ x 15½ in. (54.5 x 39.5 cm). Collection of the artist

Plate 23. *Resting in the Heart of Green Shade*, 1975. Collage with gouache, pastel, ink, and fabric on paper, 21½ x 15½ in. (54.5 x 39.5 cm). Collection of the artist

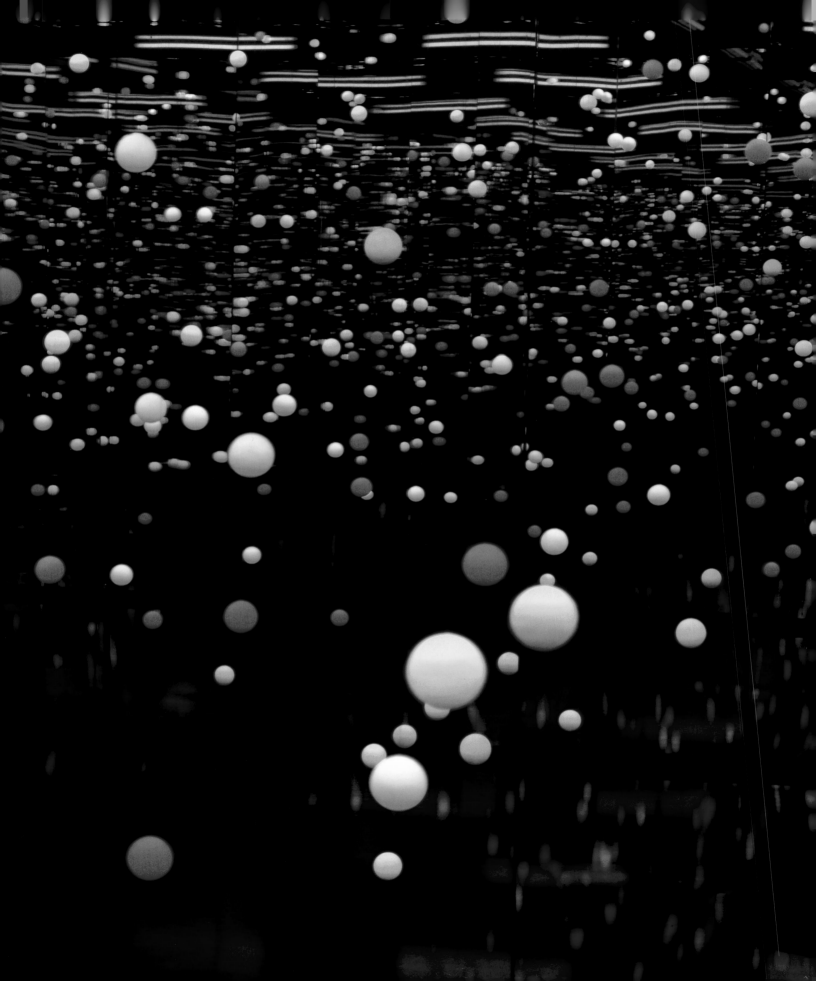

INFINITY MIRROR ROOMS

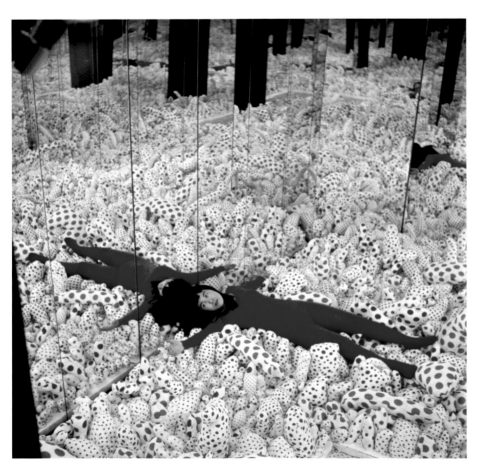

1. *Infinity Mirror Room—Phalli's Field,* 1965.
Sewn and stuffed cotton, board, and
mirrors. Installed in *Floor Show,* Castellane
Gallery, New York, 1965. No longer extant

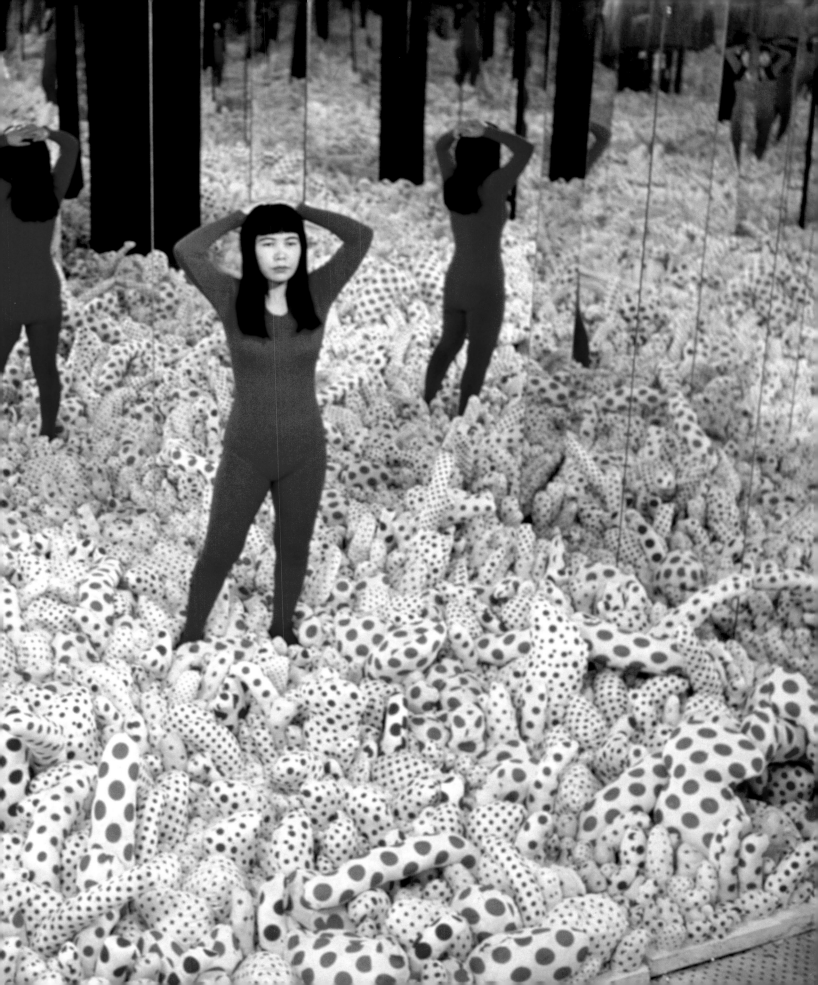

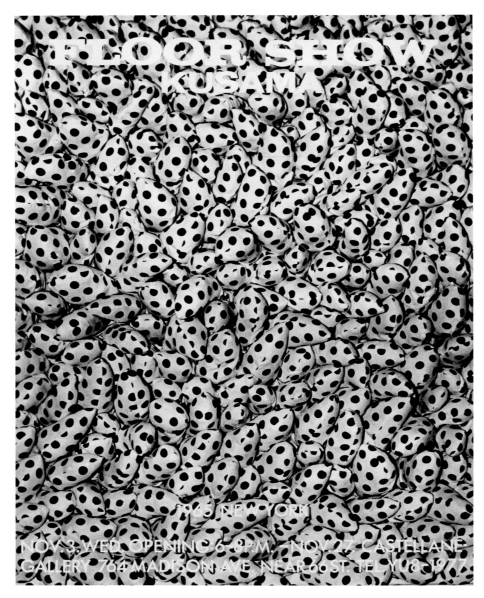

1.1. Poster for *Floor Show: Kusama,* Castellane Gallery, New York, November 3–27, 1965

OPPOSITE
1.2. Kusama in *Infinity Mirror Room—Phalli's Field*, 1965

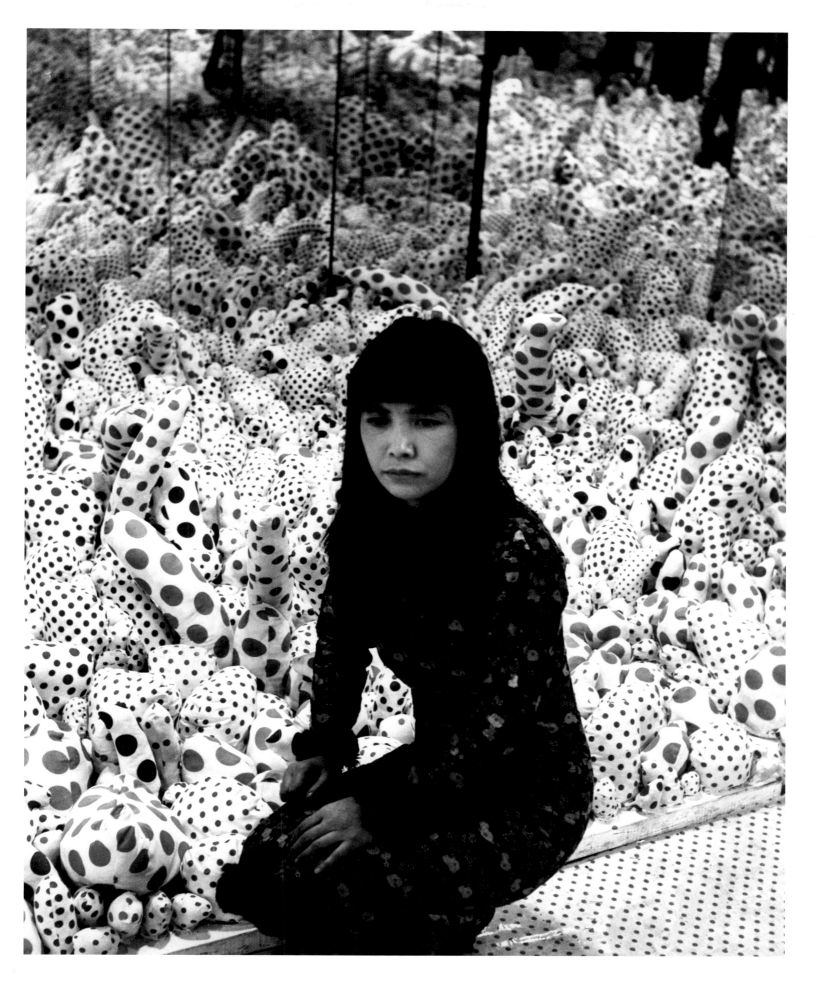

1.3. Kusama in *Infinity Mirror Room—Phalli's Field*, 1965. Reprinted in Lawrence Alloway, "Art in Escalation, the History of Happenings: A Question of Sources," *Arts Magazine* 41, no. 3 (December 1966–January 1967): 40–41

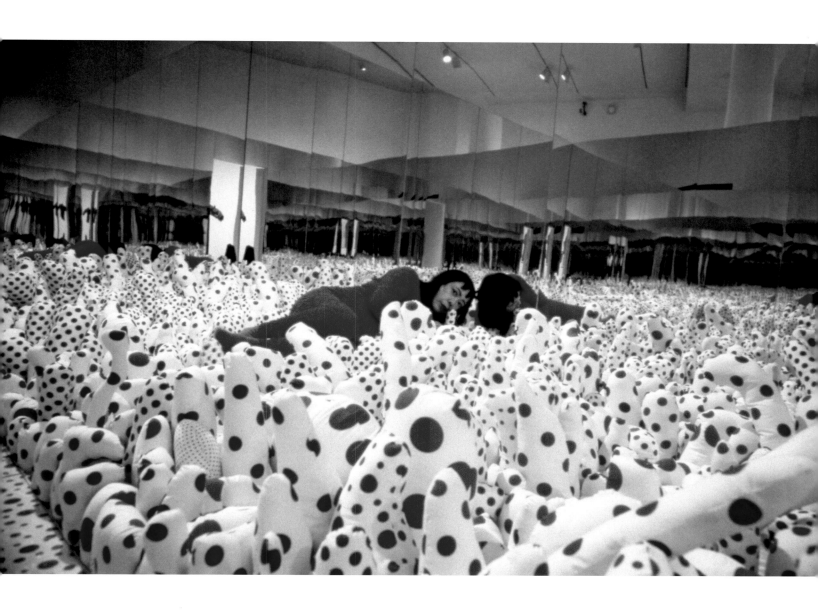

1.4. Kusama in *Infinity Mirror Room—Phalli's Field,* 1965/1998. Installed in *Love Forever: Yayoi Kusama 1958–1968,* Los Angeles County Museum of Art, 1998. Collection of Museum Boijmans Van Beuningen, Rotterdam

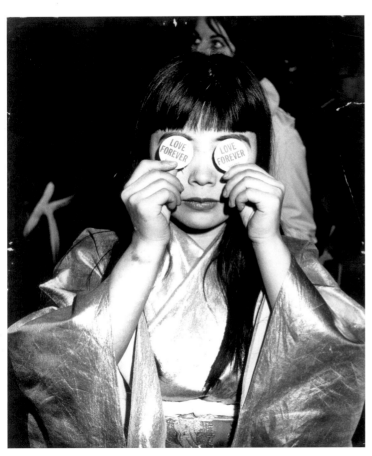

2.1. Kusama with "Love Forever" buttons at *Kusama's Peep Show*, Castellane Gallery, New York, 1966. Photograph by Hal Reiff

2. *Kusama's Peep Show or Endless Love Show*, 1966. Hexagonal mirrored room and electric lights, approx. 108 in. (274.3 cm) wide. Installed at Castellane Gallery, New York, 1966. No longer extant. Photograph by Peter Moore

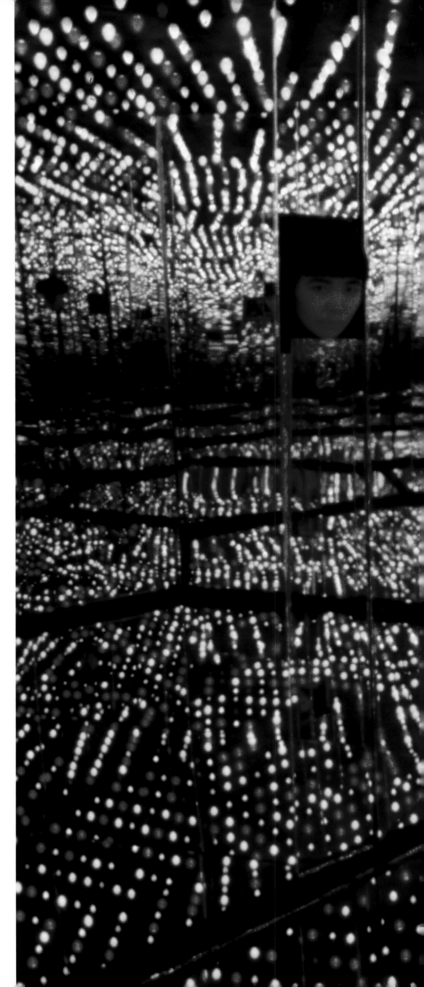

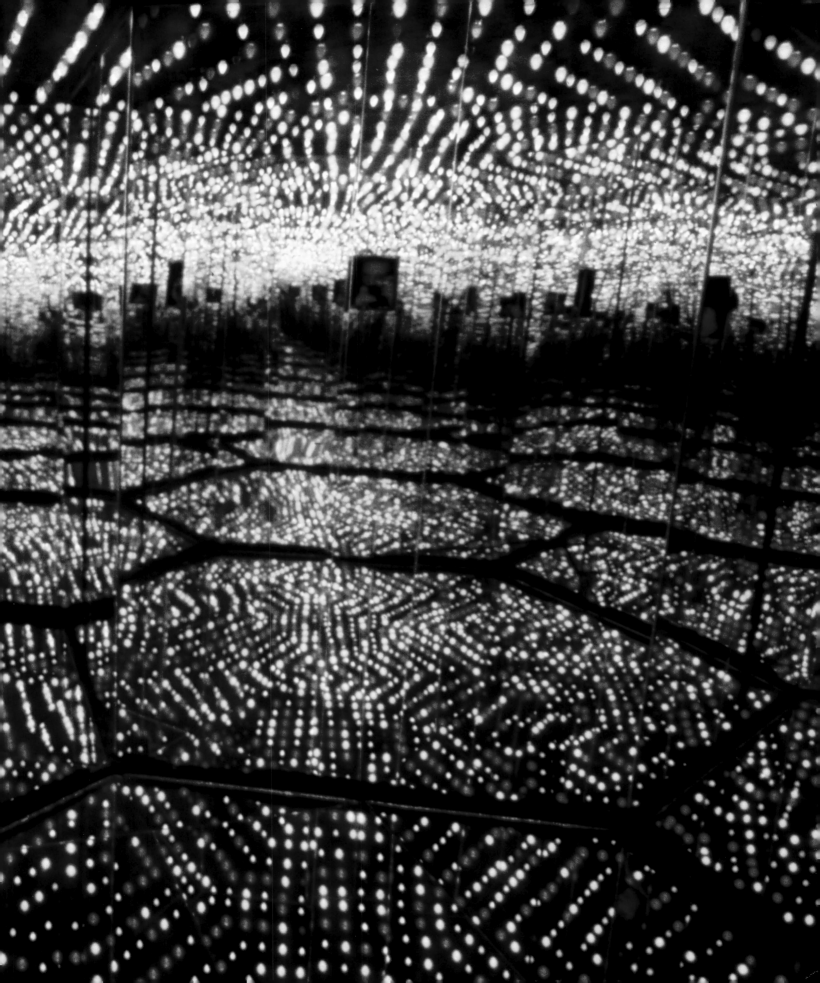

For Immediate Release

KUSAMA'S PEEP SHOW
March 15 - April 22, 1966
Opening: Tuesday, March 15, 5 - 7 p.m.

KUSAMA is exhibiting the second of her series of Infinity-Mirror Rooms at the Castellane Gallery, beginning March 15. Kusama's "Floor Show," the first of the series, was exhibited last November at the same gallery, marking the first use of the principle of the mirror room as an environment for an art show. Later on, the mirror room idea was used by Shöffer and others.

Although Kusama's "Floor Show" took place at ground level, the ceiling plays a role in her new work, which features illumination in motion, repeated to infinity, with a musical accompaniment.

Kusama will exhibit a third Infinity-Mirror Room at Sheveningen Pier in Holland, in April, when she participates in the International Zero Exhibition with Fontana, Mack, Piene, Uecker and others.

The fourth Infinity-Mirror Room will be shown, before the end of the year, in London and Stockholm. Kusama will also have a twenty-meter wide exhibit at the forthcoming Venice Biennale.

Kusama has just returned from Milan, where her one-man show at the Galleria del Naviglio, featuring proliferating phallic symbols, was the subject of illustrated articles in leading Italian newspapers. Kusama's sculptures and paintings have been reproduced in color on the covers of thirteen magazines: Le Arti (Italy), Art Voices (U.S.A.), Nieuwe Stil (Holland), Gendai Bijutsu (Japan), Asahi Journal (Japan), etc.

In April , 1965, the Stedelijk Museum of Amsterdam staged Kusama's "One Thousand-Boat Show," giving it a special room. Later on, the Museum of Modern Art of Stockholm exhibited her eleven-foot "Row Boat." During her stay in Holland, Kusama had a one-man show at the International Gallery Orez at the Hague. On May 1, Kusama will exhibit at the Thelen Gallery in Essen, Germany. Other one-man shows will follow at the Grosvenor Gallery in London, the Galerie Smith in Brussels and the Galerie Wulfengasse in Austria.

In December, 1965, New York's Channel 13 televised an interview with Kusama as well as with Warhol, Lichtenstein, Segal, Bontecou and Marisol. Previously, these interviews had been widely televised in Europe. At present, Kusama is working on an avant-garde film of her own.

2.2. Press release for *Kusama's Peep Show,* Castellane Gallery, New York, 1966

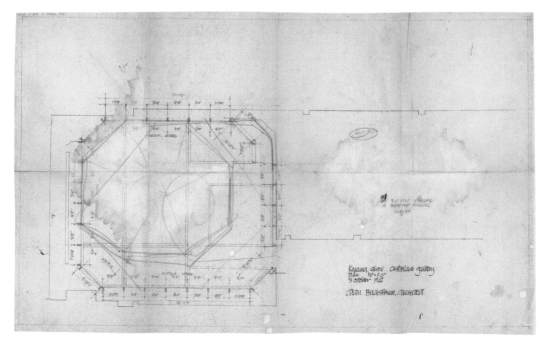

2.3. Yayoi Kusama and Alan Buchsbaum (architect). Drawing for *Floor Show*, with superimposed octagonal sketch, dated October 3, 1965

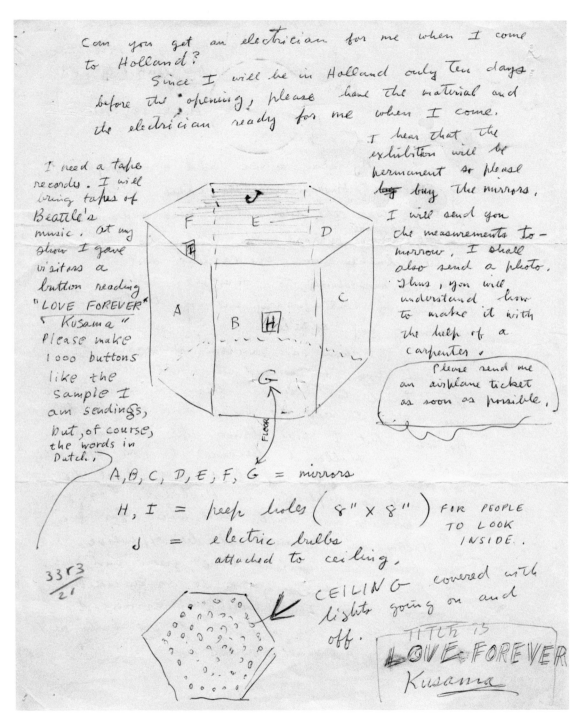

Can you get an electrician for me when I come to Holland?

Since I will be in Holland only ten days before the opening, please have the material and the electrician ready for me when I come.

I need a tape recorder. I will bring tapes of Beatle's music. At my show I gave visitors a button reading "LOVE FOREVER Kusama" Please make 1000 buttons like the sample I am sending, but, of course, the words in Dutch.

I hear that the exhibition will be permanent so please buy the mirrors. I will send you the measurements to-morrow. I shall also send a photo. Thus, you will understand how to make it with the help of a carpenter.

Please send me an airplane ticket as soon as possible.

A, B, C, D, E, F, G = mirrors

H, I = peep holes (8" × 8") FOR PEOPLE TO LOOK INSIDE.

J = electric bulbs attached to ceiling.

CEILING covered with lights going on and off.

TITLE IS

LOVE FOREVER
Kusama

2.4. Drawn proposal for *Love Forever*, 1966, as part of Zero op Zee (Zero on Sea), unrealized project at Scheveningen Pier, the Hague, Netherlands

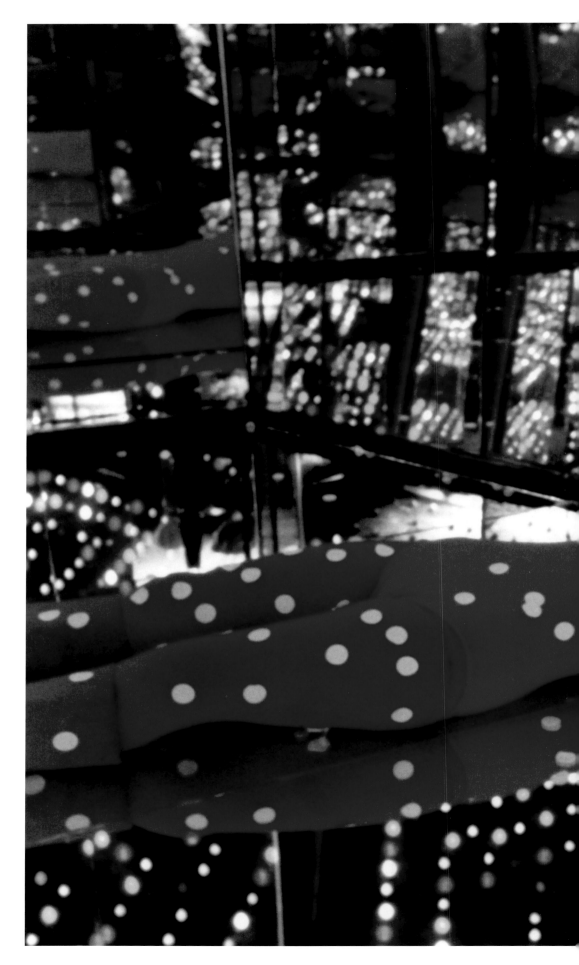

2.5. *Kusama's Peep Show or Endless Love Show*, 1966. Hexagonal mirrored room and electric lights. Installed at Castellane Gallery, New York, 1966. No longer extant

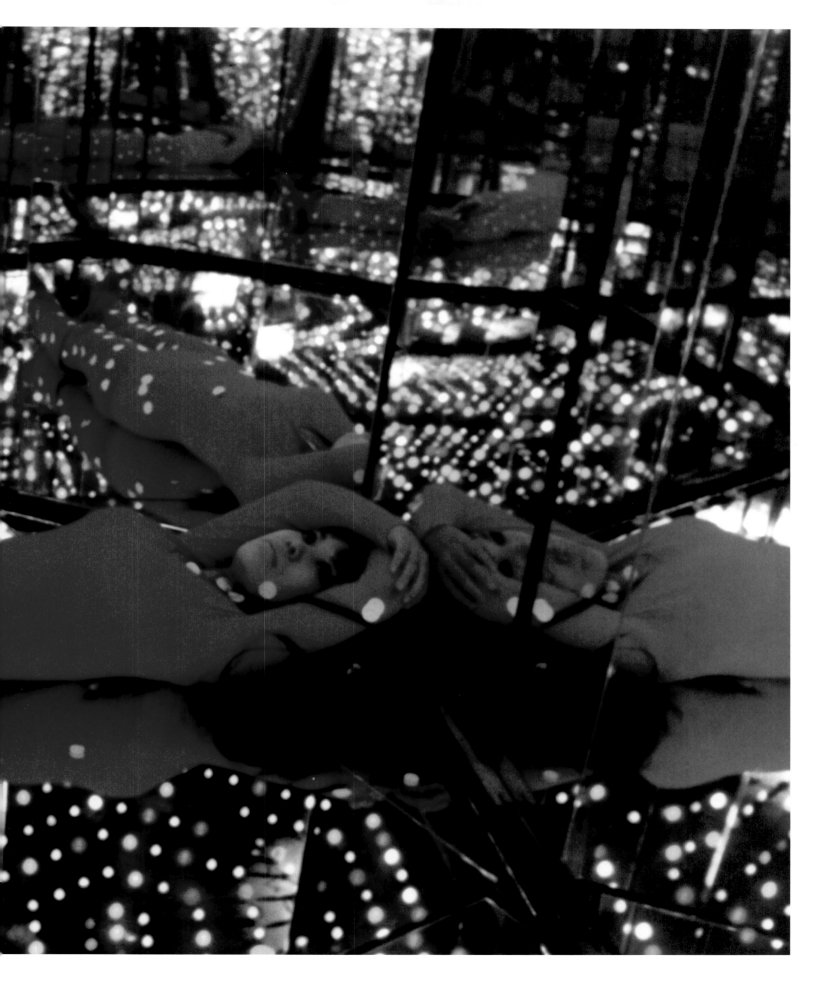

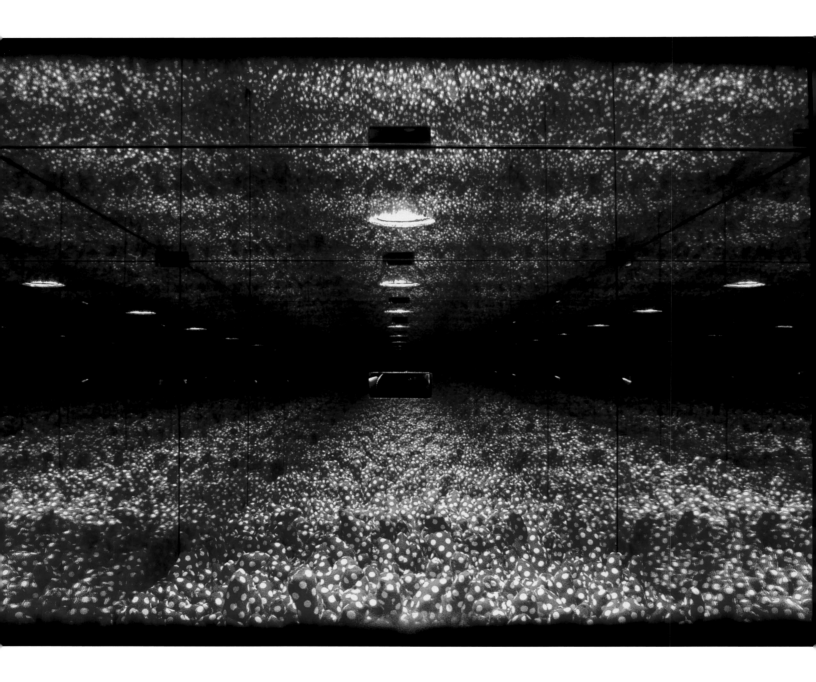

3. *Endless Love Room,* 1966–c. 1981.
Sewn and stuffed printed fabric, mirrors,
and electric light, approx. 67 x 29½ x
29½ in. (170 x 75 x 75 cm). Collection of
the Meguro Museum of Art, Tokyo
Interior and exterior views of peep-in
mirror box

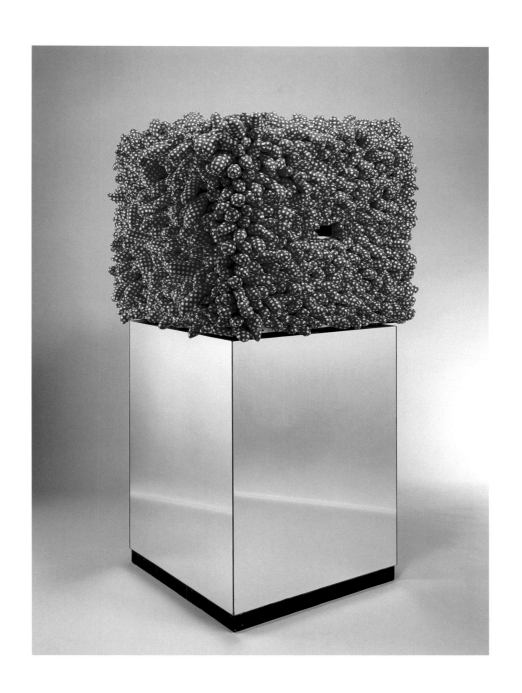

OVERLEAF
4. *Mirrored Room—Love-Forever No. 2*,
1965–c. 1981. Sewn and stuffed fabric,
electric light, and mirrors. Private
collection
Interior view of peep-in mirror box

59

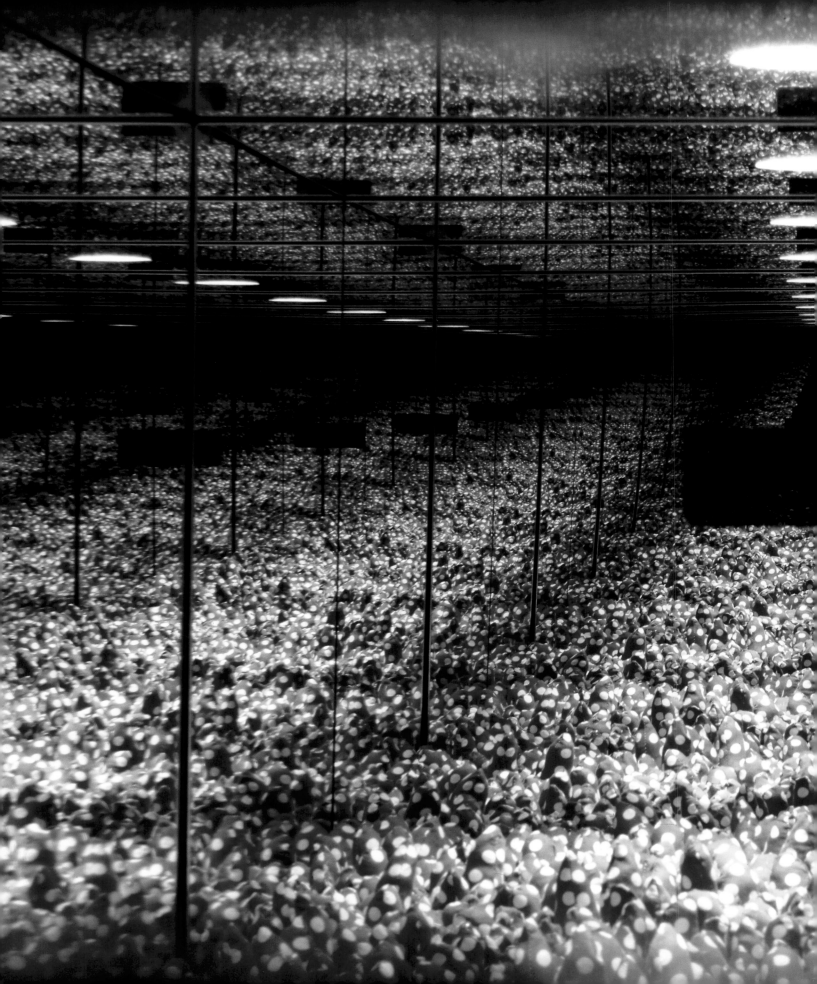

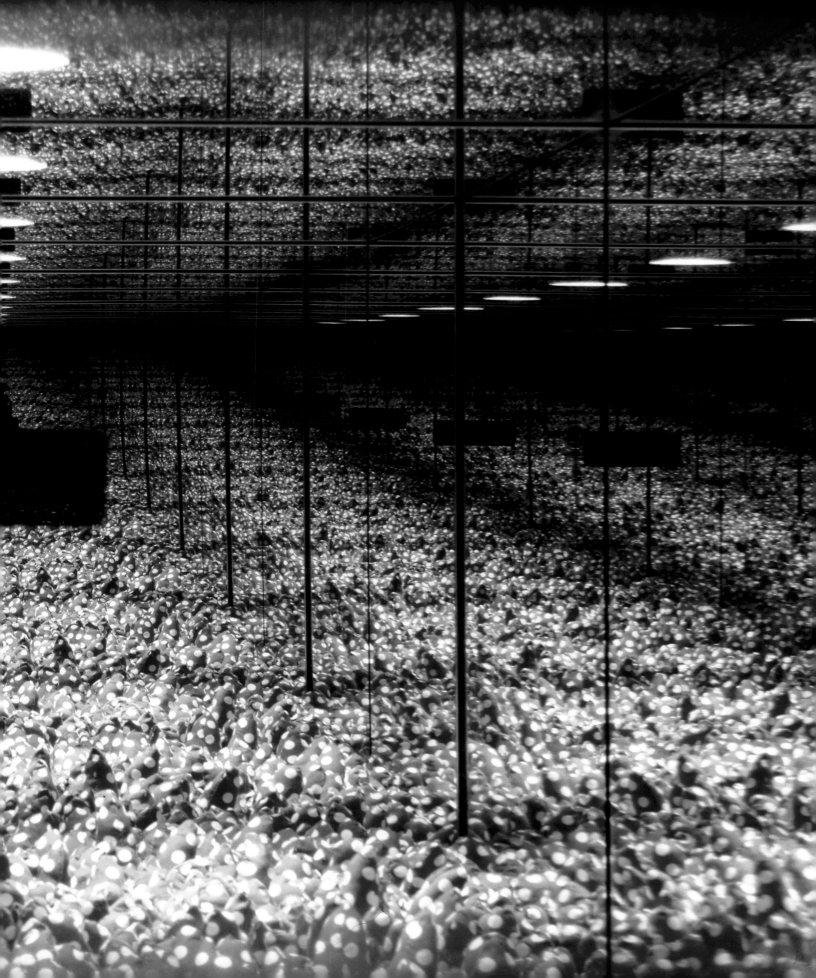

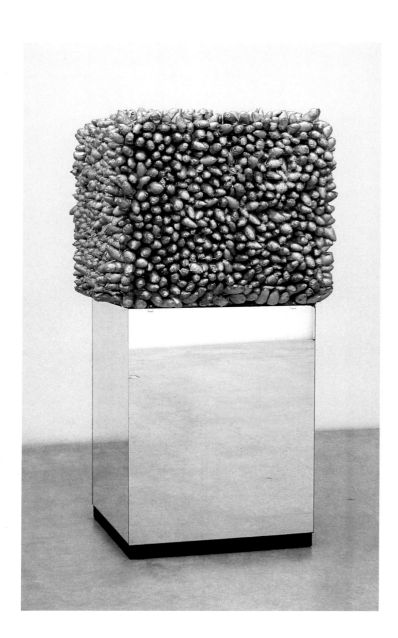

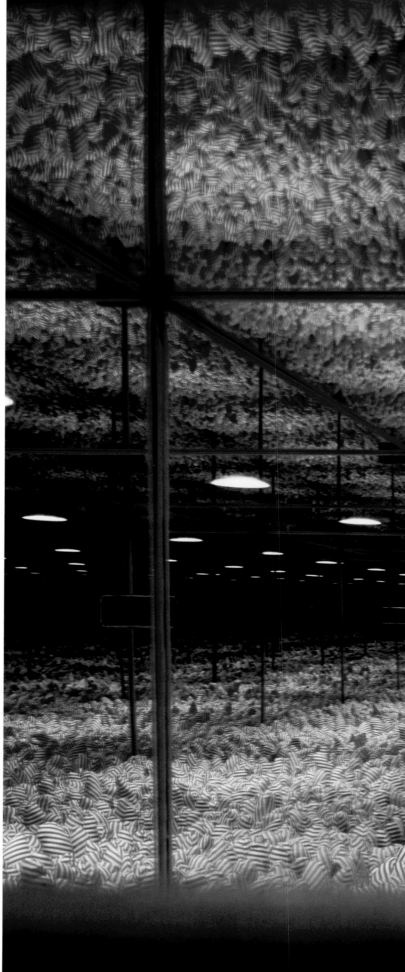

5. *Mirrored Room—Love-Forever No. 3*,
1965–c. 1981. Silver-painted sewn and
soft sculpture and mirrored base, approx.
67 x 29½ x 29½ in. (170 x 75 x 75 cm).
Takahashi Collection, Tokyo
Exterior and interior views of peep-in
mirror box

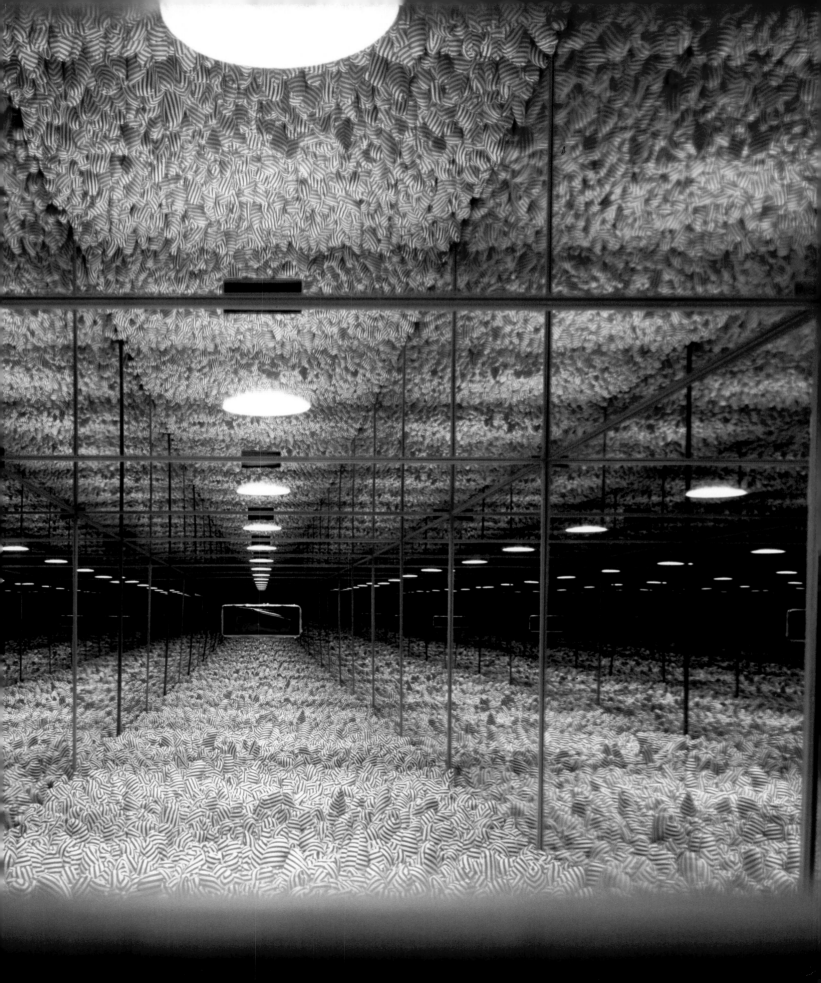

6. *Mirror Room (Pumpkin),* 1991. Mirror,
iron, wood, plaster, polystyrene, and
acrylic paint, 78¾ x 78¾ x 78¾ in. (200 x
200 x 200 cm). Exhibited at the Japanese
Pavilion, Forty-fifth Venice Biennale, 1993.
Collection of the Hara Museum of
Contemporary Art. Photograph courtesy
of Norihiro Ueno
Exterior view of peep-in mirror box inside
polka-dot room

OVERLEAF
Detail: interior view of peep-in mirror box

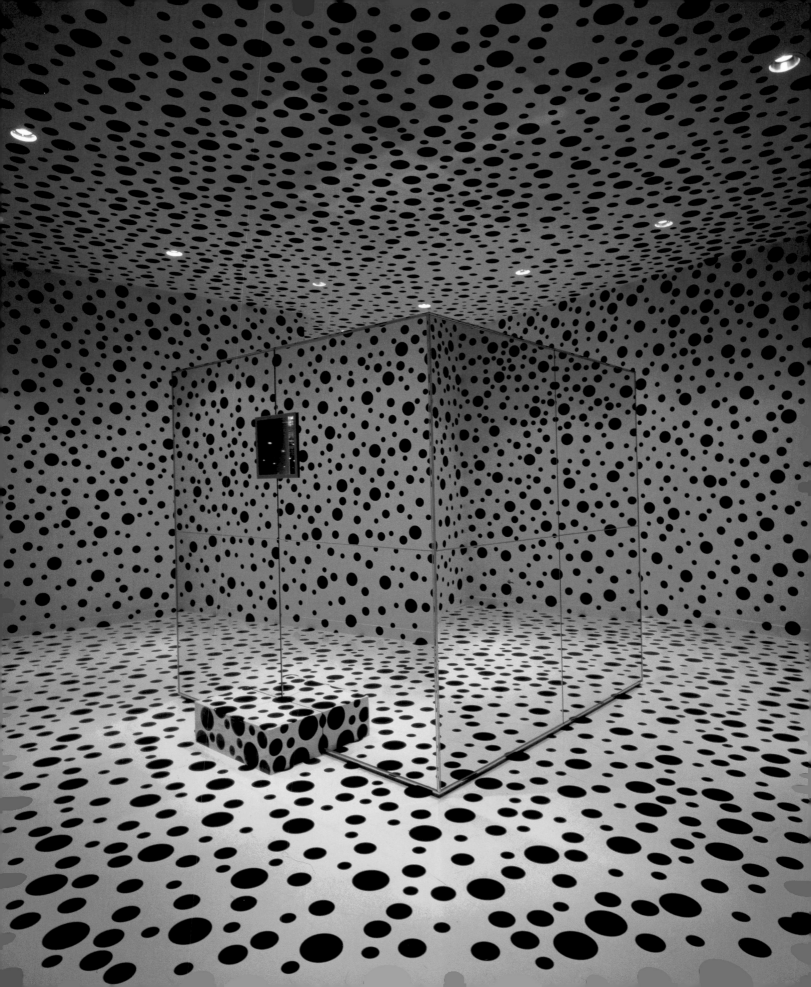

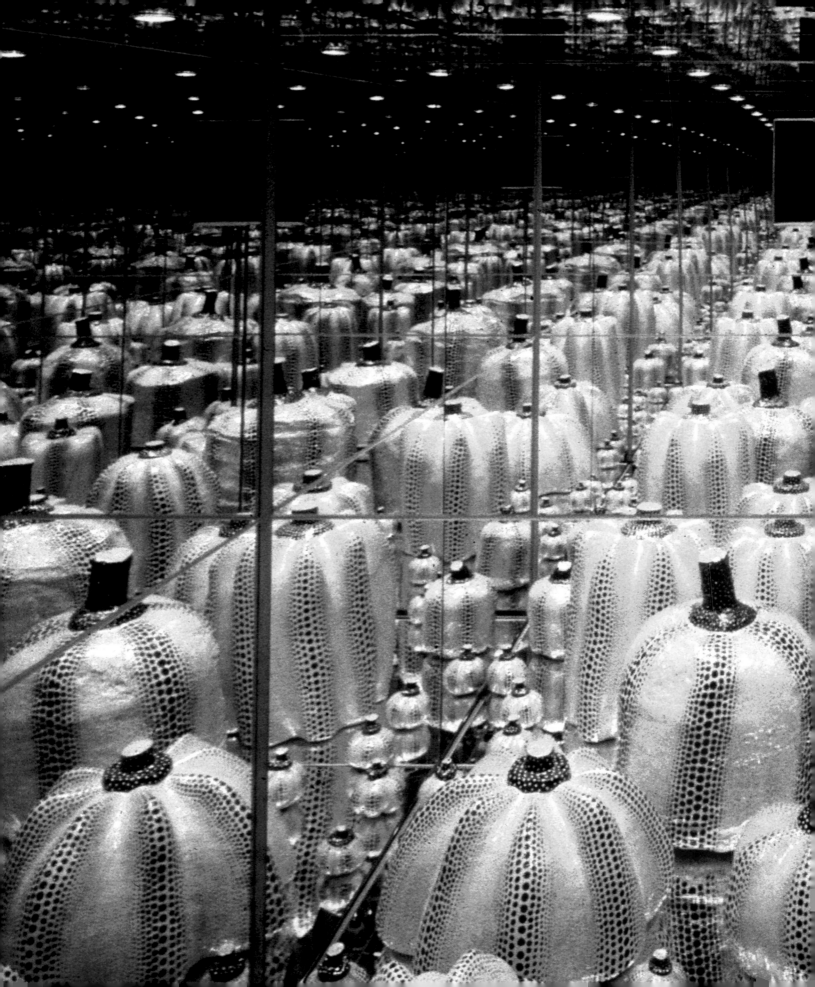

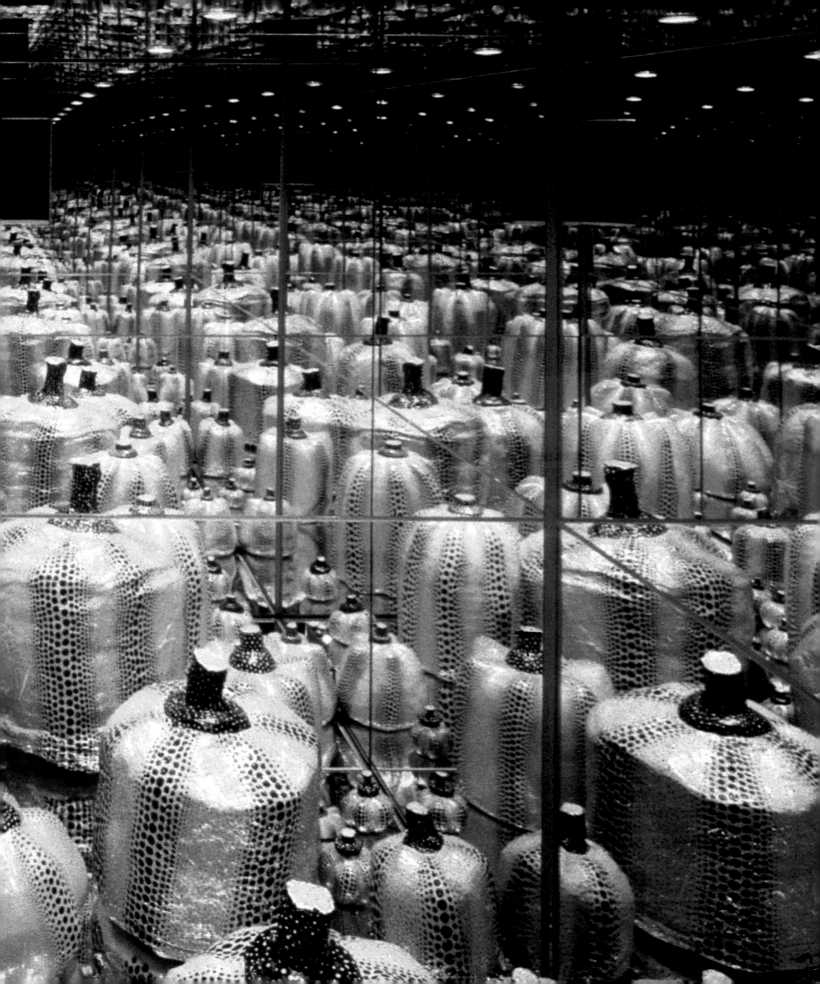

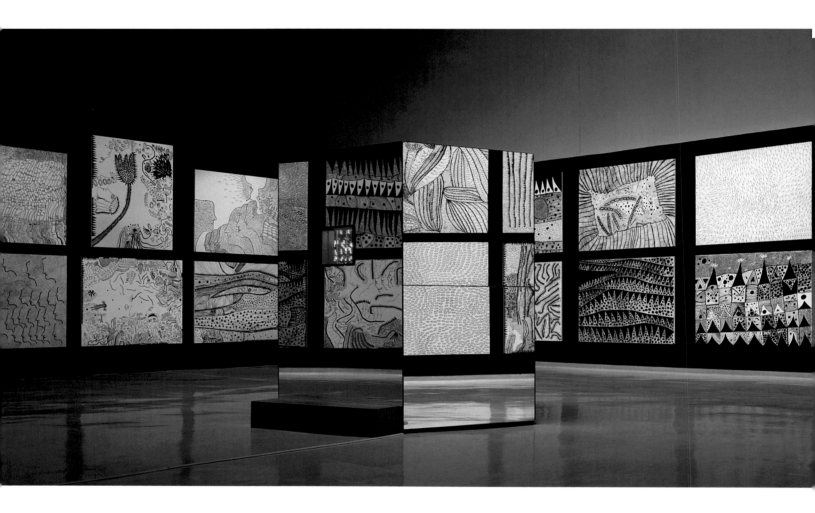

7. *Infinity Mirrored Room—Love Forever,*
1966/1994. Wood, mirrors, metal, and
lightbulbs, 82⅝ x 94½ x 80¾ in. (210 x
240 x 205 cm). Collection of Ota Fine
Arts, Tokyo/Singapore. Installed in
Kusama Yayoi: A Dream I Dreamed,
Kaohsiung Museum of Fine Arts, Taiwan,
2015. Photo courtesy of Mediasphere
Communications Ltd.
Exterior and interior views of hexagonal
mirror chamber

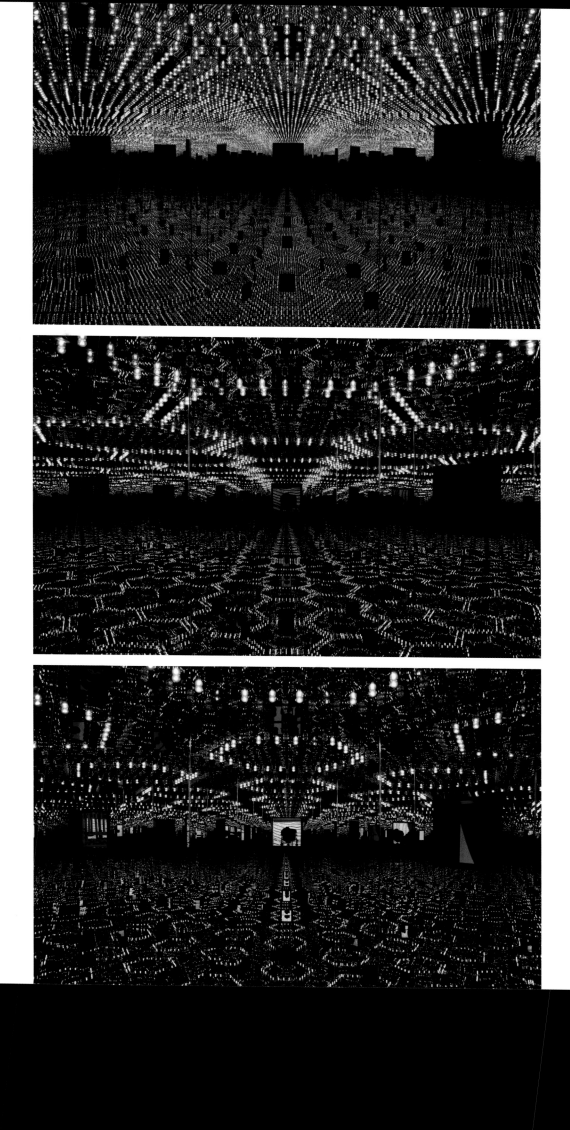

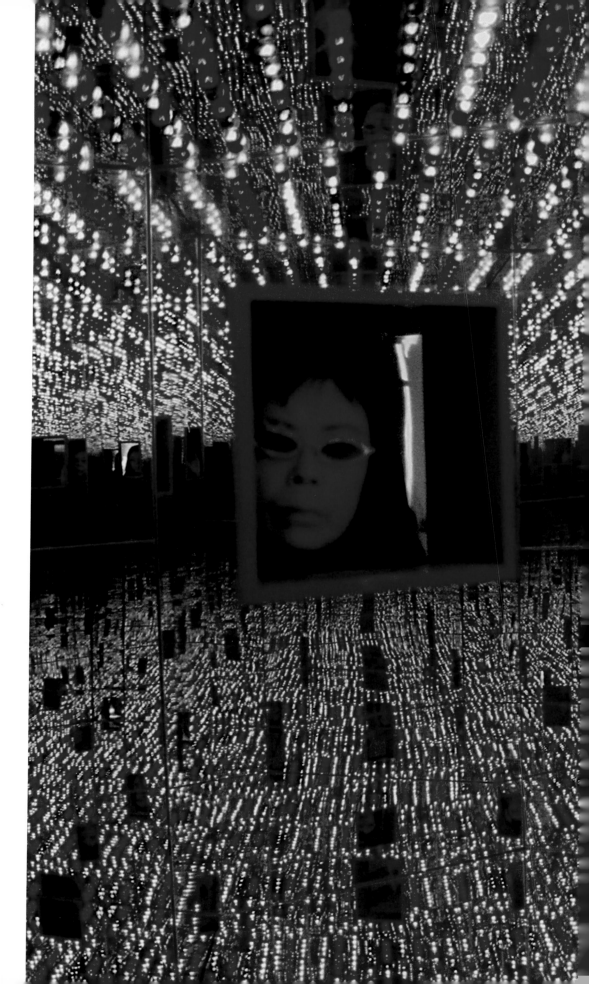

7.1. *Infinity Mirrored Room—Love Forever*,
1966/1994. Wood, mirrors, metal, and
lightbulbs. Installed in *Yayoi Kusama,*
Le Consortium, Dijon, 2000
Kusama peering into hexagonal mirror
chamber

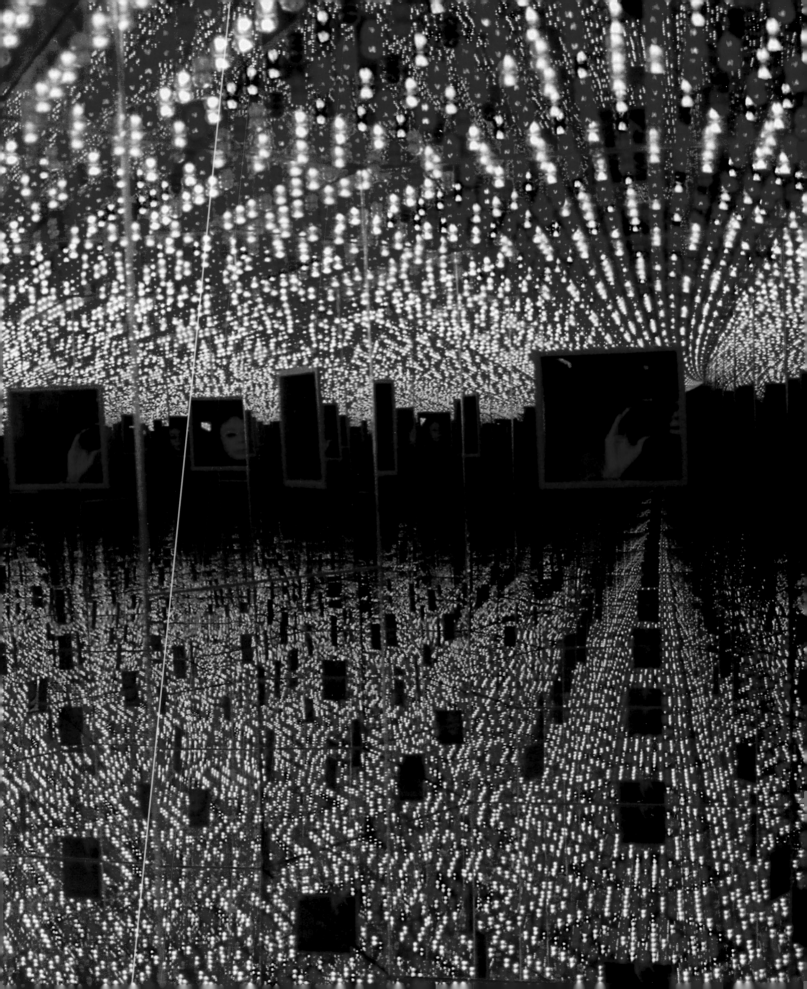

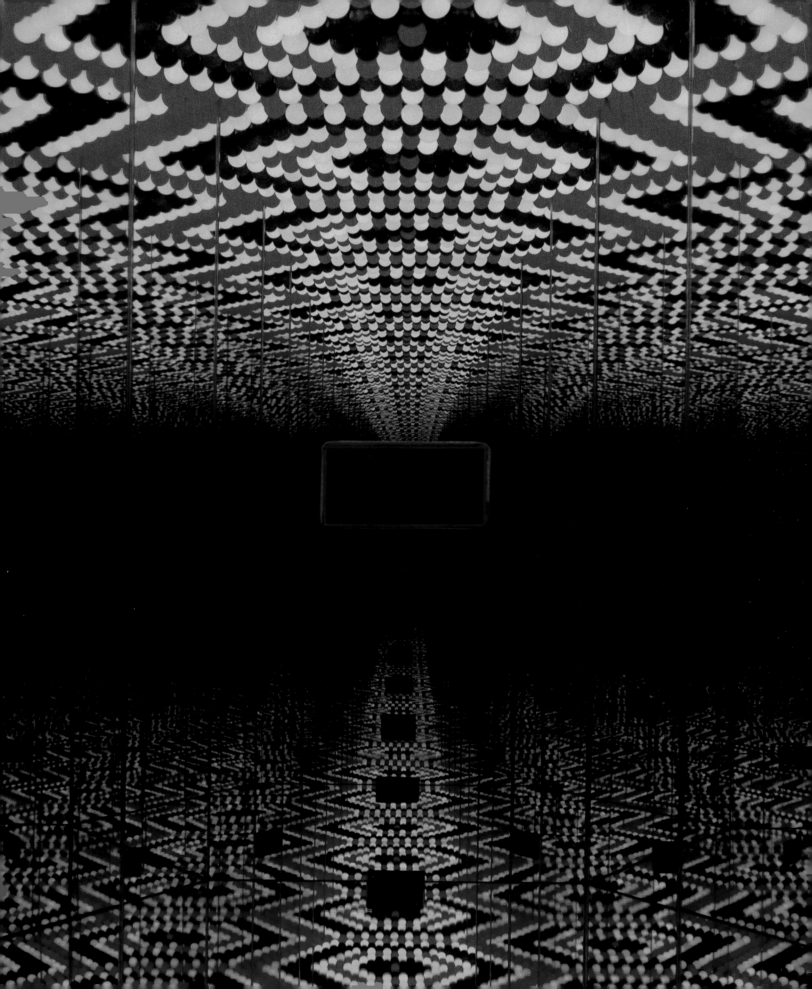

OPPOSITE
8. *Infinity Mirrored Room*, 1996. Wood,
mirrors, metal, and electric lightbulbs,
76¾ x 42⅛ x 40 in. (200 x 107 x 100 cm).
Private collection. Installed in *Recent
Works,* Robert Miller Gallery, New York,
1996
Interior view of hexagonal mirror chamber

RIGHT
9. *Infinity Mirror Room—Lights of Shinano*,
2001. Wood, mirrors, metal, and
lightbulbs, 86½ x 56⅞ x 56⅞ in. (220 x
144.4 x 144.4 cm). Collection of
Matsumoto City Museum of Art
Interior view of three light cycles in
hexagonal mirror chamber

10. *Repetitive Vision*, 1996. Formica, adhesive dots, mannequins, and mirrors, 120 x 144 x 144 in. (304.8 x 365.8 x 365.8 cm). Collection of The Mattress Factory, Pittsburgh, PA

10.1. February 1997 cover of *Artforum* featuring Kusama's *Repetitive Vision*, 1996

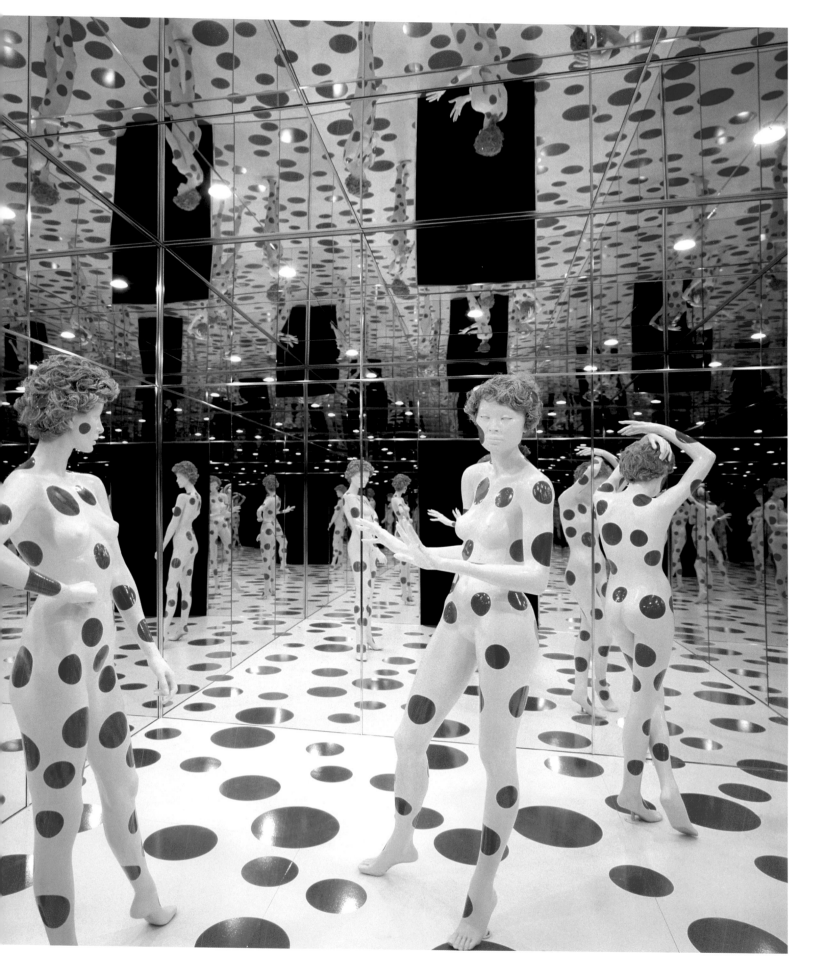

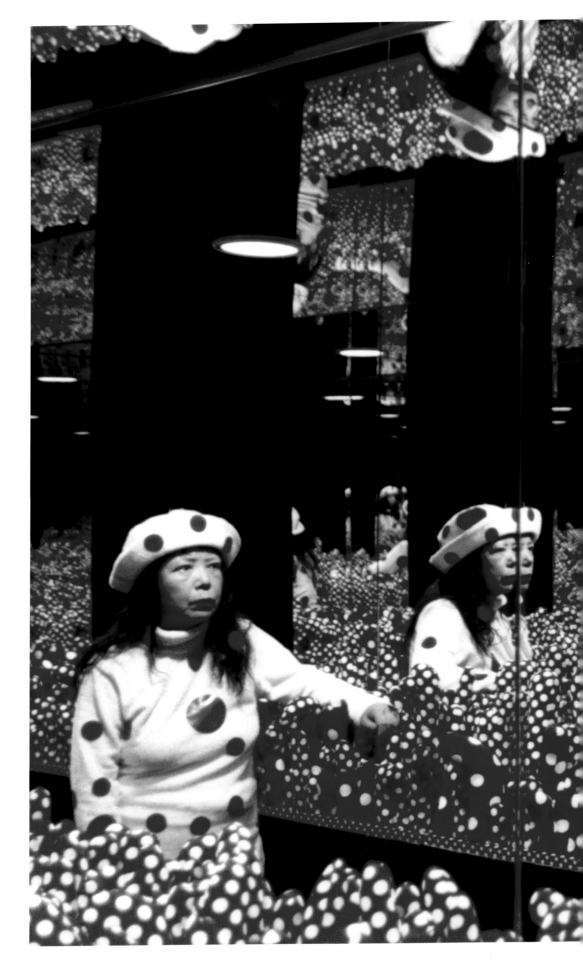

11. *Passage of Mirrors,* 1996. Sewn and stuffed fabric, wood, paint, and mirrors. Installed in *Repetition*, Art Gallery Artium, Fukuoka, 1996

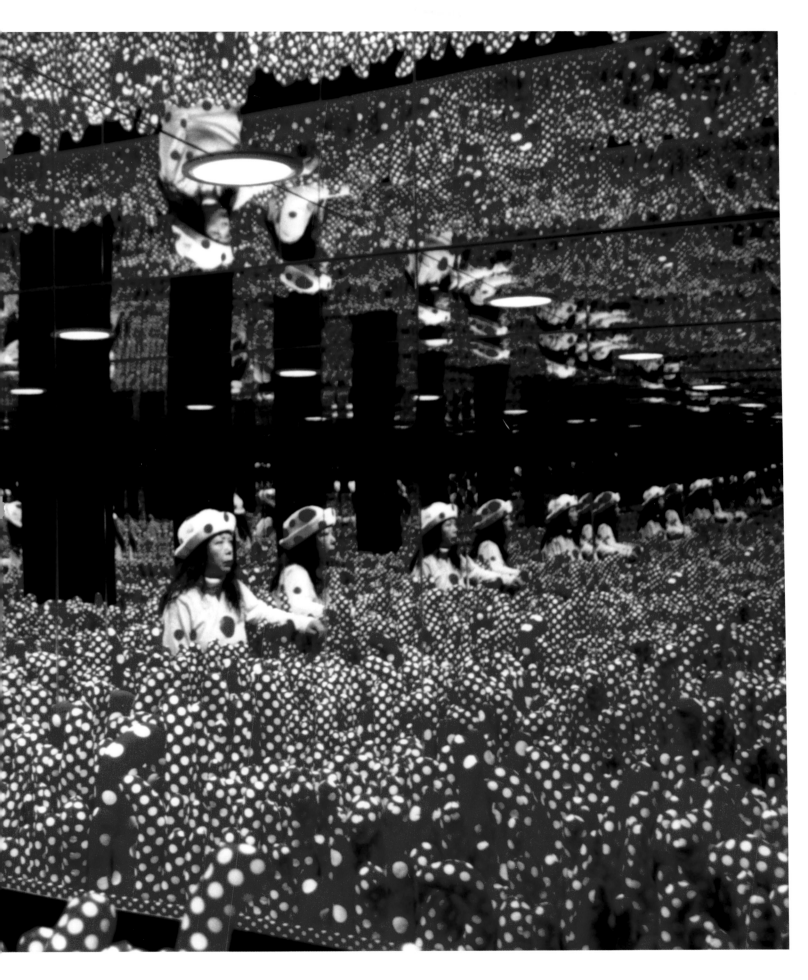

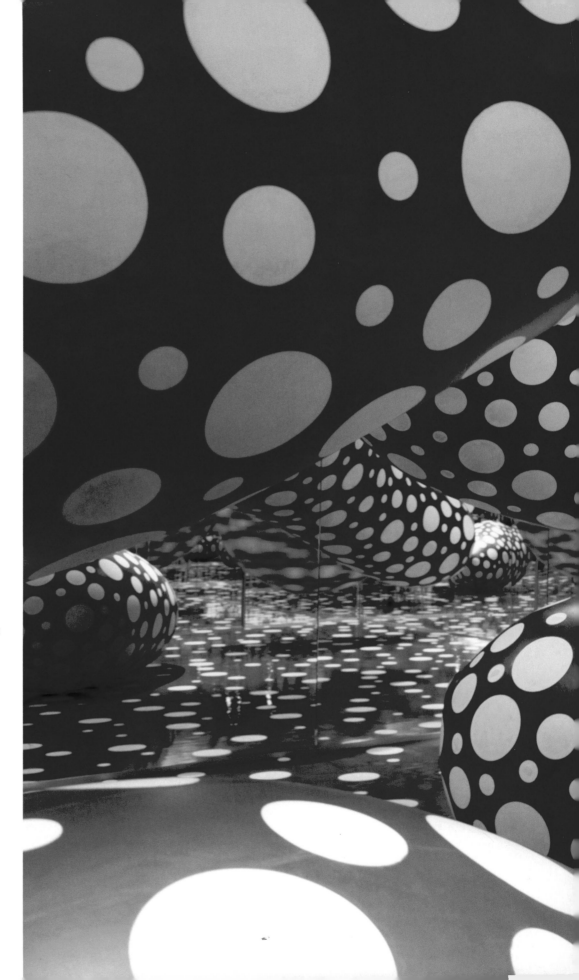

12. *Dots Obsession*, 1998. Paint, stickers, vinyl balloons, and mirrors, 110¼ x 236¼ x 236¼ in. (280 x 600 x 600 cm). Collection of Les Abbatoirs, Musée d'art moderne et FRAC Midi-Pyrénées, Toulouse

OVERLEAF
13. *Fireflies on the Water*, 2002. Mirrors, acrylic, hanging lights, and water, 126 x 174 x 174 in. (320 x 442.4 x 442.4 cm). Collection of the Whitney Museum of American Art, New York; purchase, with funds from the Postwar Committee and the Contemporary Painting and Sculpture Committee and partial gift of Betsy Wittenborn Miller, 2003.322. Installed in Yayoi Kusama's *Fireflies on the Water*, Whitney Museum of American Art, New York, June 13–October 28, 2012. Photography by Sheldan C. Collins

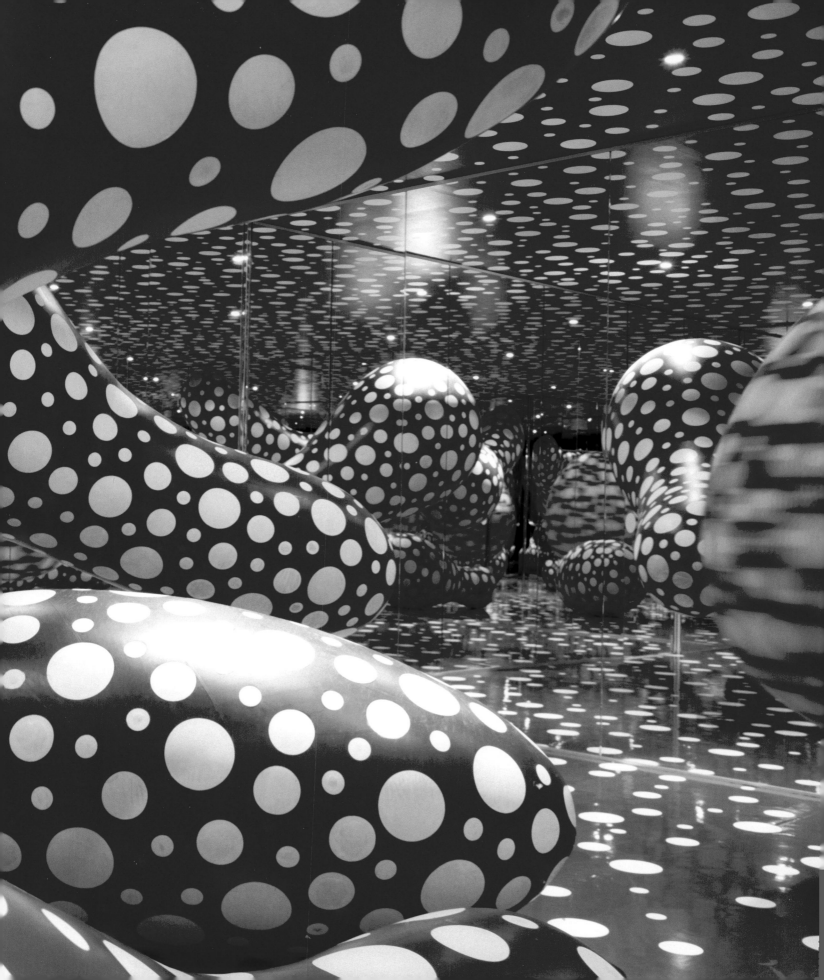

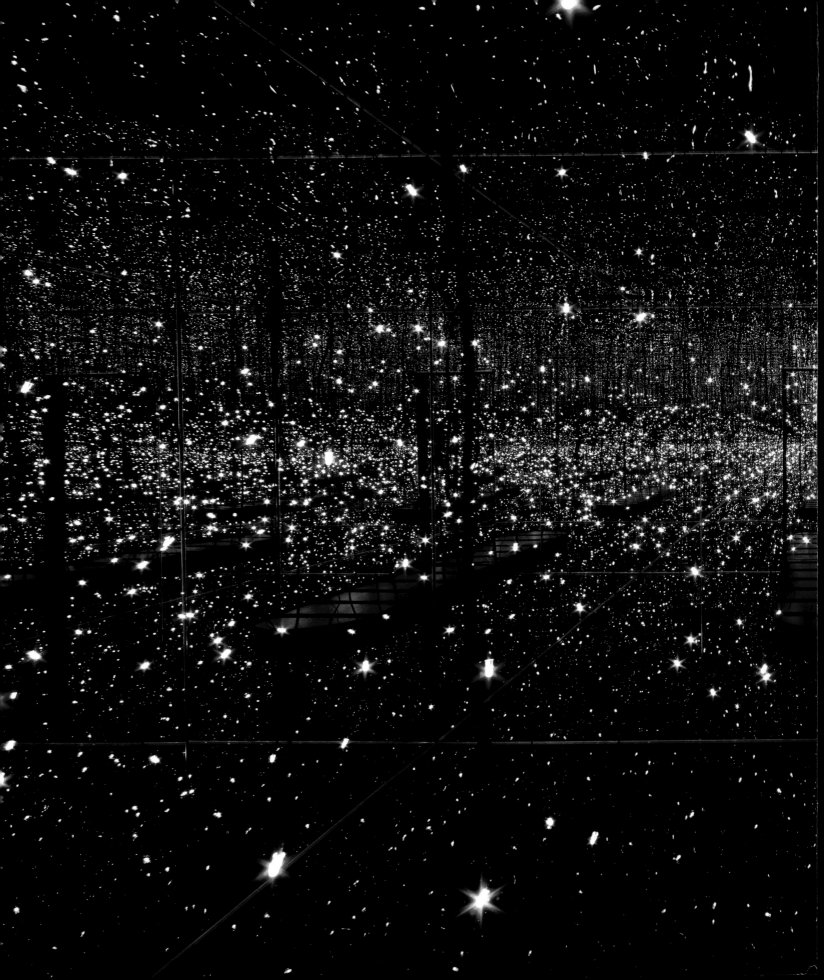

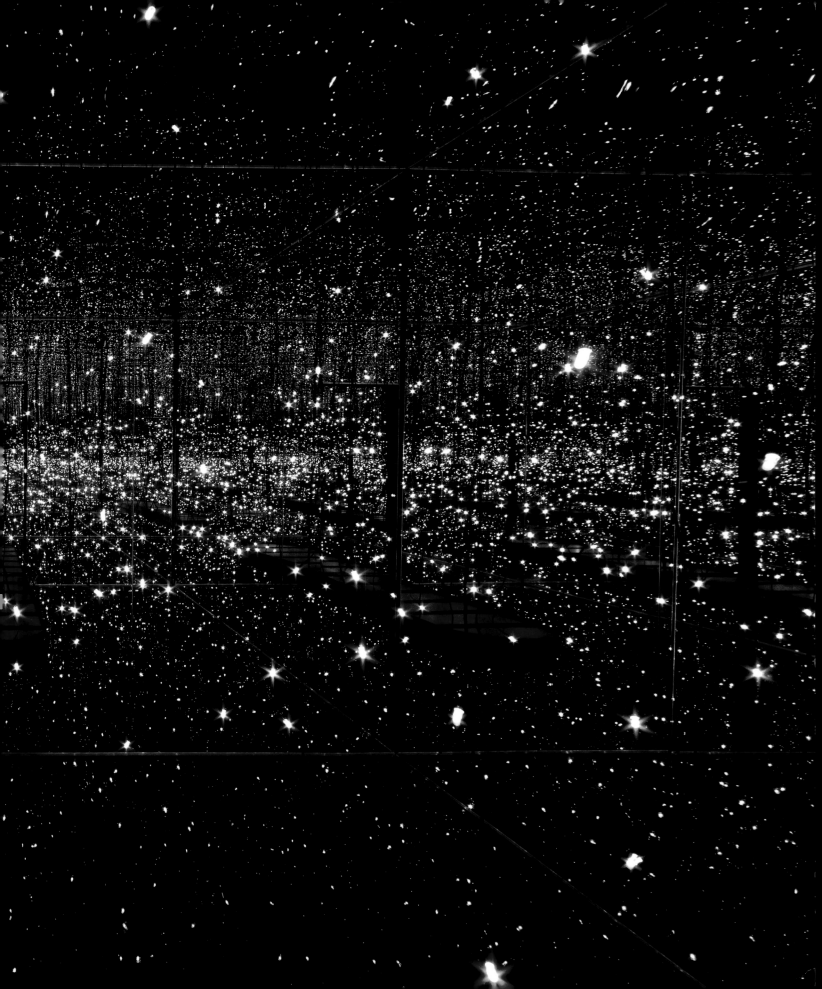

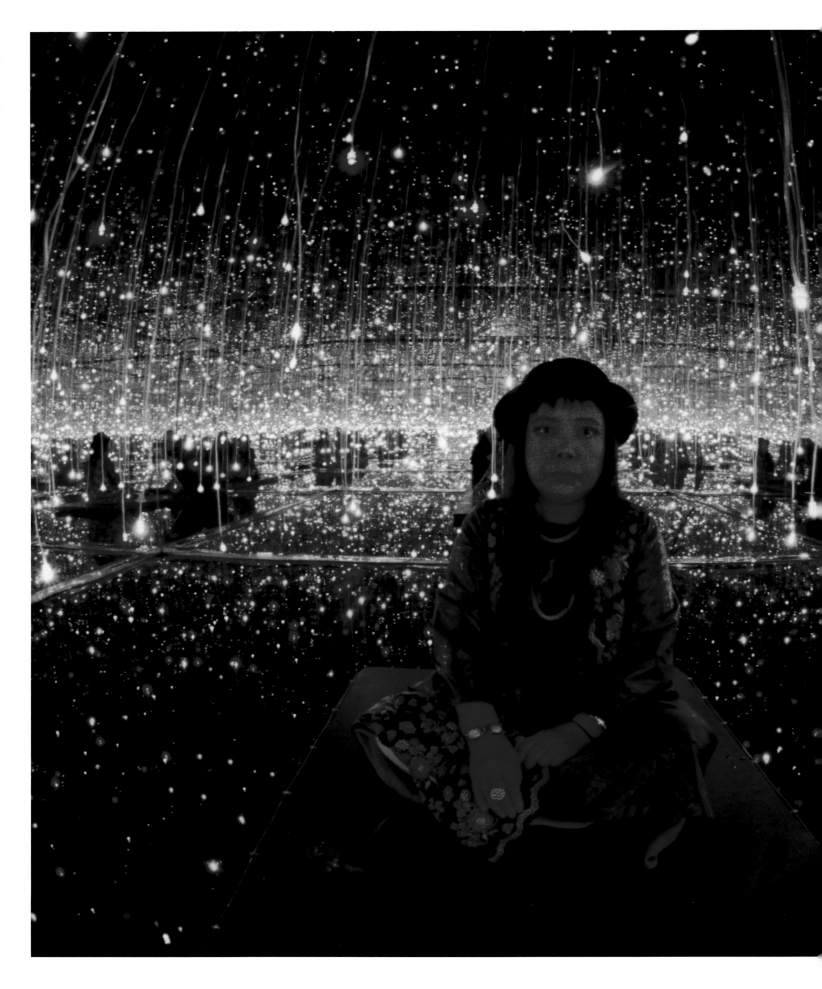

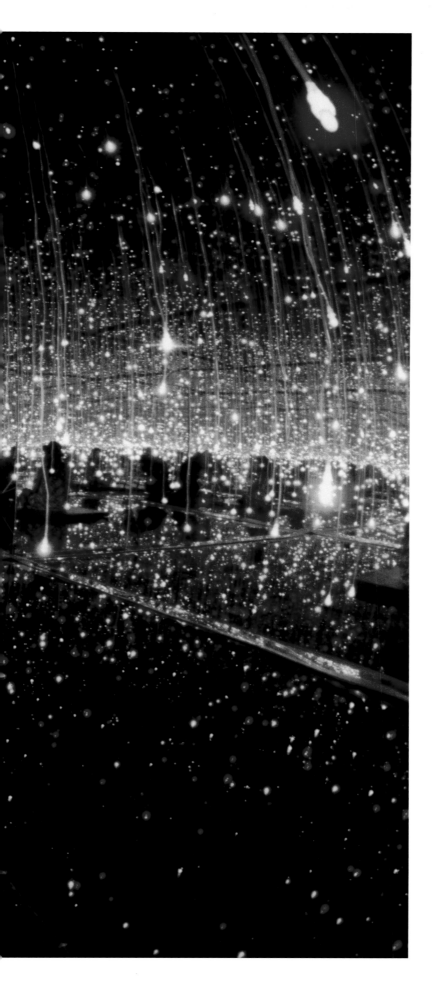

13.1. Kusama in *Infinity Mirror Room— Fireflies on the Water*, 2000. Collection of the Fonds national d'art contemporain, Paris. Installed in *Yayoi Kusama*, Maison de la culture du Japon à Paris, 2001 Photograph by Alain Dejean/SYGMA/Corbis

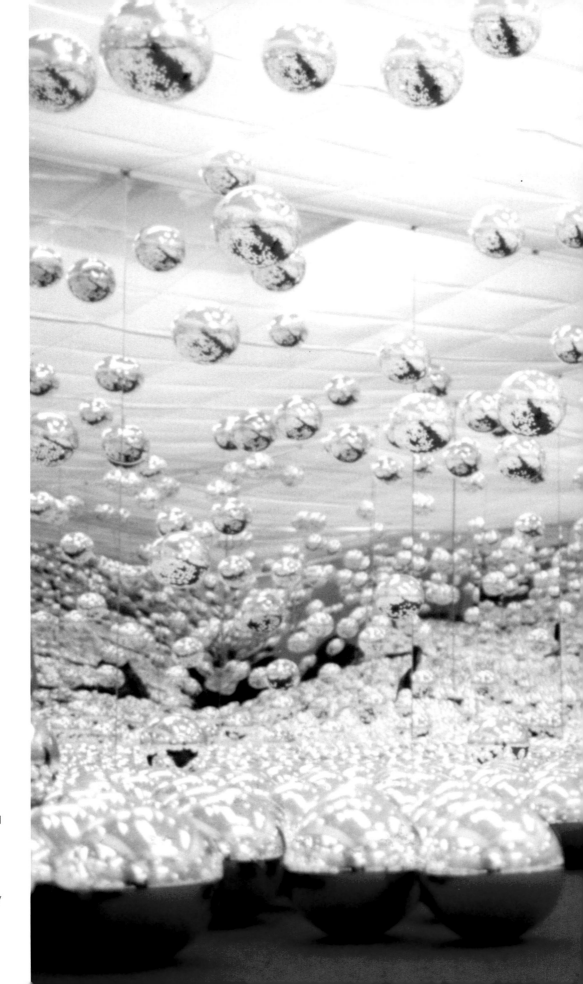

14. *Endless Narcissus Show*, 2001.
Mirrored balls, carpet, and mirrors.
Installed at the International Triennial of
Contemporary Art, Yokohama, 2001.
No longer extant

OVERLEAF
15. *Soul under the Moon*, 2002. Mirrors,
ultraviolet lights, water, plastic, nylon
thread, wood, and acrylic paint, 134 x
280 x 236 in. (340 x 712.1 x 600 cm).
Queensland Art Gallery, Brisbane,
Australia. The Kenneth and Yasuko Myer
Collection of Contemporary Asian Art.
Purchased 2002 with funds from Michael
Sidney Myer and The Myer Foundation,
a project of the Sidney Myer Centenary
Celebration 1899–1999, through the
Queensland Art Gallery Foundation and
the Yayoi Kusama Queensland Art Gallery
Foundation Appeal

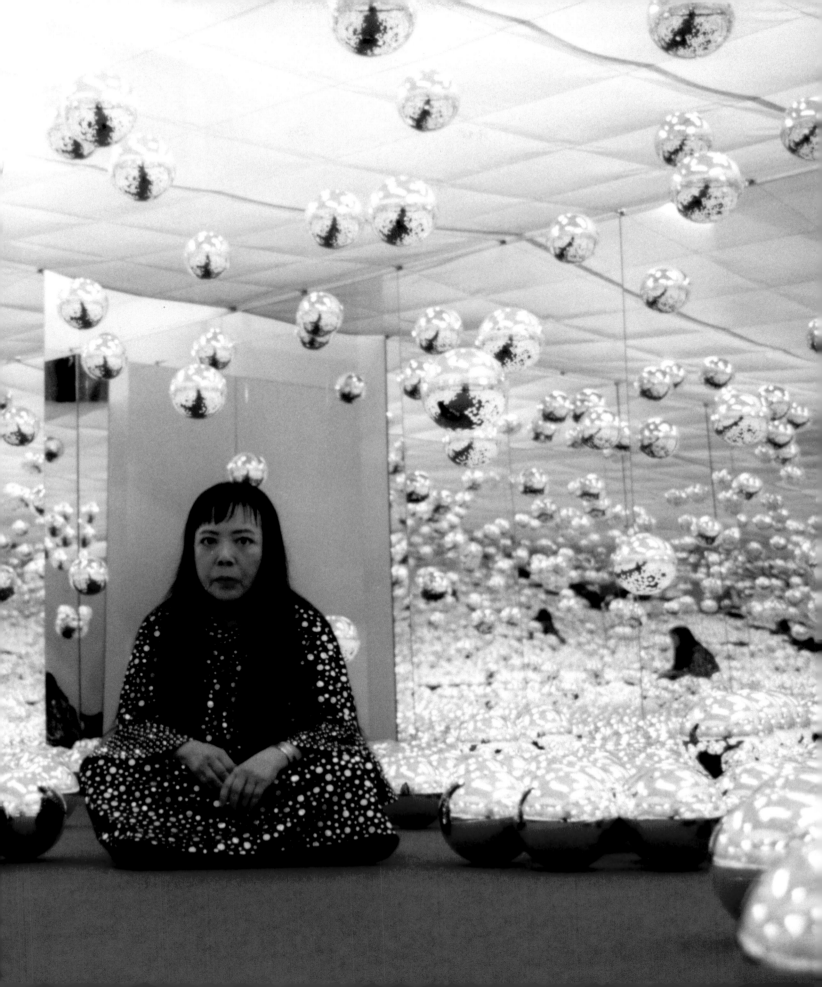

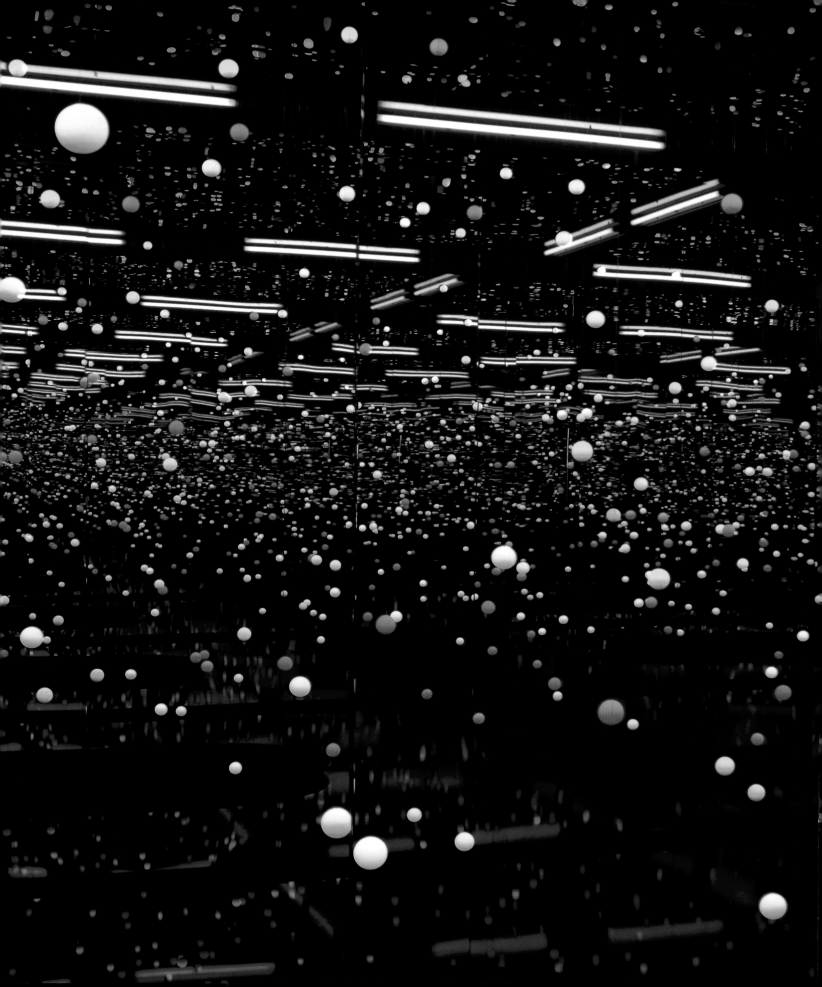

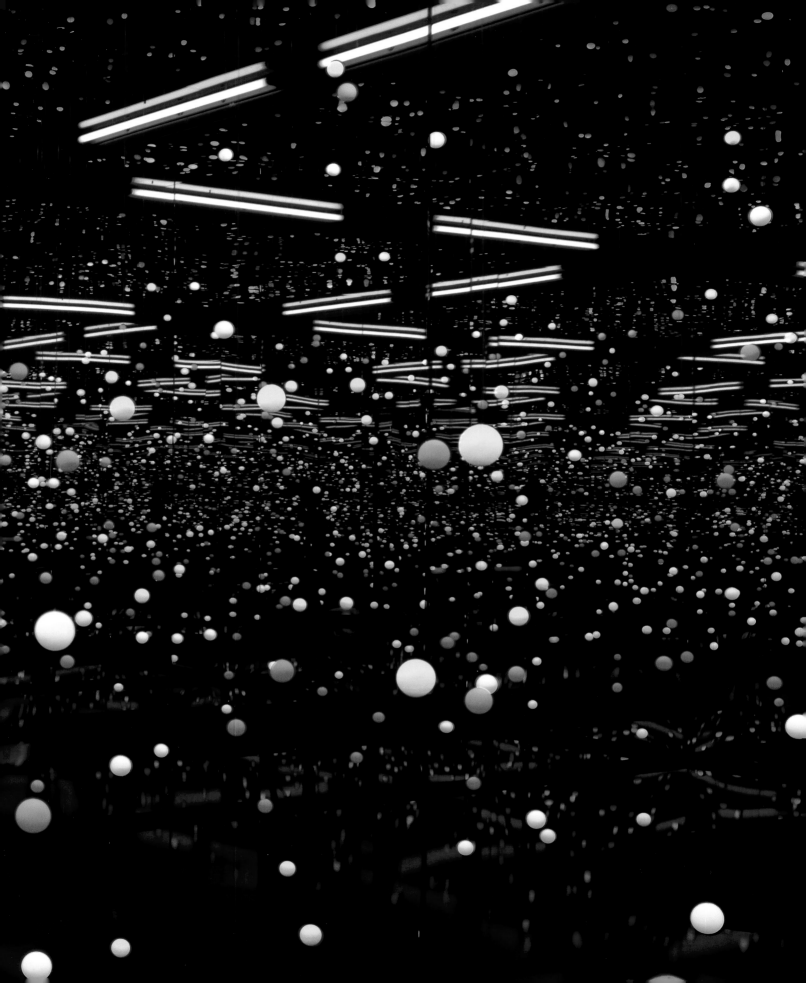

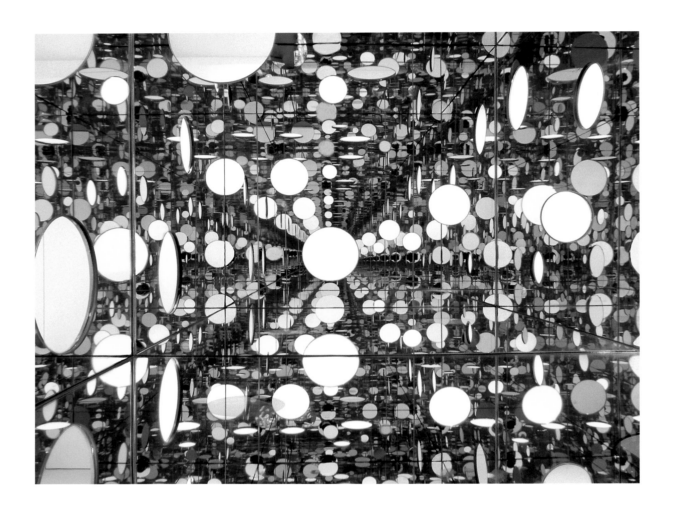

16. *The Passing Winter*, 2005.
Mirror and glass, 70⅞ x 31½ x 31½ in.
(180 x 80.5 x 80.5 cm). Collection of Tate
Modern, London. Purchased with funds
provided by the Asia Pacific Acquisitions
Committee 2008
Interior and exterior views of peep-in
mirror box

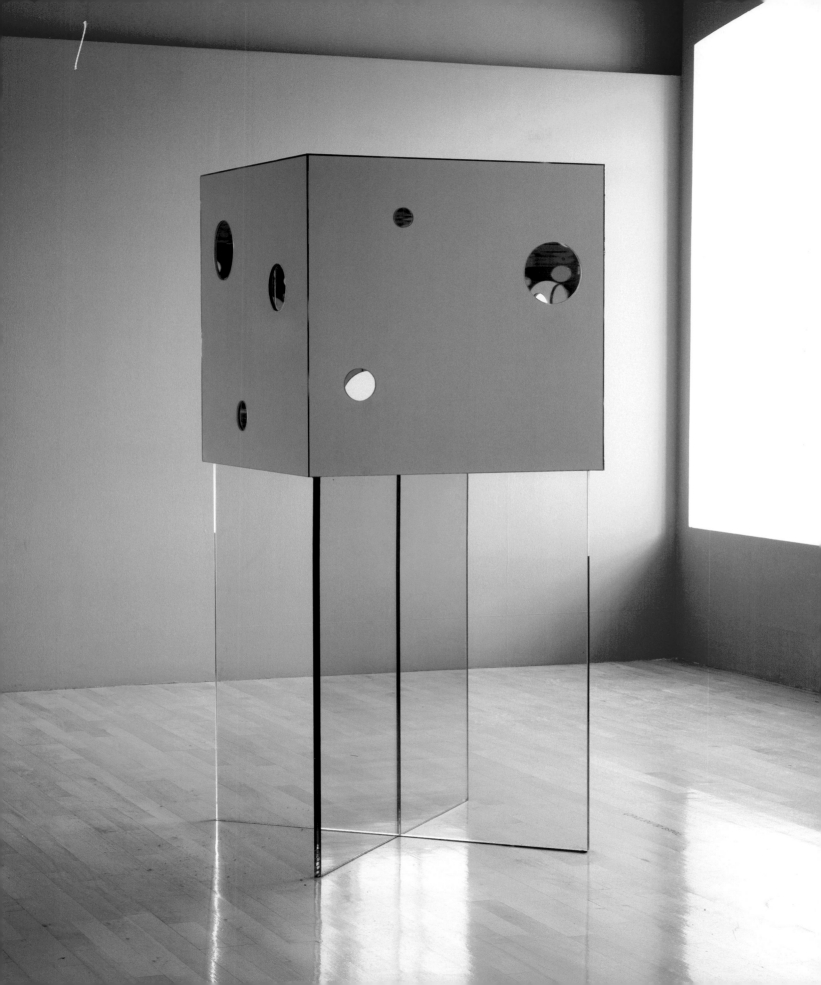

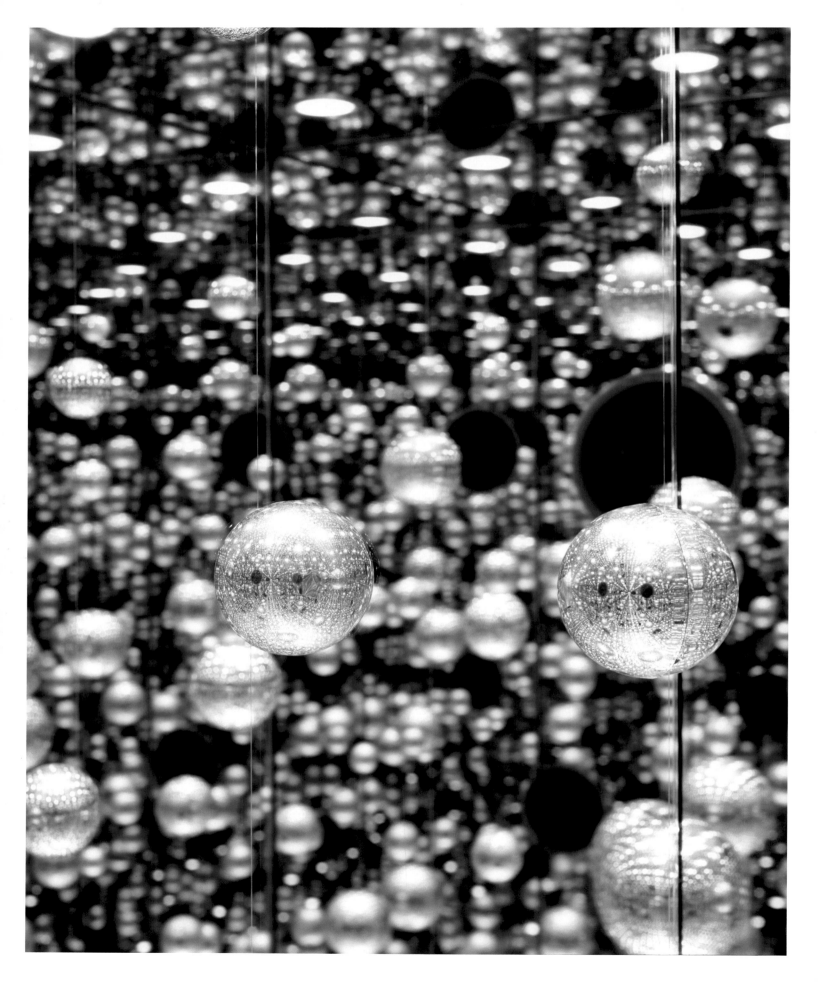

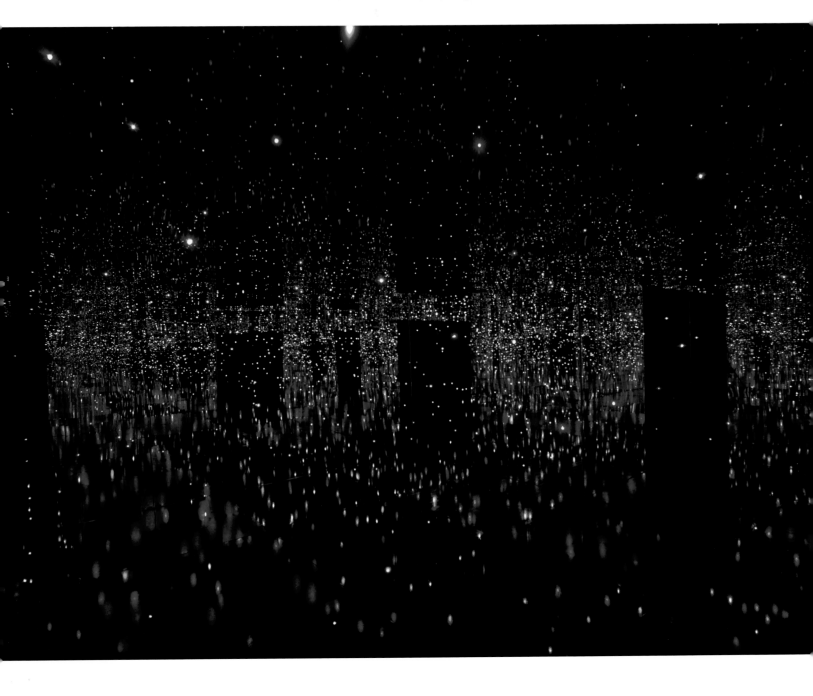

18. *You Who Are Getting Obliterated in the Dancing Swarm of Fireflies*, 2005. Hanging LED lights, black glass, and mirrors. Collection of the Phoenix Art Museum. Installed in *Kusamatrix,* Mori Art Museum, Tokyo, 2004

OVERLEAF
19. *Chandelier of Grief*, 2004/2016. Steel, aluminum, one-way mirror, acrylic, chandelier, motor, LED lights, 139¼ x 219⅛ x 189¾ in. (252.8 x 556.3 x 481.8 cm). Installed in *Yayoi Kusama,* Victoria Miro, London, 2016

OPPOSITE
17. *Rain in Early Spring,* 2002. Stainless steel balls, nylon thread, and mirrors. Collection of the Contemporary Art Museum, Kumamoto
Interior view of peep-in mirror box

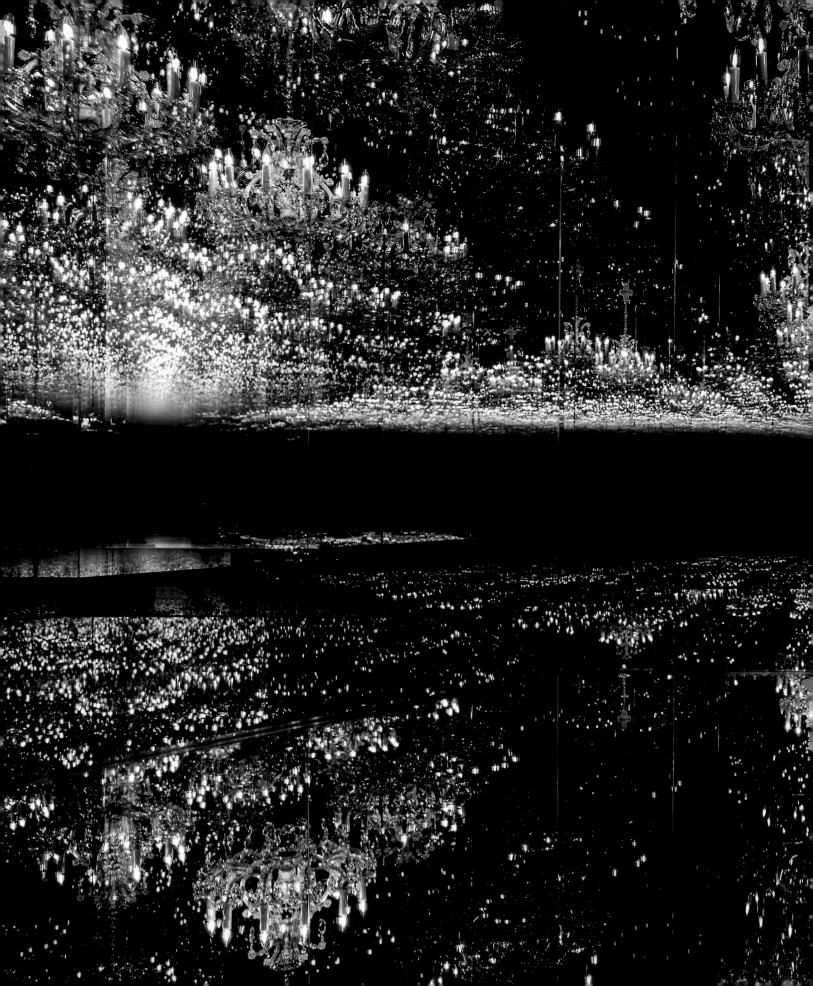

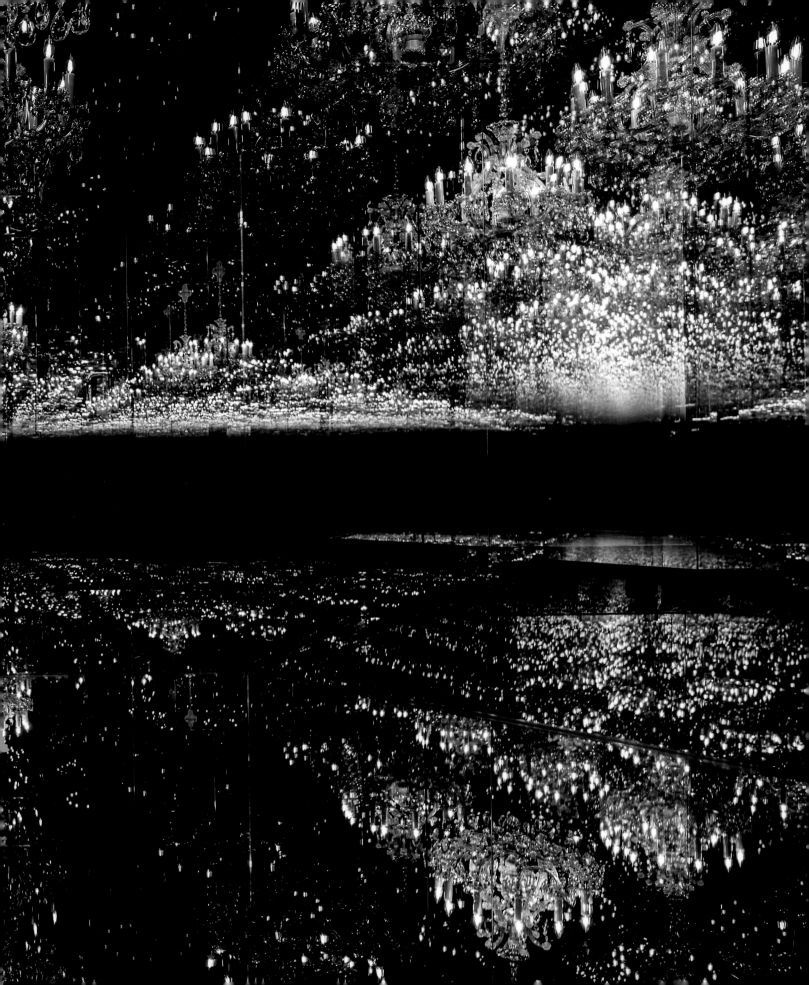

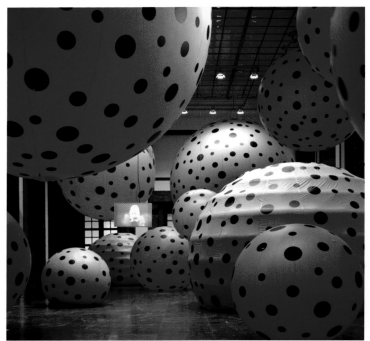

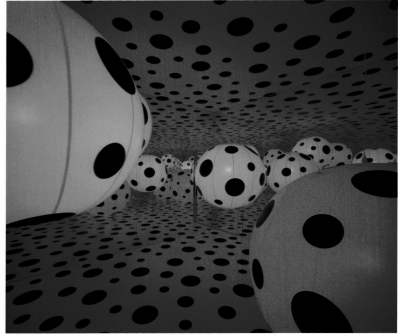

Detail: interior view, mirror room inside balloon dome. Suspended vinyl balls, LED lights, mirrors, and adhesive dots

20. *Dots Obsession—Love Transformed into Dots*, 2007. Suspended vinyl balloons, large balloon dome with mirror room, peep-in mirror dome, and projected digital video. Mirror room dome height: 156 in. (396.2 cm); diameter: 234 in. (594.4 cm). Peep dome diameter: 78 in. (198.1 cm). Installed in *Dots Obsession—Love Transformed into Dots*, Haus der Kunst, Munich, 2007

OPPOSITE
Detail: interior view, peep-in mirror dome. Stainless-steel balls, wire, and mirrors

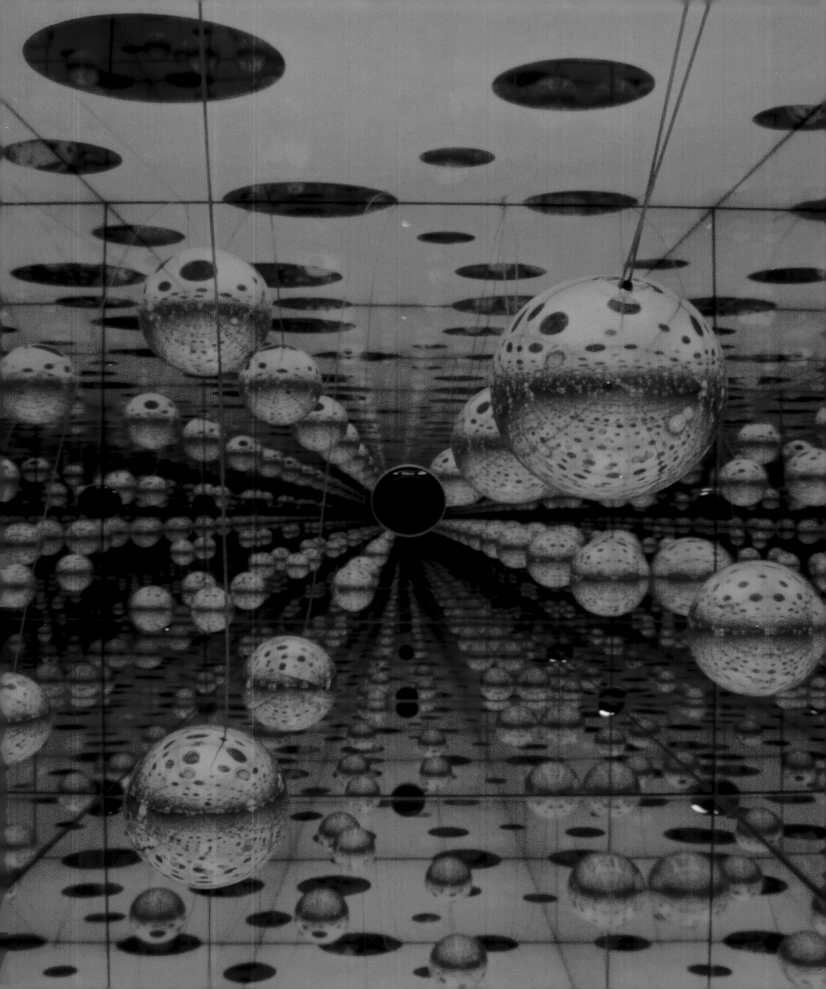

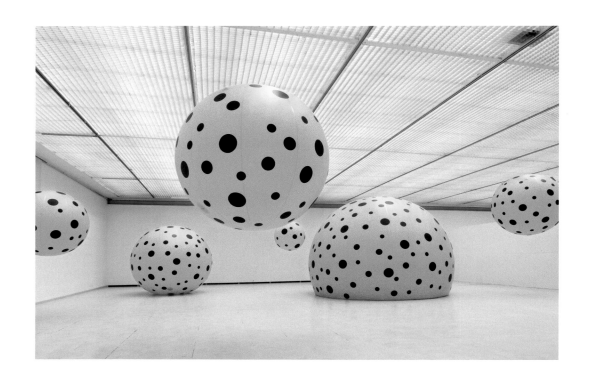

21. *Dots Obsession—Infinity Mirrored Room*, 2008. Vinyl balloons and inflatable dome with mirror room. Mirror room dome height: 156 in. (396.2 cm); diameter: 234 in. (594.4 cm). Installed in *Big in Japan*, Centre for Contemporary Art, Vilnius, Lithuania

OPPOSITE
Detail: interior view, mirror room inside balloon dome

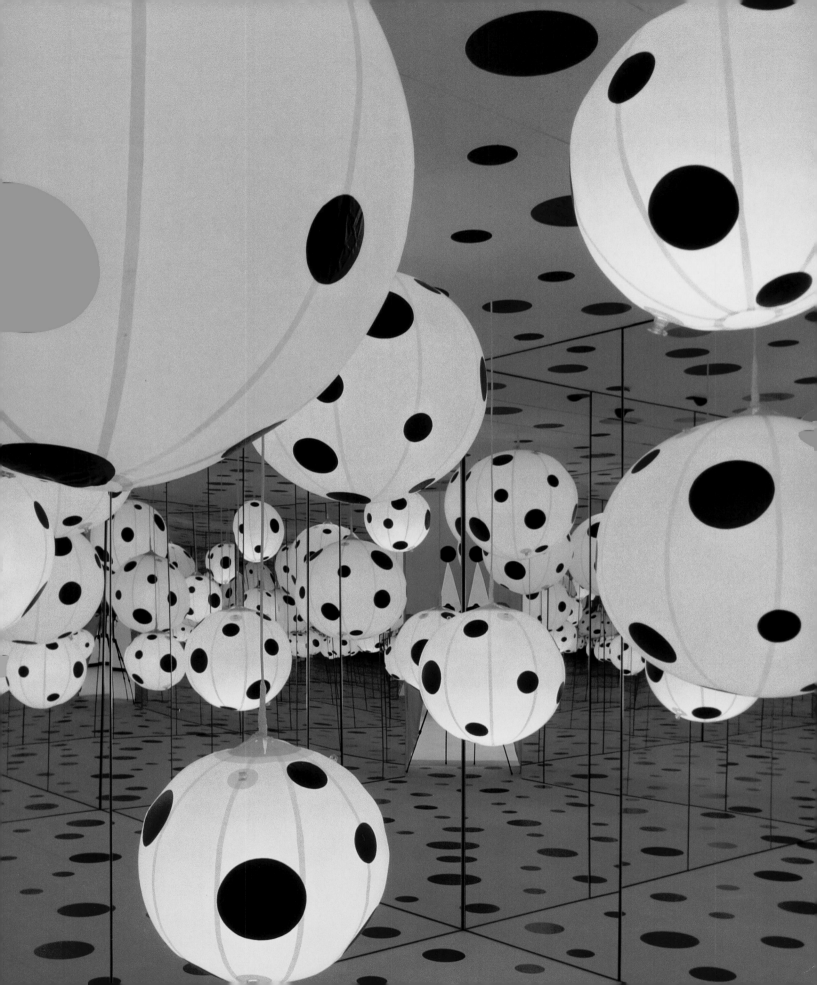

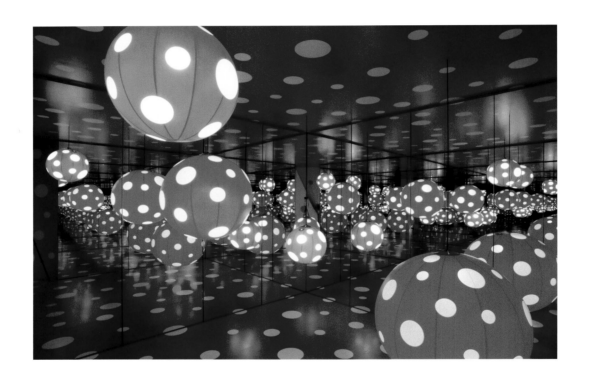

22. *Dots Obsession*, 2013. Vinyl balloons,
inflatable dome with mirror room, and
peep-in dome. Dome height: 156 in.
(396.2 cm); diameter: 234 in. (594.4 cm).
Peep-in dome diameter: 78 in. (198.1 cm).
Detail: interior view, mirror room inside
balloon dome

OPPOSITE
Detail: interior view of peep-in dome

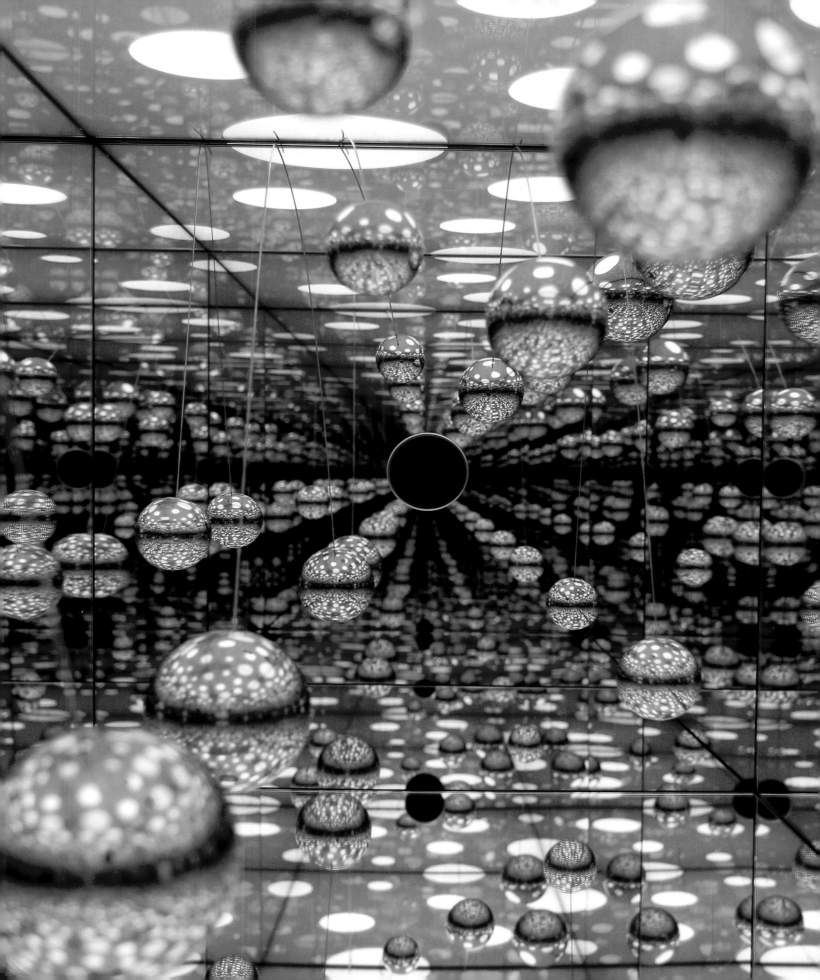

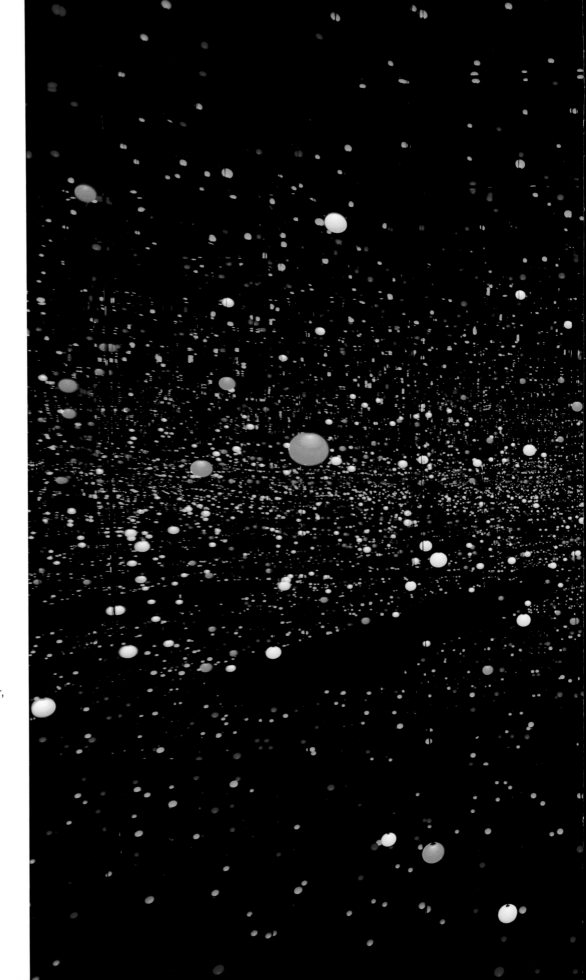

23. *Gleaming Lights of the Souls*, 2008. LED lights, round plastic bulbs, and water, 113 x 163½ x 163½ in. (287.4 x 415 x 415 cm). Collection of the Louisiana Museum of Modern Art, Humlebæk, Denmark. Installed in the *Liverpool Biennial: International 2008, MADE UP*, Liverpool

OVERLEAF
24. *Aftermath of Obliteration of Eternity*, 2009. Wood, mirrors, plastic, acrylic, LED lights, water, and aluminum, 113¾ x 163½ x 163½ in. (287.4 x 415 x 415 cm). Collection of the Museum of Fine Arts, Houston

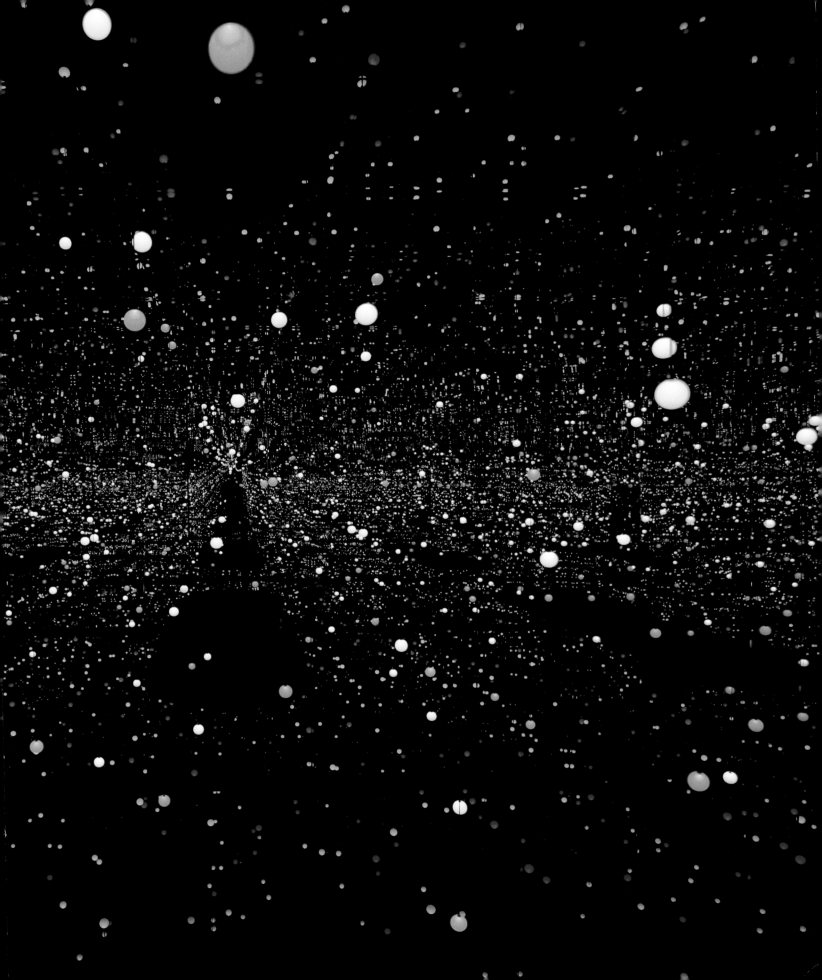

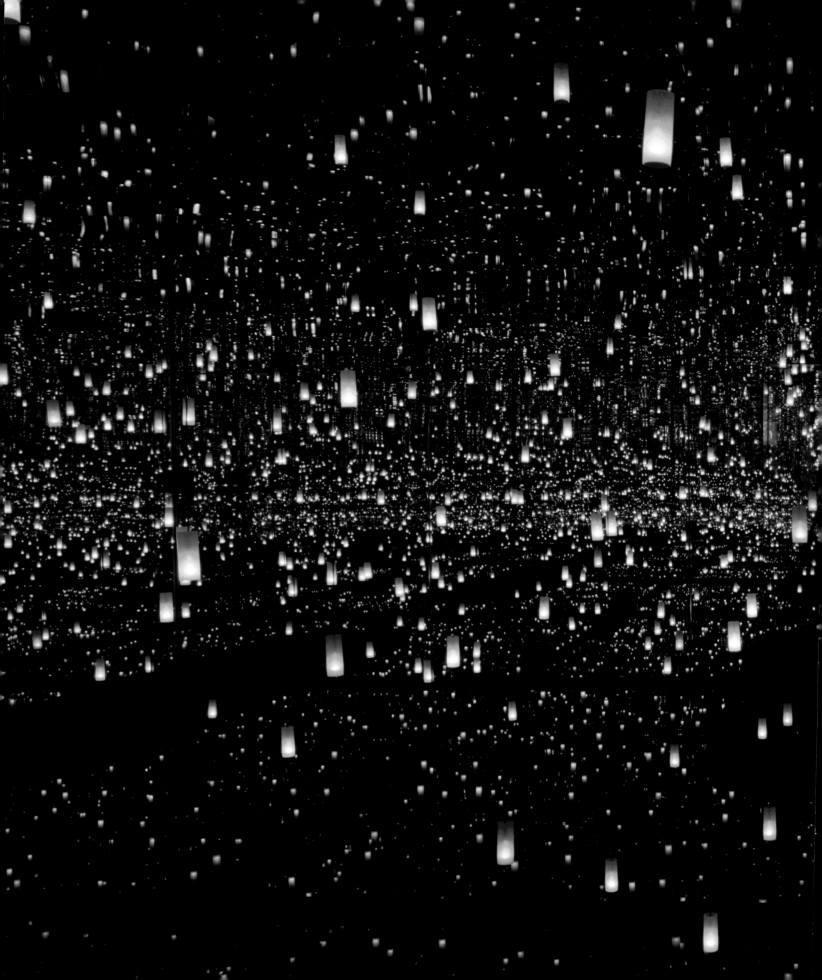

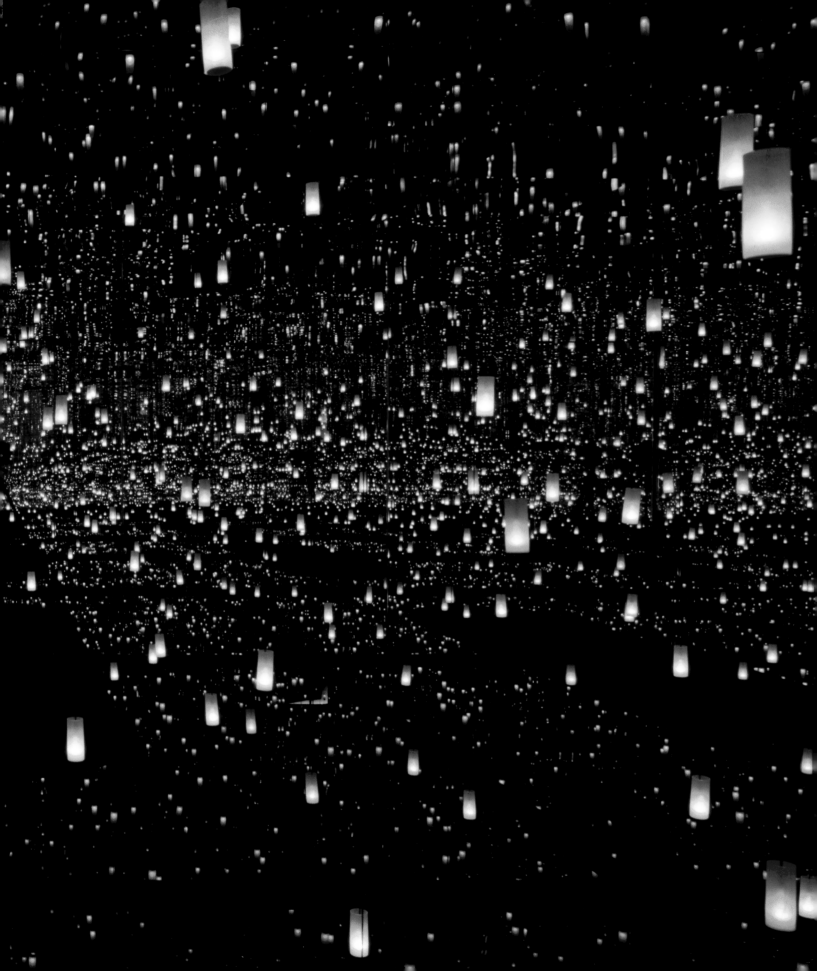

25. *Infinity Mirrored Room—Filled with the Brilliance of Life*, 2011. Wood, mirrors, plastic, acrylic, LED lights, water, and aluminum, 118 x 243 x 254 in. (300 x 617.5 x 645.5 cm). Collection of Guggenheim, Abu Dhabi. Installed in *Yayoi Kusama,* Tate Modern, London, 2012

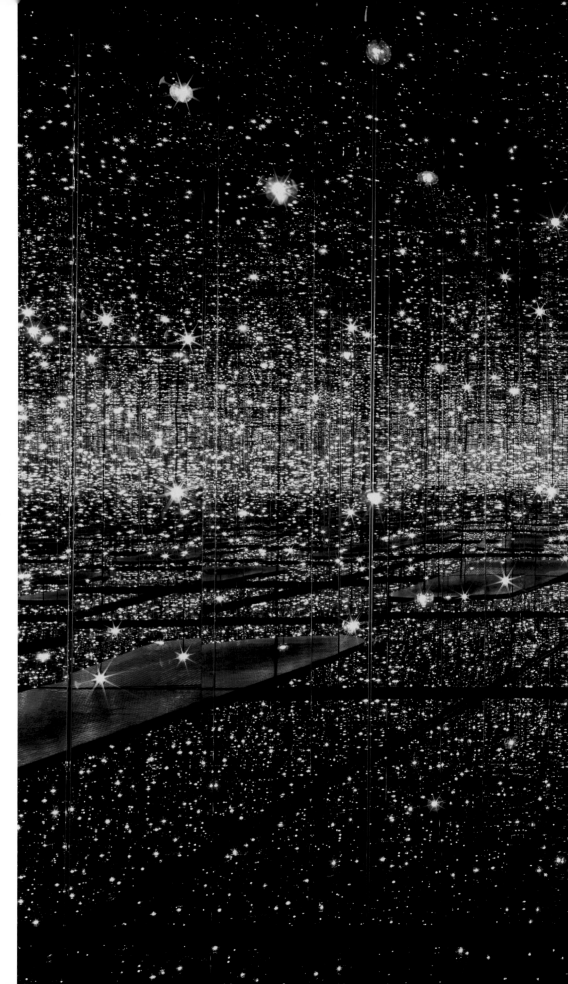

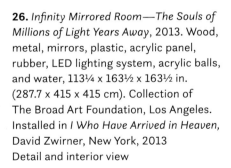

26. *Infinity Mirrored Room—The Souls of Millions of Light Years Away*, 2013. Wood, metal, mirrors, plastic, acrylic panel, rubber, LED lighting system, acrylic balls, and water, 113¼ x 163½ x 163½ in. (287.7 x 415 x 415 cm). Collection of The Broad Art Foundation, Los Angeles. Installed in *I Who Have Arrived in Heaven,* David Zwirner, New York, 2013 Detail and interior view

OVERLEAF
27. *Love Is Calling*, 2013. Wood, metal, glass, mirrors, plastic, acrylic panel, rubber, blowers, lighting element, speakers, and sound, 174½ x 340⅝ x 239⅜ in. (443 x 865 x 608 cm). Installed in *I Who Have Arrived in Heaven,* David Zwirner, New York, 2013

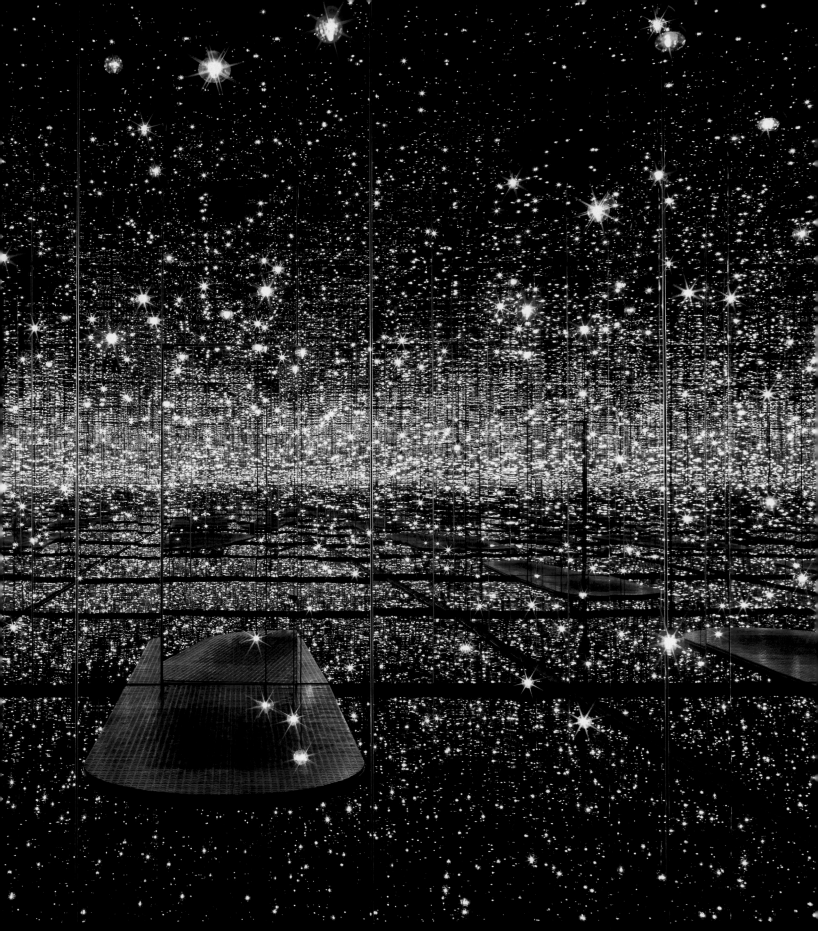

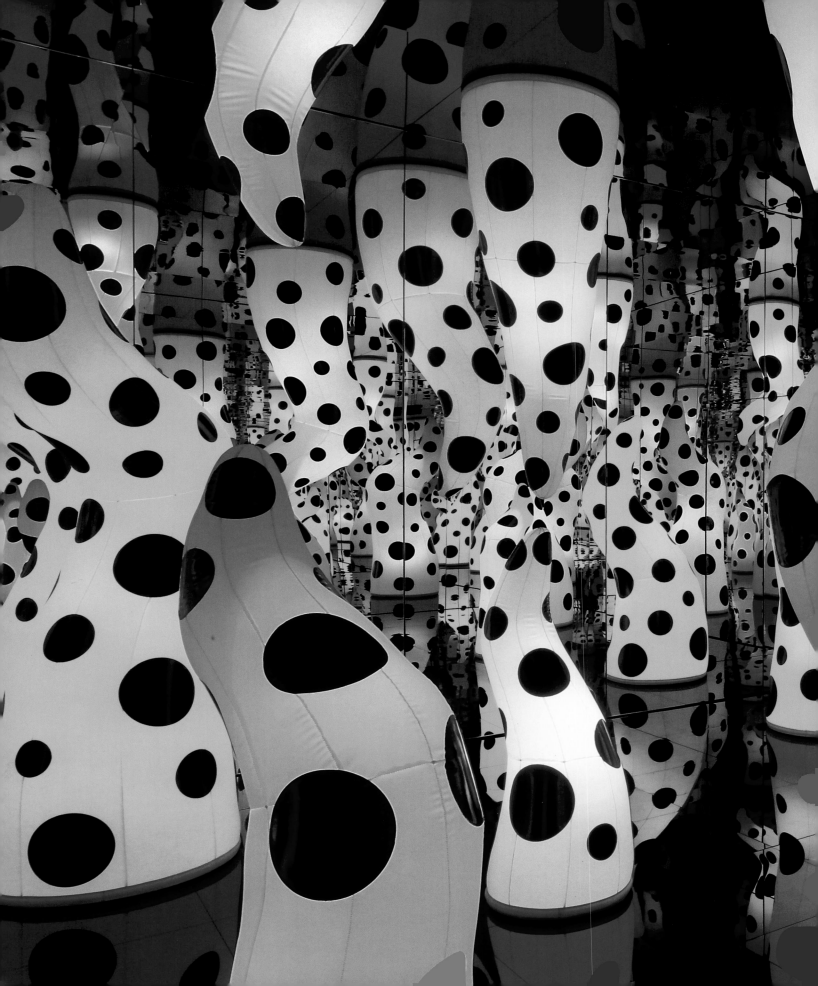

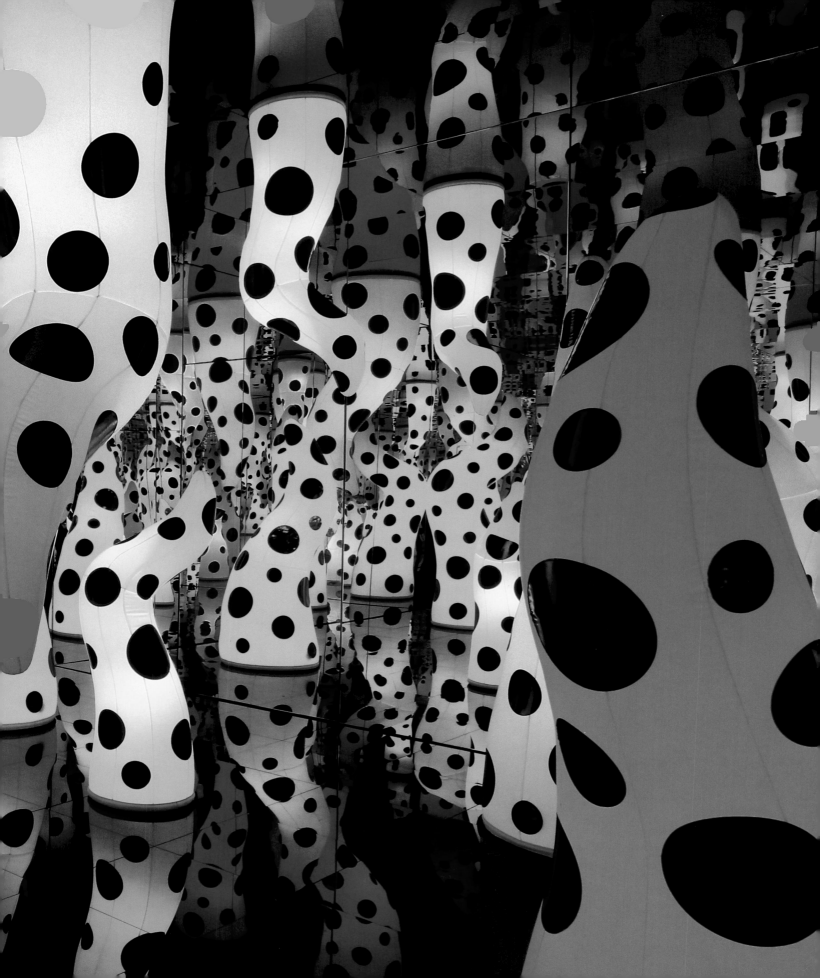

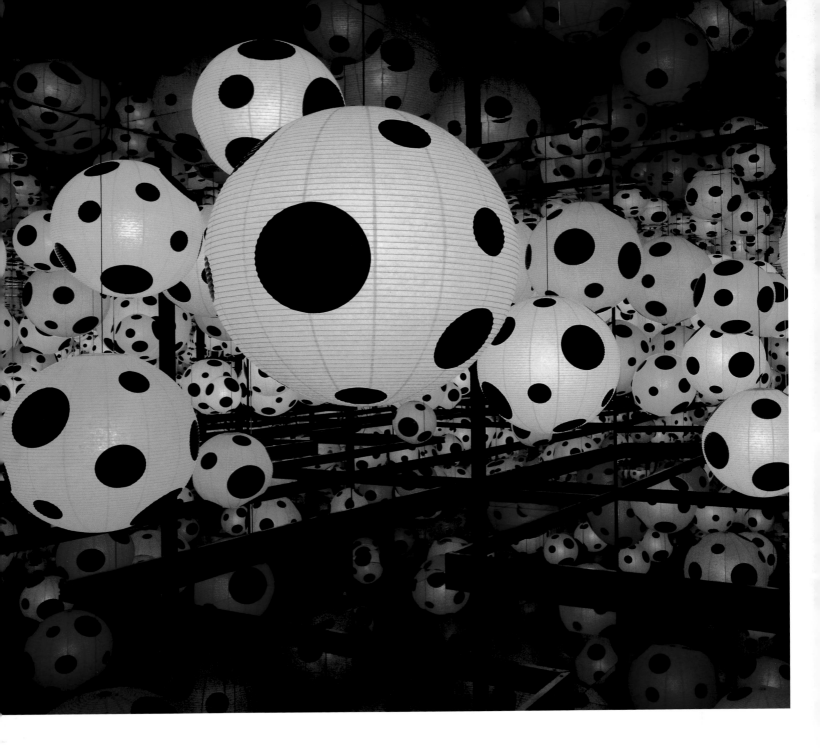

28. *Infinity Mirrored Room—Hymn of Life,* 2015. Wood, metal, paper lanterns, LED lights, water, mirrors, 118 x 243 x 254 in. (300 x 617.5 x 645.5 cm). Installed in *Yayoi Kusama: In Infinity,* Henie Onstad Kunstsenter, Høvikodden, Norway, 2015

OPPOSITE
29. *Infinity Mirror Room—Brilliance of the Souls,* 2014. Wood, metal, mirrors, foam lamps with LED system, black glass (or water), and rubber, 113⅛ x 163⅛ x 163⅜ in. (287.4 x 415 x 415 cm). Installed in *Kusama Yayoi: A Dream I Dreamed,* Kaohsiung Museum of Fine Arts, Taiwan, 2015

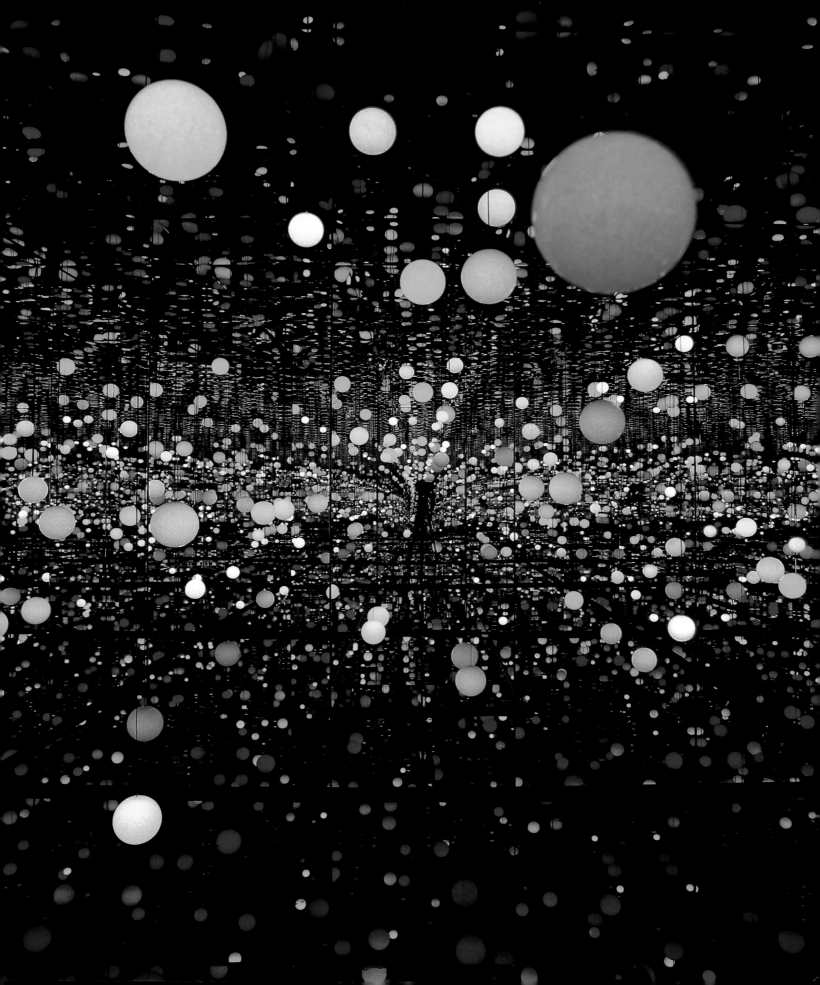

30. *All the Eternal Love I Have for the Pumpkins*, 2016. Acrylic pumpkins, LED lighting, black glass, mirrors, wood, and metal, 115⅝ x 163⅜ x 163⅜ in. (293.7 x 415 x 415 cm). Installed in *Yayoi Kusama*, Victoria Miro, London, 2016
Exterior view

OVERLEAF
Interior view

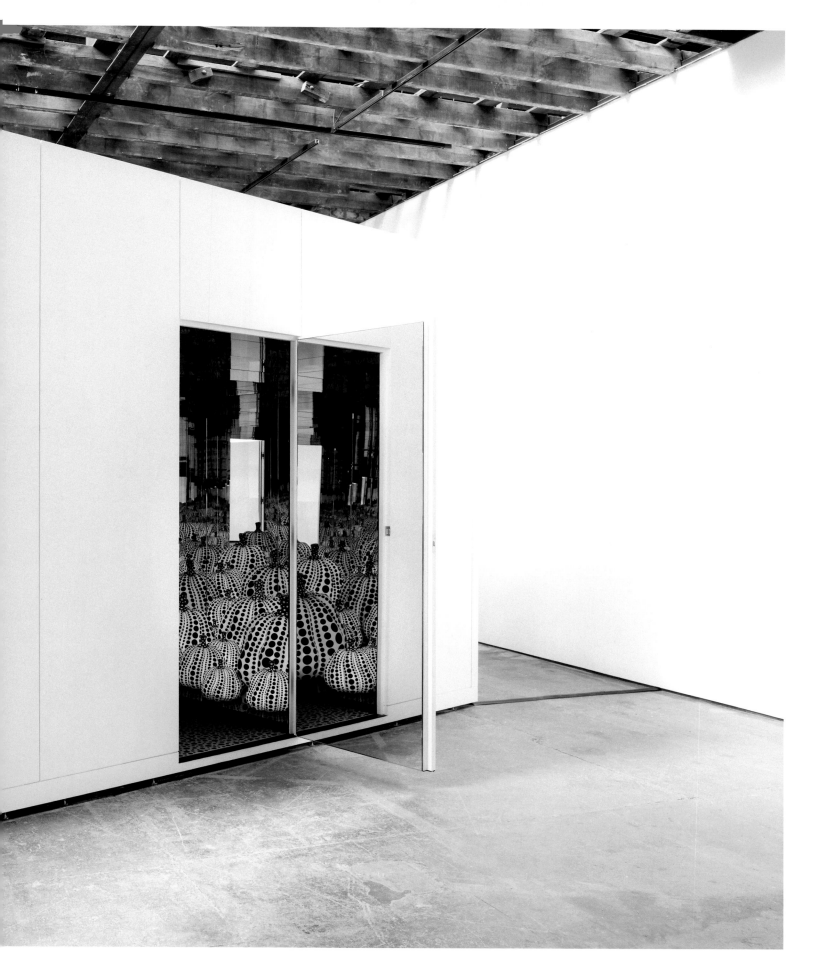

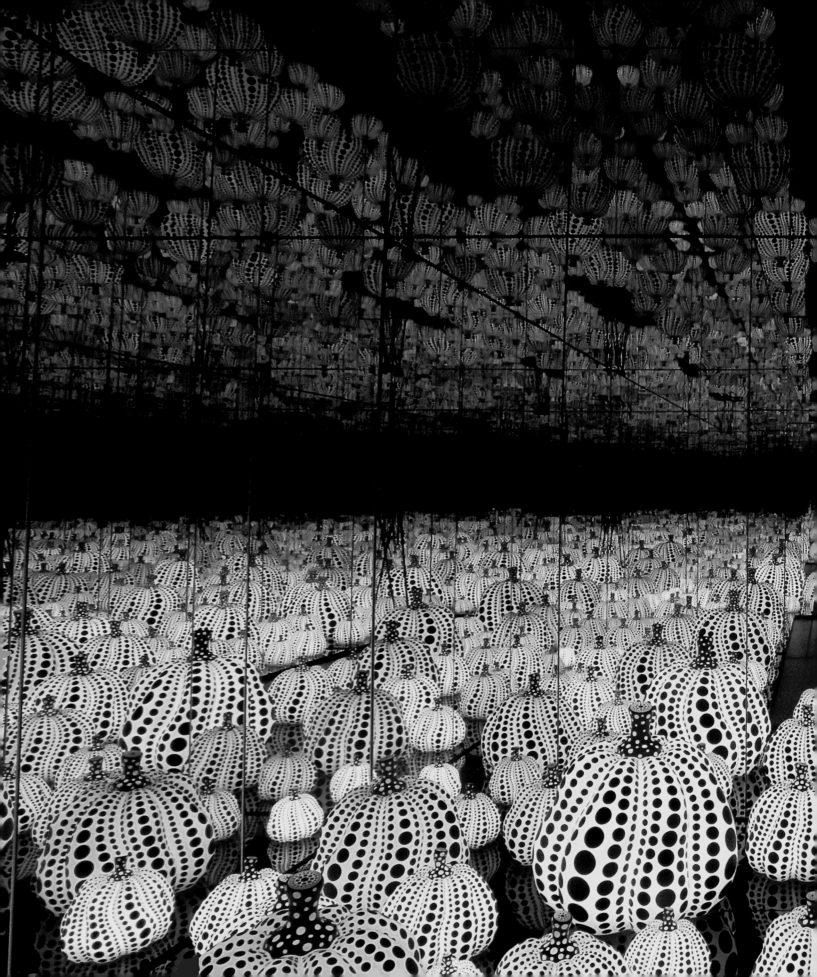

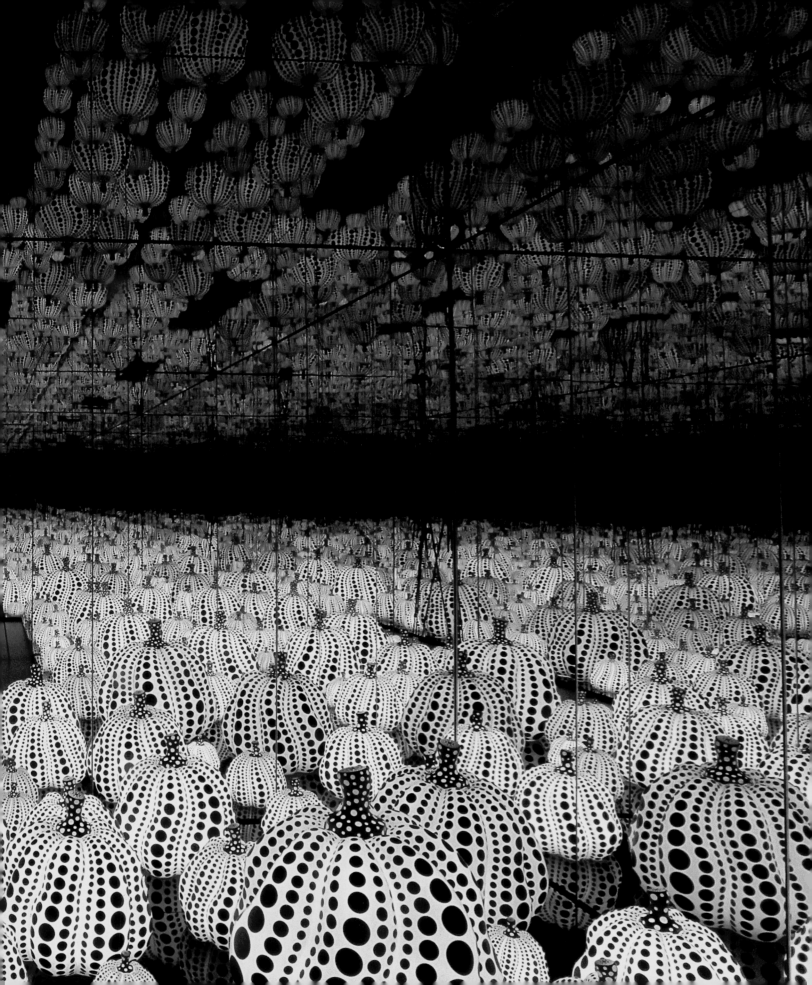

31. *Where the Lights in My Heart Go*, 2016.
Stainless steel and aluminum, 118⅛ x
118⅛ x 118⅛ in. (300 x 300 x 300 cm).
Installed in *Yayoi Kusama*, Victoria Miro,
London, 2016
Exterior and interior views of mirror room

Infinity and Nothingness

Alexander Dumbadze

It is ironic that much of the meaning of Yayoi Kusama's art is occluded by her popularity. Few artists today enjoy her renown, with eager viewers waiting in line for hours to spend forty-five seconds inside one of her Infinity Mirror Rooms.[1] These enclosed spaces, bedazzled by hanging lights that appear to always recede far off into the distance, are perfect environments for individuals obsessed with seeing images of oneself and sharing those depictions with friends and strangers. Yet it is not narcissism that draws visitors by the thousands to Kusama's unique installations, but rather the sense of perceiving something singular, of having an experience unlike any other; the ubiquity of social media only amplifies this desire.

Kusama's current fame arose against the backdrop of her relative obscurity around the turn of the millennium. Curators, critics, and a host of others began to rediscover an artist who had been one of the more colorful figures of the New York art world in the 1960s but began to fade from people's imagination after she resettled in her native Japan. When she left New York in 1973, she was well known in both art circles and wider segments of the public. She was a celebrity of a particular kind, with only Andy Warhol holding an equivalent social position, and even he did not receive as much attention as she did. In the late 1960s Kusama initiated a number of public performances protesting the horrors of the Vietnam War and the complicity of institutional structures such as Wall Street in the military-industrial complex.[2] These brief, ephemeral events were covered widely by the press in large part because of Kusama's strategic and persistent reminders to members of the media. It also helped that her performers, whom she carefully selected, were always young and almost always naked. The spectacle and resulting scandal—the utter lack of propriety—sparked a minor media furor. Kusama manipulated these situations for her own benefit, and when her political ideals melded with her belief in the liberating powers of the sexual revolution, even more notice was trained upon her by segments of the press who normally had little, if any, interest in contemporary art.

Journalists tended to exoticize Kusama, often emphasizing her ethnicity and her gender: "a pocketsized, head-strong Japanese professional sculptress and occasional love goddess" who "looks like a geisha but talks like a guru."[3] The biases Kusama faced were a challenge few of her peers had to overcome.[4] It seems she countered these misrepresentations—or at least attempted to better control her

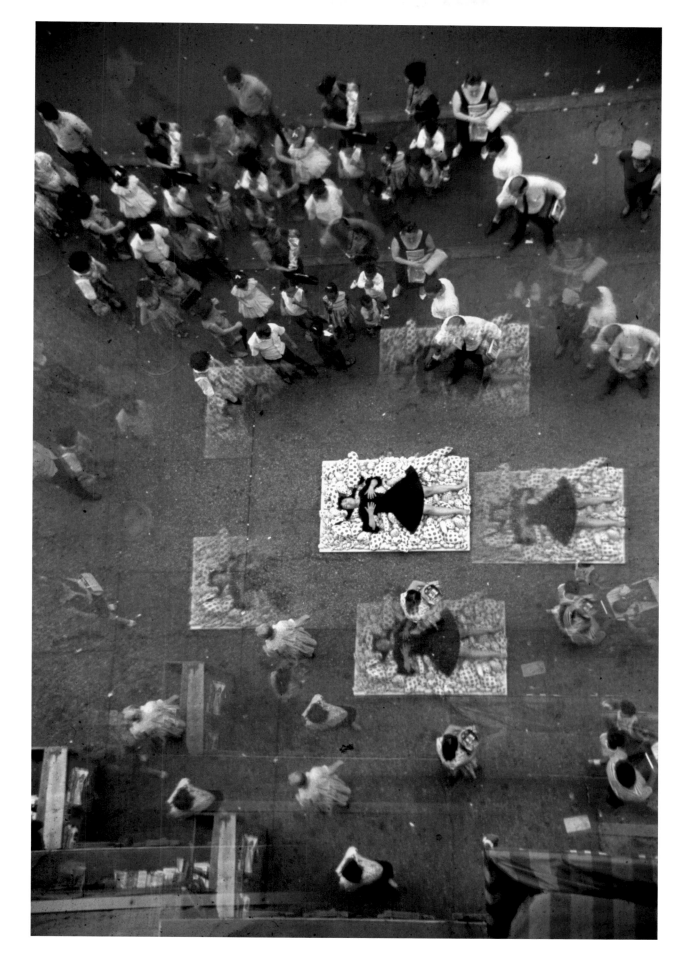

image—by having herself and her art photographed extensively. Throughout the 1960s Kusama appeared in numerous photographs. Some are casual, captured in her studio, while many others show her before installed pieces, sometimes naked, always self-consciously posed.[5] Sitting amidst her *Compulsion Furniture* (1964), reclining on the floor of *Kusama's Peep Show* (1966), or painting one of the writhing bodies in an *Anatomic Explosion* performance (1968), Kusama appears remarkably placid. Her face is drained of expression. She does not smile, she barely betrays an emotion, and yet there is a hint of sadness, an earned world-weariness that becomes a screen upon which others project their feelings. Her seeming passivity provides a buffer between her self and the world. In these photos her skin is like the densely worked surfaces of her paintings, or the arrangement of her Accumulation sculptures, or the highly polished finish of her mirrors—barriers that push back and return one's gaze.

Kusama's art during her New York period (1958–73) derived from personal experience, but its form and presentation nevertheless approached a more abstract, generally philosophical plane. In 1964 the artist and critic Donald Judd wrote in a review of one of Kusama's exhibitions, "In most art the chief interests of the artist have been subordinate—those things he thinks about most, the strongest and clearest attitudes, the psychological preoccupations. Kusama is dealing directly with her interests, developing them, making a clear and obvious form."[6] Judd wrote from a knowing perspective. He and Kusama had been friends for a while; their studios were in the same building, separated by only a floor. When the weather was warm and Judd had his windows open, he would complain to Kusama about the smell of fried onions wafting up from her kitchen.[7] At the time of his review, Judd was on the verge of penning his seminal essay "Specific Objects," which expressed his belief that the best art was neither painting nor sculpture, that the ideas of Clement Greenberg had become obsolete, and that pictorial composition should be abandoned for a conception of "wholeness."[8] These ideas ran concurrent with other themes passing through the New York art world in the mid-1960s, none perhaps more prevalent than those associated with Pop art, in which the leveling of high and low culture, the focus on consumerism, celebrities, and everyday life were a shock to the relative hermeticism of avant-garde circles and ambrosia for a new breed of collectors who shaped critical tastes with their pocket-books.[9] The discourses of Pop and Minimalism became omnipresent, but Kusama and her art were not at home in either. Judd saw affinities between what he and she did, and others recognized aspects of Pop in her Accumulation sculptures, but Kusama's work resisted easy critical classification—which has meant it has eluded standard art historical narratives as well.

Kusama's work at this time, exemplified by *No T.W.3.* (1961; pl. 30), was unabashedly different from that of her peers; her compositions' visual intensity is matched only by thoughts of the physical labor she expended on each piece. Over solid, darkly covered grounds, Kusama applied wisps of oil paint. The movement was a flick of the wrist. The gesture was quite small, but when repeated over and over again, it left small apertures through which the background color peeks. Larger circular patterns appear, suggesting, as one critic said in 1961, "a viscous Gulf Stream shifting its way through the ineffable modulations of the One."[10] There is no beginning, no end, the size of the canvas being the only constraint.

This series of paintings became known as Infinity Nets.[11] There were times in the studio when Kusama's mark making extended beyond the canvas and onto the walls, the floor, and even her furniture. An aspect of compulsion was at play here, but also a sense of creation taking on a life of its own, becoming more important than pictorial boundaries, suggesting that, for Kusama, distinctions between art and life were beside the point. Her interests lay elsewhere, in something greater. Looking back on these paintings many years later, she wrote, "My desire was to predict and measure the infinity of the unbounded universe, from my own position in it, with dots—an accumulation of particles forming the negative spaces in the net. . . . [I]n exploring these questions I wanted to examine the single dot that was my own life."[12]

Kusama was especially engaged by the work of Barnett Newman: the large scale of his canvases, his investment in the sublime, the way he imagined that the ideal position to view his art was with one's face nearly pressed against the work's surface. Newman was more spiritual than Kusama: there is the element of the true believer in the way he writes "The Sublime is Now" or applies paint in *Vir Heroicus Sublimis* (1950–51; fig. 1), where the modulations of hues and the pictorial pressure exerted by the vertical zips confronts the viewer with a hard-to-quantify presence. Kusama is more matter-of-fact. She asks questions not

Fig. 1. Barnett Newman. *Vir Heroicus Sublimis,* 1950–51. Oil on canvas, 95⅜ in. x 213¼ in. (242.2 x 541.7 cm). Museum of Modern Art, New York, Gift of Mr. and Mrs. Ben Heller

about art but rather about life. Her concerns with the nature of existence ran counter to the dominant critical trends of art writing in the late 1950s and 1960s. She was after something deeper than the psychologically imbued existentialism of Abstract Expressionism, and her practice had no truck with the formalist self-criticality of Greenberg, Michael Fried, and Rosalind Krauss. If there was an artist whose interest best aligned with Kusama's in the 1960s, it may well have been Robert Smithson, whose turn toward geology and concepts of deep time in *Spiral Jetty* (1970) and *Broken Circle/Spiral Hill* (1971) made trivial the emphasis on presentness in contemporary art.

The notion of infinity in Kusama's work from the early 1960s is metaphorical. The concept initially referred to the size of her canvases and the density of her brushstrokes. The lack of traditional compositional techniques in these paintings magnified the effect of endlessness. The paintings are, however, finite—like Kusama's process. While she may have envisioned nets and polka dots extending everywhere in her visual field during her psychotic bouts ("I woke one morning to find the nets I had painted the previous day stuck to the windows. . . . I went to touch them, and they crawled on and into the skin of my hands."), viewers' experience of these works depends on their interaction with a material thing on a wall.[13] The infinity of Kusama's mind, the spilling over of dots and nets into her life, is different from that of others, who access her world by deciphering the surging feeling in her each and every work.

Kusama continued to hone her focus. Her treatment of infinity became increasingly physical. She made assemblages and sculptures, furniture and shoes covered with

phallic bulges, mannequins with macaroni adhered from head to toe, different objects and forms that brought the logic of her paintings into three dimensions (fig. 3). She even began to make immersive environments. For her 1963 exhibition at Gertrude Stein Gallery, she fashioned *Aggregation: One Thousand Boats Show* (1963–64; fig. 2) within the main gallery space. At the center of this installation was an actual rowboat obscured by hundreds of stuffed protrusions. The walls were covered with hundreds of images of the selfsame boat; this was less about the relationship between the original and the copy than, as Jill Johnston wrote in her review, an engagement with "an infinite expansion of the image."[14]

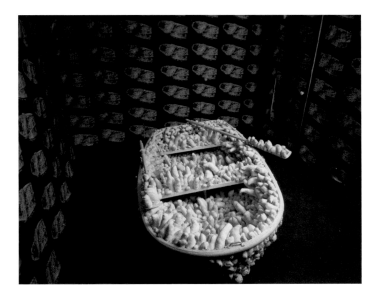

Fig. 2. *Aggregation: One Thousand Boats Show,* 1963–64, at Gertrude Stein Gallery, New York. Beatrice Perry Papers, New York

The potential of this revelation was actualized with her 1965 *Infinity Mirror Room—Phalli's Field* (pp. 46–51), for which she transformed Castellane Gallery into a mirrored room. Placed on the floor of the space were hundreds of soft sculptures made from fabric and covered with red printed polka dots. Kusama described this accumulation of phalli as a way to suppress her anxieties about sex through repetition.[15] The expanding environment suggests other things, too, as a kind of visual mathematics occurs in which each mirror continually presents the square of its reflection. The effect is punctured in spots: at the seams between the affixed mirrors, in the specificity of the floors and the ceiling. But looking straight ahead or to the side, the viewer sees himself or herself multiplied in a field of polka dots, and he or she becomes the visual center and source of meaning for the piece: any allusion to infinity is meaningless without human presence.

In common parlance, *infinity* describes things of inconceivable size. But just as something can be infinitely big, so can something be infinitely small. Generally, the idea of infinity resides in the physical world, in mathematics, and in the mind. Kusama's sense of infinity is not concerned with how two lines of different lengths can both be infinitely divisible, nor does she grapple with the way a sphere can be traversed endlessly even if its surface area is finite. Mathematical problems such as these are outside Kusama's purview. Her infinity is an existential crisis bound up in the awareness of life's temporal limits. She constantly considers her existence—"I am trapped in my life, yet I cannot escape from death"—in relation to the universe, its immensity and age.[16] It is this sublime apprehension that forms the basis for another mirrored installation, *Kusama's Peep Show* (1966; pp. 52–57). Submitted as a proposal for the unrealized Zero op Zee (Zero on Sea) exhibition in the Netherlands in 1965 and then shown at Castellane Gallery in March 1966, the hexagonal room is mirrored on all sides, floor and ceiling included. An array of small, colorful, flashing lights illuminates the space spectacularly. Two small windows grant viewers access to the interior, making them more voyeurs than the active participants in *Phalli's Field*. Peter Schjeldahl conveyed the experience well: "Peering through one of the two head-size holes in the chamber, you view a depthless, receding blaze of lights—in the farthest distance a shimmering Milky Way—plus a thousand or so reflection of your own face and that of the person at the other peep-hole."[17]

Fig. 3. Installation view of group exhibition, Green Gallery, New York, June 1962. Photograph by Rudolph Burckhardt

Schjeldahl picked up on the cosmological implications. Reflecting on the piece in 2002 Kusama wrote, "Thousands of illuminated colors blinking at the speed of light—isn't this the very illusion of Life in our transient world? In the darkness that follows a single flash of light, our souls are lured into the black silence of death."[18] Kusama's poetic description hints at the struggle to reckon with a conception of oneself within the material reality of nature, while *Kusama's Peep Show* conjures thoughts about the tremendous distance between earth and the edge of the observable universe—as well as the fact that 95 percent of the cosmos exists beyond our ability to confirm its presence. Billions of galaxies spiral around what are presumably the same number of black holes; microwave radiation still travels from the very first moments of the universe's coming into being. And if the universe began, what came before; what will come after it ends? What if the universe has instead always existed as an infinite continuum? These questions are the measure of human existence; each and every person contains a bit of stardust.

Kusama's artistic peers thought a great deal about the scale of the human body and how it activates an environment. These notions were crucial to Robert Morris's 1964 exhibition at the Green Gallery in New York (fig. 4), and they were critical to Judd, who hung all his wall pieces at a height appropriate to his own ideal viewing position. These engagements between the body and the art object were relational, but the point of reference was always local: art

Fig. 4. Installation view of Robert Morris exhibition at Green Gallery, New York, 1964–65: (from left) *Untitled (Table), Untitled (Corner Beam), Untitled (Floor Beam), Untitled (Corner Piece),* and *Untitled (Cloud)*

and its immediate context—the white cube. Kusama's ever-evolving installations aspired to something beyond art, even if what she did was resolutely art. She asked questions none of her peers did; she turned her obsessions into something philosophical: "The polka dot has the form of the sun, signifying masculine energy, the source of life. The polka dot has the form of the moon, symbolizing the feminine principle of reproduction and growth. Polka dots suggest multiplication to infinity. Our earth is only one polka dot among millions of others. . . . We must forget ourselves with polka dots! We must lose ourselves in the ever-advancing stream of eternity."[19]

The social interaction engendered in Kusama's mirrored installations was necessarily limited; only so many people could view them at one time, and while they produced a sensation of foreverness, their physicality made them restricting. Other possibilities began to present themselves. Kusama had been interested in performance for a while. In one early intervention, *14th Street Happening* (1966; pl. 24), she placed a panel of stuffed polka-dotted objects from *Phalli's Field* on a busy Manhattan thoroughfare and proceeded to recline atop, alongside, and near the sculpture. The work had much to do with Kusama. Her intrusion on a busy street disrupted the flow of people, whose movements and alterations around Kusama's prone body look, from the documentary photographs taken from a perch several stories above, like onrushing water coursing around an intractable boulder.

Kusama became more political at this time but not in ways one might expect.[20] The social turmoil gripping the United States in the late 1960s was unavoidable. Hippies became more prominent, the reaction against the Vietnam War increased significantly. The art world was not oblivious to what transpired in the streets, but it was difficult to reconcile political belief with artistic practice. Artists would go to a protest and then to the studio; these sites of expression generally ran on parallel tracks. There were notable exceptions. The Art Workers Coalition organized protests at several New York museums. A number of artists pulled out of exhibitions in solidarity with the antiwar struggle. Others, such as Hans Haacke, made institutional complicity in the war the subject of their art. Meanwhile, Lucy Lippard organized a show of Minimalist artworks at

Fig. 5. Installation view of Paula Cooper Gallery, New York, October 1968, curated by Robert Huot, Lucy Lippard, and Ron Wolin; and featuring work by Carl Andre, Jo Baer, Bob Barry, Bill Bollinger, Dan Flavin, Robert Huot, Will Insley, Donald Judd, David Lee, Sol LeWitt, Robert Mangold, Robert Murray, Doug Ohlson, and Robert Ryman. Image courtesy Paula Cooper Gallery, New York

Paula Cooper Gallery in 1968 titled *Benefit for the Student Mobilization Committee to End the War in Vietnam*—the radical aesthetic nature of the works presented as a kind of protest (fig. 5). In general, however, the aesthetic revolution occurring in Minimal, Pop, and nascent forms of Conceptual art was mostly formal and institutional, and even though these rejections of tradition can be seen as examples of the dramatic social and cultural transformation that took place in the 1960s and early 1970s, none were as unsettling as Kusama's performances.

Kusama's antiwar, antiestablishment Happenings derived in part from her fascination with hippie culture. She admired the rebellious inclinations of the hippies—how they wanted, as she put it, "to reclaim their alienated humanity."[21] The performances occurred indoors and out in many different parts of New York. Most of the outdoor works—such as her *Antiwar* Happening on the Brooklyn Bridge in 1968, in which two naked men held a banner proclaiming "self-obliteration" above two equally bare women sharing an embrace (fig. 6)—were over quickly, concluded before the police could intervene. Those that transpired indoors—whether in Kusama's studio or someone else's or in a nightclub—were longer, more elaborate, as with her "naked Happenings," which often had the appearance of theater or something at the least scripted and arranged.[22] The Happenings varied in theme and organization, and Kusama's role became not only that of a performer but also increasingly that of a facilitator. "I am not like happening people," she said in 1969, "I am a stagemaker. I stage happenings for other people. They do what they want. I watch."[23] Many of the events were quite sexual, even if Kusama refused to take part: she was not, she said, "interested in sex; like Andy [Warhol], I [am a] producer, not involved" (fig. 7).[24] The sex parties were open and sometimes very decadent. Many were just for men, others were for women, and others drew a mixed and curious crowd. In one instance in the late 1960s, *Kusama's Peep Show* was used as a prop for male group sex, which proved to be a dramatic setting for the West German television crew that had come to film a Kusama Happening.[25]

In each of her Happenings, Kusama and participants painted bodies. These sessions, called Body Festivals, sometimes took place in her studio, other times they occurred in Washington Square Park or another public location (fig. 8). When she took to the streets, she found ways to be overtly political without losing the bacchanalian

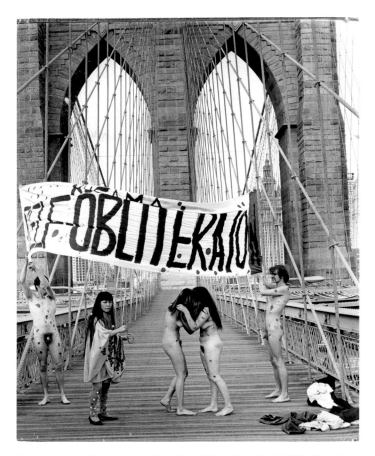

Fig. 6. *Antiwar* Happening on Brooklyn Bridge, New York, 1968. Gelatin silver print, 8½ x 8 in. (21.5 x 19.6 cm)

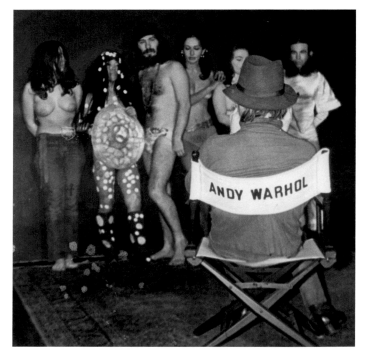

Fig. 7. Kusama at Andy Warhol's Factory, 1968

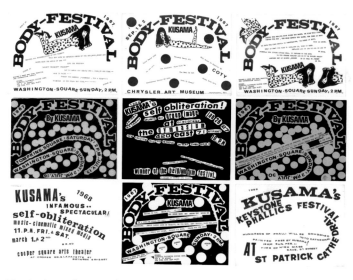

Fig. 8. Flyers, "Kusama's Weekend Body-Festival," at the Chrysler Art Museum, Provincetown, New York, September 1–2, 1967; Washington Square, New York, August 20; Tompkins Square, New York, July 16; and Washington Square, July 30, 1967. Flyer, "*Kusama's Self Obliteration!* With Music by Group Image," at the Gymnasium discotheque, New York, January 26–27, 1968. Flyer, "Kusama's Infamous Spectacular! Self-Obliteration! With music by Cinematic Mixed Media," at Cooper Square Arts Theater, New York, March 1–2, 1968. Flyer, "Kusama's Keystone Phallics Festival," at St. Patrick's Cathedral, New York, 1968

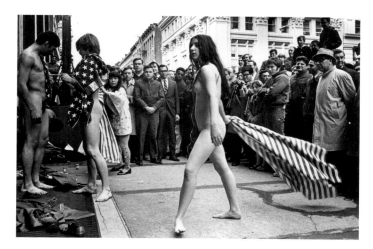

Plate 25. *Anatomic Explosion,* Reade St. near Lower Broadway, New York, 1968, Photograph by Shunk-Kender. Gelatin silver print, 8⁷⁄₁₆ x 7¹¹⁄₁₆ in. (21.5 x 19.5 cm). Museum of Modern Art, New York. Gift of the Roy Lichtenstein Foundation in memory of Harry Shunk and János Kender

aspects of her other Happenings. Kusama never said exactly why she opposed the Vietnam War.[26] One might suppose that her experiences as a youth in Japan during World War II colored her impression of the tragedy unfolding in Southeast Asia.[27] More likely, her Happenings continued her existential investigation. She chose emotionally loaded sites such as the Statue of Liberty, the Board of Elections, and St. Patrick's Cathedral (pls. 25–27). On a hot summer day in 1968, a group of four dancers—two men and two women—stood along with Kusama before the statue of George Washington at the Federal Building on Wall Street (pls. 26–27). The troupe undressed and began to move around in sensuous motions much to the shock of those who chanced upon the Happening. Kusama had already alerted the press and made sure to have the event documented. Her lawyer looked out for police. She yelled, "Stock is a fraud. . . . [T]he money made with this stock is enabling the war to continue. . . . [O]bliterate Wall St. men with polka dots on their naked bodies."[28] Before the cops arrived Kusama painted polka dots on the dancers; at one point, they held up a large banner that read, "Kusama Self-Obliteration."

Kusama used the term *self-obliteration* constantly during this period. "Obliterate your personality with polka dots," she said in 1968. "Become one with eternity. Become part of your environment. Take off your clothes. Self-destruction is the only way to peace."[29] Obliteration led to nature, to a world free from social conventions and hindrances. The dots, for Kusama, link everyone and everything—from the person to the star to the particle. She made a film titled *Kusama's Self-Obliteration* in 1967 that brings together previous works—both paintings and sculptures—with documentation of specific performances, including *Kusama's Self-Obliteration,* held at the Black Gate Theatre in New York earlier that year. The film lacks a narrative, its atonal music and the drone of a barely audible voice are all that hold the disparate sequences of imagery together (see Sutton, fig. 7). One shot shows Kusama, in Woodstock, New York, placing white dots on a large brown horse. She soon is atop the animal, which moves with a languid gait. They approach a pond, where Kusama dismounts and proceeds to place dots of fabric and paint on the water. She then covers a naked man in leaves, helping him blend into the landscape. There is another scene in which a polka-dotted Kusama stands before a tree likewise decorated with dots.

The hallucinatory power of the dots in the film creates the impression of an unstable world that moves seamlessly from the rural to the urban to the light-sound performance.

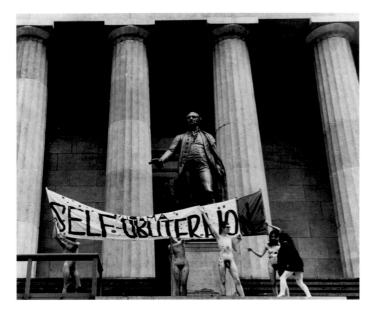

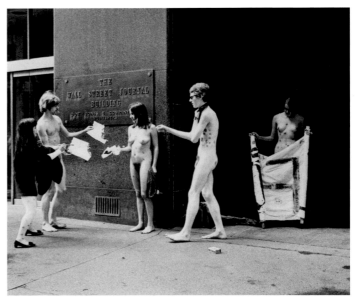

Plate 26. *Anatomic Explosion* on Wall Street, Statue of George Washington, New York, 1968. Photograph by Shunk-Kender. Gelatin silver print, 8⁷⁄₁₆ x 7¹¹⁄₁₆ in. (21.5 x 19.5 cm). Museum of Modern Art, New York. Gift of the Roy Lichtenstein Foundation in memory of Harry Shunk and János Kender

Plate 27. *Anatomic Explosion* on Wall Street, New York, 1968. Photograph by Shunk-Kender. Gelatin silver print, 8⁷⁄₁₆ x 7¹¹⁄₁₆ in. (21.5 x 19.5 cm). Museum of Modern Art, New York. Gift of the Roy Lichtenstein Foundation in memory of Harry Shunk and János Kender

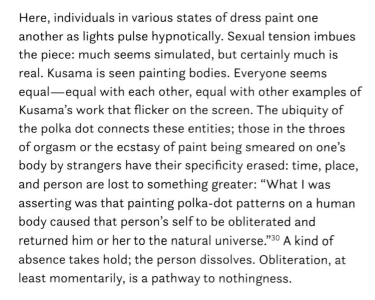

Here, individuals in various states of dress paint one another as lights pulse hypnotically. Sexual tension imbues the piece: much seems simulated, but certainly much is real. Kusama is seen painting bodies. Everyone seems equal—equal with each other, equal with other examples of Kusama's work that flicker on the screen. The ubiquity of the polka dot connects these entities; those in the throes of orgasm or the ecstasy of paint being smeared on one's body by strangers have their specificity erased: time, place, and person are lost to something greater: "What I was asserting was that painting polka-dot patterns on a human body caused that person's self to be obliterated and returned him or her to the natural universe."[30] A kind of absence takes hold; the person dissolves. Obliteration, at least momentarily, is a pathway to nothingness.

Two extremes—infinity and nothingness—are held together by polka dots. Both are absolute; neither can be confirmed given the finitude and corporeality of human beings. Infinity and nothingness must be imagined; they are the subject of reflections that lead to thoughts about being, engendered by artworks that offer glimpses of the fullness of existence. In every instance, Kusama and her art emphasize one's smallness and mortality, not with pathos or sentimentality, but rather with a kind of beauty that comes from having pondered being-in-the-universe. For brief, effervescent moments, Kusama provides viewers the possibility of experiencing one's place in nature. How generous a gift this is.

Notes

1 William Grimes, "Lights, Mirrors, Instagram! #ArtSensation: Yayoi Kusama's 'Mirrored Room' at David Zwirner Gallery," *New York Times*, December 2, 2013.

2 For an overview of Kusama's politically oriented performances, see Mignon Nixon, "Anatomic Explosion on Wall Street," *October* 142 (Fall 2012): 3–25.

3 Al Van Starrex, "Naked Happenings," *Man* (October 1968): 44; "A New Way to Be Nude," *Coronet* 7, no. 6 (June 1969): 25.

4 One of the key themes in Midori Yamamura's book *Yayoi Kusama: Inventing the Singular* (Cambridge, MA: MIT Press, 2015) is how Kusama faced prejudices because of her gender and nationality.

5 See also Lynn Zelevansky, "Driving Image: Yayoi Kusama in New York," in *Love Forever: Yayoi Kusama, 1958–1968* (Los Angeles: Los Angeles County Museum of Art, 1998), 20.

6 Donald Judd, "In the Galleries: Yayoi Kusama," *Arts* 38, no. 10 (September 1964): 69.

7 Yayoi Kusama, *Infinity Net: The Autobiography of Yayoi Kusama*, trans. Ralph McCarthy (London: Tate Publishing, 2013), 180.

8 See Donald Judd, "Specific Objects," in *Complete Writings, 1959–1975* (Halifax: Press of the Nova Scotia College of Art and Design, 1975), 181–89.

9 With regard to the latter point see, for instance, Francine du Plessix Gray, "The House That Pop Art Built," *House and Garden* 127, no. 5 (May 1965): 158–64.

10 Jack Kroll, "Reviews and Previews: Yayoi Kusama," *ARTnews* 60, no. 3 (May 1961): 15.

11 Kusama began calling her paintings Infinity Nets in the 1970s.

12 Kusama, *Infinity Net*, 23.

13 Ibid., 20.

14 Jill Johnston, "Reviews and Previews: Kusama's *One Thousand Boat Show*," *ARTnews* 62, no. 10 (February 1964): 12.

15 Kusama, *Infinity Net*, 47.

16 "A New Way to Be Nude," 31.

17 Peter Schjeldahl, "Reviews and Previews: Kusama," *ARTnews* 65, no. 3 (May 1966): 18.

18 Kusama, *Infinity Net*, 51.

19 John Gruen, "The Underground," *Vogue*, no. 152 (October 1968): 148.

20 Jo Applin has rightly observed that Kusama's political stance is hardly didactic, and if it is about anything, it is the fostering of social relations. See Jo Applin, *Yayoi Kusama: Infinity Mirror Room—Phalli's Field* (London: Afterall Books; Cambridge, MA: MIT Press, 2012), 77.

21 Kusama, *Infinity Net*, 97.

22 Howard Junker, "Theater of the Nude," *Playboy* (November, 1968): 104.

23 Chris Rainone, "The New Nudism: A Skin Freak Testifies," *Rogue* (August 1969): 59.

24 "The New Nudity," *New York Scenes* 1, no. 9 (February 1969): 25.

25 Kusama, *Infinity Net*, 100.

26 Midori Yoshimoto makes the point that Kusama was generally vague about her politics, often bringing together a variety of political positions. "The disparate mixture of political messages suggests that they were secondary to Kusama's performances." See Midori Yoshimoto, *Into Performance: Japanese Women Artists in New York* (New Brunswick, NJ: Rutgers University Press, 2005), 75.

27 Nixon, "Anatomic Explosion on Wall Street," 13–14.

28 Rainone, "The New Nudism," 57.

29 Van Starrex, "Naked Happenings," 45.

30 Kusama, *Infinity Net*, 102.

Plate 28. *Infinity Nets Yellow*, 1960. Oil on canvas, 94½ x 116 in.
(240 x 294.6 cm). National Gallery of Art, Washington, DC.
Gift of the Collectors Committee 2002.37.1

Plate 29. *No. I.Q,* 1961. Oil on canvas, 24 x 30 in.
(61 x 76.2 cm). Collection of Sandra and Howard Hoffen

OPPOSITE
Plate 30. *No. T.W.3.*, 1961. Oil on canvas, 69 x 49½ in.
(175.3 x 125.7 cm). Collection of Suzanne Deal Booth

Plate 31. *No. Green No. 1*, 1961. Oil on canvas, 70 x 49½ in (177.8 x 124.8 cm). Baltimore Museum of Art, The Edith Ferry Hooper Bequest Fund, BMA 1996.11

Plate 32. *Accumulation of Stardust*, 2001. Acrylic on canvas.
Three panels, each 76⅜ x 153⅞ in. (194 x 390.9 cm).
Matsumoto City Museum of Art

Plate 33. *Infinity-Nets,* 2005. Acrylic on canvas, 76⅜ x 76⅜ in.
(194 x 194 cm). Collection of Jerry Yang and Akiko Yamazaki

Plate 34. *Dots Obsession XZQBA*, 2007. Acrylic on canvas,
63⅞ x 63⅞ in. (162 x 162 cm). The Rachel and Jean-Pierre
Lehmann Collection

Between Enactment and Depiction: Yayoi Kusama's Spatialized Image Structures

Gloria Sutton

My nets grew beyond myself and beyond the canvases I was covering with them. They began to cover the walls and the ceiling and finally the whole universe.
—Yayoi Kusama, 1963[1]

One thing that foreigners, computers and poets have in common is that they make unexpected linguistic associations.
—Jasia Reichardt, *Cybernetics, Art and Ideas* (1971)[2]

Starting around 9 am on a typically bright Los Angeles morning, dozens of people stand in a long line circling The Broad, a newly opened museum of contemporary art designed by Diller Scofidio + Renfro and located in the city's downtown. This exponentially growing line is startling—both in its demographic diversity and patient discipline. At 11 am, when the doors open, the crowd rushes inside and quickly forms another line along a pathway demarcated by shiny new metal stanchions to procure timed tickets to enter Yayoi Kusama's *Infinity Mirrored Room—The Souls of Millions of Light Years Away* (2013; fig. 1; pp. 106–07).[3] Due to the extraordinary popularity of what has been heralded as a signature "immersive" work by the artist, visits are limited to forty-five seconds. Though brief, it is enough time to experience Kusama's ability to transform ordinary materials into a spectacular effect. Viewers enter the approximately nine-by-thirteen-foot space crafted from wood, rubber, mirrors, and off-the-shelf LED lights one at a time to stand on a modest proscenium set over a shallow reflecting pool made using simple black vinyl flooring filled with a few inches of water.[4] Darkened and dampened (in both sound and humidity), the space is dimly lit by dangling strands of jewel-toned lights suspended from the mirrored ceiling. Linked to an automated timing mechanism, the lights shift between a soft pulsating glow and a stereoscopic staccato effect that becomes all-encompassing. Once the mirrored door closes behind the visitor, the room's low-tech analogue features turn the space into a complete digital *mise-en-abyme* experience.

This is not a metaphor or analogy but an actualization of the cinematic concept in which a subject is replicated and often reconfigured in smaller forms. Inside Kusama's *Infinity Mirrored Room—The Souls of Millions of Light Years Away*, the viewer observes the multiplication of his or her own image from all geometrically conceivable angles. More specifically, most visitors endure the hours-long wait for

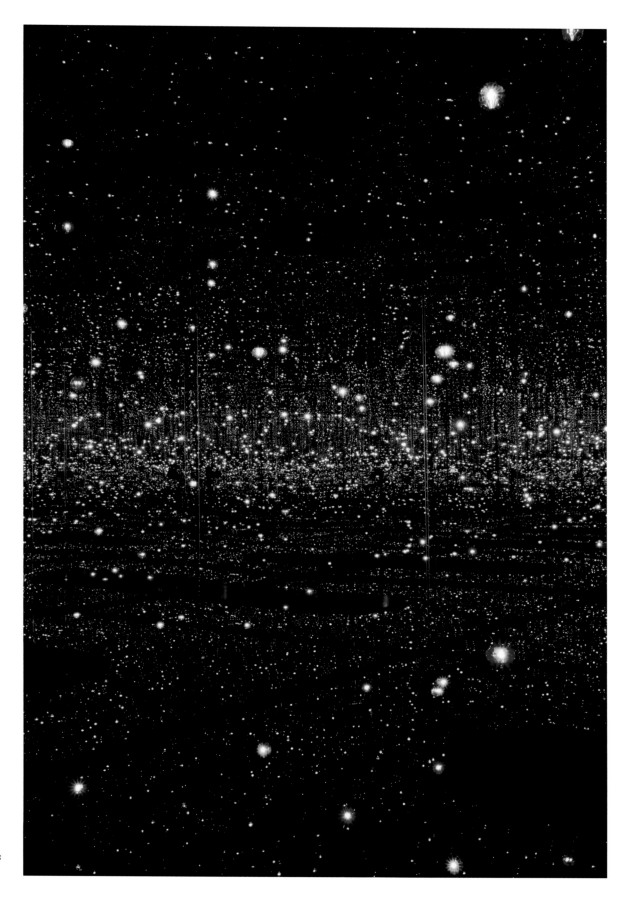

Fig. 1. Interior view of *Infinity Mirrored Room—The Souls of Millions of Light Years Away*, 2013

the express purpose of procuring a self-portrait with a smart phone inside this uniquely mirrored room, which, in effect, renders a digital image within a structure that is itself an infinity of images. In fact, the desire to take such an "image within an image" after seeing one online is the reason many visitors come to the museum in the first place.[5] The resulting digital files are uploaded and circulated, generating a type of recursive process. This Droste effect— in which each increasingly small image contains an even smaller version of itself and seems to continue ad infinitum, the only limitation being the picture resolution available at the time the image is taken—gives credence to Kusama's subtitle. The exponentially growing popularity of these images on social media and in the mass media has perhaps now made taking "selfies" a key component of the work itself. The resulting images are subject to the same type of "geometry instancing" frequently used in computer graphics to generate multiple copies of the same or similar features (background landscapes, bodies of water, cityscapes, and even animated characters) of a digital image. In this technique, complex shapes are reduced to a series of geometric planes whose hardened edges are softened or modeled through algorithmic software. Used since the 1990s with increasing sophistication, this technique has become common in digital films and video games, allowing designers to introduce slight variations in color, shadows, and positioning to elements so that they appear modulated rather than uniformly flat within the overall scene.[6]

The replication of forms or structures through digital techniques such as geometry instancing in order to expand, extend, and fill in missing information within an image is similar to the way that Kusama uses analogue techniques of repetition and patterning to construct a larger picture or representation of subjective experience. I would argue that it is within this rhetorical space between enactment and depiction—Kusama's emphasis on process on the one hand and representation on the other, foregrounded in the Infinity Mirror Rooms—that the full spectrum of the artist's polymath thinking and output resides. More specifically, this close reading of her techniques—advanced within the multiple iterations of her Infinity Mirror Rooms as well as her lesser-known Expanded Cinema projects from the mid-1960s (multisensory installations that often used sound and light projections in an experimental and performative manner to engage with audiences)—suggests that visual art's adaptation of the systems theories ushered

in by cybernetics during this same period offers a contextual backdrop against which Kusama's diverse and prolific art practice can be read anew. Doing so helps affirm how Kusama's singular career presciently signaled key shifts in postwar art writ large. This includes the first barrier-breaking exhibition of her Net paintings in the United States in 1958—an event set against the dominant discourse of Abstract Expressionism in New York; her ambitious public performances during the 1960s and 1970s that emphasized the commodity status of art;[7] her large-scale outdoor sculptures produced in the 1990s; and most recently, the infinite replication of her Infinity Mirror Rooms through social media. The fact that she frequently was (and continues to be) the only female and nonwhite artist operating in these male-dominated contexts makes Kusama a double outlier.

While she may have registered as "foreign," Kusama remained highly attuned to the semantics of the American art world during the postwar period. Importantly, the trajectory of her work signaled a shift from the modernist viewing subject associated with abstract painting to the rise of experiential multisensory installations and their virtual extension into cyberspace. Thus her lifelong motif of a net that could stretch to cover the universe—as alluded to in the quote drawn from a 1963 interview by Gordon Brown, executive editor of *Art Voice* for WABC Radio, that serves as an epigraph for this essay—can be read as a reference to a communication network. Moreover, this slide from nets to networks is exactly the type of "unexpected linguistic" association that curator Jasia Reichardt pointed to in the introduction to her book *Cybernetics, Art and Ideas*. Published in 1971, the volume recounted three years of planning for the groundbreaking 1968 exhibition *Cybernetic Serendipity: The Computer and the Arts* at the Institute of Contemporary Arts, London, which examined the intersection of computing, communication networks, and the arts. Born in Warsaw in 1933, just a few years after Kusama, and one of the few women to direct an international art center, Reichardt would have been finely attuned to the syntax of art-world outliers. *Cybernetic Serendipity* was notable not only for presenting the work of more than 325 artists to in excess of 60,000 visitors but also for detailing the influence of cybernetics on the creative process, introducing such concepts as interactivity and formal variability, which have since become endemic to contemporary art practice.[8] "Since the middle 1950s the

relationship between art and technology has been increasingly in evidence through the advent of computer-aided creative design," wrote Reichardt in 1971. "*Cybernetic Serendipity* was not an art exhibition as such, nor a technological fun fair, nor a programmatic manifesto—it was primarily a demonstration of contemporary ideas, acts and objects, linking cybernetics and the creative process."[9]

Evolving from behavioral research in antiaircraft technology used during World War II, cybernetics is most closely associated with Norbert Wiener's 1948 publication, *Cybernetics: or Control and Communication in the Animal and the Machine,* and is understood as "a science of control or predictive value—of taking account of the futurity and its 'probabilistic tendencies' and attempting to regulate its outcome through the transfer of messages."[10] Cybernetics had already permeated the wider cultural imaginary by the time of the ICA show, and an excerpt from Wiener's follow-up book, *The Human Use of Human Beings* (1964), served as the introduction to the catalogue for *Cybernetic Serendipity*. As art historian Pamela Lee explained in a 2001 article, "Well after Wiener's death in 1964, cybernetics became a pop culture buzzword used to describe phenomena as wide ranging as the centralization of power during the Cold War, modern religion, behavioral psychology, childrearing, alcoholism, dialectical materialism, deteriorating ecosystems, and visual sign systems."[11] Although Lee's analysis of cybernetics is focused on Kusama's fellow artist Robert Smithson (also represented by Castellane Gallery in New York), her observation that "what is obscure for a reader in the twenty-first century was at least tacitly understood for a sixties artist: namely, the promise of communication in general, a promise of communicating art as a system in particular" is very much applicable to understanding how Kusama's experiential installations operated at the time of their initial exhibition and how they function in their current reinstallations.[12] Moreover, I want to suggest that the recent critical and popular reception finally afforded Kusama's vital body of work not only recalibrates postwar art historical narratives, but also offers a much-needed antidote to the problematic term *post-Internet,* which is indiscriminately deployed to describe how the digital has conditioned contemporary art. More specifically, when applied to art production, *post-Internet* often refers to the ways that experiential multisensory installations become enfolded into a constantly shifting mediascape that treats images as inherently variable and reproducible, and, in the most benign cases, as mutable works equally at home in the space of the gallery or on a webpage.[13] Arguably, Kusama's decidedly analogue processes have best demonstrated how the circuits and networks of art's production echo economic changes—the shift away from the industrial model of the exchange of goods to the current peer-to-peer economy that purports to eschew ownership for sharing—while never losing sight of the fact that visual art is an inherently social enterprise that traffics in experience.

Kusama's Spatialized Image Structures

Just as geometry instancing creates variability within the repetition of a surface pattern, Kusama's Infinity Mirror Rooms build on the artist's processes of sculptural aggregation. These are skills she has cultivated in the fifty years since her first mirror room (arguably the first of its kind in contemporary art) was exhibited in *Floor Show* at the Castellane Gallery in 1965.[14] The floor of this work—aptly subtitled *Phalli's Field* (pp. 46–51)—was completely carpeted with her fabric protrusions, each printed with red dots of varying sizes and carefully constructed by hand. The subject of intense art historical scrutiny, *Phalli's Field* would become a fulcrum in the analysis of Kusama's prolific body of work.

Interpretations of *Phalli's Field* have tended to pivot between descriptions of "oceanic bliss" and "claustrophobic horror."[15] Despite the careful work of many scholars, these polarizing positions have been reinforced through a biographically overdetermined reading of the work as being "psychologically inflected."[16] Art historian Jo Applin mitigates against this interpretation by suggesting that Kusama's room is not the result of a "disintegration of the psyche," as many historians and curators have claimed, so much as it performs that process. In fact, I would extend this argument based on the fact that most published images of *Phalli's Field* feature Kusama's own body in various states of performativity: lying prone in what has become her signature red leotard, gazing at the camera while her visage is reflected exponentially in the room's mirrored paneling (see Yoshitake, fig. 1). These now-iconic images were created in collaboration with the photographer Eikoh Hosoe, whose prismatic lens telegraphed Kusama's conceptual aims in these early installations, which Hosoe actually shot before the construction of the installation

was completed (see Yoshitake, fig. 2).[17] Beyond a documentary function, these photographs support what art historian Briony Fer has described as an operational "dispersal" in Kusama's installations from the 1960s: "Kusama seems to have been keenly aware of the relationship between her installations and the photographs that were taken of them. A dispersal is enacted on the body to produce a proliferation of the body-in-pieces in the photographs as much as the installations themselves."[18] Therefore, rather than reading the resulting images as portraits of the artist's interiority, I think they arguably convey the opposite: Kusama's longstanding interest in extreme exteriority—expansive surfaces that continue ad infinitum signaled by the descriptors *endless*, *forever*, and *infinity*, which the artist frequently attaches to the titles she gives to both paintings and installations. For example, in a letter dated February 25, 1966, Kusama explained the extended surface effect of her mirrored installation: "When I had my 'Floor Show' in New York it was a great success and many people said it was the best show this season in New York. You cannot imagine how wonderful it was to walk into this room completely surrounded by mirrors and people were surprised because the mirrors reflected an infinite horizontal surface forever."[19]

Kusama's next mirror-room installation, *Kusama's Peep Show* (1966; pp. 52–57; also at Castellane Gallery), would underscore her long-standing interest in shifting models of viewership away from the purely visual toward a multisensory experience. Instead of entering the room itself, viewers were encouraged to look inside the mirrored space through two eight-inch-square windows cut into the work's hexagonal exterior. Colored bulbs lined the ceiling in specific geometric patterns, exuding an orange glow and functioning very much like the ubiquitous polka dots Kusama affixed to paintings, clothing, and sculptures as well as human and animal bodies. In addition to the pulsating lights, Kusama chose to fill the space with Beatles music, adding to the sensorial experience. The dual cutouts encouraged two viewers to look through and into the work simultaneously so that as they made eye contact the mirrored walls duplicated and dispersed their reflections throughout the interior of the space. It is exactly this type of sociability that the work brought to the fore. *Kusama's Peep Show* prioritized the interactions between viewers through the architectural dynamics of the work, both spatially and acoustically.

Kusama's emphasis on animating space through mirrors is affirmed by a series of black-and-white images shot on September 5, 1968, by photographers Harry Shunk and János Kender, who documented many of the artist's openings and performances as part of their reportage-style coverage of art world activities from the 1950s until their partnership dissolved in 1973. Three very distinct photographs of Kusama posing for the camera demonstrate how she used the reflective surface of the space in tandem with photography's own essential functionality to multiply and refract the meaning of her work. The first image presents Kusama by herself within an installation striking a dramatic pose that fills the frame (pl. 35). She is balanced on a stepladder, arms raised and spread apart to accentuate the dropped sleeves of her dress, swaths of polka-dotted fabric neatly displayed around her. The image is staged as if it were a fashion editorial from a magazine or a catalogue addressing a viewer outside of the space. This highly composed photograph captures the mirrors duplicating her body, each version seeming to recede into space while also allowing us to see her body from all sides so that the lines of fabric radiate to create a circle within the photograph. The second and third images were taken in the midst of the action. One shows Kusama dressed in a caftan and holding a paintbrush in mid-stroke surrounded by nude figures whose skin she has adorned with painted dots in a manner that accentuates the social dynamics and animated gestures essential to her work (pl. 36).

While these photographs convey how figures animated these spaces, they also help us see how Kusama conceived of the spaces less as backdrops than as machines for animation (pl. 37). This notion is exemplified through her instructions for another mirrored structure. Before *Kusama's Peep Show*, the artist proposed making a hexagonal structure for Zero op Zee (Zero on Sea), a site-specific art event planned for Scheveningen Pier in the Netherlands. In her hand-drawn plans and detailed instructions for this unrealized work, called *Love Forever* (p. 55), Kusama directed that the installation include tape machines playing her own recordings of Beatles music—just as she had done in the New York installation (pp. 52–53).[20] In addition, in a series of letters outlining her intentions, she emphasized the "necessary apparatus" of the work, how it literally and figuratively operated and needed to be calibrated like a machine. Specifically, the electrical circuitry involved in creating the piece was key and required hiring a local

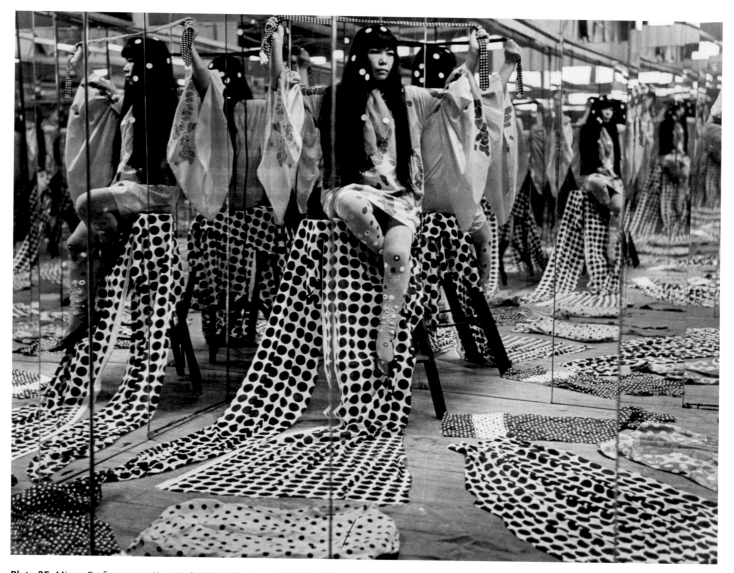

Plate 35. *Mirror Performance, New York,* 1968. Photograph by Shunk-Kender. Gelatin silver print, 7¹³⁄₁₆ x 9¾ in. (19.9 x 24.7 cm). The Museum of Modern Art, New York. Gift of the Roy Lichtenstein Foundation in memory of Harry Shunk and János Kender

electrical engineer to install the piece so that the arrangement of flashing colored lightbulbs would be synchronized to intermittently spell out the words "love" and "sex." Kusama also indicated that the mirrors themselves should be mounted "slightly apart to allow heat to escape from the hexagon and allow people to peep into the room. . . . [A]fter the people have peeped into the space they can come into the room and will be overwhelmed with light. This image will be a fantastic sensation in this exhibition."[21] As part of the project, Kusama specified that she wanted to give "visitors a button reading 'Love Forever, Kusama,'" asking that 1,000 pins be produced exactly like the sample she sent with the instructions—"but, of course, the words in Dutch."

More than just whimsical flourishes, Kusama's appropriation of popular culture (pop songs and popular slogans) suggests ways of questioning the often-assumed heteronormative definitions of love and longing that help popular culture reach its mass scale. This important political position is underscored through a range of complex works that German cultural critic Diedrich Diederichsen succinctly surveyed in a 2009 essay: "Later on, she mounts actions against the Vietnam War, stages hippie satires against Nixon, organizes gay orgies and a gay wedding ceremony, praises the feminine and feminine principles, repeatedly and more or less explicitly promotes the use of hallucinogenic drugs and praises free sexuality, especially among

members of diverse ethnic groups and attacks the conventions of everyday life."[22]

Well beyond these activities of the 1960s and 1970s, Kusama's critical gestures provided a model that would become central to a diverse range of successive feminist strategies that attempted to deconstruct gendered representations within mass cultural ideology and consumer imagery. Simply put: critiquing popular media using those same forms of media would become a hallmark of the semiotic turn of art in the 1970s and well into the 1990s. These practices include the image/object lessons gleaned from the photographic work of Sarah Charlesworth, who, like Kusama, looked to the conventions of mass media and fashion advertising as a source for her techniques of deftly parsing the semiotics of commodity fetish, reflection, and iconicity. In her series *Objects of Desire* (1983–88), for example, the artist rephotographed advertising images, fashion spreads, and other magazine sources that often depicted the female body and printed her appropriated forms against saturated Cibachrome color fields encased in matching lacquered frames. Dara Birnbaum extended these issues into her critique of the norms of broadcast TV and pseudo-female empowerment through her video *Technology/Transformation: Wonder Woman* (1978–79). Using techniques of fragmentation and repetition and employing footage from the US television series (1975–79) based on the DC Comics character, Birnbaum cuts and loops the moment that secretary Diana Prince spins and makes the physical and psychological transformation into the female superhero. Uncannily, Birnbaum's video features a sequence in which Wonder Woman uses the edge of her gold wrist cuff to cut herself out of a mirrored room similar in scale and dimension to *Phalli's Field* (fig. 2). Another point of reference can be found in the work of Pipilotti Rist, whose own career began with the appropriation of a Beatles song set against contrasting imagery of female subjectivity. Her early single-channel video *I'm Not the Girl Who Misses Much,* produced in 1986 while Rist was still in art school, features a static camera trained on a female figure who frenetically dances and chants lyrics from "Happiness Is a Warm Gun" (fig. 3). In a 2007 interview Rist cited Kusama's influence on her own self-described obsessive and fanatical production habits. *Pixelwald (Pixel Forest)* (2016), her recent room-scale installation of glowing strands of LED lights through which visitors walk, is a clear nod to Kusama's *Infinity Mirrored Room—The Souls of Millions of Light Years Away.*[23]

The complex ways in which Kusama's own body has figured in her works and the ways this has been read within the scholarship cast an important light on the durational aspects of the viewing strategies deployed by the artist.[24] Relaying the ways Kusama chose to pose for the camera and how her editorial selections convey a sense of calculated posturing—simultaneously critiquing and proliferating the ways mass media often present sexualized female bodies—most of the documentation of the Infinity Mirror Rooms highlights the temporal effects of those works.[25] The published photographs of *Phalli's Field* and *Kusama's*

Fig. 2. Dara Birnbaum. *Technology/Transformation: Wonder Woman*, 1978–79. Single-channel color video; sound; 5 minutes 50 seconds. Courtesy Electronic Arts Intermix, New York

Fig. 3. Pipilotti Rist. *I'm Not the Girl Who Misses Much*, 1986. Single-channel color video; sound; 5 minutes. Courtesy Luhring Augustine, New York

Peep Show document the seemingly spontaneous ways Kusama interacted with the mirrors and the sculptures in a type of live event or performance while also depicting her staging still images to be circulated after the fact for the express purpose of publicity, as the images by Shunk and Kender indicate. In both cases, I would argue that Kusama's subject is the act of mediation itself, which counters the tendency to distinguish between the live event (usually connoted as primary) and the document (often considered secondary). The two often converge within Kusama's oeuvre, challenging the linear sequence of events. This temporal division between the audience of the live event and that of the static document—and artistic interventions intended to disrupt these distinctions—would become key characteristics of performance art's discourse in the 1990s, another area that Kusama's practice during the 1960s helped advance and which has not been fully credited.[26]

Moreover, the resulting sensational images of *Kusama's Peep Show* have eclipsed or forestalled consideration of the more subtle social dynamics at play within that work and *Phalli's Field* (and the more recent Infinity Mirror Rooms the artist has continued to produce and re-create) as well as their connections to the interactive experiments associated with Expanded Cinema. Broadly construed, the practice of Expanded Cinema registered the ways that artists attempted to examine the role of media (namely mass media, photography, and film) and formally interrogate these mechanisms of mediated representation, incorporating those formats in their artworks alongside more established mediums (painting and sculpture). Expanded Cinema was a close counterpart to the media art experiments that exploded in New York in the late 1950s and early 1960s. Referring primarily to multimedia projects, the term developed simultaneously in the United States and Europe to describe a range of practices, including that of New York–based artist Stan VanDerBeek, who is often credited with coining the phrase and whose multiscreen projections and proto–interactive artworks of the 1960s and 1970s prioritized a transparency of process—making visible the construction and circulation of images and demonstrating how meaning hinged on audience engagement.[27] Simultaneously, Malcolm Le Grice in London, Birgit Hein in Germany, and VALIE EXPORT in Vienna would engage the theories and processes associated with Structural film to create and exhibit their own conceptually rigorous forms of Expanded Cinema.[28]

Allusions to voyeurism and sexual display in *Kusama's Peep Show*, while certainly apt, are not the only associations suggested by the work. What remains curiously unexamined is its machinic impulse, which was activated regardless of viewer presence and gave new meaning to the phrases "Endless Love" and "Love Forever," which appeared in the installation's subtitle and documentation. In a 2012 interview, Richard Castellane recalled that the lights installed along the ceiling of *Kusama's Peep Show* made a continuous whirring noise. The ungainly electric circuitry and the heat generated by the bulbs undoubtedly created a machinic environment; Castellane said "the rhythm of that machine" was an audible and pulsating noise that went "faster and faster."[29] Of course, the sound of the whirring lights and pop tunes of *Kusama's Peep Show* are not transmitted by the still images taken by photographers. The perspectives of Peter Moore, in particular, conveyed within a handful of static shots, have come to define not only interpretations of *Kusama's Peep Show* but also many of the highly subjective and dynamic audiovisual events associated with Fluxus, Judson Memorial Church performances, Happenings, and Expanded Cinema events in New York City during the 1960s—events with which Kusama's own sculptural installations, media performances, and public events intersected. As a result, interpretations of these intentionally variable encounters are often historically fixed by a single grainy image, not because it is definitive or even accurate, but merely because it is extant and affirmed through subsequent recirculation in the literature—a circumstance that often reduces dynamic multimedia events to static objects.

Expanding Histories

The fact that Kusama created multiple Infinity Mirror Rooms confirms the artist's interest in moving away from the modernist emphasis on originality and singularity toward a collective experience exemplifying broader shifts in the reception of multimedia art practices that coalesced under the loose rubric of Expanded Cinema in the 1960s. No less significant than the ways her contemporaries Robert Rauschenberg, Andy Warhol, and Claes Oldenburg melded the formal syntax of sculpture with the temporal dynamics of mass media, Kusama's Infinity Mirror Rooms combined a renewed understanding of the strategies of the

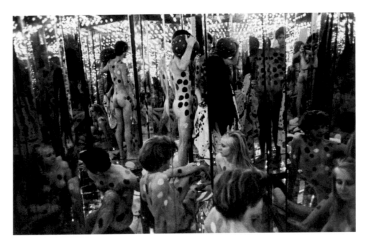

Plate 36. *Mirror Performance, New York,* 1968. Photograph by Shunk-Kender. Gelatin silver print, 6⅝ x 9¹¹⁄₁₆ in. (16.9 x 24.6 cm). The Museum of Modern Art, New York. Gift of the Roy Lichtenstein Foundation in memory of Harry Shunk and János Kender

Plate 37. *Mirror Performance, New York,* 1968. Photograph by Shunk-Kender. Gelatin silver print, 8⁷⁄₁₆ x 7¹¹⁄₁₆ in. (21.5 x 19.5 cm). The Museum of Modern Art, New York. Gift of the Roy Lichtenstein Foundation in memory of Harry Shunk and János Kender

historical avant-garde with the emergence of new transmission and reproduction technologies. While the rise of Expanded Cinema in all its various international permutations was related to the availability of more portable electronic devices, including compact film cameras and affordable editing equipment introduced in the 1960s, it is not defined simply in visual terms. In fact, I argue that it does not hinge on technological developments in film but on the introduction of network-based models of communication.[30] These included the development of fiber-optic cable and satellite networks that allowed for the real-time transmission of images over vast geographical distances and inspired many of the projects included in the *Cybernetic Serendipity* exhibition—and, more specifically, the ways these early systems determined the protocols and behaviors that conditioned the ways artists have used the digital networks that followed.

Engagement with these emerging communication structures during the mid-1960s was distinct from the broadcast and televisual experiments of the early 1970s and the subsequent emergence of video art. Artists such as Douglas Davis, Frank Gillette, Wulf Herzogenrath, Shigeko Kubota, Otto Piene, Carolee Schneemann, Gerd Stern, Aldo Tambellini, and VanDerBeek, to name only a few individuals, were less occupied by the rhetoric of revolution that video artists promoted a decade later.[31] These artists engaged a slightly earlier social sphere in which art and technology intersected with growing social movements and the scientific discourse developing around behavioral theories of liberation, control, and feedback associated with cybernetics.[32] Not simply an accretion of recording and playback technology, Expanded Cinema was a means to assess the wider cultural experience of the 1960s at the moment the era was fundamentally transformed by the rise of a new digital computing economy.[33]

The multimedia projects of Rauschenberg (Experiments in Art and Technology), Warhol (the Exploding Plastic Inevitable), and Oldenburg (Ray Gun Theater) are readily recognized within the discourse on Expanded Cinema and its enculturation of cybernetics and communication theories into the field of postwar art. Yet Kusama also engaged in similar types of live mixed-media experiments, such as the experimental light-projection performance *Kusama's Self-Obliteration,* presented at the Black Gate Theatre on New York's Lower East Side in June 1967 (fig. 4). An open, flexible space dedicated to staging "Electro Media Events," Black Gate Theatre was established by Tambellini

and Piene; it operated above the 200-seat Gate Theatre, which had been opened by Tambellini in the fall of 1966 as "the only theater to show avant-garde, underground films in continuous showing, till midnight, seven days a week" (including works by Stan Brakhage, Robert Breer, Bruce Conner, Maya Deren, Ed Emshwiller, George Kuchar, and others.)[34] Notably, both venues were part of an informal international network that would introduce work by non–US artists and filmmakers such as Takahiko Iimura and Nam June Paik as well as Kusama. Like many emerging artist-run spaces engaged in interdisciplinary performances that incorporated techniques from film, dance, theater, music, and poetry, Black Gate Theatre's "Electro Media Events" were intended to challenge the conventional divide between audience and performer by prioritizing multisensory experiences. As the press release announcing its inaugural programming exclaimed, "Electro Media Events must be experienced in terms of the totality of their live presentations. The experience of simultaneity-multi electric stimuli and shifting time-space relationships are one in the Electro Media Event."[35] Black Gate Theatre operated like a proto–research center that allowed artists to investigate the dialectical properties of creation and destruction that would become lifelong themes for Tambellini and Piene's multimedia projects and public artworks—projects that would attain wider recognition through exhibitions at the Howard Wise Gallery in New York as well as residencies at Boston's WGBH public television station and the Center for Advanced Visual Studies at the Massachusetts Institute of Technology in the 1970s.[36] Similar to the ways that Kusama deployed the term *obliteration* as a synecdoche for many themes—including the trauma of war, the expansion of human consciousness, and the dematerialization of the human body—Tambellini would attach the word *black* to various projects, including the name of the theatre, as a way to distinguish the multimedia experiments from the independent film programs presented in the downstairs theater.[37] Likewise, Piene's use of light—to both illuminate and blind—would also become recurring themes that overlapped with motifs in Kusama's practice.

In *The New Bohemia*, critic John Gruen chronicled the transformation of New York's Lower East Side and East Village into "a radically different Bohemia symptomatic of an international movement in the arts."[38] Black Gate Theatre was part of this landscape, along with the Film-

Fig. 4. *Kusama's Self-Obliteration* at the Black Gate Theatre, New York, June 1967. Photograph by Ted Wester. Aldo Tambellini Archives; courtesy Anna M. Salamone

makers' Cinematheque, the Bridge Theater, and other new venues where audiences were "exposed to cinematic free-for-alls that range from grueling exercises in boredom to events that are neither cinema, music, dance, painting, poetry, nor drama, but often deafening and blinding combinations of all of them."[39] *Kusama's Self-Obliteration* fit Gruen's descriptors: It was part lecture (critic Gordon Brown discussed Kusama's significance as an artist) and total light show, complete with women in silver bathing suits dancing to the distorted sounds created by Fluxus artist Joe Jones under black lights surrounded by a packed house of onlookers. Kusama painted fluorescent polka dots onto select body parts of the dancers so that when the black lights were turned on, the figures seemingly disappeared, leaving only the dots hovering and gyrating in space (figs. 5–6).[40] According to Tambellini, the live sounds were actually the amplified noises made by "about thirty live frogs in a tank full of water that Jones would rub under their bellies to stimulate their production [of] sound as Kusama painted dots over the bodies of female models."[41] Using live frogs as the soundtrack to a performance would have been novel even for an experimental art audience accustomed to the staccato pacing of underground films and the dramatized spontaneity of performance art and Happenings. The rhetoric of Happenings and performances during this period put a premium on aleatory, chance operations. And while Kusama's painted dots and use of light projectors to illuminate the bodies of the dancers seemed to appear more improvisational than choreographed, Tambellini noted that the artist left very little to chance while preparing for *Self-Obliteration*:

[Kusama] advertised in the *Village Voice* with a photograph of herself naked lying on a mat, her back completely covered with painted dots. There were several days of preparations and Joe Jones, besides coming to change the water and stroke the frogs on a daily basis, had rented a delivery tricycle and rode around 2nd Avenue with a sign to advertise the show. Joe Jones was hit by a car. With his leg in a cast, I saw him one early morning arguing with Kusama because she thought the frogs had no sense of rhythm as she was painting the dots. She took a small drum and beat out the timing saying "I want beat dot, beat dot, beat dot." Joe Jones screamed back, "My frog music is not polyphonic, your drum is." The day of the event it was pouring rain and full of heat and humidity, the Black Gate was packed with a standing room only audience. The place looked eerie with purple lights and it was full of undercover police as they thought it was going to be a sex show. Her performance was going to be preceded by a talk by Gordon Brown, Art Critic. . . . Finally, Gordon appeared, the show began, with all the noise, we never knew if the frogs croaked, Kusama painted the dots on the models and the police made no arrests.[42]

Sequences from this event would form large portions of the experimental film also titled *Kusama's Self-Obliteration,* filmed by Jud Yalkut and released later in 1967 (fig. 7). Often misconstrued as a straight documentary, the twenty-three-minute 16mm film incorporated footage of performances at Black Gate Theatre as well as Group 212 in Woodstock, New York, and other outdoor presentations of *Self-Obliteration* and is actually more akin to the experimental films of the period. It remains more formally and conceptually abstract than didactic, deploying dissolves, overexposures, fast- and slow-motion sequences, handheld camera motions, zooms, and wide-angle pans to reflect Kusama's concept of "self-obliteration" as an allegory for annihilation and dematerialization as intimated through her performances at the Black Gate Theatre.

In addition, in May 1971 Kusama participated in the media-art festival Eyeconosphear at the State University of New York at Buffalo, which drew an audience of "film and video artists, electronic musicians, and media experts from across the country to give workshops, raps, lectures and performances."[43] Part of the university's spring arts festival, this event was designed to have students "personally

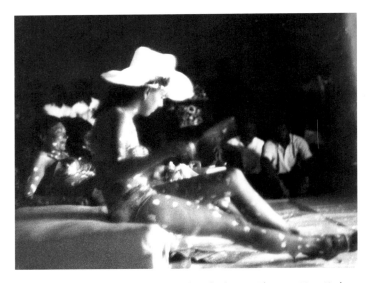

Fig. 5. *Kusama's Self-Obliteration* at the Black Gate Theatre, New York, June 1967. Photograph by Ted Wester. Aldo Tambellini Archive; courtesy Anna M. Salamone

participate in the creation of the latest electronic art forms which are transforming the contemporary consciousness."[44] The university's student-run paper, *The Spectrum,* heralded the event as in the typically aphoristic language of the period: "radical restructuring of information systems, integration of new images into everyday life, heightening awareness levels to explore and implode the mediaopolis. Eyeconosphear: expansion of conscious, sensory intensification, media realization."[45] The festival announcement was accompanied by the following graphic linguistic play on the title's meaning:

EYECONOSPHEAR
iconOSPHEAR
iconOSPhear
icon 0 sphere
EYE can HEAR[46]

The title alone conveys the multisensory mash-up that many of the participants attempted over the four days of the festival (May 3–9). Its hands-on approach and emphasis on workshops encapsulated the pedagogical models that organizer Gerald O'Grady advanced in establishing the legendary media-studies program at SUNY Buffalo (a program that helped pave the way for many future such academic departments as well as broaden the reception of media art in North America).[47] On Sunday, May 9, Kusama staged a live outdoor *Self-Obliteration* event at the neigh-

boring Buffalo State Teacher's College. This was another mixed-media affair; here, however, instead of live frogs, Kusama directed a live musical performance by the University of Buffalo Percussion Ensemble, whose earlier credits included playing at television studios and Carnegie Hall. She appeared with the musicians as they played and improvised while *Kusama's Self-Obliteration* was projected onto large screens temporarily erected for the event. The festival program employed the artist's characteristically esoteric language to describe her intentions: "Kusama asks you to become one with eternity by obliterating your personality and returning to the primordial state of union with the eternal forces of nature."[48]

Yalkut, Kusama's cameraman on the *Self-Obliteration* film, was not only a filmmaker and multimedia artist associated with Expanded Cinema, he was also one of the field's most ardent reporters, documenting and writing about the various festivals and events that dotted the experimental media landscape. Further, he was featured in Gene Youngblood's key volume, *Expanded Cinema*, which established the American interpretation of Expanded Cinema as "expanding consciousness." Published in 1970 with an introduction by R. Buckminster Fuller, *Expanded Cinema* propelled the previously unknown curator and critic to international attention and made him a requisite presence at such events as the festival in Buffalo, where he was the keynote speaker. Though Kusama was not cited by Youngblood (a symptomatic blind spot), her approach to media was very much in line with his interpretation. "Synesthetic and psychedelic mean approximately the same thing," wrote Youngblood, who added that "under the influence of mind-manifesting hallucinogens one

experiences synesthesia."[49] Like Kusama, Youngblood was focused on the ways abstract imagery facilitated what he labeled a "cosmic consciousness." However, his predisposition to draw formal connections between filmic and digital imagery tethers his notion of Expanded Cinema to a particularly Greenbergian concept of modernism (albeit with a countercultural bent) in which works are read as a negation of the pictorial in an effort to elevate or foreground the transcendent self.

Eyeconosphear also included contributions by the "alternative media think tank" Raindance Corporation, a collective of artists, scientists, writers, and media activists who named themselves in ironic homage to the RAND Corporation, the public-policy think tank formed to provide sociological and consumer research to the US military. According to O'Grady, members of the Raindance Corporation—including Skip Blumberg, Beryl Korot, Ira Schneider, and others—distributed Portapak videotape recording and playback equipment (released by Sony in 1967) to students. O'Grady noted that it was the first time the equipment was made available on the campus.[50] The act of distributing media technology and providing tutorials on how to document countercultural events and other forms of alternative programming exemplified the group's DIY ethos. Their operating philosophy and hands-on technical instructions were advanced through their many publications, especially the influential newsletter *Radical Software,* published between 1970 and 1974. Coedited by video artist Beryl Korot, whose multichannel videos often explore the affinities between weaving and computer programming, *Radical Software* functioned as a manifesto and "how-to" manual featuring descriptive essays on newly available recording and editing equipment with the idea that artists could not only outfit themselves with the necessary technical skills to become savvy media activists but also shape the emerging public discourse on media, television, and communications.

Another Eyeconosphear participant was VanDerBeek. His *Movie-Drome* (1963), a prototype for an "experience machine," and subsequent experiments in cultural "intercomming" shared many affinities with Kusama's interests in perceptual investigations within visual art to generate shared cultural experiences through multimedia environments—endeavors that, the artists posited, could potentially ameliorate Cold War tensions by enabling viewers to embrace racial, sexual, and cultural diversity. VanDerBeek,

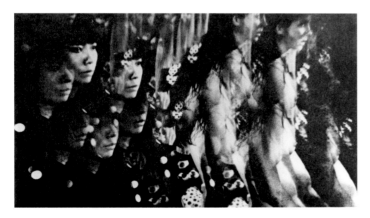

Fig. 6. Flyer for *Kusama's Self-Obliteration* at the Fillmore East, New York, December 6–7, 1968. Photographs by J. Good

Fig. 7. Stills from *Kusama's Self Obliteration*, filmed by Jud Yalkut, 1967

in fact, followed Kusama's *Self-Obliteration* event on May 9 at Eyeconosphear by asking participants to enter a darkened campus building to be subjected to one of his extended multiscreen, multimedia projections called *Media (W)rap Around Or A Man with No Close*. This featured news reports of civil rights protests alongside fashion advertising and images used in Western art history courses as well as VanDerBeek's own computer-generated films and handmade abstract 35mm slides. Like many of his works, the event included the artist reading excerpts from an article published in the March 1971 issue of *Filmmakers Newsletter* in which he opined on the potential for artists to use media technology to "understand the mind-body-brain by having it externalized in some way." VanDerBeek noted how this "social behavior" presented the contemporary artist with difficulties, which he described as the "moral struggle as well as the technical struggle, to try to understand both media and the messages at the same time."[51]

Like many early Expanded Cinema events occurring away from the cultural locus of New York City—and thus the documentary lens of Peter Moore—Eyeconosphear produced no iconic documentation and, thus, has fallen out of reference and potentially, like many lesser-studied events, out of art history. However, its lesson—creating a shared material,

historical, and political relationship among the audience is a paramount goal of art—remains. It also tempers an overemphasis on techniques of image projection and the profusion of screens that has dominated the discourse on more recent "immersive" installations within visual art.

Self-Contained Replication Chambers

After 2000 Kusama resumed creating environments that turn on the social dynamics of her mirror room experiments from the 1960s—self-contained replication chambers designed expressly for the transmission of images. These structures emphasize perceptual shifts that are not dictated by a cinematic *dispositif* but enacted through the architecture of built space. Frequently described as immersive environments implying a reliance on moving images, Kusama's subsequent Infinity Mirror Rooms were given titles that make cosmological allusions: *Soul under the Moon* (2002; pp. 86–87), *Infinity Mirrored Room—Aftermath of Obliteration of Eternity* (2009; pp. 102–03), *Infinity Mirrored Room—Filled with the Brilliance of Life* (2011; pp. 104–05). Individually, however, each work remains, in both pragmatic and conceptual terms, a visual loop, a self-referential

system. Exhibited together as a group or series of rooms, they create another type of *mise-en-abyme* in which there is a play of subtexts that literally mirror one another, reflecting the process of deconstruction itself, in which stable meanings give way to a continuous play of signifiers so that the works resist a singular reading. Distinct from absorption, the act of immersion is historically informed, and as Kusama's own installation history has demonstrated, viewing experiences depend as much on the configuration of the audience as on emergent technologies of projection or amplification.[52] Rather than repeating the tired pseudo-liberatory rhetoric of "activating the viewer," Kusama's spaces underscore the overriding theme of Expanded Cinema, and Eyeconosphear, in particular: the notion that communication itself remains visual art's most vital enterprise.

To this end, I argue that the Infinity Mirror Rooms operate less as metaphors for the mind or an internalization of mental processes than as conceptual folding operations—what film historian Giuliana Bruno has articulated as the pleats and folds that constitute the fabrics of the visual as a means to theorize the ways that images remain material even in our current virtual and digital world. Pointing to Bruno's invocation of tactile forms such as fabrics and their patterns of movement to explicate the ways that images operate is specifically germane to Kusama's practice, which has used textiles (canvas for paintings, wearable fashion designs, abstract fabric sculptures) to create surfaces for bodies as well as images. Bruno reminds us that "materiality is not a question of materials but rather concerns the substance of material relations," and those relations, she asserts, "manifest themselves on the surface of different media."[53] Extending this logic, Kusama's image structures enact the mediated transformations that Bruno argues are sited texturally on the surface of images in a manner that Gilles Deleuze called a "texturology." This is a philosophical and aesthetic conception in which art's "matter is clothed . . . signifying the texture of enveloping."[54] Kusama's rooms can be understood to enact Deleuze's notion of enveloping through texturology, the intertwining of matter through which impressions are conveyed to the senses so that a medium is a living environment of expression, transmission, and storage.[55] In this way, Kusama's Infinity Mirror Rooms operate more as experience machines that rely on subjective multisensory moments than as immersive cinematic spaces that remain purely visual.

Systems Thinking

A social phenomenon similar to that which occurred at The Broad repeated itself a few blocks away, at Hauser Wirth & Schimmel, where collectors and students alike filled the newly opened commercial gallery to see *Revolution in the Making: Abstract Sculpture by Women, 1947–2016*. The exhibition, curated by Paul Schimmel and art historian Jenni Sorkin, presented the work of women artists who challenged the modernist vocabulary of sculpture throughout the postwar period. Participants included Ruth Asawa, Lee Bontecou, Louise Bourgeois, Gego, Eva Hesse (Kusama's one-time neighbor in New York), and Sheila Hicks. The exhibition also featured one of Kusama's signature forms, *A Snake* (1974; pl. 38). "A stuffed fabric polyp, notoriously phallic," in the words of art historian Anne Wagner, who noted in the accompanying catalogue that the sinuous line of silver protrusions was produced in Japan by Kusama "in 1973 after sixteen years in the United States . . . as a gift to the sculptor Donald Judd, her long-time friend."[56] Wagner argued that *A Snake* can be viewed as "a reaction against the hard edges" of Judd's own signature forms.[57] Moreover, she asserted that the broader issue is not the fact that "women make specially muscular or mutable sculpture, but rather that their sustained engagement with a widening range of materials and processes has meant that sculpture can now enact, rather than depict, its *own* transformational capacities."[58]

A key curatorial imperative in *Revolution in the Making* was to recuperate craft and validate its techniques and the use of domestic materials within the established pantheon of high (read: male) modernist abstraction. Kusama's inclusion in the exhibition is fitting and also suggests the need to consider craft's disciplinary corollary, design. Specifically, the often-misunderstood theories of cybernetics (and second-order cybernetics that deal with self-organizing systems) provide a generative backdrop against which Kusama's lifelong examination of and experimentation with repetition, pattern, aggregation, and perceptual conditions (visual, physical, and sensory) can be reconsidered beyond the established narratives.[59] Mirroring Kusama's own timeline, a new type of thinking emerged in the decade before World War II, and its development accelerated thereafter in a complex intertwining of the military-industrial research culture and the American counterculture. As communications scholar Fred Turner has explained, "the same military industrial research world that brought forth

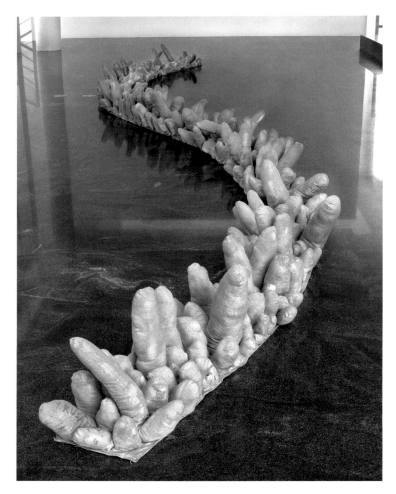

Plate 38. *A Snake*, 1974. Sewn and stuffed fabric with silver paint, 256 x 10 x 12 in. (650.2 x 25.4 x 30.5 cm). Kunstsammlung Nordrhein-Westfalen, Düsseldorf. Photograph by Michael Bodycomb, New York

nuclear weapons—and computers—also gave rise to a free-wheeling, interdisciplinary and highly entrepreneurial style of work" that embraced "a new cybernetic rhetoric of systems and information."[60] This resulted in collaborative projects that began "to imagine institutions as living organisms, social networks" and "the gathering and interpretation of information as keys to understanding not only the technical but also the natural and social worlds."[61] This type of systems thinking became closely associated with the new design discipline called cybernetics and in particular what Wiener famously outlined in his 1948 book as feedback—how messages (forms of patterns and organization) were "a means of controlling machinery and society with machines including, by analogy, at least, biological organisms."[62] Biological, mechanical, and information systems could, therefore, "be seen as analogues

of one another," managing "themselves by sending and receiving messages, and metaphorically, at least, all were simply patterns of ordered information in a world otherwise tending to entropy and noise."[63]

In addition to positing the ontological construction of the control management of "man-machine systems," cybernetics introduced new models of cognition. Sociologist Andrew Pickering demonstrated in his recent book, *The Cybernetic Brain,* that "the brain was not a thinking machine but an acting machine, an immediately embodied organ intrinsically tied into bodily performances" with direct connections to psychiatry.[64] Viewing cybernetics as the historical, cultural, and social backdrop against which Kusama's entire career can be read suggests altogether different ways of pathologizing not Kusama herself, but rather human behavior. More specifically, it shows how her works reflect our patterns of

interaction with one another and the machines and apps that we use so repeatedly and obsessively.

Finally, it is Kusama's indefatigable ability to oscillate between the depictive function and the durational experience of her spatialized forms (painted, sculpted, filmed, photographed, graphically rendered, and architecturally scaled) that may prove to have the most resounding effect on the recalibration of contemporary art history and digital culture writ large. The exponentially broadening reach and reception of Kusama's work outside the network of the contemporary art world confronts the current tendency to hold belatedly discovered or rediscovered aesthetic practices distinct from those that forge anti-aesthetic positions. In a sense, I would argue that Kusama's enduring influence resides not in her signature forms (sculptural and environmental) but rather in the recombinant nature of those very structures (economic and social) that short circuit the binary and perceived oppositions between internal and external, tangible and ephemeral, thereby challenging the parameters of subjectivity and identity that have problematically come to define globalization. Moreover, the fact that Kusama's signature historical sculptures and paintings and recent experiential works such as the Infinity Mirror Rooms have been the subject of intense international reexamination through scholarly and popular exhibitions and publications alike is a testament to what art historian Mignon Nixon identified as the "psycho-political geometry of the polka dot." Nixon observed that "where her art enlarges and proliferates, it also reduces," absorbing and concentrating external excess.[65] Ultimately, Kusama's works continue to both enact and depict the social dynamics that have come to condition not only our interactions with machines but also how we use machines to communicate with one another. Anticipating symptomatic behaviors —from the voyeurism of Kusama's Peep Show to the Droste effect of social media—Kusama's Infinity Mirror Rooms consistently show how material technology transforms our immaterial selves.

Notes

1 Udo Kultermann, "Miss Yayoi Kusama: Interview Prepared for WABC Radio by Gordon Brown, Executive Editor of *Art Voices*," in *De nieuwe stijl: Werk van de international avant-garde,* ed. Armando, 162–64 (Amsterdam: De Bezige Bij, 1965); extract reprinted in Laura Hoptman, Udo Kultermann, Yayoi Kusama, and Akira Tatehata, *Yayoi Kusama* (London: Phaidon, 2000), 109.

2 Jasia Reichardt, introduction to *Cybernetics, Art and Ideas*, ed. Jasia Reichardt (New York: Graphic Society Ltd., 1971), 11.

3 I want to thank Sarah Loyer, curatorial assistant at The Broad, Los Angeles, for her expertise and insights on the collection during my visit on March 30, 2016.

4 At the Hirshhorn *Infinity Mirrored Room—The Souls of Millions of Light Years Away* is installed with acrylic flooring in lieu of water.

5 This fact underscores how Kusama's influence extends beyond the field of contemporary art and has become an arbiter of popular culture, including the domains of design and music. The singer Adele recounted how seeing *Infinity Mirrored Room—The Souls of Millions of Light Years Away* on Katy Perry's Instagram inspired her to include a video of the work in a live performance of her 2016 hit single "When We Were Young" on the televised Brit Awards show. Adele went on to say that Kusama was one of her favorite artists, and the anecdote became a central feature of The Broad's own press and marketing materials. See the feature on the museum's YouTube channel: https://youtu.be/KbqRhXqkQ.

6 For the technical details and cultural history of rendering space in digital form, see Michael Nitsche, *Video Game Spaces: Image, Play, and Structure in 3D Worlds* (Cambridge, MA: MIT Press, 2008), especially "Cinema and Game Spaces," 79–85.

7 Art historian and critic Martha Buskirk points out how Kusama's *Narcissus Garden*, an installation of 1,500 mirrored balls at the 1966 Venice Biennale, challenged the distinctions between what Buskirk calls "refined art-world trade" and more overt commercial exchange when the artist "posted signs that offered the silver balls for sale" to protest the fact that her "work had not been embraced by the increasingly enthusiastic market for American pop art." Martha Buskirk, *Creative Enterprise: Contemporary Art between Museum and Marketplace* (London and New York: Continuum, 2012), 210–11. See also Marin Sullivan's close reading of the photographic documentation of the Venice installation, which she argues was about not the "commodity status of art outright, but its rarefied status within economic exchange." Marin R. Sullivan, "Reflective Acts and Mirrored Images: Yayoi Kusama's *Narcissus Garden*," *History of Photography* 39, no. 4 (2015): 416.

8 Reichardt, introduction to *Cybernetics, Art and Ideas,* 11. Reichardt edited the July 1968 issue of *Studio International* that served as the catalogue for the *Cybernetic Serendipity* exhibition. A second revised version was published in the journal's September 1968 issue.

9 Ibid., 11 and 14.

10 Pamela Lee, "'Ultramoderne': Or, How George Kubler Stole the Time in Sixties Art," *Grey Room,* no. 2 (Winter 2001): 58.

11 Ibid., 59.

12 Ibid., 60. Art historian Caroline Jones's work on the relationship between art and technology in the postwar period and contemporary installation art remains key here; see Caroline Jones, ed., *Sensorium: Embodied Experience, Technology, and Contemporary Art* (Cambridge, MA: MIT Press; MIT List Visual Arts Center, 2006).

13 For a more detailed examination of the connections among contemporary moving images, Expanded Cinema, and these post-Internet conditions, see Gloria Sutton, *The Experience Machine: Stan VanDerBeek's* Movie-Drome *and Expanded Cinema* (Cambridge, MA: MIT Press, 2015), 192.

14 This refers to the longstanding issue of delayed reception and the uneven critical attention afforded Kusama's work in New York during

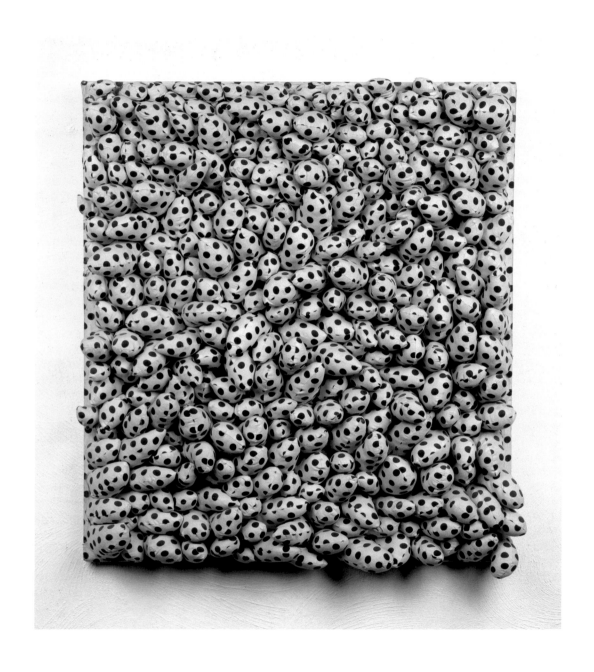

Plate 39. *Blue Spots*, 1965. Stuffed cotton, kapok, and wood, 32⅝ x 27½ x 5 in. (83 x 70 x 13 cm). Agnes and Frits Becht Collection, the Netherlands

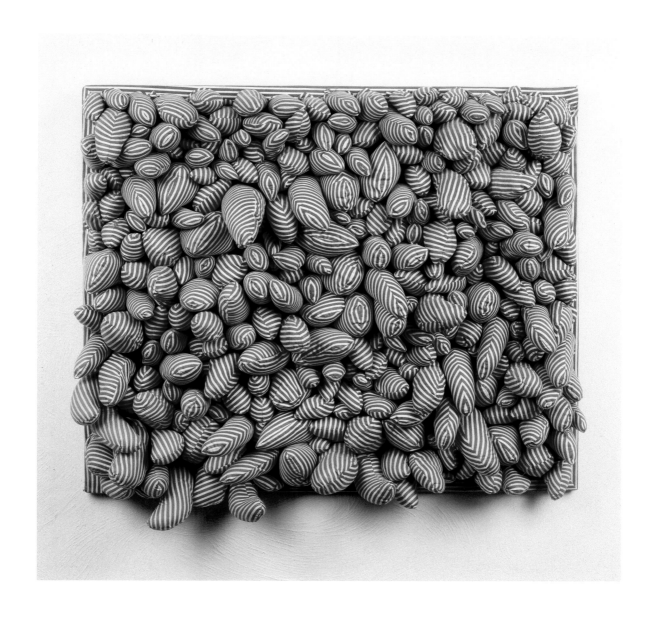

Plate 40. *Red Stripes*, 1965. Stuffed cotton, kapok, and wood, 27½ x
32⅝ x 7⅞ in. (70 x 83 x 20 cm). Agnes and Frits Becht Collection,
the Netherlands

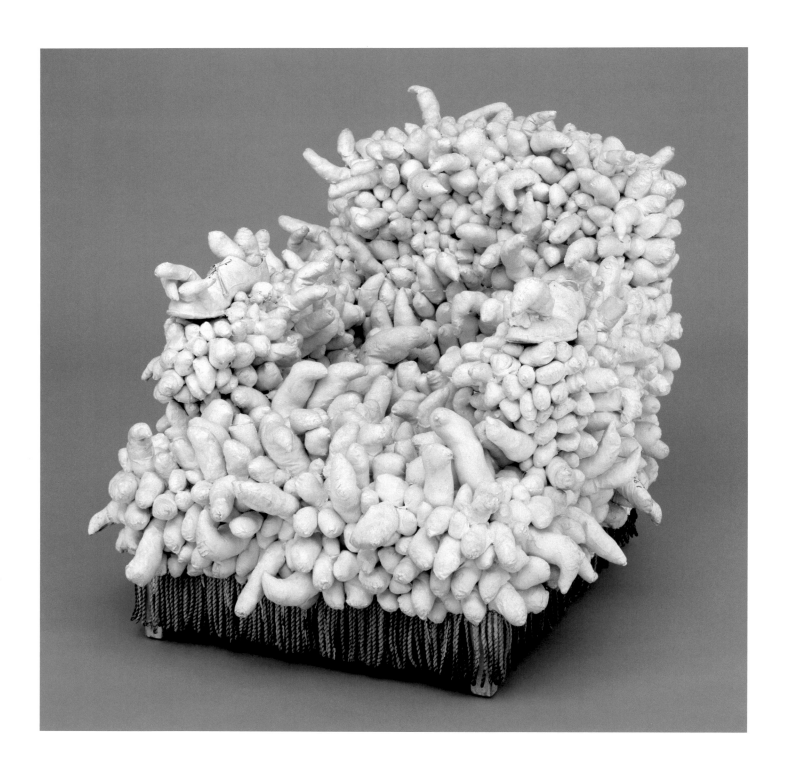

Plate 41. *Arm Chair*, 1963. Paint, chair, shoes, and sewn and
stuffed cloth pouches, 38 x 38 x 50 in. (96.52 x 96.52 x 127 cm).
Collection of the Akron Art Museum, Gift of Mr. Gordon Locksley
and Mr. George Shea

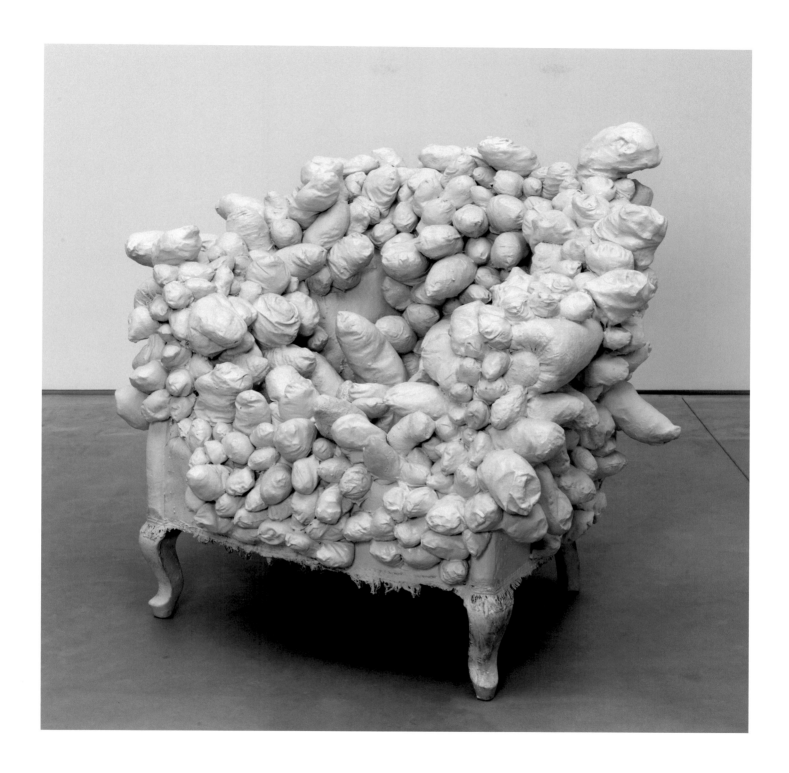

Plate 42. *Accumulation*, 1962–64. Sewn and stuffed fabric with paint on wood chair frame, 34½ x 38 x 33 in. (87.63 x 96.52 x 83.82 cm). The Rachofsky Collection and the Dallas Museum of Art through the DMA/amfAR Benefit Auction Fund

Plate 43. *Flowers—Overcoat*, 1964. Cloth overcoat, plastic flowers, metallic paint, and wood hanger, 50¾ x 28⅞ x 5¾ in. (128.9 x 73.3 x 14.6 cm). Hirshhorn Museum and Sculpture Garden, Washington, DC. Joseph H. Hirshhorn Bequest and Purchase Funds, 1998

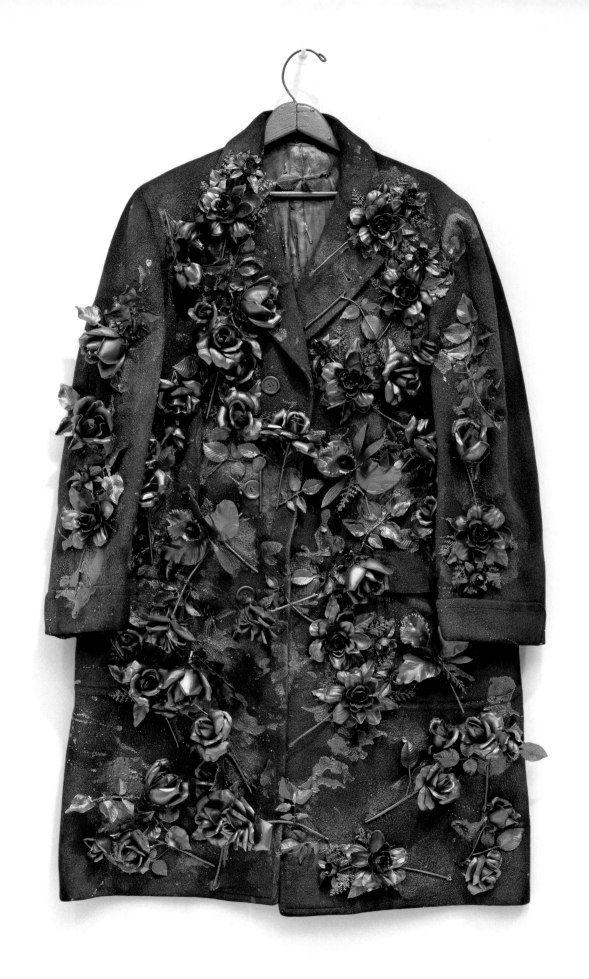

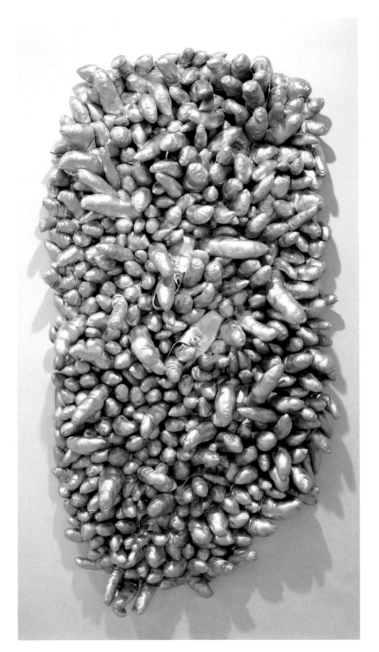
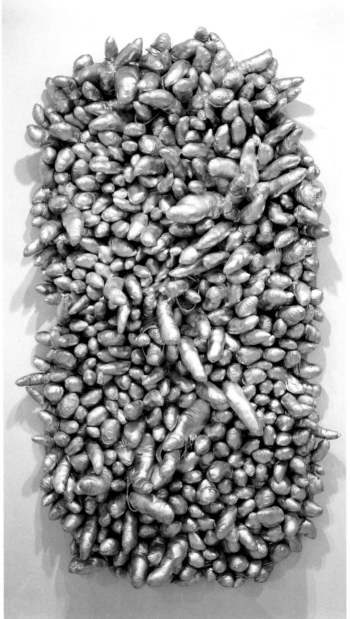

Plate 44. *Ennui*, 1976. Sewn and stuffed fabric with silver paint
and shoes. Two panels, each 72 x 38½ x 9 in. (183 x 98 x 23 cm).
Takahashi Collection, Tokyo

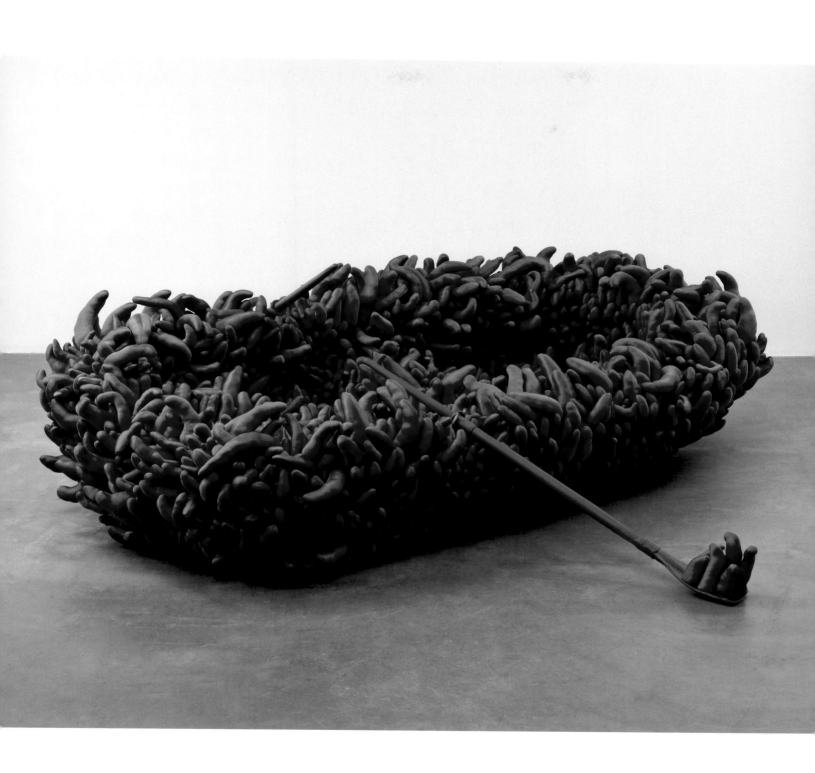

Plate 45. *Violet Obsession*, 1994. Stuffed cotton over rowboat and oars, 43¼ x 150⅜ x 70⅞ in. (109.8 x 381.9 x 180 cm). Museum of Modern Art, New York. Gift of Mr. and Mrs. Joseph Duke

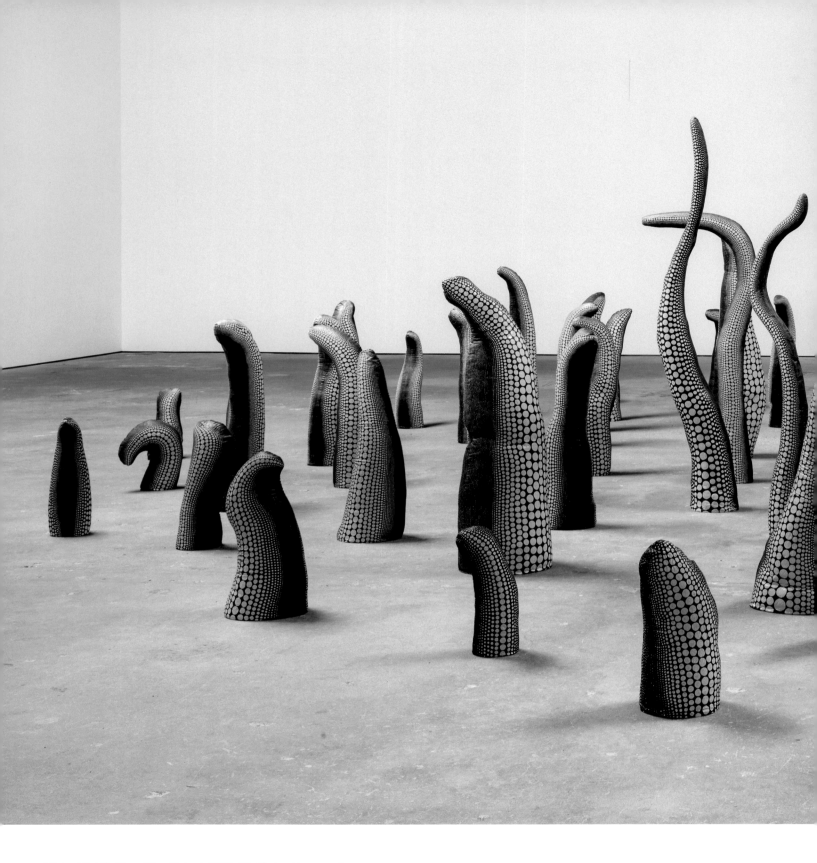

Plate 46. *Life (Repetitive Vision)*, 1998. Stuffed cotton, urethane, paint, and wood. Fifty-eight parts, dimensions variable. Courtesy of David Zwirner, New York; Ota Fine Arts, Tokyo/Singapore; Victoria Miro, London

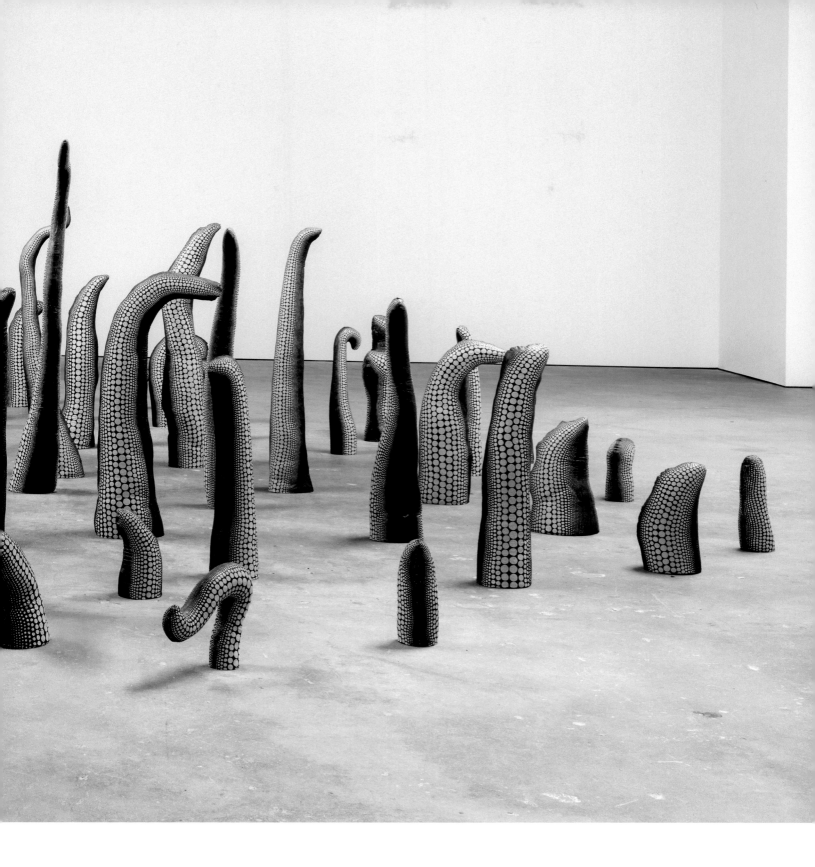

A Universe of Dots: An Interview with Yayoi Kusama

Melissa Chiu

Melissa Chiu: Kusama-san, let's talk about your current work. We're sitting here in your studio, surrounded by new paintings, and I think I have interrupted your daily routine of painting with this interview. So tell me about what is on your mind with these new works. We're surrounded by at least fifty large works on canvas.

Yayoi Kusama: I start to paint every day from 9 am in the morning until it gets dark. Sometimes I continue painting past lunchtime and forget how the time passes. I go back to my room at night to sleep, only to rest my body to create something the next day.

I started to make these new paintings at quite a large size. I am making them all this size now. When I start the paintings my mind is completely empty. I don't know what I will do or how the painting will turn out. Each is different. I don't think anything or prepare before I paint.

When I was young, maybe ten years old, I started to make art like this from my mind. It always seems fresh when I see it. When I finish the painting I have a great energy. I still want to find out new things through my work. It's a spiritual energy that I need. This is how I live—every day until my death I question myself. The process is important because it shows how I feel and think. I am always thinking about the cosmos when I start a painting. It allows for imagination. My inspiration is my view of life and philosophy. These change and develop every day. I keep making art.

MC: The cosmos also seems like an obvious reference to your Infinity Mirror Rooms. Was that a part of your thinking when you created them?

YK: Yes, they are linked. My paintings are all related to this, some of them are here [we look at photos in a binder of her recent paintings], such as Where the Lights Go, Let's Talk about Love, Footprints of the Universe, Flowers that Bloomed In Heaven (pl. 62), Where Love Accumulates, and Going Beyond the Days of Sorrow.

MC: Looking at the paintings and seeing these titles, it makes me think about the idea of impermanence, which seems to be one of the common threads running through your work since the 1950s, in all its different media. Can you talk about this?

Fig. 1. Yayoi Kusama with recent works in Tokyo, 2016. Photo by Tomoaki Makino. Courtesy of the artist © Yayoi Kusama

YK: I have written many poems on this subject, and I add this quality and philosophy to my paintings. I get energy from my works being seen around the world. I love to see my works being seen by young people. I introduce these philosophies into my paintings for the next generation.

MC: On other occasions you've spoken of hardship. It can't have been an easy decision to become an artist! What were some of the greatest challenges for you to overcome?

YK: Early in my life I remember the sacrifices during the war. This was the hardest time of my life. I don't want to ever see this happen again. People being killed and the sacrifices people made. After I die, I hope that people see that my paintings are about love and peace and spirituality. This is why I am painting. I keep on painting. Whenever I finish a painting, it is like the perfect thought and reflects my thinking. I don't ever want to stop painting. Painting and making poetry are everything for me. I am so happy to have chosen to be an artist, even though I had many difficulties.

MC: When did you choose to be an artist? There can't have been many role models?

YK: When I was eight or ten years old I began to paint every day. My parents were really against me doing paintings. I have always been interested in the things around me. That's when I started to paint. Art is like an endless ocean. I can feel a sense of infinity, the heaven and sky—all a sense of infinity that I can feel through the ocean.

MC: Representations of infinity are everywhere in your works—Infinity Net paintings and then Infinity Mirror Room installations. One of the original ideas for the exhibition at the Hirshhorn was to focus on the historical significance of the Infinity Mirror Rooms, and the starting point in some ways is *Infinity Mirror Room—Phalli's Field*, a work you created in 1965 at Castellane Gallery, New York (pp. 46–51). This was a work I focused on in my book *Asian Art Now* (2010) and was the genesis of this exhibition. In that book I argued that this work was a true precursor and you, a pioneer. It is multigenre, part-performance, part-sculpture, part-installation art that has a great deal of relevance for art practice today. What was the intention behind this work when you created it?

YK: *Infinity Mirror Room* is indeed a multigenre work, so your thought is to the point. Every time I make an infinity room, it is a new piece. It comes from my feelings. It's the same as my paintings as they have changed and evolved. They come from my heart or my feelings at that moment. For *Phalli's Field* I wanted to show that I am one of the elements—one of the dots among the millions of dots in the universe. In this work, by burying myself within the infinite polka dots, my mental power is strengthened as a polka dot. This was a challenge where my body becomes one with the polka dots that praise the world. An existence of each and every living thing in a vast developing universe possessing an infinity of dots.

Infinity is infinite energy encompassing the future. I have been fighting through art to weave a new world by using my own philosophy. Creation is a new ambition to develop my own philosophy further and further.

MC: *Infinity Mirror Room—Phalli's Field* was created when you lived in New York. This period in your career, from 1958 to 1973, is well documented, from your friendships with artists such as Joseph Cornell and Donald Judd to your performances and artworks. Looking back now, what are your memories of this time in your life? Why did you go to New York in the first place?

YK: The time I spent in New York was the starting point of the art that I had been thinking of since childhood. It was an important period when my imagination was allowed to be free. The art world in Japan was too narrow-minded, feudalistic, and it was hard to do what I wanted, so with a troubled mind I decided to go to New York. I was always interested in seeking out new ideas, the new avant-garde, and then new audiences. People started to follow me. I am sorry I cannot fully speak in English. Better to look at my paintings here. *[Kusama points to her paintings around the studio.]*

MC: It's good to hear words from you, too, since you are a poet.

YK: *[Kusama sings one of her poems, "Sadness Like That" (1983)]*

> so down am I
> that even autumn leaves in the Shinano sun
> are helpless to console me
> so long has my heart grieved
> thinking back it began at birth
> what was I in a previous life
> this morning dark-hearted I thought of hanging myself
> this evening of throwing myself on the railroad tracks
> I saw the tracks floating through the fields black in
> the dusk
> walking upon them, back and forth
> without love life is empty without hope
> tired of thinking of nothing but extinction
> I search for a place to die
> ah! so weary like a beggar
> I bend down to vomit beside the road
> hair white and thinning back hunched over
> silently watching the encroaching shadows of age
> come, Death, if you will let me embark for the cosmos

MC: That poem is very moving. There's an authenticity of experience to the expression. What were the circumstances in which you wrote this work?

YK: No particular experience, but, yes, based on a more general experience. I did have hardship in my life. It was very challenging for my family during the war. Even the atomic bomb has had an impact on my work. *[Kusama shows a picture of herself set against a recent painting that appeared in an April 2016 issue of* Time *magazine.]* This is a painting titled *Footprints of the Atomic Bomb,* which I painted this year. This is about many people's sacrifice. And I hope it will never be repeated. I am not only talking about the bomb but war and conflict in general.

MC: How do you think your work changed when you returned to Japan?

YK: After my return, I developed my works further by having the philosophies and thoughts that I had cultivated daily in America as a foundation. I felt like I had a lot more freedom.

MC: Your presence, standing or lying at the center of your works, was an important feature of the earlier Infinity

Mirror Rooms. This sense of performativity positions the mirror rooms as much as Happenings or performances as art objects and installations. *Kusama's Peep Show* (1966; pp. 52–57) has a self-consciousness about spectacle but also, perhaps more importantly, about the gaze. How much was feminism a part of your thinking at the time? Or was it more about the body—or the counterculture?

YK: I was thinking of art as a whole and not from a feminist viewpoint. America, too, had many conservative aspects, so I drove myself eagerly to make art, to set my heart ablaze, and to establish the world and society of freedom as a human being.

MC: At that time there were few women and fewer Asian women in the art world. Was it an important act to include yourself in photographs with your art?

YK: Throwing art, my body, and everything into the work and declaring that thought, or the desire to express and expand what I wanted, was more dominant; race or gender were secondary to these.

MC: Recently you created *All the Eternal Love I Have for the Pumpkins* (2016; pp. 112–15), and instead of your figure we have multiple pumpkins.

YK: I want to show the landscape, an accumulation of pumpkins, like creatures talking to you. This is the kind of environment I wanted to show. I like pumpkins, everyone loves pumpkins. They're a source of energy.

MC: There have been a number of retrospective exhibitions of your work in the past few years. In 2014 *The Art Newspaper* said that two million museum visitors had seen your work in touring exhibitions around the world, making you the most "popular" artist of the year. What do you think your legacy will be?

YK: My art will continue to fight. I am focused on creation with all my energy. My works talk to people all over the world, and it has been received with much interest. Many visitors came to my exhibition in Latin America. It is my real hope. I want to bring joy and happiness through art. I have no regrets to have spent all my life making art.

This interview was conducted on June 30, 2016, in Tokyo.

Plate 47. *I Love Myself, I Adore Myself So*, 2010. Acrylic on canvas, 76⅜ x 76⅜ in. (194 x 194 cm). Collection of the artist

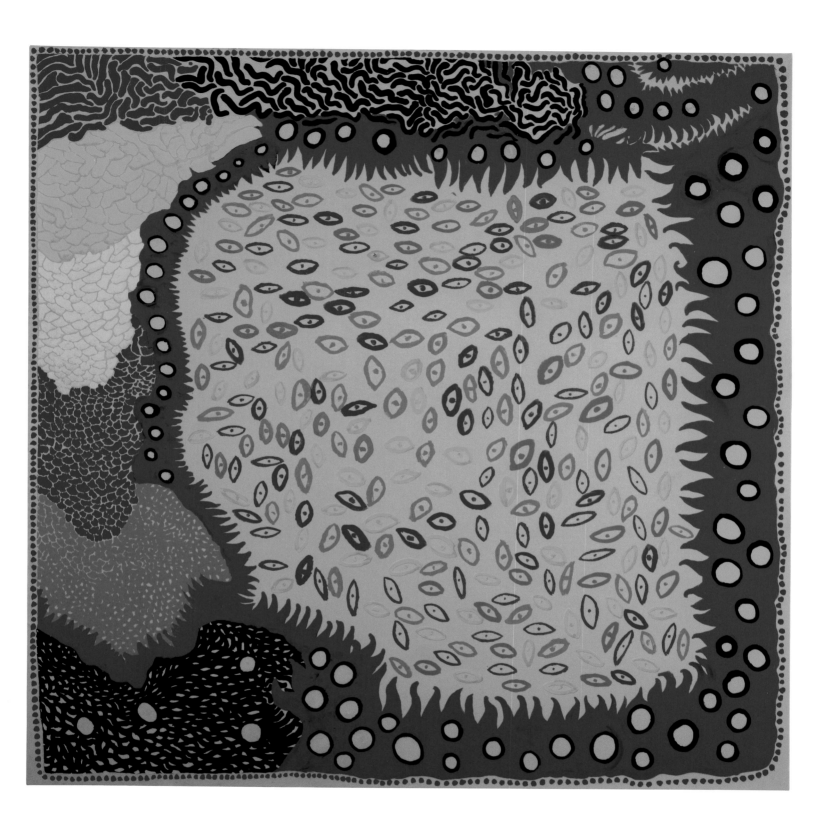

Plate 48. *Memory of Love*, 2013. Acrylic on canvas,
76⅜ x 76⅜ in. (194 x 194 cm). Collection of the artist

Plate 49. *Story after Death*, 2014. Acrylic on canvas,
76⅜ x 76⅜ in. (194 x 194 cm). Collection of the artist

Plate 50. *I Who Have Taken an Anti-Depressant*, 2014. Acrylic on canvas, 76⅜ x 76⅜ in. (194 x 194 cm). Private collection

Plate 51. *Aggregation of Spirits*, 2016. Acrylic on canvas,
76⅜ x 76⅜ in. (194 x 194 cm). Collection of the artist

Plate 52. *Living on the Yellow Land*, 2015. Acrylic on canvas,
76⅜ x 76⅜ in. (194 x 194 cm). Collection of the artist

Plate 53. *Pleasure to Be Born,* 2016. Acrylic on canvas, 76⅜ x 76⅜ in.
(194 x 194 cm). Collection of the artist

Plate 54. *Searching for Love*, 2013. Acrylic on canvas, 76⅜ x 76⅜ in.
(194 x 194 cm). Miyoung Lee and Neil Simpkins

Plate 55. *Whispering of the Heart*, 2015. Acrylic on canvas,
76⅜ x 76⅜ in. (194 x 194 cm). Collection of the artist

Plate 56. *The Wind Blows*, 2016. Acrylic on canvas, 76⅜ x 76⅜ in.
(194 x 194 cm). Collection of the artist

Plate 57. *Flowers that Bloomed Today,* 2012. Acrylic on canvas,
76⅜ x 76⅜ in. (194 x 194 cm). Collection of the artist

Plate 58. *Far End of Disappointment*, 2015. Acrylic on canvas,
76⅜ x 76⅜ in. (194 x 194 cm). Collection of Mr. Guoqing Chen

Plate 59. *My Heart Soaring in the Sunset*, 2013. Acrylic on canvas,
76⅜ x 76⅜ in. (194 x 194 cm). Courtesy of David Zwirner, New York;
Ota Fine Arts, Tokyo/Singapore; Victoria Miro, London

Plate 60. *My Heart's Abode*, 2016. Acrylic on canvas, 76⅜ x 76⅜ x 2¾ in. (194 x 194 x 7 cm). Courtesy Yayoi Kusama Inc.; Ota Fine Arts, Tokyo/ Singapore; David Zwirner, New York; and Victoria Miro, London

Plate 61. *All about My Heart*, 2015. Acrylic on canvas, 76⅜ x 76⅜ in.
(194 x 194 cm). Collection of the artist

Plate 62. *Flowers that Bloomed in Heaven,* 2015. Acrylic on canvas,
76⅜ x 76⅜ in. (194 x 194 cm). Collection of the artist

Plate 63. *Ends of the Universe, Abode of Love,* 2012. Acrylic on
canvas, 63¾ x 63¾ in. (162 x 162 cm). Mr. and Mrs. Charles Diker

Plate 64. *Unfolding Buds*, 2015. Stuffed cotton, metal, and acrylic paint, 59 x 23⅝ x 25⅝ in. (150 x 60 x 65 cm). Collection of the artist

OVERLEAF
Paintings, from left: *Pleasure to Be Born*, 2016; *Story after Death*, 2014; and *Adoration of Life*, 2016. Collection of the artist. Sculptures, from left: *Unfolding Buds*, 2015; *Welcoming the Joyful Season*, 2014; *When the Flower of My Heart Blooms*, 2015; *A Tower of Love Reaches Heaven*, 2014; *With All My Flowering Heart*, 2014; *All about My Flowering Heart*, 2015; *My Adolescence in Bloom*, 2014. Collection of the artist

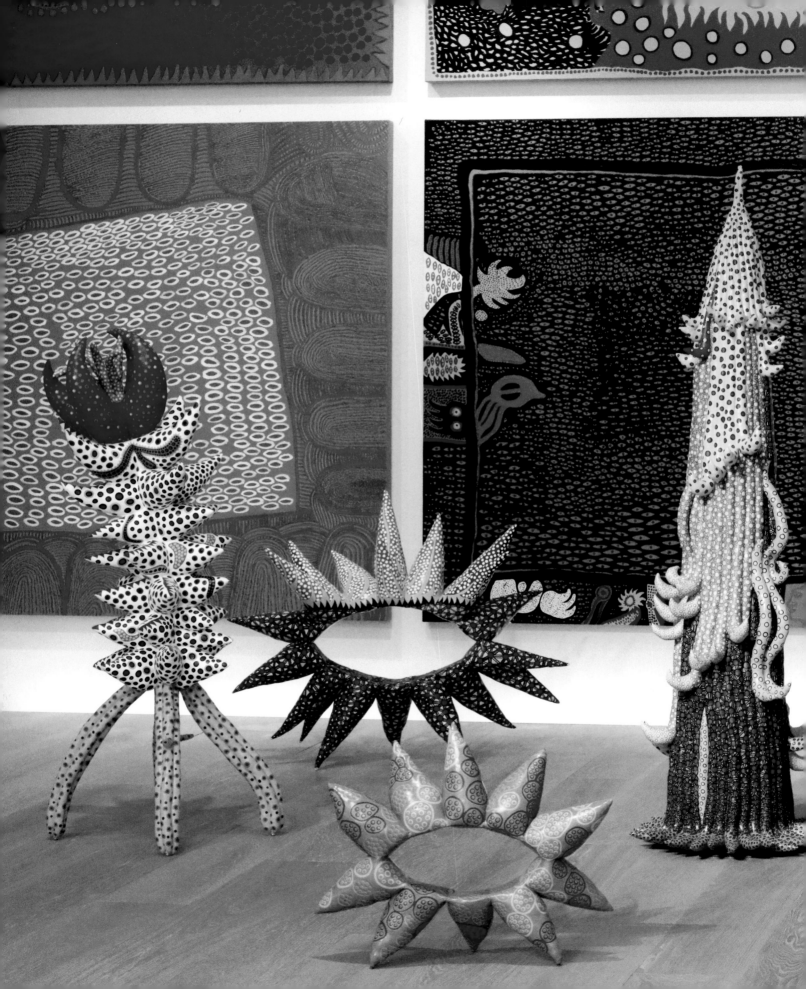

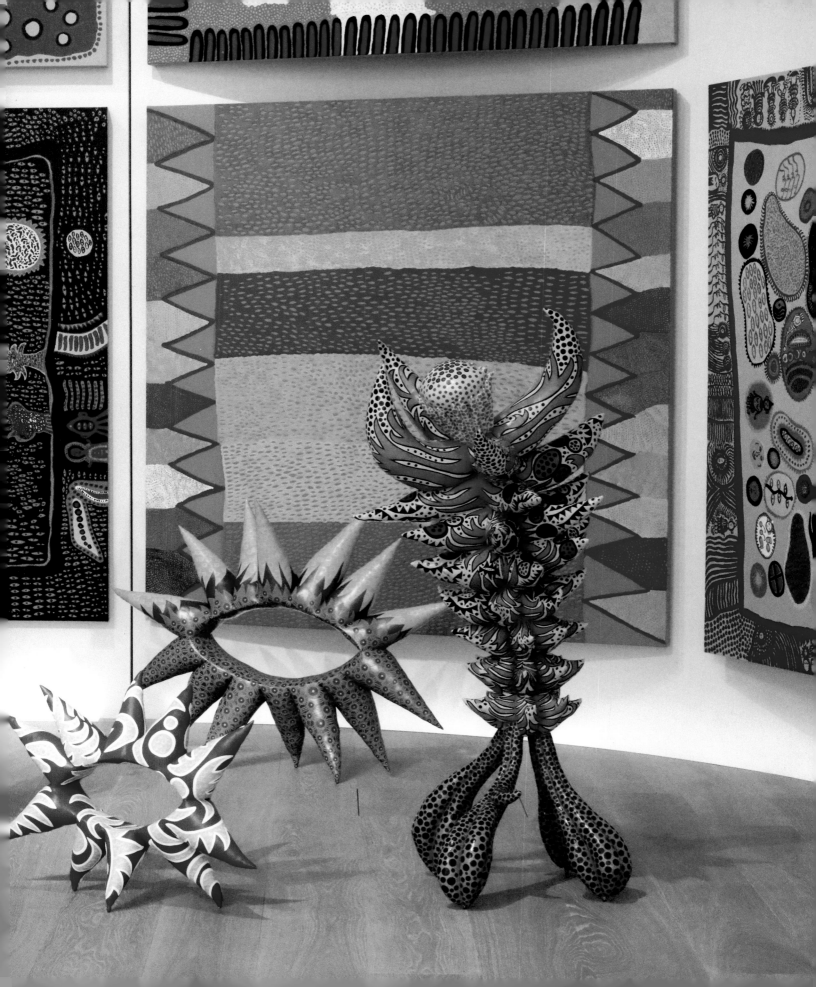

Chronology

Compiled by Miwako Tezuka

1929

March 22: Yayoi Kusama is born in Matsumoto, a city in the Nagano prefecture in Japan (fig. 1).

1935

Kusama begins to experience visual and auditory hallucinations:

> One day suddenly my voice
> became the voice of a violet
> Stilling my heart Stopping my breath
> You're for real, aren't you?
> All you little things who
> happened today
>
> The violets on the tablecloth break free
> and crawl over my body
> One by one they stick to me
> Sumire flowers, violets
> have come to steal my love
>
> The danger is growing, isn't it?
> Just standing there inside the fragrance
> Look—even on the ceiling and pillars[1]

Unable to comprehend or speak about such illusions (now understood as symptoms of neurosis), Kusama begins drawing pictures of these sensations and experiences. Kusama's mother does not understand her need to draw and paint, and she forbids the child from practicing art. Her anger frequently descends into physical abuse targeted at Kusama, who is the only member of the family to shun filial duties and social conformity.

1937

Japan invades China.

1938

The National General Mobilization Law stipulates that when a national emergency is declared the Japanese government can issue any orders necessary "to control material and human resources."

1941

Kusama enters Matsumoto First Girls' High School.

An amendment to the National General Mobilization Law gives the government authority over virtually every aspect of Japanese society in order to win the war.

Fig. 1. The Kusama family, c. 1940–41; Yayoi Kusama is the second from the right

Fig. 2. *Harvest,* 1945. Ink and mineral pigments on silk, 23 x 28½ in. (58.5 x 72.5 cm). Matsumoto City Museum of Art

December 7: Japan attacks Pearl Harbor; the United States declares war on Japan the following day and enters World War II.

1942

Kakei (Teruo) Hibino, a practitioner of *Nihonga,* or Japanese-style painting, arrives at Kusama's school, replacing his predecessor, who specialized in *yōga,* Western-style painting. Kusama, now thirteen, frequents Hibino's studio to watch him paint; by 1943 she is taking private lessons from him.

1944

In July, together with her classmates, Kusama is mobilized to sew parachutes in a military factory. US air raids intensify in November and target such plants. Kusama later recalls: "American B29's flying in broad daylight. The air raid alert went off every day, so that I could barely feel my life." The disruption of her education and the psychological strain caused by the war cast a shadow over Kusama: "My adolescence was spent in the closed darkness; especially because of the war, many dreams I had rarely, if at all, saw the light of the day."[2]

RIGHT
Fig. 3. *Loquat Leaves,* 1948. Graphite on paper, 21⅛ x 15⅜ in. (53.7 x 39.2 cm). Collection of the artist

1945

Conditions in the textile factory and malnutrition take a toll on Kusama's health. She is released from duty in the winter and spends hours drawing flowers and fruits.

August 15: Following the dropping of atomic bombs on Hiroshima and Nagasaki, Japan surrenders to the Allies, and World War II ends.

November: Kusama's *Nihonga* painting *Harvest* (fig. 2) is shown in the *All Shinshū Art Exhibition*, a group show in Nagano City (November 16–18) that travels to Ueda (November 21–23), Matsumoto (November 27–29), and Iida (December 3–5).

1948

Kusama enters Kyoto Municipal Hiyoshigaoka Upper Secondary School, which will prepare her to enter the Kyoto City University of Arts. She soon finds herself at odds with the school's conservatism and technical focus as well as the patriarchal hierarchy of the field of *Nihonga.* As a result, she works mostly in isolation (figs. 3–4).

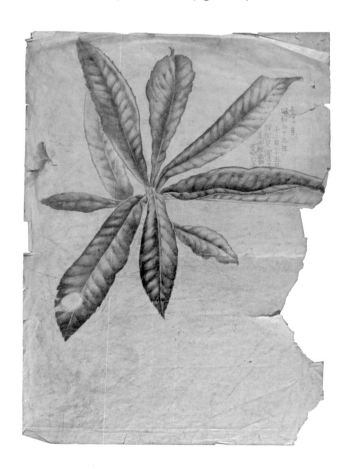

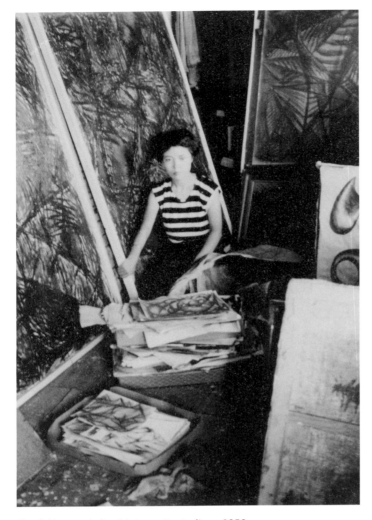

Fig. 4. Kusama in her Matsumoto studio, c. 1950

1949
Kusama graduates from the *Nihonga* program at the Kyoto Municipal Hiyoshigaoka Upper Secondary School and returns to Matsumoto. There she paints a major *Nihonga* work, *Lingering Dream,* that is accepted in a juried exhibition in Tokyo (September 21–October 8), which is sponsored by an artists' association called Creative Arts and challenges the traditional strictures of *Nihonga*. The show travels to Nagoya (October 15–21), Osaka (November 1–6), and Kyoto (November 8–13).

1952
March 18–19: Kusama mounts her first solo exhibition—featuring more than 200 works, including oil paintings, *kōsai* (watercolor using deer-glue binder), and drawings—at the Matsumoto City Community Center.

October: A second solo show at the Matsumoto City Community Center (October 31–November 2) features 270 new works by Kusama. Although the exhibition brochure mentions works in oil, photographic documentation of 106 pieces in the exhibition reveal no such paintings. The exhibition most likely consists solely of watercolors executed at a uniform size of approximately 10⅝ x 7½ inches (27 x 19 cm) and hung at regular intervals—an early demonstration of Kusama's refined sense of space.

Poet and critic Shūzō Takiguchi contributes a text to the exhibition brochure, saying that Kusama "unswervingly exposes her life's energy in her tableaux without following any traditions of *Nihonga* or any stylistic conventions of modern art."[3]

One of the visitors to the show is Shihō Nishimaru, a psychiatrist from Shinshū University in Matsumoto. On first seeing her work, he determines that Kusama suffers from cenesthopathy, a syndrome in which patients experience strange bodily sensations that are medically unexplainable.

December 13: Nishimaru presents a paper on Kusama and her art at the annual conference of the Kantō Psychiatric and Neurotic Association at the University of Tokyo. The paper, "Genius Woman Artist with Schizophrenic Tendency," suggests she experiences periods of intense creativity—resulting in numerous paintings—alternating with bouts of unproductivity. Nishimaru's presentation captures the attention of a critic from the important art journal *Mizue* and the psychiatrist Ryūzaburō Shikiba, which leads to opportunities for Kusama to exhibit in Tokyo.

1953
September: Kusama receives a scholarship from the Japanese Ministry of Culture and Education to study at the Académie de la Grande Chaumière in Paris. However, she turns it down when the opportunity for a solo exhibition in Tokyo arises.

1954
Kusama has her first solo exhibition in Tokyo, at the Shirokiya Gallery (February 27–March 3), which is housed in a department store in Nihonbashi, then one of the most prominent art districts in the city. The exhibition—which has been arranged with the help of Ryūzaburō Shikiba—

Fig. 5. May 1954 cover of *Mizue*, featuring Kusama's *Flower Bud No. 6*, 1952

features seventy-two paintings, including *Flower Bud No. 6* (1952), which graces the cover of the May issue of *Mizue* (fig. 5).

1955

January: Kusama's solo exhibition of forty-five works at Takemiya Gallery, Tokyo (January 21–31), is curated by Shūzō Takiguchi, who has introduced many new talents at the gallery (including On Kawara, with whom Kusama will share a studio in New York from 1965 to 1967).

June: On the recommendation of Takiguchi, Kusama is one of twenty-five artists featured in the Japanese section of the biennial *International Watercolor Exhibition* at the Brooklyn Museum (June 4–13). This exposure results in the purchase of two works by Kusama from the exhibition by Western collectors.

November: Kusama sends nine of her paintings to Seattle-based painter Kenneth Callahan. She also visits the American Embassy in Tokyo and obtains the mailing address of painter Georgia O'Keeffe. Kusama writes on November 15, saying that she had seen O'Keeffe's *The Black Iris (II)* (1926) in the collection of art collector and Tokyo resident John C. Denman, who was chief pilot of Northwest Airlines. Kusama sends O'Keeffe thirteen watercolors and asks for

advice on how to make a life as an artist in the United States. To her surprise, O'Keeffe responds with generous, if cautionary, guidance about the US art world.

1956

O'Keeffe contacts the Betty Parsons Gallery, New York, about arranging a show for Kusama but is unable to arrive at an agreement with the gallery.

1957

Kusama obtains a US visa and prepares for her move by burning nearly 1,000 of her artworks. Her departure from Matsumoto Station in November is marked by a gathering of locals, including the city's mayor, and a speech from her father (fig. 6).

Kusama arrives in Seattle on November 19 and immediately starts working. Within weeks her first US solo exhibition, featuring some sixty watercolors, opens at the Zoë Dusanne Gallery, Seattle (December 8–28; figs. 7–8). Although she quickly makes her mark in the Seattle art scene, Kusama is set on New York as her ultimate destination and aspires to become part of that city's burgeoning avant-garde art scene. Recalling her resolve at the time, she later says:

Fig. 6. Kusama's airline ticket to Seattle, 1957

Fig. 7. Kusama with Zoë Dusanne at her solo exhibition at the Dusanne Gallery, Seattle, December 1957

1959

The first of Kusama's large white Net paintings are shown in a group exhibition at Nova Gallery, Boston (June 3–30); in a solo show at Brata Gallery, New York (October 9–29); and in a solo show, *Recent Paintings by Yayoi Kusama,* again at Nova Gallery (November 23–December 12). The Brata exhibition catches the attention of many art critics, including Donald Judd, who reviews it in the October issue of *Art News* and commends Kusama as "an original painter." Other major reviews appear in the *New York Times* (by Dore Ashton), *Arts* magazine (by Sidney Tillim, who compares Kusama's work to Jackson Pollock's *Shimmering Substance,* 1946), and *Art in America* (by Lucy Lippard).

1960

March: Kusama's work is included (with abstract paintings by Mark Rothko) in *Monochrome Malerei* (Monochrome Painting), an exhibition at the Städtisches Museum Leverkusen, Schloss Morsbroich, in Leverkusen, West Germany (March 18–May 8). The show also presents work by such artists as Lucio Fontana, Yves Klein, Piero Manzoni, Heinz Mack, Günther Uecker, and Henk Peeters who are affiliated with the art movement Zero. Like the other artists

If I wanted to develop and widen that path [to art], staying in Japan was out of the question. My parents, the house, the land, the shackles, the conventions, the prejudice. . . . For art like mine—art that does battle at the boundary between life and death, questioning what we are and what it means to live and die—this country was too small, too servile, too feudalistic, and too scornful of women. My art needed a more unlimited freedom, and a wider world.[4]

1958

Kusama arrives in New York in June and rents a room in an apartment on the Upper West Side of Manhattan. By the end of the year she has moved to a spacious Greenwich Village loft at 70 East Twelfth Street. Soon tiring of the predominance of action painting, Kusama begins to create her monochromatic Net paintings (later known as Infinity Net paintings). Many of the canvases in this series are enormous, filling the walls of her apartment from floor to ceiling (fig. 9).

Fig. 8. Article on Kusama in *The Mainichi,* November 12, 1957

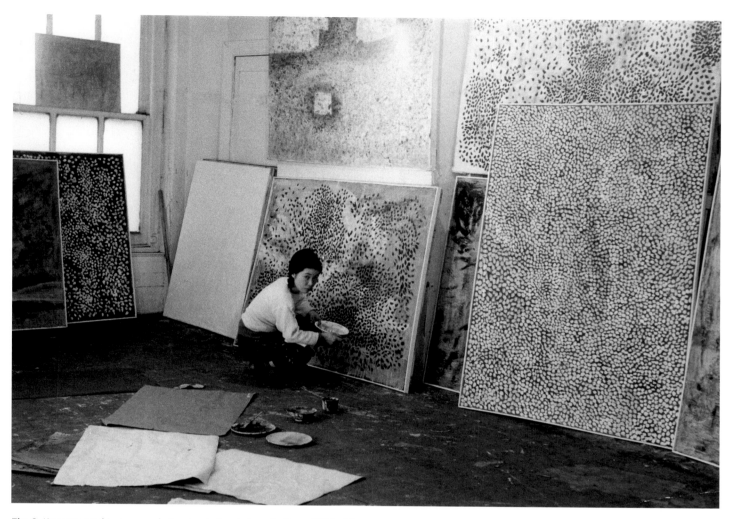

Fig. 9. Kusama working on an abstract painting in her studio, c. 1958–59

in the show, Kusama reacts against the dominance of Abstract Expressionism—in her case, by ridding paintings of the lyricism evident in her previously exhibited works and concentrating on the monotonous, repetitive, and "boring" method of her Net paintings (fig. 10).[5]

April: Kusama's solo exhibition at Gres Gallery in Washington, DC (April 19–May 14), includes colored Net paintings and is reviewed in the *Washington Post*. An exhibition of water-colors follows at the gallery in December of 1961 (fig. 11).

May: Kusama signs a contract—her first—with Stephen Radich Gallery, New York.

1961

A solo exhibition of large-scale Net paintings, *Recent Paintings: Yayoi Kusama,* opens at Stephen Radich Gallery (May 2–27; fig. 12) and receives several reviews, including one by Stuart Preston of the *New York Times*. The largest canvas in the show is thirty-three feet wide (9.75 m) and covers an entire gallery wall. News of this exhibition reaches Henk Peeters, who in June writes the gallery inquiring about Kusama. This correspondence launches a long-lasting friendship between the two artists that increases exposure of Kusama's work in Europe. At this time, she is also gaining attention in Brazil (fig. 13).

Fig. 10. Kusama in her loft c. 1961

Kusama begins to create soft sculptures from fabric tubes that appear eerily phallic. These works—at first white and later painted in various colors or made from dotted or striped cloth—become the sculptural series known as Accumulations. Kusama later says these cylindrical forms were an expression of her fear of sex: "By continuously reproducing the forms of things that terrify me, I am able to suppress the fear . . . and lie down among them. That turns the frightening thing into something funny, something amusing."[6] She also says these works are the result of her incessantly painting nets and dots on canvases as well as on every surface in her studio, including walls and furniture—an overflow of her two-dimensional obsessions into real space.[7]

Kusama's Net painting *No. P.3.B.* is included in *Annual Exhibition 1961: Contemporary American Painting* at the Whitney Museum of American Art, New York (December 13, 1961–February 4, 1962).

GRES GALLERY 1729 TWENTIETH STREET WASHINGTON 9 D. C.
YAYOI KUSAMA WATERCOLORS
WATERCOLORS YAYOI KUSAMA
YAYOI KUSAMA WATERCOLORS
WATERCOLORS YAYOI KUSAMA
YAYOI KUSAMA WATERCOLORS
WATERCOLORS YAYOI KUSAMA
YAYOI KUSAMA WATERCOLORS
WATERCOLORS YAYOI KUSAMA
YAYOI KUSAMA WATERCOLORS
WATERCOLORS YAYOI KUSAMA
NOV. 21 - DEC. 23, 1961, HOURS 11 - 6, TUES. - SAT. DU 7-1047

Fig. 11. Announcement card for *Yayoi Kusama: Watercolors*, Gres Gallery, Washington, DC, 1961

Fig. 12. Poster for *Recent Paintings: Yayoi Kusama*, Stephen Radich Gallery, New York, 1961. Beatrice Perry Papers

Fig. 13. Louis Wiznitzer, "Young Japanese Painter Conquers Manhattan," *Revista do Globo* (Brazil), June 1961. Beatrice Perry Papers

1962

March: Henk Peeters curates a group exhibition entitled *Tentoonstelling Nul* (Nul Exhibition) at the Stedelijk Museum, Amsterdam (March 9–25). Kusama, the only artist from the United States, is represented by two works from 1961: *No. P.3.B.*, a red and black painting, and the monumental *White X.X.A.*, which at more than eight feet tall and almost twenty feet long (approximately 2.44 x 6.1 m), is two feet larger than Jackson Pollock's largest poured painting.[8]

June: Kusama's soft sculptures *Accumulation No. 1* and *Accumulation No. 2* (both 1962) are presented in a group exhibition at Green Gallery, New York. It also features works by newly emerging Pop artists such as Claes Oldenburg, James Rosenquist, and Andy Warhol (see Dumbadze, fig. 3).

November: Kusama shifts her focus to sculptural works that increasingly address themes of phallophobia. In order to overcome her fear, she obsessively covers furniture with phallic protuberances.

1963

May: Kusama becomes a permanent resident of the United States when she receives her Green Card.

October: Kusama participates in *No Show* at Gertrude Stein Gallery, New York (October 8–November 2; fig. 14), a group exhibition featuring artists—such as Stanley Fisher, Sam Goodman, Allan Kaprow, and Boris Lurie—who are not following the trend of Pop art.

December: Gertrude Stein Gallery, New York, presents Kusama's *Aggregation: One Thousand Boats Show* (December 17, 1963–January 11, 1964; fig. 15). The exhibition marks the first presentation of an immersive installation by Kusama. At the center of the gallery is an actual rowboat and a pair of oars that are covered by white fabric tubes and high-heeled shoes. Covering the walls of the gallery are hundreds of posters featuring the same black-and-white photographic image of the phallusized boat. Exhibition space and artwork blend together with no definable beginning or end. According to Stein, the idea for an environmental installation had been percolating in Kusama's mind since she moved to New York.[9]

Fig. 14. Poster for *No Show*, featuring Allan Kaprow, Yayoi Kusama, Stanley Fisher, and others, Gertrude Stein Gallery, New York, 1963

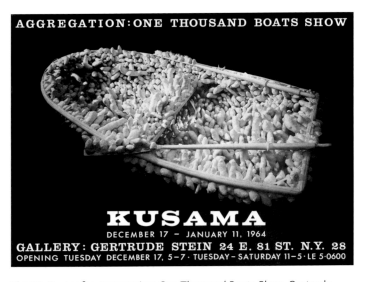

Fig. 15. Poster for *Aggregation: One Thousand Boats Show*, Gertrude Stein Gallery, New York, 1963

1964

Castellane Gallery, New York, presents *Driving Image Show* (April 21–May 9; fig. 16), a solo exhibition highlighting the diversity of Kusama's work. It features Net paintings, Accumulation sculptures, and an installation using mass-produced items such as dry pasta and mannequins. Kusama covers the floor of the gallery with pieces of loose macaroni that create a sharp snapping sound when visitors walk on them while viewing the exhibition (fig. 17).

1965

Kusama begins to incorporate mirrors into her three-dimensional works.

March: Kusama moves into a studio space that she shares with On Kawara at 404 East Fourteenth Street.

April: Kusama participates in the *Nul 1965* exhibition at the Stedelijk Museum, Amsterdam (April 15–June 8). It gathers the artists affiliated with the German Zero and the Dutch Nul groups as well as a number of artists from Japan's Gutai Art Association, such as Jirō Yoshihara, Akira Kaneyama, Shōzō Shimamoto, Atsuko Tanaka, Saburō Murakami, Sadamasa Motonaga, and Tsuruko Yamazaki.

November: *Floor Show* at Castellane Gallery introduces the first of Kusama's mirror rooms, *Infinity Mirror Room— Phalli's Field* (pp. 46–51). In the installation, phallic soft sculptures with red-on-white polka-dot patterns densely populate the floor of the gallery, and mirrors erase the

Fig. 17. A photo-collage by Kusama from 1966 showing the artist in her studio with sculptures, 1964

boundaries between the reverberating images and tangible space. The work's endless reflections simulate the artist's hallucinatory episodes that result from her use of anti-depressants and make spectators part of her art and her world.

December: Kusama is included in *Inner and Outer Space,* an international survey exhibition of modern art at the Moderna Museet, Stockholm, curated by Pontus Hultén (December 26, 1965–February 13, 1966). Thematically focused on monochromatic expressions, the exhibition presents works by such European artists as Kazimir Malevich, Naum Gabo, and Yves Klein along with American artists Barnett Newman, Mark Rothko, Kenneth Noland, Donald Judd, and Robert Rauschenberg.

1966

Kusama's recent engagement with spatial installations that include aspects of audience participation such as *Driving Image Show* and *Phalli's Field* gradually leads her to consider taking her art into the public sphere. She also begins to incorporate electric lights into her three-dimensional works.

January: *Driving Image Show,* which originated at Castellane Gallery in 1964, travels to Naviglio Gallery, Milan (January 26–February 9), and M. E. Thelen Gallery, Essen, West Germany (May 2–27). Logistical complications and delays require Kusama herself to ship thirty works from New York

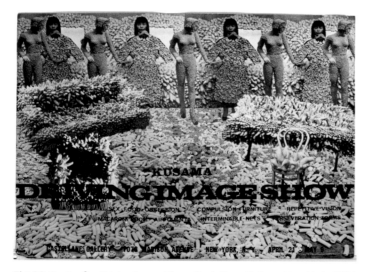

Fig. 16. Poster for *Driving Image Show,* Castellane Gallery, New York, 1964

to Milan and to fabricate eight more objects in the Milan studio of Lucio Fontana.

March: Castellane Gallery presents Kusama's first psychedelic artwork, *Kusama's Peep Show* (March 16–April 22; pp. 52–57). This consists of a hexagonal box lined with mirrors and lit by multicolored electric lights that rapidly flash in seventeen different patterns. Viewers look into the box through two small windows. For the duration of this exhibition, pop music is played alongside the kinetic work to induce synesthetic effects. A circular pin with the words "Love Forever" is given to each visitor. Kusama later explains the meaning of this phrase: "This was the materialization of a state of rapture I myself had experienced, in which my spirit was whisked away to wander the border between life and death."[10]

June: Kusama presents the outdoor installation *Narcissus Garden,* consisting of 1,500 plastic mirror balls, outside the Italian Pavilion at the Venice Biennale. When Kusama begins selling the balls to visitors for two dollars apiece as a critique of the commodification of art, she upsets the authorities and is swiftly stopped.[11]

Summer: Kusama stages *14th Street Happening* (pl. 24), in which the artist moves one of the phallus-covered floor panels from *Phalli's Field* into the street and then lies on top of it as passersby gaze down on her. The event is documented in twenty-nine color slides by the Japanese photographer Eikoh Hosoe, who often photographed Kusama in her studio (fig. 18).

1967

Kusama's work takes an increasingly psychedelic turn, reflecting the rise of the New Left and hippie culture in the United States and beyond. Her participatory works evolve into orgiastic events staged in her studio and elsewhere. Often involving gay and lesbian participants, Kusama supports homosexual rights with these events. She also collaborates with psychedelic light artists to create interactive events at nightclubs and theaters and stages politically charged street performances set against the backdrop of the US involvement in Vietnam.

On three consecutive nights in June, Kusama produces the audio-visual-light performance *Kusama's Self-Obliteration*

Fig. 18. Kusama in her studio, c. 1966. Photograph by Eikoh Hosoe

at the Black Gate Theatre, New York. This event involves painting polka dots on the bodies of participants in the Happening. She later says: "Polka dots can't stay alone, like the communicative life of people, two and three and more polka dots became movement. . . . When we obliterate nature and our bodies with polka dots, we become part of the unity of our environment. I become part of the eternal, and we obliterate ourselves in Love."[12]

In July, Kusama begins appearing in parks and hip hangouts as a would-be agent for social change. Audiences become participants in her work by painting polka dots on each other's bodies using Day-Glo colors. The themes of the infinite expansion of art into life and a suspended sense of self continue in a series of Happenings that Kusama calls Body Festivals staged over the next two years at various locations, including New York's Washington Square Park and Tompkins Square Park.

Several Happenings featuring Kusama are documented in the film *Kusama's Self-Obliteration*, produced and directed by the artist and shot by the experimental media artist Jud Yalkut. It is screened at various venues in New York over the following year and wins prizes in 1968 at the Fourth International Experimental Film Competition at Knokke-le-Zoute, Belgium; the Ann Arbor Film Festival; and the Second Maryland Film Festival.

1968

Once public nudity is permitted in art in New York (beginning in January 1968) Kusama stages a new series of Happenings called *Anatomic Explosions* (see Dumbadze, fig. 6; pls. 25–27) in which she directs a handful of professional dancers—men and women—covered with painted polka dots during guerrilla-style performances in locations of political significance. Kusama generally remains clothed for these performances, while other participants are fully nude and scatter when police approach. The first of these Happenings occurs on July 14 on Wall Street, in front of a statue of George Washington and across the street from the New York Stock Exchange. The series continues on July 17 at the Statue of Liberty; on September 8 at the United Nations; on October 13 at Trinity Church (where Kusama is arrested); and on November 3—just two days before the US presidential election—at the New York City Board of Elections. The last in the series takes place after the election, on November 11 on Reade Street and lower Broadway in Manhattan. Kusama, together with three men and a woman, distribute copies of an open letter to president-elect Richard Nixon that contains the message: "Anatomic explosions are better than atomic explosions."[13]

Kusama promotes her activities beyond the field of fine art—in areas such as fashion, publishing, film, and theater—through the Associated Press and other media companies. She hires a public relations firm, controls and documents her media appearances, and becomes an iconic counterculture presence in New York and beyond. She is dubbed the "priestess of polka dots" and a "hippie queen" in the Western media, and her activities are increasingly covered in the Japanese media—which focuses almost entirely on the scandalous elements of sex and nudity in her work and pays little attention to its artistic merits. Kusama's family considers these reports shameful and terminates its financial support of the artist (fig. 19).

Kusama later says of her Happenings, "My idea was to bring out the unknown parts in people by reflecting the mirror of time with my mirror."[14]

1969

Kusama continues to stage Happenings of an increasingly political nature.

On April 6, Kusama and Louis Abolafia, the Love Party's candidate for mayor of New York, kicked off his campaign with an "Easter Sunday 'Bust-Out'" at the Sheep Meadow in Central Park.

On August 24, Kusama and eight naked men and women mount *Grand Orgy to Awaken the Dead at MoMA* in the Museum of Modern Art's sculpture garden. The models pose as if they are sculptures coming to life, and Kusama calls for a rebellion against authoritarian arts institutions that determine the value and hierarchy of art. In a press release, Kusama proudly proclaims: "RENOIR, MAILLOL, GIACOMETTI, PICASSO. I positively guarantee that these characters will all be present and that all will be nude." The following day, the *New York Daily News* features a photograph from the Happening on the front page with the headline "But Is It Art?" (fig. 20).

Fig. 19. Kusama on the cover of *New York Scenes,* "The New Nudity," February 1969

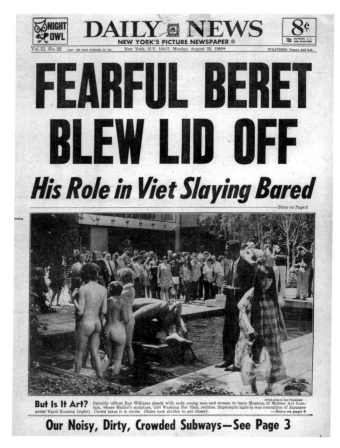

Fig. 20. Front page of the *New York Daily News,* August 25, 1969, featuring coverage of Kusama's *Grand Orgy to Awaken the Dead* at the Museum of Modern Art

1970

Kusama returns to Japan for the first time since moving to the United States in 1957, staying from March until mid-April. The purpose of the visit is to stage orgiastic Happenings at Expo '70 in Osaka and thereby bring the sexual revolution to Japan. Kusama is arrested at the first event, staged on March 13 in central Tokyo, a development that only enhances her reputation as the scandalous "international queen of the Happening."[15] She attempts other semi- and fully clothed Happenings while in Japan but faces obstruction from the authorities (fig. 23).

After returning to New York, Kusama continues her series of Happenings (figs. 21–22). Yet, increasingly weary of the demands of staging these events and the attendant publicity, she begins to curtail her public appearances in the United States while continuing to participate in exhibitions in Europe (fig. 24).

1971

November: *Kusama's Self-Obliteration* (1967), described as the "Psychology of an Orgasm," is screened at the First Annual New York Erotic Film Festival.

1972

Kusama is mostly absent from the New York art scene. Her interest in writing and literary projects emerges around this time, and she drafts the semiautobiographical "Love Story of Tokyo Lee," which is not published but contains many ideas that appear in her later novels.

1973

Kusama returns to Japan after sixteen years in the United States. She initially plans a brief visit, but when her health declines, she decides to remain in Japan.

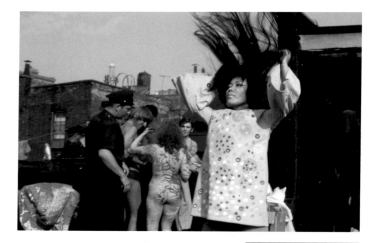

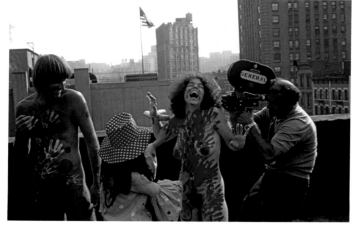

Figs. 21–22. Kusama's avant-garde fashion and body-painting show (New York Rooftop Performance), 1970. Photographs by Ushio Shinohara

Fig. 23. Kusama leading participants in a Happening wearing a five-person orgy dress, Akasaka, Tokyo, 1970

Fig. 24. Kusama in her New York apartment, 1971. Photograph by Tom Haar

She begins creating a series of intimately poetic collages using elements her friend Joseph Cornell had given her in New York; indeed, with their complex mix of fragmentary images, organic and inorganic, these works are reminiscent of Cornell's art. During this period Kusama also creates works in ceramic and gouache as well as drawings.

1975
February: Kusama is hospitalized in Tokyo.

November: Kusama publishes "Odyssey of My Struggling Soul" in the magazine *Geijutsu Seikatsu*. The essay examines her psychosis and becomes a standard source for the artist's biography.

December: Kusama's first solo exhibition since returning to Japan, *Message of Death from Hades* at Nishimura Gallery, Tokyo (December 1–13), features thirty-five collages created since 1973. While a few Japanese newspapers and magazines mention the show, and the exhibition makes a lasting impression on Akira Tatehata, the editor of Shinchō-sha Publishing, Kusama is largely neglected by Japanese art critics during the 1970s.[16]

1976
Renowned art critic Shin'ichi Segi curates the solo exhibition *Yayoi Kusama: Obsessional Art, A Requiem for Death and Life* at Osaka Forms Gallery, Tokyo (August 9–19; fig. 25). The exhibition presents the artist's recent collages and soft sculptures.

Fig. 25. Kusama with Shūzō Takiguchi at *Yayoi Kusama: Obsessional Art, A Requiem for Death and Life,* Osaka Forms Gallery, Tokyo, 1976

1977

Kusama voluntarily admits herself to a hospital in March. She sets up studios in and near the hospital and begins writing poems and stories. An opportunity to publish arises when she meets an editor who is captivated by her recollections of New York. In just three weeks, Kusama completes the manuscript for her first novel, *Manhattan Suicide Addict,* a fictionalized account of her life as an artist in the 1960s; it is published in 1978 (fig. 26).

1978

Kusama's work is included in *Shapes of Chair: From Design to Art* at the National Museum of Art, Osaka (August 19–October 15, 1978), and she has several solo exhibitions in Matsumoto.

1979

Accumulation No. 2 (1962) and *Compulsion Furniture* (1966) are included in *Weich und Plastisch: Soft Art* at Kunsthaus Zürich (November 16, 1979–February 4, 1980).

1980

Kusama's activities increase significantly this year, highlighted by five solo exhibitions.

May: The Tokyo American Center hosts a solo exhibition featuring works by Kusama that have never been shown before (May 27–June 5). *Kusama's Self-Obliteration* (1967) is screened on the opening day of the show.

July: A solo exhibition opens at Gallery Tōshin, Tokyo (July 1–15). Architect Tadashi Yokoyama provides a keen analysis of Kusama's oeuvre in his review: "Her obliteration always carries some lightness and cheerfulness that lead us to salvation. [Her art] is something that could be extremely confusing but never fails to transform itself into always vivid imagery."[17]

Fig. 26. Cover of *Manhattan Suicide Addict,* 1978

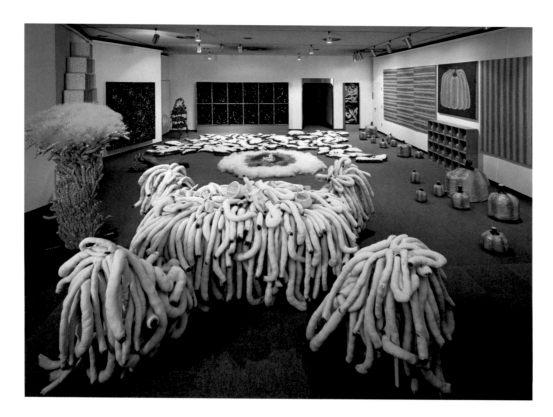

Fig. 27. *Obsession* exhibition, Fuji Television Gallery, Tokyo, 1984. Photograph by Shigeo Anzai

August: The Tōkyū department store in Nagano presents 200 works by Kusama in the exhibition *Yayoi Kusama's Return from the Light and the Shadow of a Swamp.*

1981

Five of Kusama's large works created between 1958 and 1981 are included in *The 1960s: A Decade of Change in Contemporary Art,* a major exhibition at the National Museum of Modern Art, Tokyo. This exhibition helps lay the groundwork for Kusama's reemergence as an important Japanese—and international—artist.

1982

A substantial selection of works from the artist's New York period are featured at Fuji Television Gallery, Tokyo (March 16–April 10)—the first in a series of Kusama exhibitions mounted by the gallery (other shows follow in 1984, 1986, 1988, 1991, and 1994) (fig. 27). Poet Kazuko Shiraishi praises her Accumulation sculptures and Net paintings: "These images of proliferation are at once fearful and pleasurable; they act, converse, and become messages; we realize that she is playing comfortably in them. . . . Such a recognition of Kusama in Japan comes far too late."[18]

1983

Kusama's second novel, *The Hustler's Grotto of Christopher Street,* receives the Literary Award for New Writers from *Yasei Jidai* magazine. This story detailing the complex relationship among three characters—the female owner of a male prostitution club, a young black prostitute, and his white male client—shocks readers and reveals Kusama's intimate knowledge of the underbelly of New York.

December: Kusama's mother dies.

1984

Kusama is featured in major exhibitions in Japan and abroad: *Collectie Becht* (The Becht Collection) at the Stedelijk Museum, Amsterdam (March 16–May 6); *Two Decades of Contemporary Painting: 1960–80* at the Museum of Modern Art, Gunma, Japan (April); *Blam! The Explosion of Pop, Minimalism, and Performance, 1958–1964* at the Whitney Museum of American Art, New York (September 20–December 2); and *40 Years of Japanese Contemporary Art* at the Tokyo Metropolitan Art Museum (October 12, 1984–December 8, 1985).

1985–87

Kusama presents *Flowers of Basara* (fig. 28) on the grounds of Tokyo's Jōshin-ji Temple on April 9, 1985. Under full cherry blossoms, the artist, dressed in red and wearing a black hat, binds together trees, the ground, and the space between with white and red plastic tape.

Kusama remains a presence in international survey exhibitions that feature work from her New York period, often in relation to Minimalism and Pop art: *Japanese Contemporary Paintings* at the National Gallery of Modern Art, New Delhi (October 1985); *Reconstructions: Avant-Garde Art in Japan, 1945–1965* at the Museum of Modern Art, Oxford (December 8, 1985–February 9, 1986); and *Japon des Avant-Garde, 1910–1970* at the Musée national d'art moderne, Centre Georges Pompidou, Paris (December 11, 1986–March 2, 1987).

A selection of Kusama's works from the 1980s—strongly rhythmic paintings and organic and lyrical soft sculptures—are featured in the solo exhibition *Yayoi Kusama* at the Musée des Beaux-Arts de Calais (December 13, 1986–

January 31, 1987) and the Musée Municipal in Dole, France (March 21–May 31, 1987).

The Kitakyūshū Municipal Museum of Art organizes the first major Japanese retrospective of Kusama's art (March 3–29, 1987). Seventy-nine works introduce audiences to the full range of her oeuvre, from her pre–New York period (including works from her adolescence) to the present. The exhibition also includes two works that, with their focus on proliferation and repetition, are evidently based on *Phalli's Field. Mirrored Room—Love-Forever No. 2* and *No. 3* (both 1965–c. 1981; pp. 60–63) each consist of a mirrored base on which is set a cube covered with silver phallic protrusions. Viewers can peek inside the cube through small openings, just as in *Kusama's Peep Show* (1966).

1988

Focusing on the themes of accumulation, obsession, and repetition, Kusama establishes a pattern of presenting new work in a major solo show every few years from this point on.

Fig. 28. *Flowers of Basara* Happening, Jōshin-ji Temple, Tokyo, April 1985

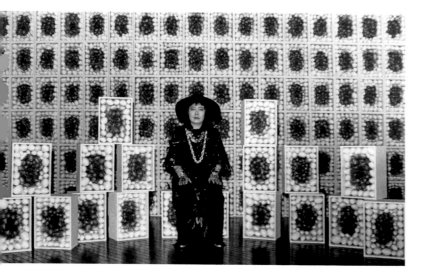

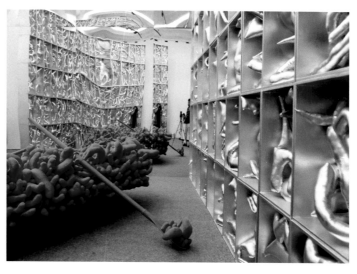

Fig. 29. Kusama with *Stamens in the Sun* at Center for International Contemporary Arts, New York, 1989

Fig. 30. *Genesis,* 1992–93, and *Pink Boat,* 1992, installed at the Japanese Pavilion, Venice Biennale, 1993

1989

September: A significant reevaluation of Kusama's art takes place with *Yayoi Kusama: Retrospective* at the Center for International Contemporary Arts, New York (September 27, 1989–January 31, 1990; fig. 29). The exhibition, curated by Alexandra Munroe, reintroduces Kusama as an important artist within the context of postwar American art and examines her role as a female artist who challenged the patriarchal society of Japan.

November: The Museum of Modern Art, Oxford, presents *In Context: Yayoi Kusama, Soul-Burning Flashes* (November 5, 1989–January 7, 1990), which continues the international reassessment of her work.

1992

The retrospective exhibition *Bursting Galaxies* opens at the Sōgetsu Art Museum (September 21–October 31) and travels to Niigata City Art Museum (November 7–December 13).

1993

Akira Tatehata, commissioner of the Japanese Pavilion at the Venice Biennale, selects Kusama to represent the country, the first time a single artist has been chosen. The pavilion features an entryway displaying Accumulation works (fig. 30) that leads to a room-size installation, *Mirror Room (Pumpkin)* (1991; figs. 31–32; pp. 64–67). The space is completely covered with black-on-yellow polka dots and

features a large mirrored cube at its center; peeking through a small opening, visitors see that the interior of the cube is lined with mirrors that reflect infinitely expanding images of yellow pumpkin sculptures with black polka dots that are set on the floor of the cube. Her official participation in the Biennale solidifies Kusama's acclaim and accelerates her emergence on the international museum circuit.

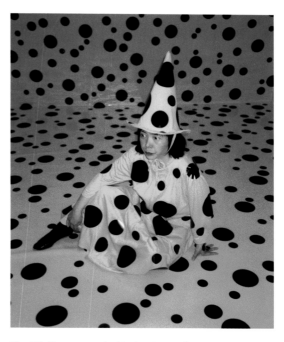

Fig. 31. Kusama at the Venice Biennale, 1993

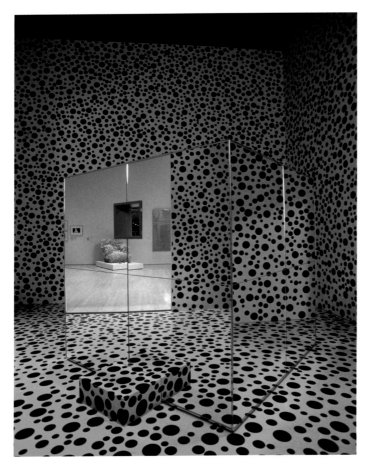

Fig. 32. *Mirror Room (Pumpkin)*, 1991, and (in reflection) *Accumulation No. 1*, 1962, at *Japanese Art after 1945: Scream Against the Sky*, San Francisco Museum of Modern Art, 1995

1994

With opportunities for exhibitions increasing, Kusama resumes production of ambitious large-scale installations using her now-signature motifs of polka dots, pumpkins, and mirrors.

September: Kusama's first permanent outdoor installation, *Pumpkin* (fig. 33), is unveiled at the *Out of Bounds* exhibition at Benesse Art Site, Naoshima (September 15–November 27).

1996

Two major New York venues, Paula Cooper Gallery (May 3–June 21) and Robert Miller Gallery (September 17–October 19), present solo exhibitions of Kusama's art. Both shows receive critical praise and awards from the International Association of Art Critics–United States—

recognitions that acknowledge Kusama's significant contributions to postwar American art.

1997

Kusama begins to use inflated balloons covered with polka dots in her Dots Obsession series of installations.

February: The cover of *Artforum* features Kusama's *Repetitive Vision* (1996; pp. 74–75) as installed at the Mattress Factory, Pittsburgh.

Ennui (1976; pl. 44) is included in the group show *De-Genderism: Détruire dit-elle/il*, an exhibition curated by Yuko Hasegawa at the Setagaya Art Museum (fig. 34).

1998

March: *Love Forever: Yayoi Kusama 1958–1968* opens at the Los Angeles County Museum of Art (March 8–June 8). The exhibition focuses on her years in New York and acknowledges her significance as an artist during the transition from Abstract Expressionism to Minimalism. Curator Lynn Zelevansky notes Kusama's influence on contemporary American artists, particularly Los Angeles–based artists such as Mike Kelley, while New York artist Jon Waldo considers Kusama "a unique bridge between outsider art and fine art."[19] The exhibition travels to the Museum of Modern Art, New York (July 9–September 22), and the Walker Art Center, Minneapolis (December 13, 1988–March 7, 1999); an expanded version travels to the Museum

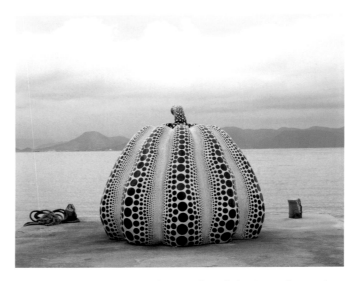

Fig. 33. *Pumpkin,* 1994. Fiberglass reinforced plastic, urethane paint, and metal. Benesse Art Site, Naoshima

Fig. 34. *Ennui*, 1976, at *De-Genderism*, Setagaya Art Museum, 1997

of Contemporary Art, Tokyo (April 29–July 4, 1999), marking a hometown triumph for the artist.

June: Robert Miller Gallery presents the solo exhibition *Yayoi Kusama: Now* (June 11–August 7).

2000

May: *Infinity Mirror Room—Phalli's Field* (1965) is reproduced at the Biennale of Sydney (May 26–July 30).

November: *Infinity Mirror Room—Fireflies on the Water* (pp. 80–83), which utilizes 150 evanescently flickering lights over a water-filled floor and is based on the artist's childhood memory of fireflies hovering over a river in Matsumoto, debuts in the traveling exhibition *Yayoi Kusama*. The show, focusing on her large-scale installations, opens at Le Consortium in Dijon, France (November 4, 2000–January 20, 2001), and travels to Maison de la culture du Japon, Paris (February 12–May 19, 2001); Kusthallen Brandts Klædefabrik, Odense, Denmark (June 16–September 2, 2001); Les Abattoirs, Toulouse (October 5, 2001–January 6, 2002); Kunsthalle Wien, Vienna (February 8–April 28, 2002); Artsonje Center, Seoul (February 15–May 11, 2003); and Artsonje Museum, Gyeongju, South Korea (July 4–September 28, 2003).

2001

Yokohama 2001: International Triennial of Contemporary Art (September 2–November 11), Japan's first large-scale

international triennial, presents Kusama among more than 100 artists from around the world. She is represented by two installations: *Endless Narcissus Show* (pp. 84–85) is a large mirror-lined room with 1,500 metallic mirror balls hanging from the ceiling and resting on the floor, while *Narcissus Sea* consists of 2,000 mirror balls floating in the Yokohama Canal.

2002

April: To mark its grand opening, the Matsumoto City Museum of Art mounts a major retrospective of Kusama's art featuring more than 280 works (April 11–May 4).

July: The Osaka art-and-design collective graf organizes *YAYOI KUSAMA furniture by graf* (July 6–August 4), an exhibition focusing on furniture designed by Kusama and fabricated by graf.

September: Kusama presents *The Obliteration Room* (pl. 65) at the Asia Pacific Triennial of Contemporary Art, Queensland, Australia (September 12, 2002–January 27, 2003). Visitors can place colorful dot stickers anywhere they like in an all-white furnished space.

2004

An increasing number of international exhibitions keep Kusama busy with frequent overseas travel. When she is in Japan, she concentrates on making art, spending many solitary hours in her studio.

February: *Kusamatrix* opens at the Mori Art Museum, Tokyo (February 7–May 9) and travels to the Museum of Contemporary Art, Sapporo (June 5–August 22). It features several environmental installations using Kusama's signature motifs and materials: polka dots, balloons, and mirrors. A new site-specific mixed-media installation, *Hi, Konnichiwa!*, with its larger-than-life sculptures of female figures, highlights the artist's playfulness. At the time of this exhibition, Kusama joyously proclaims the return of youth in a poem:

> Do you know that outrageous news
> that youth is coming to you all?
> Youth, carrying with it both death and life,
> creeps up on you soundlessly from behind.
> I forsake my previous, dark life, regenerate

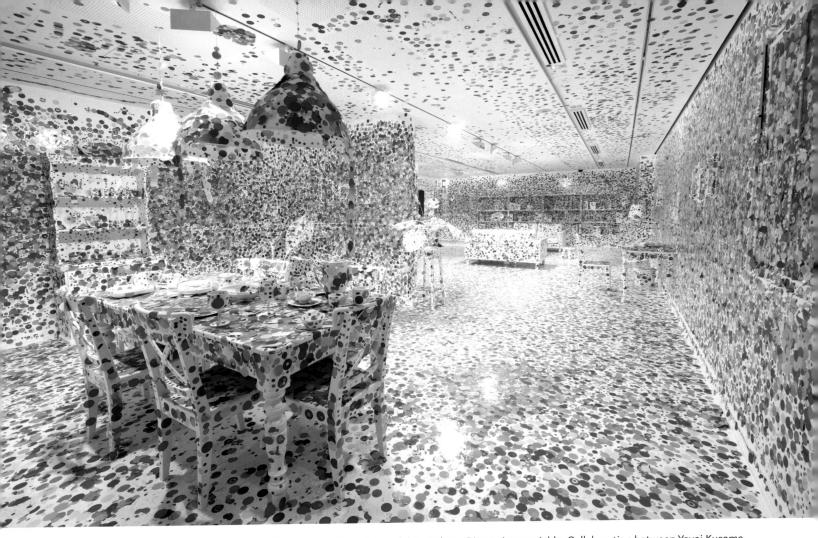

Plate 65. *The Obliteration Room*, 2002–present. Furniture, white paint, and dot stickers, Dimensions variable. Collaboration between Yayoi Kusama and the Queensland Art Gallery, Brisbane, Australia. Commissioned Queensland Art Gallery, Brisbane, Australia. Gift of the artist through the Queensland Art Gallery Foundation, 2012. Collection of the Queensland Art Gallery, Brisbane, Australia

and in the time of stillness granted me by my destiny,
I want to sing in praise of life from the bottom of
my heart.[20]

Obsessively repeated patterns of dots and nets appear in a new cycle of drawings executed in black marker on large white canvases. Over the next four years Kusama creates fifty works densely filled with figurative motifs such as human faces, eyes, and flowers. She calls this series Love Forever, a title that she has used previously and one that expresses what has long been her main message. As she increasingly contemplates mortality, given her advanced age and the realities of the post–9/11 world, she is determined to forge a message of eternal love that she believes defies death and destruction:

What is beauty? It is the prototype of love.
Who cares if death is lying in wait.
Run the royal road fast.[21]

March: *Fireflies on the Water* (2002; pp. 80–83) appears in the 2004 Whitney Biennial at the Whitney Museum of American Art, New York (March 11–May 30), where it attracts large numbers of visitors who line up to experience the mirrored room one at a time.

October: A major retrospective gathering early works, paintings and sculptures of the 1990s and 2000s, and recent installations, *Yayoi Kusama: Eternity-Modernity* tours Japan, appearing at the National Museum of Modern Art, Tokyo (October 26–December 19); the National Museum of Modern Art, Kyoto (January 6–February 13, 2005);

Hiroshima City Museum of Contemporary Art (February 22–April 17, 2005); Contemporary Art Museum, Kumamoto (April 29–July 3, 2005); and Matsumoto City Museum of Art (July 30–October 10, 2005).

2006

Kusama receives the Order of the Rising Sun, one of the Japanese government's most prestigious decorations, and the Japan Art Association's Praemium Imperiale.

September: For the public art installation *Ascension of Polka Dots on the Trees,* Kusama has trees in Singapore's shopping district wrapped with white-on-red polka-dotted fabric during the Singapore Biennale (September 4–November 12).

2008

Yayoi Kusama: Mirrored Years opens at the Museum Boijmans Van Beuningen, Rotterdam (August 23–October 19), and travels to the Museum of Contemporary Art, Sydney (February 24–June 8, 2009), and the City Gallery, Wellington, New Zealand (September 27, 2009–February 7, 2010). The exhibition includes many immersive installations, including *Phalli's Field, Walking on the Sea of Death* (1981), *I'm here but nothing* (2000), and *Fireflies on the Water.*

The documentary film *Yayoi Kusama: I Adore Myself,* directed by Takako Matsumoto, is released (fig. 35). The film follows Kusama for a year and a half as she completes the Love Forever drawing series.

2009

Kusama starts a new painting sequence, My Eternal Soul, using acrylic paints in brilliant colors, including gold and silver. The series, whose large square canvases feature detailed and often dense brushstrokes, continues to this day, numbering almost 500 paintings.

November: Kusama receives the Person of Cultural Merit award from the Japanese government.

2011–12

The major retrospective *Yayoi Kusama,* organized by the Tate Modern, London, and curated by Frances Morris, opens at the Museo Nacional Centro de Arte Reina Sofia, Madrid (May 10–September 12, 2011), and travels to the Centre Pompidou, Paris (October 10, 2011–January 9,

2012); the Tate Modern (February 9–June 5, 2012); and the Whitney Museum of American Art, New York (July 12–September 30, 2012).

A solo exhibition focusing on the artist's recent paintings, *Kusama Yayoi: Eternity of Eternal Eternity,* opens at the National Museum of Art, Osaka (January 7–April 8), and continues on a tour of unprecedented scale: Museum of Modern Art, Saitama (April 14–May 20); Matsumoto City Museum of Art (July 14–November 4); Niigata City Art Museum (November 10–December 24); Shizuoka Prefectural Museum of Art (April 13–June 23, 2013); Oita Art Museum (July 12–October 20, 2013); and the Museum of Art, Kochi (November 2, 2013–January 13, 2014).

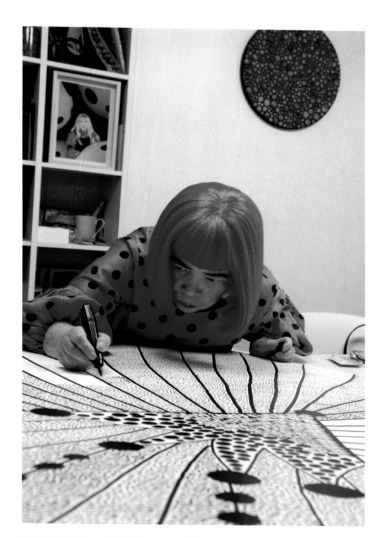

Fig. 35. Still from *Yayoi Kusama: I Adore Myself,* directed by Takako Matsumoto, 2008

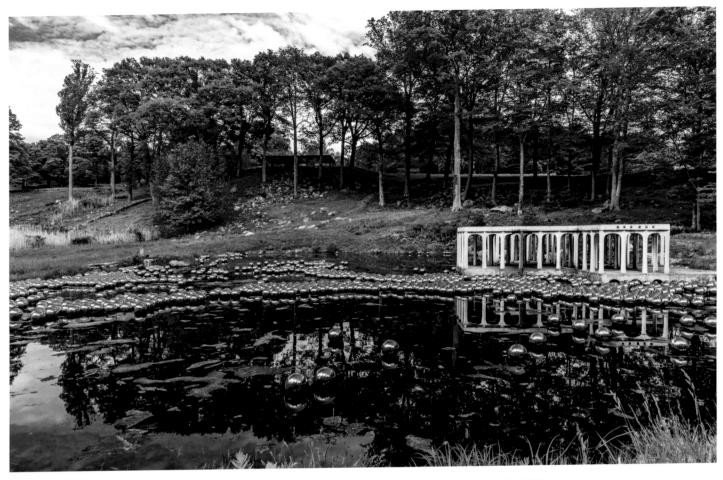

Fig. 36. *Yayoi Kusama: Narcissus Garden*, the Glass House, New Canaan, Connecticut, May 1–November 30, 2016

2013

Yayoi Kusama: Infinite Obsession, curated by Philip Larratt-Smith and Frances Morris, appears at Fundación Costantini Museo de Arte Latinoamericano de Buenos Aires (June 30–September 16); Centro Cultural Banco do Brasil, Rio de Janeiro (October 12, 2013–January 20, 2014); Centro Cultural Banco do Brasil, Brasilia (February 18–April 27, 2014); Instituto Tomie Ohtake, São Paulo (May 22–July 27, 2014); Museo Tamayo Arte Contemporáneo, Mexico City (September 25, 2014–January 19, 2015); and Fundación CorpArtes, Santiago, Chile (March 7–June 7, 2015). The *Rio Times*'s Chesney Hearst reports a comment made by local street artist Di Couto: "I admire how she was a strong woman and went against the family and against society for art. I admire her courage. That inspires me a lot."[22] More than 2.5 million people visit the exhibition on this Central and South American tour.

An exhibition of her most recent works, *Yayoi Kusama: A Dream I Dreamed*, curated by Kim Sunhee, appears at the Daegu Art Museum, South Korea (July 16–November 3); the Museum of Contemporary Art Shanghai (December 15, 2013–March 30, 2014); the Seoul Arts Center (May 4–June 15, 2014); the Kaohsiung Museum of Fine Arts, Kaohsiung City, Taiwan (February 7–May 17, 2015); and the National Taiwan Museum of Fine Arts, Taichung City (June 6–August 30, 2015).

2014

In January, Kusama receives the Ango Award, named for the avant-garde novelist Ango Sakaguchi and honoring those who have encouraged a rebellious spirit and creative imagination in the Japanese people.

2015–17

In Infinity, a survey of Kusama's entire career—including her works in fashion and design—opens at the Louisiana Museum of Modern Art, Humlebæk, Denmark (September 17, 2015–January 24, 2016) and travels to the Henie-Onstad Kunstsenter, Høvikodden, Norway (February 19–May 15, 2016); the Moderna Museet, Stockholm (June 11–September 11, 2016); and the Helsinki Art Museum (October 7, 2016–January 8, 2017).

In May 2016, *Narcissus Garden,* first presented in 1966, is recreated with 1,300 reflective steel balls and installed at Philip Johnson's Glass House in New Canaan, Connecticut (fig. 36).

At the age of eighty-seven, Kusama continues to produce work daily, and her belief in art and the role of artists in society is consistent with ideals she espoused at the start of her career. In 1952 she said:

> Art, for its innate universality, belongs not only to its author; it is to be shared by everyone. And artists bear a duty to present their work to the audience. If small work by us, the artists, can be of some humble help to and be seen by as many people as possible and be a reference used to train their critical thinking in some form, then, there would be no greater happiness for the artists than that.[23]

In 2013 she wrote:

> I'm at the last spurt of my life, so I am making art passionately.
> In any case, a crucial moment starts now.[24]

Notes

1 Yayoi Kusama, "Violet Obsession" in *Shishū: Kakunaru urei* (Collected Poems: Such Sorrows) (Tokyo: Jiritsu Shobō, 1989), 176–77; reprinted in Yayoi Kusama, *Infinity Net: The Autobiography of Yayoi Kusama,* trans. by Ralph McCarthy (London: Tate Publishing, 2013), 65.
2 From an article by Kusama published in an unidentified Japanese magazine, c. 1957; reprinted in Yayoi Kusama, *Kusama Yayoi, Tatakau* (Tokyo: Access, 2011), 11.
3 Shūzō Takiguchi quoted in Yayoi Kusama, *Mizutama no rirekisho* (Tokyo: Shūeisha, 2013), 157.
4 Kusama, *Infinity Net,* 93.
5 Yayoi Kusama, "Onna hitori kokusai gadan o yuku," *Geijutsu shinchō* 137 (May 1961): 127–30; quoted in Midori Yoshimoto, "Nyūyōku o 'mugen no ami' de akkan suru: Kusama Yayoi, Nyūyōku de tsutaerareta hatsukoten," *Bijutsu techō* 64, no. 965 (April 2012): 54.
6 Sayaka Sonoda, *Yayoi Kusama: Locus of the Avant-Garde* (Nagano: Shinano Mainichi Shimbun, 2013), 25.
7 Yayoi Kusama, "Kusama Yayoi intabyū," *Bijutsu techō* 54, no. 825 (September 2002): 134–40.
8 Yayoi Kusama to Henk Peeters, February 2, 1962, Kusama calendar-diary, folder "Calendar-diary," Kusama Papers, Tokyo.
9 Manami Fujimori, "Nyūyōku āto-kai to Kusama Yayoi," *Bijutsu techō* 64, no. 965 (April 2012): 53.
10 Kusama, *Infinity Net,* 51.
11 Lucio Fontana advanced money for the fabrication of the mirror balls at a factory in Florence.
12 Yayoi Kusama and Judd Yalkut, "The Polka Dot Way of Life," *New York Free Press,* February 15, 1968.
13 "4 in Nude Protest the War in Vietnam," *New York Times,* November 12, 1968.
14 Kusama (speaking in 1978) quoted in Sayaka Sonoda, *Locus of the Avant-Garde* (Nagano: Shinano Mainichi Shimbun, 2013), 33.
15 Ren Fukuzumi, "Pafōmansu āto kara fasshon eno tenkai," *Bijutsu techō* 64, no. 965 (April 2012): 58.
16 In 1993, Tatehata, in his role as commissioner of the Japanese Pavilion, would choose Kusama to represent the country at the Venice Biennale.
17 Tadashi Yokoyama, "Endlessly Multiplying Nets and Dots: on Yayoi Kusama's Self Obliteration exhibition," *Ikebana Ryūsei* (November 1980): 24–27; reprinted in Ren Fukuzumi, "The 1970s–1980s Media and Critique of Kusama: From the Queen of Scandal to the Great Artist," *Bijutsu techō* 64, no. 965 (April 2012): 70.
18 Kazuko Shiraishi, "Yayoi Kusama: The Breath and the Proliferation of the Nets," *Bijutsu techō* 34 (June 1982): 201.
19 Manami Fujimori, "Curator Interview: Lynn Zelevansky," *Bijutsu techō* 64, no. 965 (April 2012): 76; Edward M. Gomez, "A 60's Free Spirit Whose Main Subject was Herself," *New York Times,* July 5, 1998.
20 Yayoi Kusama, *Hi, Konnichiwa: Yayoi Kusama Art Book* (New York: Kodansha, 2013), 3.
21 Yayoi Kusama, *Watashi daisuki = I Like Myself* (Tokyo: Infas, 2007), 32.
22 Chesney Hearst, "Yayoi Kusama Exhibition Opens at CCBB," *Rio Times,* October 8, 2013.
23 Yayoi Kusama, "The Painter's Appeal: Open Your Eyes to Art," *Shinano ōrai,* November 1952; reprint with partial translation in Sayaka Sonoda, *Yayoi Kusama: Locus of the Avant-Garde* (Nagano: Shinano Mainichi Shimbun, 2013), 116, 117.
24 Kusama, *Mizutama no rirekisho,* 69.

Annotated Bibliography

Alex Jones

This bibliography traces the evolution, interpretation, and context of Kusama's environments. Distinct from the comprehensive bibliographies compiled by Reiko Tomii in 1989 (see Karia below) and Hitoshi Dehara in 2004 (in *Yayoi Kusama: Eternity-Modernity*, Tokyo: Bijutsu Shuppansha, for the exhibition of the same name at the National Museum of Modern Art, Tokyo), the following selection seeks to emphasize the interdisciplinary achievement of the Infinity Mirror Rooms. Taking into account their belated contextualization, the bibliography highlights English-language scholarship on Kusama published since 1989, tracing the ongoing reevaluation of her influence on postwar art as well as her perennial relevance.

Applin, Jo. "*I'm Here, but Nothing*: Yayoi Kusama's Environments." In *Yayoi Kusama*, edited by Frances Morris, 186–90. New York: DAP, 2012. Exhibition catalogue.
Applin takes a broad view of Kusama as one of the first installation artists of the postwar period who made "the environmental conditions of her artwork central to her practice." Beginning with the artist's expansive, noncompositional Net paintings, Applin characterizes Kusama's practice as a mode of "world building" meant to facilitate relational spaces in which the viewer becomes an active participant.

———. *Yayoi Kusama: Infinity Mirror Room—Phalli's Field*. London: Afterall Books; Cambridge, MA: MIT Press, 2012.
Applin's analysis of Kusama's first Infinity Mirror Room encompasses its "psychosexual drama," its art historical connections to Minimalism and Pop art, and the participatory activation of the work. Applin broadens her interpretation of the "strange relational habits and effects" facilitated by Kusama's mirror rooms and their related performances through political theorist Hannah Arendt's theories on the ethics of community building and multiple modalities of being.

Benedikt, Michael. "New York Letter: Light Sculpture and Sky Ecstasy." *Art International* 10, no. 9 (September 1966): 46–47.
Surveying the trend of light as medium in the New York art scene, Benedikt nominates *Kusama's Peep Show* (1966) at Castellane Gallery as the most extravagant example of all, calling Kusama "an arch-romantic of light." He praises her use of mirrors as a means to achieve endlessly proliferating images and is receptive to the conceptual impact of the work's disembodying effects.

———. "New York Letter: Sculpture in Plastic, Cloth, Electric Light, Chrome, Neon, and Bronze." *Art International* 10, no. 1 (January 1966): 98–100.
This sole substantial review of Kusama's *Floor Show* exhibition at Castellane Gallery describes its various elements, which, aside from *Infinity Mirror Room—Phalli's Field* (1965), included a grouping of Accumulation sculptures and *My Flower Bed* (1962), a "blatantly sinister" sculpture made of red-painted mattress springs and knitted work gloves, which Benedikt says emphasizes Kusama's fascination with "the processes of growth, repetition, and proliferation."

Bishop, Claire. *Installation Art: A Critical History*. New York: Routledge, 2005.
In this major survey, a section devoted to the use of mirrors focuses on the simultaneous efforts of Kusama and Lucas Samaras in 1966. Bishop connects both artists' use of mirrors to their interest in "doubled and mimetic relationships between the self and environment" and draws on Jacques Lacan's theory of the mirror stage in her analysis of the power of reflections to "destabilize the ego's fragile veneer."

Castellane, Richard. "On Kusama." In *Yayoi Kusama: Early Drawings from the Collection of Richard Castellane*, by Richard Castellane and David Moos, 44–45. Birmingham, AL: Birmingham Museum of Art. 2000. Exhibition catalogue.
Having hosted three of Kusama's pivotal exhibitions in New York—*Driving Image Show* (1964), *Floor Show* (1965), and *Kusama's Peep Show*—Castellane reflects on his early support of the artist. He describes her

use of infinity as a compositional element and a spatial innovation that is present in her works on paper as well as in her installations.

Douroux, Xavier, Franck Gautherot, Robert Nickas, and Vincent Pécoil. *Yayoi Kusama.* Dijon: *Les Presses du Réel*, 2001. **Exhibition catalogue.**

This catalogue for Kusama's environment-focused solo show at Le Consortium, Dijon is dominated by an extensive "visual biography" of the artist, focusing on the late 1960s with material reprinted from international tabloids, porn magazines, press releases (i.e. "PRIESTESS OF NUDITY, YAYOI KUSAMA, OPENS FASHION BOUTIQUE"), promotional posters, and documentation of Kusama's Happenings. Many photos featuring panels of spotted phalli evidence the fact that, after *Floor Show,* Kusama repurposed elements of *Phalli's Field* for her "orgy" performances.

Gautherot, Franck, Jaap Guldemond, and Seungduk Kim, eds. *Yayoi Kusama: Mirrored Years*, Dijon: *Les Presses du Réel*, 2009. **Exhibition catalogue.**

This catalogue for the Museum Boijmans Van Beuningen survey, which loosely focused on Kusama's use of mirrors, features notable essays by Midori Yamamura and Diedrich Diederichson. In "Obsession as Revolution: Yayoi Kusama Follows Up a Hallucination with the Social Reality," Diederichson understands Kusama's increasing involvement in the counterculture of the late 1960s as the natural progression of her unique "logic of expansion," which carried the artist's work from painting and sculpture into totalizing environments over the course of the decade, ultimately arriving at the space of society itself.

Group Zero. Philadelphia: Institute of Contemporary Art; University of Pennsylvania, 1964. **Exhibition catalogue.**

The first Zero group museum exhibition in the United States included three paintings—*No. T.W.3.* (1961; pl. 30), *No. Green No. 1* (1961; pl. 31), and *The West* (1960)—and a mixed-media work, *No. B.3.* (1962), by Kusama. In his curatorial essay, Samuel Adams Green describes experiments with the medium of light by Zero-affiliated artists, giving evidence to the context of environmental work then flourishing among Kusama's European peers. With language that seems to foreshadow Kusama's Infinity Mirror Rooms, he explains, "In the 'night exhibitions' of the 50's in Dusseldorf, it was said by a critic that 'One is caught in a net of light which builds a magic space from movement.' Light as we know it implies space without beginning or end."

Hasegawa, Yuko, and Pamela Miki. "The Spell to Re-integrate the Self: The Significance of the Work of Yayoi Kusama in the New Era." *Afterall: A Journal of Art, Context, and Enquiry,* no. 13 (Spring–Summer 2006): 46–53.

In the view of Hasegawa and Miki, Kusama's work operates at the point of disconnect between the internal self and the exterior world, her aim being to reconcile "physical reality and our virtual reality" through her techniques of self-obliteration. Hasegawa suggests that the renewed interest in Kusama among younger audiences is related to intensified feelings of dissociation between identity and reality within our digital information society, and that Kusama's conception of infinity takes on new resonance in the age of endless "accumulation of data."

Hirst, Damien. "Damien Hirst Questions Yayoi Kusama across the Water, May 1998." In *Yayoi Kusama: Now,* n.p. New York: Robert Miller Gallery, 1998. **Exhibition catalogue.**

This gallery show, premiering during the "Kusamania" sparked by the concurrent retrospective organized by Los Angeles County Museum of Art and the Museum of Modern Art, included gold-painted Accumulations and *Venus de Milo* statues covered with Infinity Nets. Here, Kusama is interviewed by Hirst—then at the height of his own international prominence—about her self-described illness and outlook in later life. Kusama attributes a Surrealist, even mythic symbolism to her recent sculptures *Pink Boat* (1993) and *Violet Obsession* (1994; pl. 45), revealing an evolution of the rowboat motif since her first use of it in 1963.

Hoptman, Laura. "Down to Zero: Yayoi Kusama and the European New Tendency." In *Love Forever: Yayoi Kusama, 1958–1968,* by Lynn Zelevansky, 42–60. Los Angeles: Los Angeles County Museum of Art, 1998. **Exhibition catalogue.**

Hoptman strives to distinguish Kusama from the European "New Tendency," emphasizing the performativity of her practice in contrast to the more objective, mechanized experiments of her peers in the German Zero and Dutch Nul groups. Hoptman argues that Kusama's strongest affinities are with the "flamboyant performances" of Yves Klein and Piero Manzoni, which, like Kusama's own, were "carefully documented through photography, film, radio, and press releases." She also draws attention to the paradox between the concept of self-obliteration and Kusama's performativity of the self.

Hoptman, Laura, Udo Kultermann, Yayoi Kusama, and Akira Tatehata. *Yayoi Kusama.* London: Phaidon, 2000.

This compilation brings together essential source material, including historical reviews and interviews by and with Hoptman, Kultermann (see Kultermann, "Driving Image, Essen, 1966," below), Tatehata, Gordon Brown (see Kultermann, "Miss Yayoi Kusama," below), and Jud Yalkut (see Kusama and Yalkut, "The Polka Dot Way of Life," below).

Johnston, Jill. "Reviews and Previews: Kusama's *One Thousand Boat Show.*" ARTNEWS 62, no. 10 (February 1964): 12.

In a positive review of Kusama's first environmental installation, Johnston compares *Aggregation: One Thousand Boats Show* to Allan Kaprow's *Apple Shrine* (1960) and emphasizes the strength of the installation as a total environment: "The photographs do not simply play tricks with the spectator by way of startling him when he sees the real thing; they are actually a reiterated extension of the boat, suggesting an infinite expansion of the image."

Jones, Amelia. *Body Art: Performing the Subject,* 5–12. Minneapolis: University of Minnesota Press, 1998.

Highlighting Kusama in the introduction to her survey, Jones describes a modality of her work in which the viewer is forced into a "reversible relation" with the self and environment, reflecting Kusama's own performative merging of herself with her artworks. Drawing a comparison to Carolee Schneemann's *Interior Scroll* (1975), Jones posits that "Kusama enacts her body in a reversibility of inside and out, the work of art/the environment via an enactment of Kusama and vice-versa."

Judd, Donald. "In the Galleries: Yayoi Kusama." *Arts* 38, no. 10 (September 1964): 68–69.
Though he had previously praised Kusama's Net paintings and Accumulations, Judd finds *Driving Image Show* distasteful. He writes that her Accumulation sculptures are lowered to "Pop Artiness or literalness" by the embellishments Kusama has incorporated, such as shoes and silverware, and he is similarly uninterested by the macaroni covering the floor.

———. "Specific Objects." *Arts Yearbook* 8 (1965): 74–83.
In this seminal article, Judd postulates a new type of three-dimensional artwork that is not governed by the traditional boundaries of sculpture or painting. An important characteristic of Judd's "specific object" is that it is not defined by its discrete parts but rather that "the thing as a whole, its quality as a whole, is what is interesting." He cites Kusama's phallic furniture (from *Driving Image Show*) and rowboat (from *Aggregation: One Thousand Boats Show*, 1963) as examples in which the artist's singular, "obsessive" vision is translated into objects that embody an aesthetic cohesiveness and intensity.

Kaprow, Allan. *Assemblage, Environments & Happenings*. New York: Harry N. Abrams, 1966.
Photographs from Kusama's *Driving Image Show* are included in Kaprow's highly influential text under the umbrella of "Environments." Though Kusama was not involved with Kaprow's Happenings in New York, she would adopt his terminology to describe the nude performances she conducted in the late 1960s.

Karia, Bhupendra, Alexandra Munroe, and Reiko Tomii. *Yayoi Kusama: A Retrospective*. New York: Center for International Contemporary Arts, 1989. Exhibition catalogue.
This catalogue remains a substantial scholarly source, with a thoroughly researched chronology and bibliography by Reiko Tomii. Munroe's lead essay, "Obsession, Fantasy, and Outrage," presents a feminist reading of Kusama that strongly influenced subsequent, biographically determined interpretations. The exhibition renewed both popular and scholarly interest in the artist.

Kataoka, Mami. "Yayoi Kusama: An Infinite Consciousness Directed at the Cosmos." In *Look Now, See Forever*, edited by Reuben Keehan. Brisbane: Queensland Art Gallery and Gallery of Modern Art, 2001. http://interactive.qag.qld.gov.au/looknowseeforever/. Exhibition catalogue.
Drawing on the Buddhist principle of cosmic connectedness, Kataoka credits Kusama with having "a bird's-eye view of the entire universe." She relates the artist's embodiment of an expanded consciousness to her work's transgenerational appeal and its resistance to art historical classification. The short essay is decidedly celebratory but emphasizes a spirituality in Kusama's work not often addressed by Western interpreters.

Kultermann, Udo. "Driving Image, Essen, 1966." In Hoptman, Kultermann, Kusama, and Tatehata, *Yayoi Kusama*, 84–93.
After including her in his 1960 exhibition *Monochrome Malerei* (Monochrome Painting), Kultermann remained an avid supporter of Kusama, and here he identifies *Driving Image Show* as a landmark in the evolution of what would later be called installation art: "*Driving Image* was a crucial point in this development, as here what is important is the total ensemble, not the individual work. The unifying patterned surface of the objects, and even the acoustic effect of the music, all contribute to the overall work."

———. "Miss Yayoi Kusama: Interview Prepared for WABC Radio by Gordon Brown, Executive Editor of *Art Voices*." In *De nieuwe stijl: Werk van de international avant-garde*, edited by Armando, 162–64. Amsterdam: De Bezige Bij, 1965. Extract reprinted in Hoptman, Kultermann, Kusama, and Tatehata, *Yayoi Kusama*, 100–05.
In this profoundly revealing interview, originally conducted in 1964, Kusama explains her Net paintings and Accumulation sculptures as manifestations of an inner "repetitive image" that "overflows the limits of time and space." She also identifies "psychosomatic problems" afflicting modern urban society as a starting point of her artistic expression.

Kusama, Yayoi, and Judd Yalkut. "The Polka Dot Way of Life." *New York Free Press*, February 15, 1968. Reprinted in Hoptman, Kultermann, Kusama, and Tatehata, *Yayoi Kusama*, 110–12.
When asked by Yalkut in this interview to explain the underlying philosophy of her "Self-Obliteration" performances, Kusama answers in characteristically sweeping fashion, alluding to the cosmic scale that informs her exploration of infinity: "Our earth is only one polka dot among a million stars in the cosmos. Polka dots are a way to infinity. When we obliterate nature and our bodies with polka dots, we become part of the unity of our environment. I become part of the eternal, and we obliterate ourselves in Love."

Minemura, Toshiaki. "I *Are* Infinitely Others." In *Yayoi Kusama: Infinity∞Explosion*, n.p. Tokyo: Fuji Television Gallery, 1986. Exhibition catalogue.
This poetic reflection on Kusama's work and persona characterizes her lifelong undertaking as a confrontation with infinity in nature. Making a connection that Laura Hoptman would expand upon in her later essay (see above), Minemura compares Kusama to Yves Klein, calling both geniuses united in "the pursuit of the frightening extreme of the absolute."

———. "The Soul Going Back to Its Home." In *Yayoi Kusama Collage: 1952–1983*, n.p. Tokyo: Nabis Gallery; Fuji Television Gallery, 1991. Exhibition catalogue.
Minemura analyzes Kusama's body of collaged works on paper made following her return to Japan in 1973, focusing in particular on *Soul Going Back to Its Home* (1975; pl. 8). He emphasizes their embodiment of complex subject-object relationships and observes "a condensed and reflective forcefulness" driving the collages that marks a turning point in the artist's work and consciousness.

Morris, Frances, ed. *Yayoi Kusama.* New York: DAP, 2012. Exhibition catalogue.

This catalogue accompanying the important Tate Modern retrospective features historically focused scholarly contributions from Jo Applin, Mignon Nixon, and Midori Yamamura (see individual entries in this bibliography). In her introductory essay, Morris frames the exhibition as an effort to historicize Kusama's work, focusing on the cultural and political background of her formative years, on "her work's transgressive political agency," and on her environmental installations as "sites of 'psychic fragmentation' as relational, social spaces, connected to participatory happenings of the late 1960s."

Munroe, Alexandra. "Revolt of the Flesh: Ankoku Butoh and Obsessional Art." In *Japanese Art after 1945: Scream against the Sky,* 189–201. New York: Abrams, 1994. Exhibition catalogue.

Munroe employs Kusama's term "Obsessional Art" to characterize a tendency in Japanese art of the 1960s in which "obsession was both an artistic style and psychological state." She analyzes obsession in the work of Tatsumi Hijikata, Tetsumi Kudō, Tomio Miki, and Kusama as being rooted in a particular darkness engrained in the postwar Japanese psyche. The text importantly offers a critical context for Kusama's work (particularly her phallic aggregations) separate from that of American Abstract Expressionism and proto-Minimalism.

Nakajima, Izumi. "Yayoi Kusama between Abstraction and Pathology." In *Psychoanalysis and the Image: Transdisciplinary Perspectives on Subjectivity, Sexual Difference, and Aesthetics,* edited by Griselda Pollock, 127–60. Malden, MA: Blackwell, 2006.

Employing a psychoanalytic approach that nonetheless avoids pathologizing the artist, Nakajima seeks a feminist re-viewing of Kusama's Net paintings of the late 1950s. Grounding her argument in global art contexts of the postwar period, and particularly the sociopolitical underpinnings of American Abstract Expressionism, Nakajima frames Kusama's Net painting as a calculated response to these conditions, in resistance to dominant readings of these works as products of Kusama's "obsessive" tendencies.

Nixon, Mignon. "Anatomic Explosion on Wall Street." *October* 142 (Fall 2012): 3–25.

In this meticulously researched account of Kusama's late-1960s nude Happenings and political protests, Nixon chides scholars of the artist's work for underrepresenting or dismissing the political significance of these performances. Offering a defense of Kusama's offbeat activism, she argues that "the artist proposed a more speculative mode of political resistance" by deploying "ludic tactics to dramatize the absurdity of war—and the ridiculous lengths to which war protest must go to attract the attention of newspapers."

———. "Infinity Politics." In Morris, *Yayoi Kusama,* 176–85.

Here, Nixon draws out the significance of Kusama's subversive politics, which she laments "have been subsumed in an overarching narrative of private obsession" in the scholarship on her New York years. She emphasizes that the "defiance of gestural abstraction" behind Kusama's Net paintings fall under the same banner of willful protest as her later antiwar Happenings.

O'Doherty, Brian. Review. *New York Times,* December 29, 1963.

This review of *Aggregation: One Thousand Boats Show* at Gertrude Stein Gallery perceptively emphasizes its impact as a total environment, warning visitors that the installation "should not be dismissed as a surrealist caper." O'Doherty argues that "[w]ithout the environment, or shrine, or atmosphere" of the darkened, wallpapered installation, "her surrealist sprouting objects are unremarkable. With the appropriate environment, they swing in a way that opens the imagination to wonder and deliberate awe."

Pollock, Griselda. "Yayoi Kusama: Three Thoughts on Femininity, Creativity and Elapsed Time." *Parkett* 59 (2000): 107–23.

Comparing the critical emphasis on Kusama's pathology to the mythologization of Vincent van Gogh, Pollock urges the need to read Kusama's work as a "calculated engagement" with her cultural context, namely the Euro-American male-dominated social structure of New York in the 1960s. Pollock's feminist reading instead presumes a historically located psychological trauma of alterity experienced by Kusama, a condition to which her inventive and transgressive practice was a necessary response.

Posner, Helaine. "Self and World: Negotiating Boundaries in the Art of Yayoi Kusama, Ana Mendieta, and Francesca Woodman." In *Mirror Images: Women, Surrealism, and Self-Representation,* edited by Whitney Chadwick, 157–79. Cambridge, MA: MIT Press, 1998.

Posner unites Kusama, Mendieta, and Woodman through the shared engagement of their bodies in a "dynamic physical exchange with the built or natural environment." While asserting the distinctly feminist qualities of this practice, Posner historicizes the artists' mediations on self and world as being "deeply rooted in the Surrealists' wish to embrace duality and contradiction." She cites Kusama's "inhabited installations" as a manifestation of the artist's effort to confound the boundaries between the self and the external world.

Rannells, Molly. *Multiplicity.* Boston: Institute of Contemporary Art, 1966. Exhibition catalogue.

Featuring *Kusama's Peep Show,* this exhibition encompassed contemporary works based on modular repetitions within the single object or object-group, using "commercial/industrial source-materials." Rannells compares European and American tendencies within this trend to contextualize an international checklist that included Donald Judd, Agnes Martin, and Andy Warhol as well as Günther Uecker, members of the French GRAV collective, and Kusama, unifying their efforts as affirming "the absence of any fixed 'boundaries'" in their art.

Schjeldahl, Peter. "Reviews and Previews: Kusama." *ARTnews* 65, no. 3 (May 1966): 18.

Schjeldahl's description of the mirrored chamber in his resoundingly positive review of *Kusama's Peep Show* offers important sensory details: "Meanwhile, a loud tape of Beatles songs blends in your ears with the lively rattle (like metal popcorn) of the light switches, reinforcing your sense of having been removed to another, and rather awesome, world."

Seki, Naoko. *Yayoi Kusama, In Full Bloom: Years in Japan.* Tokyo: Museum of Contemporary Art, Tokyo, 1999. Exhibition catalogue.
Mounted in Tokyo alongside the LACMA/MoMA *Love Forever, Yayoi Kusama, 1958–1968* exhibition (see Zelevansky below), this show surveyed Kusama's early 1950s output and later career and was intended to bookend the more focused American retrospective. In her title essay, Seki suggests the need for a broader conversation on the spatial innovations of Kusama's later installation work: "The large sculptures and balloons of recent years, which are placed in monumental, liberated spaces, cannot be explained in terms of obsessive tendencies like the previous accumulations. . . . How might they be explained?"

Sommer, Ed. "Letter From Germany: Yayoi Kusama at the Galerie M. E. Thelen, Essen." *Art International* 10, no. 8 (October 1966): 46.
In his review of the German presentation of *Driving Image Show,* Sommer describes its failure as an immersive environment: "The walls and the ceiling and even a section of the room remained untouched by Kusama's transmuting webs. By this confinement the alienated world was hindered in encroaching upon the beholder's perceptual habits and tended to be reducible to a display of nicely though somewhat casually decorated objects." Sommer also makes a connection between Kusama's accumulations and Günther Uecker's nail-studded furniture works.

Tatehata, Akira. *Yayoi Kusama: My Solitary Way to Death.* Tokyo: Fuji Television Gallery, 1994. Exhibition catalogue.
Kusama's third solo show at Fuji Television Gallery included a recreation of *Kusama's Peep Show,* her hexagonal mirrored chamber from 1966, newly titled *Infinity Mirrored Room—Love Forever* (pp. 68–71). The exhibition title, *My Solitary Way to Death,* was shared by another work featuring a white ladder set upright between two mirrored bases so that it receded infinitely into space. Tatehata, who had selected Kusama to represent Japan in the Venice Biennale the previous year, reflects primarily on this sculpture in his catalogue essay, comparing it to the earlier phallus-covered ladder, *Traveling Life* (1964).

Tomii, Reiko. "Shikaku hyōshō to shite no aidentitī" (Identity as Visual Representation). *Art Communications,* no. 6 (1997): 12–23.
This was the first article to focus on Kusama's active construction of her self-image through staged photography, a major theme in recent scholarship that emphasizes the groundbreaking performativity of Kusama's practice (see entries on Jones, Posner, and Yoshimoto in this bibliography).

Westenholz, Caroline. "Zero on Sea." In *Nul = 0: The Dutch Nul Group in an International Context,* by Colin Huizing, Tijs Visser, and Antoon Melissen, 92–118. Schiedam: Stedelijk Museum Schiedam, 2011.
Assembling letters, artists' proposals, and press coverage, Westenholz reconstructs Zero op Zee (Zero on Sea), an outdoor festival planned for September 1965 on Scheveningen Pier in the Hague that was ultimately cancelled due to poor weather and lack of funds. Organized by affiliates of the Nul group, Zero op Zee would have been a landmark for site-specific installation art, with participants from Europe, Japan, and the United States. Kusama's proposal was for a new iteration of *Kusama's Peep Show,* renamed *Love Forever,* into which visitors would have been able to walk.

Yamamura, Midori. *Yayoi Kusama: Inventing the Singular.* Cambridge, MA: MIT Press, 2015.
This scholarly monograph on Kusama, grounded in Yamamura's rigorous archival study, explains Kusama's practice in relation to a postwar ontology shared by her peers in the international avant-garde. The book discusses for the first time Kusama's environments in relation to Expanded Cinema and psychedelic light shows. Yamamura attributes Kusama's turn to performance and social activism to the failure of her work to gain traction in the press and the market as had that of her male competitors, particularly Andy Warhol, Claes Oldenburg, and Lucas Samaras.

Yoshimoto, Midori. "Performing the Self: Yayoi Kusama and Her Ever-Expanding Universe." In *Into Performance: Japanese Women Artists in New York,* 45–77. New Brunswick, NJ: Rutgers University Press, 2005.
Within Yoshimoto's comparative examination of Kusama, Yoko Ono, Takako Saito, Mieko Shiomi, and Shigeko Kubota, this chapter demonstrates the development of Kusama's early environments into performance. She analyzes the artist's deliberate self-fashioning in a performative mode through the close reading of iconic photographs, including nude portraits of the artist reclining upon *Accumulation II* (by Hal Reiff) and standing within *Aggregation: One Thousand Boats Show* (by Rudolph Burckhardt).

Zelevansky, Lynn. "Flying Deeper and Farther: Kusama in 2005." *Afterall: A Journal of Art, Context, and Enquiry,* no. 13 (Spring–Summer 2006): 54–62.
After organizing the landmark 1998 retrospective *Yayoi Kusama: Love Forever, 1958–1968* (see below), Zelevansky revisits the artist's later work. She contrasts the "abject toughness" of Kusama's earlier output with the "apparent cheerfulness" of her childlike prints and sculptures, examining her own initial distaste for the latter. Correlating Kusama's shift in style to the emergence of Japan's "culture of cuteness" (*kawaii*) in the 1980s and 1990s, Zelevansky credits the development with showing the same "extraordinary sensitivity to cultural atmosphere and stimuli" that characterized Kusama's New York years.

———. *Love Forever: Yayoi Kusama, 1958–1968.* Los Angeles: Los Angeles County Museum of Art, 1998. Exhibition catalogue.
In her curatorial essay, "Driving Image: Yayoi Kusama in New York," Zelevansky traces the evolution and impact of Kusama's major bodies of work through a feminist psychological lens. She assesses the reasons for Kusama's fall from prominence after this period, arguing that her "idiosyncratic involvement with autobiography, the body, and the feminine voice," which were problematic in the 1960s, have become increasingly admired by postmodern audiences.

Zohar, Ayalet. "The Jewel, the Mirror, and the String of Beads." *N. Paradoxa* 33 (January 2014): 5–15.
Zohar reads Kusama's *Narcissus Garden* (1966) and Infinity Mirror Rooms through traditional Japanese mythological, religious, and classical poetic symbolism. While acknowledging that Kusama has never cited such allusions in her work, Zohar argues that her use of the name "Narcissus" in 1966, as well as the religious or spiritually tinged titles of her recent paintings, invite a mythological reading. She presents a Japanese perspective on "cultural images of reflection and mirroring" in response to Western, psychoanalytical interpretations of Kusama's invocation of Narcissus and use of mirrors.

Exhibition Checklist

Infinity, 1952
Ink on paper
9 x 12 in. (23.2 x 30.3 cm)
Collection of the artist
p. 16

A Woman, 1952
Pastel, tempera, and black ink on buff paper
13⅝ x 9¾ in. (34.6 x 24.8 cm)
Sheldon Inwentash and Lynn Factor, Toronto
p. 16

Untitled, 1952
Ink, gouache, oil pastel, and pastel on paper
10½ x 7⅜ in. (26.8 x 18.8 cm)
Collection of the artist
p. 34

Accumulation of Dots, 1953
Ink on paper
8⅞ x 12 in. (22.6 x 30.5 cm)
Collection of the artist

The Island in the Sea No. 1, 1953
Gouache and pastel on paper
9½ x 13½ in. (24.1 x 34.3 cm)
Private collection. Courtesy David Zwirner,
New York/London
p. 18

The World of Insect, 1953
Ink, gouache, and pastel on paper
8¾ x 7⅝ in. (22.3 x 19.4 cm)
Collection of the artist
p. 35

A Man, 1953
Ink, gouache, and pastel on paper
11½ x 8¾ in. (29.4 x 22.4 cm)
Collection of the artist
p. 35

Column No. GOL, 1953
Tempera and pastel on paper
14⅛ x 12⅝ in. (35.9 x 32.1 cm)
Collection of Mark Diker and Deborah Colson
p. 36

The Hill, 1953 A (No. 30), 1953
Gouache, pastel, oil, and wax on paper
14⅜ x 12⅜ in. (36.3 x 31.4 cm)
Hirshhorn Museum and Sculpture Garden,
Washington, DC, Museum Purchase, 1996
p. 36

Horizontal Love, 1953
Spray enamel and ink on paper
16¼ x 13⅛ in. (41.3 x 33.4 cm)
Blanton Museum of Art, The University of
Texas at Austin, Gift of the Center for
International Contemporary Arts; Emanuel
and Charlotte Levine Collection, 1992
p. 37

Column No. 1, 1953
Tempera and pastel on paper
15 x 12¾ in. (38.1 x 32.4 cm)
Miyoung Lee and Neil Simpkins
p. 38

Game No. 5 (Cosmos), 1953
Pastel and gouache on paper
10 x 10 in. (25.3 x 25.3 cm)
Collection of the artist

Inward Vision No. 4, 1954
Pastel with black ink, watercolor, and
tempera on buff paper
13⅛ x 16⅛ in. (33.3 x 41 cm)
Collection of Carla Emil and Rich Silverstein
p. 18

M.A.M. Egg, 1954/1963
Tempera and pastel on paper
11⅛ x 13¼ in. (28.3 x 33.7 cm)
Private collection
Courtesy David Zwirner, New York/London
p. 38

Flower QQ2, 1954
Pastel, tempera, and ink on paper
16¾ x 13¾ in. (42.5 x 34.9 cm)
Private collection
Courtesy David Zwirner, New York/London
p. 17

Hidden Flames, 1956
Pastel, ink, and watercolor on paper
13½ x 9⅞ in. (34.3 x 25.1 cm)
Collection of Daniel Rowen and Stuart Sproule
p. 19

Nets and Red No. 2, 1958/c. 1963
Pastel on paper with synthetic netting
11 x 8⅝ in. (27.9 x 21.9 cm)
Private collection
Courtesy David Zwirner, New York/London
p. 39

Resting in the Heart of Green Shade, 1975
Collage with gouache, pastel, ink, and
fabric on paper
21½ x 15½ in. (54.5 x 39.5 cm)
Collection of the artist
p. 43

Polka Dots of Polka Dots, 1975
Collage with pastel, ink, and fabric on paper
21½ x 15½ in. (54.5 x 39.5 cm)
Collection of the artist
p. 43

Flower, 1975
Collage with pastel, ink, and fabric on paper
15⅝ x 21⅜ in. (39.8 x 54.3 cm)
Collection of the artist
p. 42

Going through the Glacier, 1975
Collage with pastel, ink, and fabric on paper
15⅝ x 21½ in. (39.6 x 54.5 cm)
Collection of the artist

Waiting for Spring in the Hole, 1975
Collage with pastel, ink, and fabric on paper
15½ x 21⅝ in. (39.5 x 54.8 cm)
Collection of the artist

Birds, 1975
Collage with watercolor and ink on paper
25¾ x 20¼ in. (65.5 x 51.5 cm)
Takahashi Collection, Tokyo

Ennui, 1976
Sewn and stuffed fabric with silver paint
and shoes
Two panels, each 72 x 38½ x 9 in.
(183 x 98 x 23 cm)
Takahashi Collection, Tokyo
p. 162

Violet Obsession, 1994
Stuffed cotton over rowboat and oars
43¼ x 150⅜ x 70⅞ in. (109.8 x 381.9 x 180 cm)
Museum of Modern Art, New York. Gift of
Mr. and Mrs. Joseph Duke
p. 163

Life (Repetitive Vision), 1998
Stuffed cotton, urethane, paint, and wood
Fifty-eight parts, dimensions variable
Courtesy of David Zwirner, New York;
Ota Fine Arts, Tokyo/Singapore;
Victoria Miro, London
pp. 164–65

Accumulation of Stardust, 2001
Acrylic on canvas
Three panels, each 76⅜ x 153⅞ in.
(194 x 390.9 cm)
Matsumoto City Museum of Art
pp. 134–35

The Obliteration Room, 2002–present,
installed 2017
Furniture, white paint, and dot stickers
Dimensions variable
Collaboration between Yayoi Kusama and the
Queensland Art Gallery, Brisbane, Australia
Commissioned Queensland Art Gallery,
Brisbane, Australia
Gift of the artist through the Queensland Art
Gallery Foundation, 2012. Collection of the
Queensland Art Gallery, Brisbane, Australia
p. 210

Infinity-Nets, 2005
Acrylic on canvas
76½ x 76½ in. (194.31 x 194.31 cm)
Collection of Jerry Yang and Akiko Yamazaki
p. 136

Dots Obsession XZQBA, 2007
Acrylic on canvas
63⅞ x 63⅞ in. (162 x 162 cm)
The Rachel and Jean-Pierre Lehmann
Collection
p. 137

Dots Obsession—Love Transformed into Dots,
2007, installed 2017
Suspended vinyl balloons, large balloon dome
with mirror room, peep-in mirror dome, and
projected digital video
Balloons: 59 in. (150 cm); 98⅜ in. (250 cm);
118 in. (300 cm) diam.
Courtesy Victoria Miro, London
pp. 94–95

*Infinity Mirrored Room—Aftermath of
Obliteration of Eternity*, 2009
Wood, mirrors, plastic, acrylic, LEDs,
and aluminum
163½ x 163½ x 113¾ in. (415 x 415 x 287.4 cm)
Collection of the artist
pp. 102–03

I Love Myself, I Adore Myself So, 2010
Acrylic on canvas
76⅜ x 76⅜ in. (194 x 194 cm)
Collection of the artist
p. 170

Ends of the Universe, Abode of Love, 2012
Acrylic on canvas
63¾ x 63¾ in. (162 x 162 cm)
Mr. and Mrs. Charles Diker
p. 186

Flowers that Bloomed Today, 2012
Acrylic on canvas
76⅜ x 76⅜ in. (194 x 194 cm)
Collection of the artist
p. 180

*Infinity Mirrored Room—The Souls of Millions
of Light Years Away*, 2013
Wood, metal, mirrors, plastic, acrylic panel,
rubber, LED lighting system, and acrylic balls
113¼ x 163½ x 163½ in. (287.7 x 415.3 x
415.3 cm)
Collection of the artist; The Broad Art
Foundation, Los Angeles
pp. 106–07

Memory of Love, 2013
Acrylic on canvas
76⅜ x 76⅜ in. (194 x 194 cm)
Collection of the artist
p. 171

My Heart Soaring in the Sunset, 2013
Acrylic on canvas
76⅜ x 76⅜ in. (194 x 194 cm)
Courtesy of David Zwirner, New York;
Ota Fine Arts, Tokyo/Singapore;
Victoria Miro, London
p. 182

Searching for Love, 2013
Acrylic on canvas
76⅜ x 76⅜ in. (194 x 194 cm)
Miyoung Lee and Neil Simpkins
p. 177

I Who Have Taken an Anti-Depressant, 2014
Acrylic on canvas
76⅜ x 76⅜ in. (194 x 194 cm)
Private collection
p. 173

My Adolescence in Bloom, 2014
Stuffed cotton, metal, and acrylic paint
61 x 32⅝ x 29½ in. (155 x 83 x 75 cm)
Collection of the artist
pp. 188–89

The Season of Blossoming Red Buds, 2014
Stuffed cotton, metal, and acrylic paint
24 x 29½ x 11¾ in. (61 x 75 x 30 cm)
Collection of the artist

Story after Death, 2014
Acrylic on canvas
76⅜ x 76⅜ in. (194 x 194 cm)
Collection of the artist
p. 172

Surrounded by Heartbeats, 2014
Stuffed cotton, metal, and acrylic paint
76¾ x 29½ x 25⅝ in. (195 x 75 x 65 cm)
Collection of the artist

A Tower of Love Reaches Heaven, 2014
Stuffed cotton, metal, and acrylic paint
77⅛ in.; 23⅝ in. diam. (196 cm; 60 cm diam.)
Collection of the artist
pp. 188–89

Welcoming the Joyful Season, 2014
Stuffed cotton, metal, and acrylic paint
37¾ x 43¼ x 18½ in. (96 x 110 x 47 cm)
Collection of the artist
pp. 188–89

With All My Flowering Heart, 2014
Stuffed cotton, metal, and acrylic paint
24 x 29½ x 11¾ in. (61 x 75 x 30 cm)
Collection of the artist
pp. 188–89

All about My Flowering Heart, 2015
Stuffed cotton, metal, and acrylic paint
37¾ x 43¼ x 18½ in. (96 x 110 x 47 cm)
Collection of the artist
pp. 188–89

Far End of Disappointment, 2015
Acrylic on canvas
76⅜ x 76⅜ in. (194 x 194 cm)
Collection of Mr. Guoqing Chen
p. 181

Living on the Yellow Land, 2015
Acrylic on canvas
76⅜ x 76⅜ in. (194 x 194 cm)
Collection of the artist
p. 175

My Love Is Buried in Ten Petals, 2015
Stuffed cotton, metal, and acrylic paint
24 x 29½ x 11¾ in. (61 x 75 x 30 cm)
Collection of the artist

Unfolding Buds, 2015
Stuffed cotton, metal, and acrylic paint
59 x 23⅝ x 25⅝ in. (150 x 60 x 65 cm)
Collection of the artist
p. 187

When the Flower of My Heart Blooms, 2015
Stuffed cotton, metal, and acrylic paint
24 x 29½ x 11¾ in. (61 x 75 x 30 cm)
Collection of the artist
pp. 188–89

Whispering of the Heart, 2015
Acrylic on canvas
76⅜ x 76⅜ in. (194 x 194 cm)
Collection of the artist
p. 178

All about My Heart, 2015
Acrylic on canvas
76⅜ x 76⅜ in. (194 x 194 cm)
Collection of the artist
p. 184

Flowers that Bloomed in Heaven, 2015
Acrylic on canvas
76⅜ x 76⅜ in. (194 x 194 cm)
Collection of the artist
p. 185

The Wind Blows, 2016
Acrylic on canvas
76⅜ x 76⅜ in. (194 x 194 cm)
Collection of the artist
p. 179

Aggregation of Spirits, 2016
Acrylic on canvas
76⅜ x 76⅜ in. (194 x 194 cm)
Collection of the artist
p. 174

Pleasure to Be Born, 2016
Acrylic on canvas
76⅜ x 76⅜ in. (194 x 194 cm)
Collection of the artist
p. 176

*Infinity Mirrored Room—All the Eternal Love
I Have for the Pumpkins,* 2016
Wood, mirrors, plastic, acrylic, and LEDs
163⅜ x 163⅜ x 115⅝ in. (415 x 415 x 293.7 cm)
Collection of the artist
pp. 112–15

My Heart's Abode, 2016
Acrylic on canvas
76⅜ x 76⅜ x 2¾ in. (194 x 194 x 7 cm)
Courtesy Yayoi Kusama Inc.; Ota Fine Arts,
Tokyo/Singapore; David Zwirner, New York;
and Victoria Miro, London
p. 183

Pumpkin, 2016
Fiber-reinforced plastic
96½ x 96½ x 102⅜ in. (245 x 260 x 260 cm)
Collection of the artist

Off-cut of Infinity Net Painting, 1960
Oil on canvas
14¼ x 389¾ in. (36 x 9.9 m)
Collection of the artist
(Not illustrated and not included in
the Hirshhorn's presentation)

Credits

We would like to thank all those who gave their kind permission to reproduce material. Individual works of art appearing herein may be protected by copyright in the United States of America or elsewhere, and may not be reproduced in any form without the permission of the rights holders. In reproducing the images contained in this publication, the Museum obtained the permission of the rights holders whenever possible. In those instances where the Museum could not locate the rights holders, notwithstanding good-faith efforts, it requests that any contact information concerning such rights holders be forwarded so that they may be contacted for future editions.

Artists' Copyrights

All works by Yayoi Kusama © Yayoi Kusama.

© Dara Birnbaum and Electronic Arts Intermix (EAI), New York: p. 144, fig. 2.

© Heinz Mack / Artists Rights Society (ARS), New York / VG Bild-Kunst, Bonn: p. 25, fig. 13.

© Christian and Franziska Megert / Artists Rights Society (ARS), New York/ ProLitteris, Zurich: p. 23, fig. 10.

© Robert Morris / Artists Rights Society (ARS), New York: p. 123, fig. 4.

© Barnett Newman / Artists Rights Society (ARS), New York: p. 121, fig. 1.

© Henk Peeters / ARS, New York. Courtesy of the ZERO foundation, Düsseldorf: p. 24, fig. 12

© Pipilotti Rist / Luhring Augustine, New York, and Hauser & Wirth: p. 144, fig. 3

Photographic Credits

All images courtesy and © Yayoi Kusama unless listed below.

Courtesy Akron Art Museum: plate 41.

© Oscar van Alphen / Nederlands Fotomuseum: p. 23, fig. 10.

© Shigeo Anzai: p. 205, fig. 27.

Courtesy of the Baltimore Museum of Art, photo by Mitro Hood: plate 31.

Courtesy Brendan Becht, photo by Marianne Dommisse: p. 24, fig. 11; plates 39–40.

Courtesy of the Birmingham Museum of Art, Alabama: plate 5.

Courtesy of the Blanton Museum of Art, University of Texas at Austin, photo by Rick Hall: plate 14.

Courtesy of Suzanne Deal Booth, photo by Colin Doyle: plate 30.

© Bungeishunju, p. 203, fig. 23

Courtesy of Ethan Cohen Gallery and © Ushio Shinohara: p. 202, figs. 21–22.

Courtesy Paula Cooper Gallery, New York: p. 123, fig. 5.

Photograph by Alain Dejean/SYGMA/Corbis: pp. 82–83.

Courtesy of Mr. and Mrs. Charles Diker, photo by Cathy Carver: plate 63.

Courtesy of Mark Diker and Deborah Colson, photo by Mark Diker: plate 12.

Courtesy Gagosian Gallery: plate 29.

Photographs by J. Good: p. 149, fig. 6.

© Tom Haar: p. 203, fig. 24.

Hirshhorn Museum and Sculpture Garden, Washington, DC; photos by Cathy Carver: plate 13; plate 43.

Photo by Eikoh Hosoe: p. 14, fig. 2; plate 24; pp. 46–47; p. 200, fig. 18.

Photo by Francis Keaveny: frontispiece.

Courtesy of the Rachel and Jean-Pierre Lehmann Collection: plate 34.

Photo by Tomoaki Makino: p. 167; fig. 1.

Courtesy Matsumoto City Museum of Art: plate 32; p. 191, fig. 2.

Courtesy of the Mattress Factory, Pittsburgh, PA, photo by John Charley: pp. 74–75.

Photo courtesy of Mediasphere Communications: pp. 68–69.

Courtesy Victoria Miro, London, photo by Thierry Bal: pp. 92–95, pp. 112–15, pp. 116–17; photo by Robert Glowacki: plate 60.

Photo by Peter Moore: pp. 52–53.

© The Museum of Modern Art / Licensed by SCALA / Art Resource, NY: p. 121, fig. 1; plate 45.

Courtesy National Gallery of Art, Washington, DC: plate 28.

Courtesy National Museum of Modern Art, Tokyo: p. 15, fig. 3.

Courtesy of Beatrice and Hart Perry collection: p. 121, fig. 2; p. 197, figs. 12–13; photo by Rudolph Burckhardt: p. 122, fig. 3; photo by Cathy Carver: plate 19; photo by Hal Reiff: p. 22, fig. 8.

© Matthew Placek / Courtesy of the Glass House, a site of the National Trust for Historic Preservation, New Canaan, Connecticut: p. 212, fig. 36.

Courtesy Queensland Art Gallery, Australia, photo by QAGOMA Photography: pp. 86–87; plate 65.

Courtesy The Rachofsky Collection, photo by Michael Bodycomb, New York: plate 38; photo by Kevin Todara: plate 42.

Photograph by Hal Reiff: p. 52.

Courtesy of Pipilotti Rist/ Luhring Augustine, New York, and Hauser & Wirth: p. 144, fig. 3.

Courtesy of the Setagaya Art Museum: plates 7–8.

Photos by Shunk-Kender © J. Paul Getty Trust. The Getty Research Institute. Digital Images © The Museum of Modern Art / Licensed by SCALA / Art Resource, NY: plates 25–27, 35–37.

Aldo Tambellini Archives, courtesy of Anna M. Salamone, photographs by Ted Wester: p. 147. fig. 4; p. 148, fig. 5.

© Tate, London 2016: pp. 88–89; pp. 104–105.

Photo by TPG Digital Art Services: plates 2 and 4.

Photo courtesy of Norihiro Ueno: p. 65.

Photo by Harrie Verstappen: p. 30, figs. 15–16.

Courtesy Whitney Museum of American Art, New York, photo by Sheldan C. Collins: pp. 80–81.

Courtesy ZERO Foundation, Düsseldorf: p. 24, fig. 12; p. 25, fig. 13; p. 55.

Courtesy of David Zwirner, New York: p. 6; plates 3, 6, 16–17, 46.

Published in 2017 by the Hirshhorn Museum and Sculpture Garden
and DelMonico Books • Prestel

 Smithsonian

DelMonico Books, an imprint of Prestel, a member of the
Verlagsgruppe Random House GmbH

Prestel Verlag
Neumarkter Strasse 28
81673 Munich

Prestel Publishing Ltd.
14–17 Wells Street
London W1T 3PD

Prestel Publishing
900 Broadway, Suite 603
New York, NY 10003

www.prestel.com

Edited by Tom Fredrickson with Rhys Conlon
Designed by Miko McGinty Inc.
Production coordinated by Luke Chase, DelMonico Books • Prestel

Printed and bound in China

Library of Congress Cataloging-in-Publication Data

Names: Yoshitake, Mika, editor. | Kusama, Yayoi. Works. Selections. |
 Hirshhorn Museum and Sculpture Garden, organizer, host institution.
Title: Yayoi Kusama : infinity mirrors / Edited by Mika Yoshitake ; With
 contributions by Mika Yoshitake, Gloria Sutton, Alexander Dumbadze,
 Melissa Chiu, Miwako Tezuka, Alex Jones.
Other titles: Yayoi Kusama (Hirshhorn Museum and Sculpture Garden)
Description: New York : DelMonico Books/Prestel, 2017. | "This catalogue is
 published in conjunction with the exhibition Yayoi Kusama: Infinity
 Mirrors, organized by the Hirshhorn Museum and Sculpture Garden,
 Smithsonian Institution, Washington, DC, February 23-May 14, 2017." |
 Includes bibliographical references.
Identifiers: LCCN 2016034312 | ISBN 9783791355948
Subjects: LCSH: Kusama, Yayoi—Exhibitions. | Installations
 (Art)—Japan—Exhibitions.
Classification: LCC N7359.K87 A4 2017 | DDC 709.2—dc23
LC record available at https://lccn.loc.gov/2016034312

A CIP catalogue record for this book is available from the British Library.

ISBN: 978-3-7913-5594-8

Cover: *Infinity Mirrored Room—All the Eternal Love I Have for the Pumpkins*, 2016.
Wood, mirror, plastic, black glass, LED. Collection of the artist. Courtesy of Ota
Fine Arts, Tokyo/Singapore, and Victoria Miro, London. © Yayoi Kusama

Frontispiece: Yayoi Kusama in *Kusama's Peep Show or Endless Love Show*, 1966.
Wood, mirrors, metal, and lightbulbs. Installed at Castellane Gallery, New York,
1966. Photo by Francis Keaveny. Courtesy of the artist © Yayoi Kusama

Page 6: *Infinity Mirrored Room—The Souls of Millions of Light Years Away*, 2013.
Wood, metal, mirrors, plastic, acrylic panel, rubber, LED lighting system, and
acrylic balls. Courtesy of David Zwirner, New York. © Yayoi Kusama

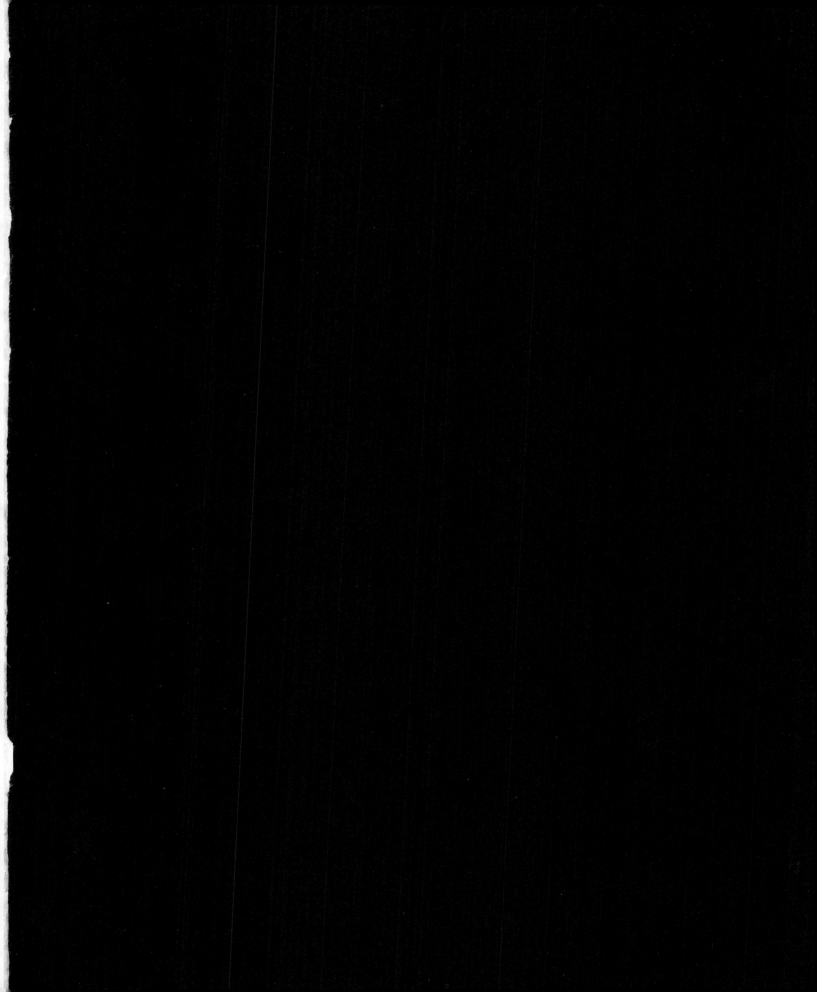